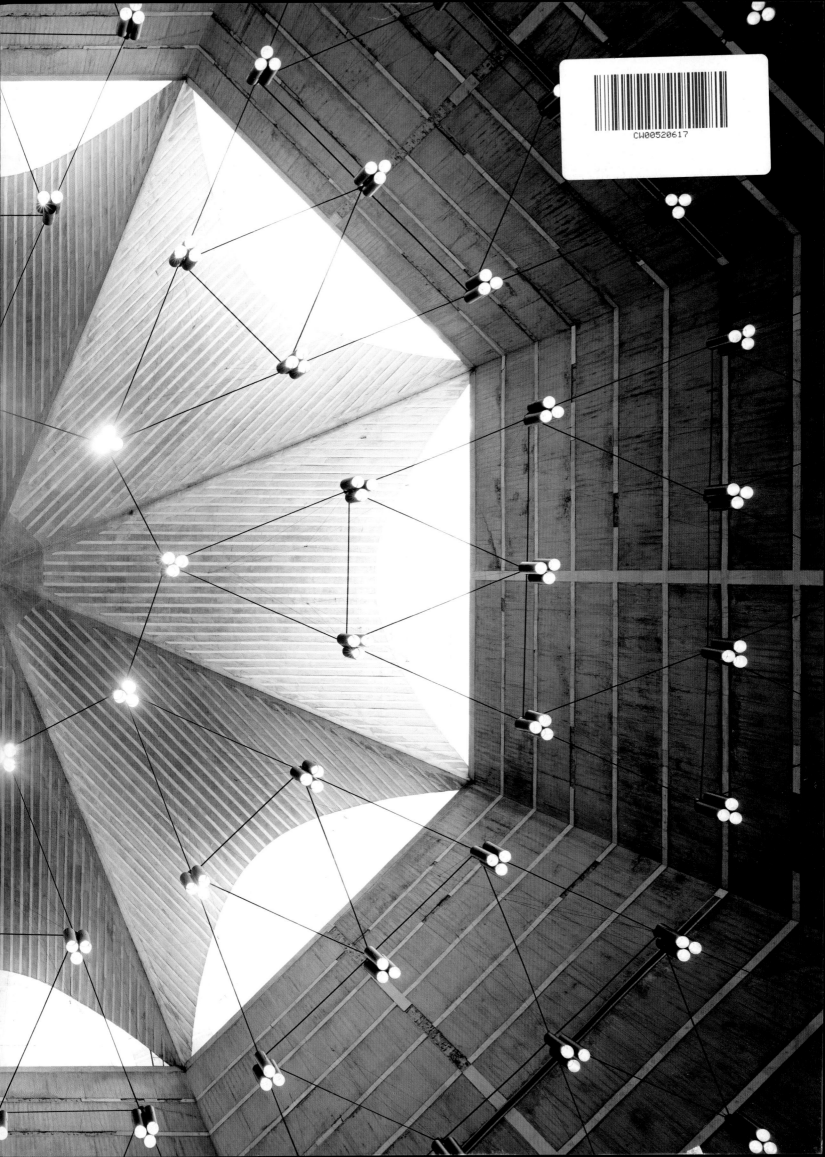

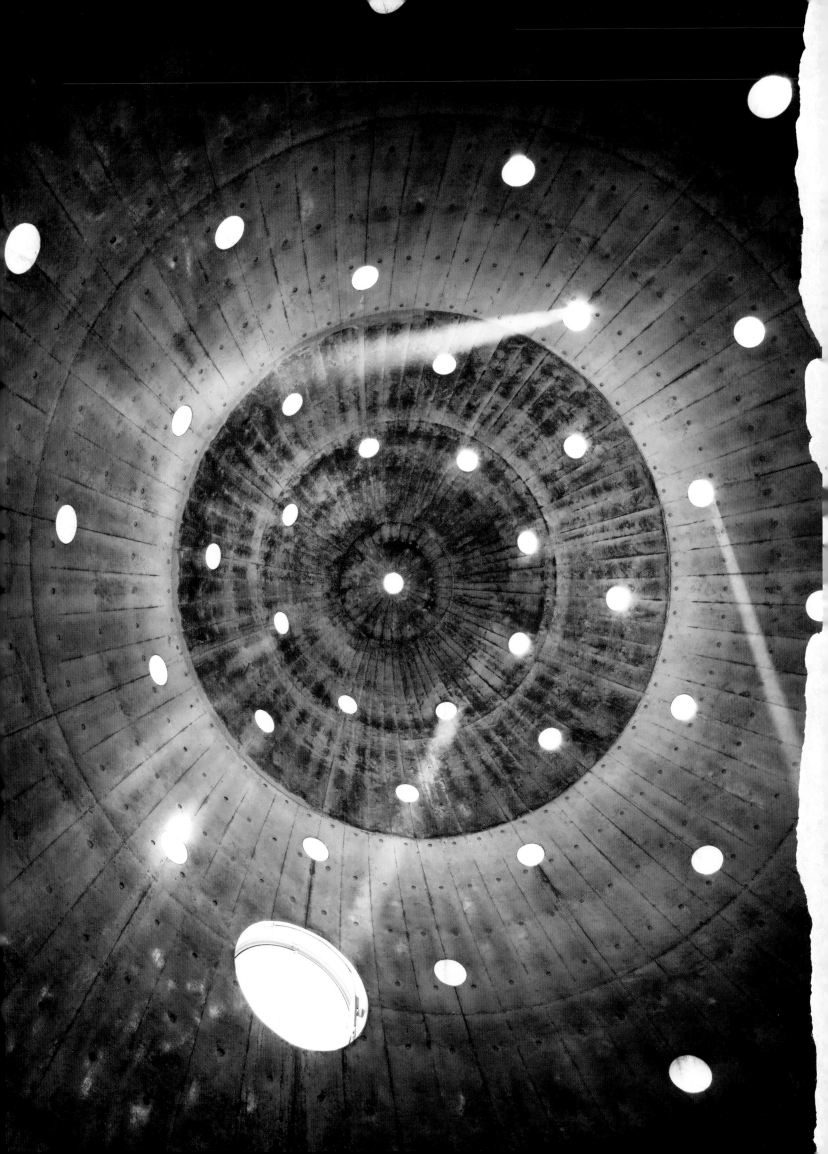

ALEXANDER GORLIN

KABBALAH

IN ART AND ARCHITECTURE

Editorial director: Suzanne Slesin

Design: Stafford Cliff

Managing editor: Regan Toews

Production: Dominick J. Santise, Jr.

Assistant editor: Deanna Kawitzky

Research assistant: Perri Lapidus

בראשית ברא אלהים

POINTED LEAF PRESS, LLC.
WWW.POINTEDLEAFPRESS.COM

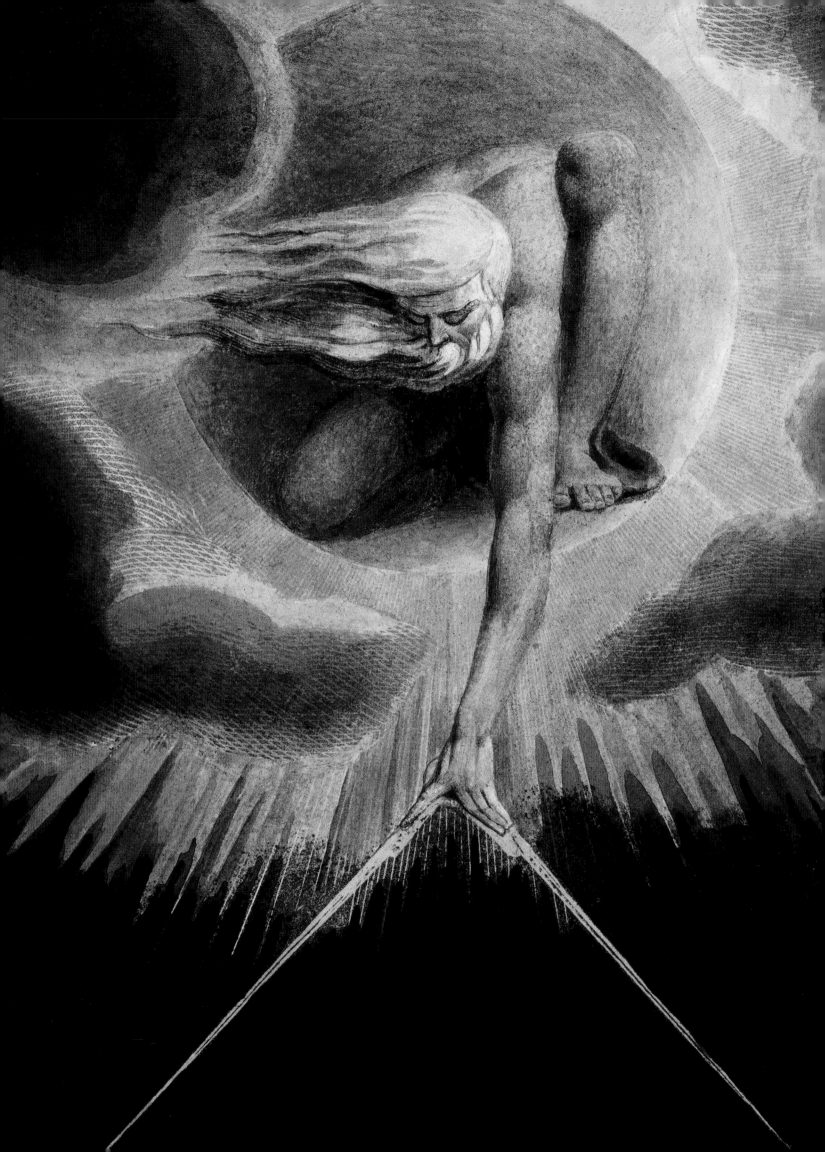

CONTENTS

את השמים ואת הארץ

Kabbalah as a source of inspiration | קבלה

Alexander Gorlin

This book is a personal interpretation of the Kabbalah as a source of evocative ideas that have either inspired, or are illustrated by, significant works of art and architecture. The idea of esoteric Jewish mysticism having a place at the table of contemporary art has been raised previously, but not in the more comprehensive manner, as presented here. Kabbalah, which in Hebrew means "that which has been received," is the Jewish mystical tradition that stretches back at least 3,500 years. Kabbalists believe the secrets they possess were handed down since the time of Abraham, but the main body of teaching was not resolved fully until the medieval period of the twelfth century, culminating in the *Zohar*, the Book of Radiance, of 1280, and subsequently, in 1570, the teachings of Rabbi Isaac Luria in Safed, Palestine. The Kabbalah seeks to understand the mystical inner workings of God, and to direct initiates to an ecstatic experience of the Divine. It views the universe as a vast interconnected system of forces in which God and mankind have a direct relationship of checks and balances, with the actions of each reverberating on the other in mysterious ways. There are multiple levels of reality, from the visible world to the incomprehensible space of the divine. Ultimately, the entire cosmos is a code for the name of God and the Torah, his revealed holy scripture. In the Kabbalah, the Torah and its Hebrew words and letters are synonymous with God Himself, and therefore one of the mystic's goals is to attempt to understand the hidden meanings behind the literal words of the Bible.

The Kabbalah is filled with metaphors pregnant with meaning for art and architecture; much of its imagery is at once abstract and richly literal in its descriptions of the heavenly realm. The *Zohar* is a poem of light and dark, a rainbow of colors and materials. There is ample reference to metaphors of the celestial world of chambers, houses, palaces, pillars, dwellings, and even interiors through the elaborate curtains concealing the ark of the covenant. Since the early twentieth century, there has also been an explosion of scholarship about the Kabbalah, initially led by Gershom Scholem, the great Jewish scholar of the Hebrew University in Israel. He opened the door to previously inaccessible material, from the 1920s through the 1980s, bringing the fruits of primary textual research to the English speaking world. In fact, the publication of Scholem's 1941 book, *Major Trends in Jewish Mysticism*, opened the eyes of many artists and architects to the provocative and visual mysteries of the Kabbalah.

The book found a receptive audience already schooled in the art of the "other," such as African primitive art and Surrealism. Interest in the Kabbalah has blossomed over the past twenty years, through Scholem's students—such as Professor Moshe Idel—and with numerous publications and institutes devoted to spreading the word, as more people have been attracted to spirituality and mysticism as a means of transcending the everyday and disquieting aspects of the present. Research continues, with a major ongoing English translation of the *Zohar*, by Daniel Matt, which has been subsidized by Margot Pritzker of the architectural Pritzker Prize family, an exposition of the Kabbalah by the literary scholar Harold Bloom and, of course, the promotions in our pop culture by celebrities such as Madonna. Until relatively recently, the Kabbalah was only for the Jewish devout, where its study was traditionally allowed only for men over the age of forty. It therefore remained a largely forgotten, if not strange part of the "occult" in the Western literary tradition.

My own journey into the proverbial "orchard" of the Kabbalah began as an architect faced with the task of designing a synagogue in Kings Point, New York, in 1995. I was aware of the absence of an authentic style of design for synagogues due to the lack of opportunity of the Jewish people to develop a style of their own, often confined to physical ghettos or thrown out of their host countries. In the nineteenth century they often adopted the architectural style of the places in which they lived, either classical, Byzantine, or "exotic." I chose instead to search beyond the themes of the Old Testament, such as the "burning bush" that became the hackneyed images of synagogue design of the 1960s, for more authentic sources of inspiration. To my amazement, Scholem's books revealed a world I had not known about before, as well as a series of ideas and concepts that were immediately relevant to the design of the synagogue.

OPPOSITE The ark for North Shore Hebrew Academy, in Kings Point, New York, built in 1999, is a cube of light fractured by two inverted triangles that evoke not only the Star of David but the pattern of the *Sefirot* as well. The *Sefirot* is also the diagram on the curtain in front of the ark, and the facets of the triangles recall the crystalline crown of *Keter*, the highest of intersecting points of light. The triangles of glass also serve an acoustical purpose, reflecting sound back to the congregation as they pray facing the ark.

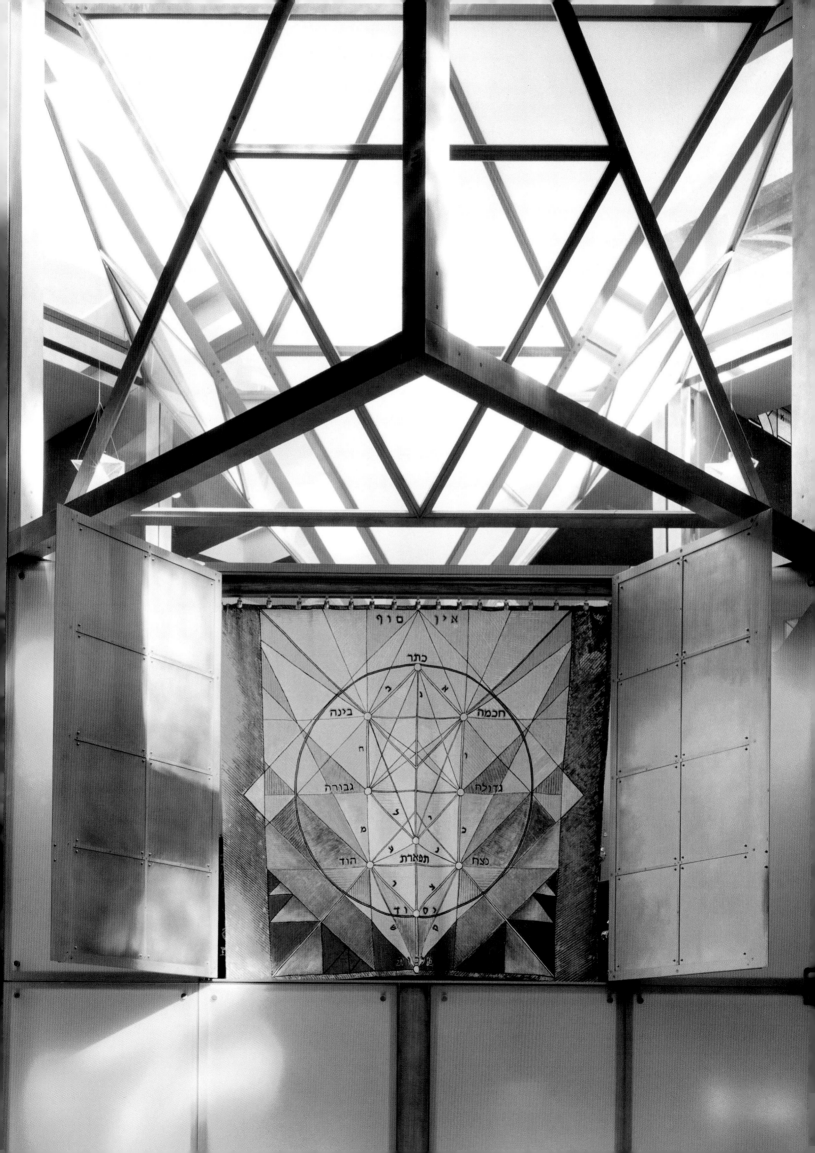

As I studied the texts in more depth, it became apparent that many of these ideas had already been in circulation in the world of architecture, art and literature, especially at the beginning of the Abstract Expressionist period of American art in the early 1950's. These artists had been involved with the subconscious world of myths and images from Surrealism and dreams through the psychoanalysts Sigmund Freud and Carl Jung. It was a small step to the mysticism of the Kabbalah, with its more abstract, conceptual ideas. In the American poet Allen Ginsberg's famous poem *Howl* of 1955, he references "bop kabbalah." In the 1950s, the American Abstract Expressionist Barnett Newman, who was Jewish, entitled many of his paintings with Hebraic names. The artist also designed a synagogue for an exhibition at the Jewish Museum in 1961 with the theme of *Tzimtzum*, the Kabbalistic creation theme. The art historian Dore Ashton, who personally knew the Russian-born painter Mark Rothko, compared his use of light to the radiance of the *Zohar*. In 1963, the American architect Louis Kahn based a plan of a synagogue in Philadelphia on the Tree of the *Sefirot*. Architect Steven Holl acknowledged he studied the writings of Scholem for the design of his 1990 St. Ignatius Chapel in Seattle, Washington. Certainly most unusual is the German artist Anselm Kiefer's explicit use of the most esoteric Kabbalistic themes for over twenty years. In literature, the Argentinian writer Jorge Luis Borges quotes from the *Zohar*, and in his 1949 story *The Aleph*, he writes: "In the Kabbala, that letter signifies *Ein-Sof*, the pure and unlimited godhead; it has also been said that its shape is that of a man pointing to the sky and the earth, to indicate that the lower world is the map and mirror of the higher."

I was raised in a fairly traditional Jewish background, and while we were not strictly Orthodox, we kept kosher at home. My father had emigrated from Minsk, Byelorussia, in 1924, and my paternal grandfather was a rabbi, as are two of my uncles. The literature of the Old Testament was a constant presence in my upbringing. I went three times a week to Talmud Torah, Hebrew School, in Forest Hills, New York. There I was exposed to the architectural projects of the Bible: Noah's Ark, the Tabernacle in the desert, and Solomon's Temple. The relentless detail of each project held great mystery to my receptive mind, and of course I did my own reconstruction of the Temple in Jerusalem for a school paper. To my surprise, in my mid-teens, my otherwise apparently rational mother took my sister and me to her very own Kabbalistic astrologer, a Mr. Obloe, in an old apartment on West End Avenue in Manhattan that was straight out of a Woody Allen film. We were informed that the astrologer had been the "family advisor" for two generations. This was my first direct exposure to a form of Kabbalah, although I must admit I was more mystified than impressed at his observations, limited as they were to the signs of the Zodiac. Subsequently, I attended the Cooper Union School of Architecture, the virtual academy of the mysteries of modernism, where dean John Hejduk held court as the chief keeper of the faith. Here, Le Corbusier was God and his every word and mark on paper was studied with fetishistic intent. In this atmosphere, my long-forgotten interest in the Bible as a secret source of architectural inspiration was revived, as I learned from Professor Joseph Rykwert how the Old Testament influenced architecture from the Renaissance to modernism in his book

Adam's House in Paradise. I also added my own observations in a paper published in the Japanese publication *Architecture + Urbanism* in 1985, entitled *Biblical Imagery in the Work of Louis L. Kahn*. This experience culminated in my thesis for Cooper Union, which, at least at the time, in 1978, seemed radical, entitled *Reconstruction of Ezekiel's Vision of the Temple*. In the face of absolute abstract modernism in the school, I chose to revive history by a study of the detailed description of the Temple in Jerusalem in its apocalyptic glory as presented in the *Book of Ezekiel*. Of course, as the structure was symmetrical in plan, my thesis advisor, Raimund Abraham, strongly suggested it be "violated" in some way, so I placed it on axis with the subway lines in the Beaux Arts plan of Union Square in Manhattan. The sacred and profane city battled for dominance, as in William Blake's poem *Jerusalem*. At least I had made public my private obsession with my Jewish identity in relationship to my chosen path of architecture.

All of this lay dormant again for twenty years until, as noted above, I was commissioned to design a synagogue that revived not only my archeology of Biblical projects, but added a layer of Kabbalistic commentary to the mix. All this would be quite academic except for the fact that the synagogue was built for the North Shore Hebrew Academy in Kings Point, New York—formerly of East Egg fame in *The Great Gatsby*, and once an anti-Semitic community. The building was inspired by direct themes from the Kabbalah, from the overall form to the details of the stained glass windows, the ark, its ritual curtain, and the eternal light. The later synagogues I have designed all have at least some reference to the themes in the Kabbalah.

This book is a re-reading of art and architecture through the lens of the Kabbalah. As the Kabbalah is a theory of correspondence with everything connected to everything else, it is not inappropriate to ascribe Kabbalistic meanings to art or architecture—in illustration, allusion, metaphor, symbol, or parallel, even when clearly not intended, as in American architect Frank Gehry's museum in Bilbao, Spain. Gehry told me he had wanted to design a synagogue for years, and when I asked him about the Kabbalah, he told me he "tried to study the *Zohar*, but it was too difficult."

A brief summary of the basic themes of the Kabbalah follows, with more detail in the introduction to the individual chapters. The earliest sources for the Kabbalah are the study of the first lines of the book of *Genesis* and the vision of Ezekiel that recounts the Divine "Throne-Chariot." These passages of the Bible were considered too "mind bending" and were forbidden to be taught except to a select few. It was written that "one should not teach the Act of Creation to two or the Divine Chariot to one, unless he is wise and understands by himself." The world of mysticism was referred to as the "orchard," from the Hebrew word *pardes,* which is an acronym for the four levels of interpretive meaning of the Torah: *P'shat, Remez, Drash,* and *Sod*.

OPPOSITE The interior of the North Shore Hebrew Academy Sanctuary is focused on the ark that radiates light diffused from a skylight. As the Torah is the light, so does the ark holding the sacred scrolls illuminate the congregation sitting in a radial pattern around it.

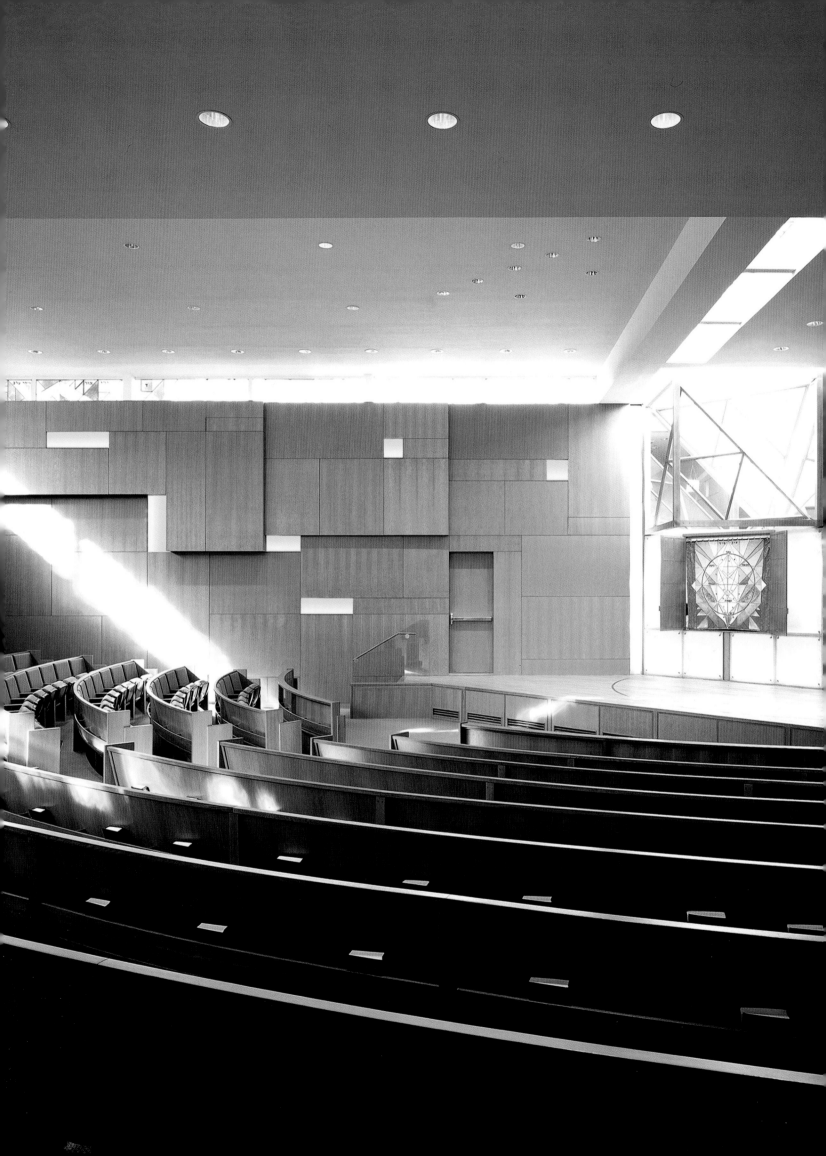

P'shat is the literal or simple meaning; *Remez* refers to an allusive meaning and also to *gematria*, the transposition of numbers from the letters, as in *aleph* =1, *bet* = 2, etc; *Drash* is a more elaborate interpretation; and *Sod* is the secret, ultimate meaning. In the Talmud, a famous story relates that of four eminent rabbis who entered the "orchard," only one, Rabbi Akiva, "entered in peace and left in peace." The dangers of the ascent, and subsequent descent, to or from a vision of God on his throne, were too much for Rabbi ben Zoma, who went mad, Rabbi ben Azai, who died, and Rabbi ben Abuya, who became a heretic. Nevertheless, proceed with this book at your peril; you have been forewarned!

The vision of Ezekiel was set in 586 B.C.E. in Babylon, where the Babylonians exiled the Israelites after the destruction of Jerusalem. At the beginning of the book, Ezekiel beholds a vision of a strange flying chariot with four faces: a man, a lion, an ox, and an eagle. Above are "wheels within wheels," the rims inset with eyes, and above them, "the appearance of a man on a throne" in vivid colors. This enigmatic image inspired an entire school of mysticism that sought the ultimate goal of witnessing God on his throne. The journey of ascent entailed the passage through the seven heavenly palaces, the *Hekhalot*, which were guarded by ferocious angels and secret passwords. These images of ascension have their roots in Jacob's dream: "Here a ladder was set up on the earth, its top reaching the heavens, and here messengers of God were going up and down on it." The ladder is the mythical axis mundi connecting heaven and earth, and implies a series of hierarchical worlds. The idea of multiple worlds, where sacred shrines such as the Tabernacle or the Temple in Jerusalem are a copy of a heavenly model, is basic to the Kabbalah. The pattern below as based on the pattern above is a refrain repeated numerous times in the *Zohar*.

Including the world of daily existence, there are a total of four worlds, in ascending order: *Asiyah*, Action, the material world in which we live; *Yetzirah*, or the Creation, the world of angels; *Beri'ah*, the Formation, or the world of the Throne-Chariot; and finally, *Atzilut*, the Emanation, or the internal world of God. Combining the four levels of meaning with the four worlds gets very complicated and this is only the beginning of the mystical labyrinth in which one gets entangled. After the mystical books of the Throne-Chariot and heavenly Palaces, most important texts are: the third century *Sefir Yetzirah*, the Book of Creation, the tenth century *Sefer Bahir*, the Book of Brightness, and most important, the *Zohar*, the Book of Radiance, which was attributed to Moses de Leon around 1290.

In the enigmatic but enormously influential *Sefir Yetzirah*, which, according to different scholars, is dated anywhere from the first to fourth century A.C.E.: the world was created "with thirty-two mystical paths of wisdom… He created the world… ten *sefirot* of nothingness and twenty-two letters of foundation." The 22 letters are the Hebrew alphabet, combined with ten *sefirot* that later Kabbalists would associate with "emanations" from God. Since God completely filled the space of the cosmos, the world is literally carved out. The *Yetzirah* uses the words "hewed" or "engraved," as in writing. Creation took place specifically in Hebrew words and

letters, the holy language of the Divine. Furthermore, the Torah, the revealed scripture of God, is a code for the entire universe, and equivalent to the secret name of God. God's Holy Name, which has magical powers, has versions of 4 letters—called the Tetragrammaton—12, 42, and the grand 72-letter Name, the exact pronunciations of which have all been forgotten. One of the powers that the holy Name includes is to bestow life on inanimate material, the beginning of the Golem legend. The concept of gematria, the system of assigning numerical value to a word or phrase, transposes meanings to numerological significance. This intense emphasis on language, letters, and numbers is unique to the Kabbalah and was one of the concepts that was of great interest to Christian scholars during the Renaissance.

The idea of the ten *Sefirot* of light is elaborated in the *Book of the Bahir*, or Brightness, written in the twelfth century. The ten *sefirot* are the structure of the Divine usually portrayed as a geometric, tree-like diagram of interconnected points of light. This network of forces are balanced left and right between, for example, *Hesed* (Mercy) and *Din* (Judgment), and up and down, *Keter* (Crown) and *Malkhut* (Kingdom). The *Bahir* also introduces the idea that one of the ten *sefirot*, *Malkhut*, also called *Shekhinah*, is female, so that gender dualism is now part of the fundamental nature of God. The medieval period of Kabbalah culminated in the *Zohar* that was considered for centuries one of the three foundation books of Judaism, alongside the Bible and the Talmud. It is believed to be among the devout to have been written in the early second century A.C.E., by Rabbi Simeon ben Yochai. However, Scholem and many modern scholars now believe that Rabbi Moses de Leon wrote most of the material in the late thirteenth century, claiming to have copied an ancient manuscript. In fact when a wealthy Kabbalist asked to pay de Leon's widow for the original text, she said there was none and that "he wrote from his own mind."

The *Zohar* is a poetic and evocative series of interconnected stories, homilies and mystical revelations about the nature of the *Sefirot* and the world of the Throne-Chariot. It was written shortly before Dante Alighieri's *Divine Comedy* of 1317, and some of its passages appear to echo the *Zohar*, as in, "Because the light divine so penetrates/ The Universe, according to its merit,/ That naught can be an obstacle against it" *(Paradise, Canto xxxii)*. The *Zohar* was originally kept secret, except to a small group of adherents, but gradually, after its publication in Mantua in 1558-1560, it became more widely available, eventually becoming one of the pillars of Jewish tradition. After the exile of the Jews from Spain in 1492, various groups of Kabbalists settled in Israel in the town of Safed, where it is believed Rabbi ben Yochai was buried. One of its great scholars was Rabbi Isaac Luria, also called Ari, the Lion. He arrived in 1570 and died only two years

OPPOSITE To illustrate the Kabbalistic theme animating the design of the North Shore Synagogue as a "broken vessel," the beams separate and pull apart to let light flow into the spaces in between. The gaps are filled with stained glass in a fractured geometric pattern inscribed with Hebrew text and letters. The phrases are from *Genesis* and recreate the moment when language and light were in formation, filling the void of the *Tzimtzum* with patterns of "circle and line."

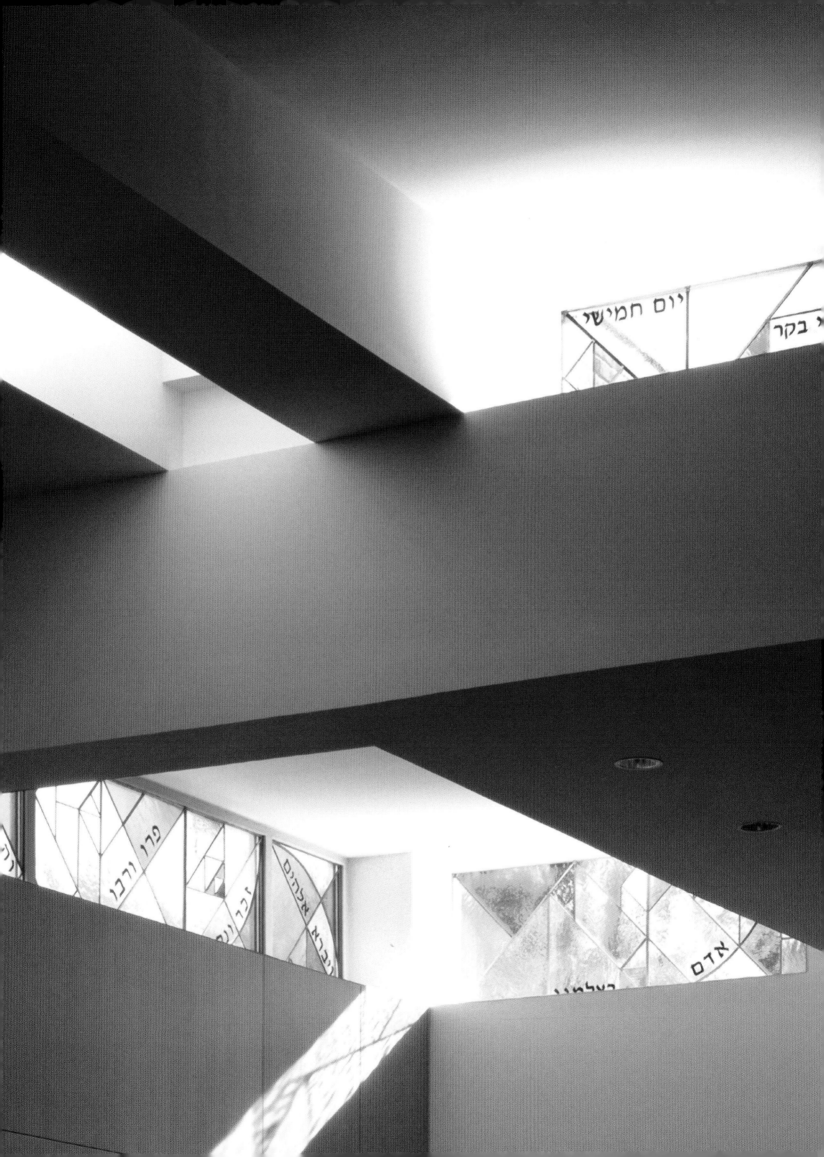

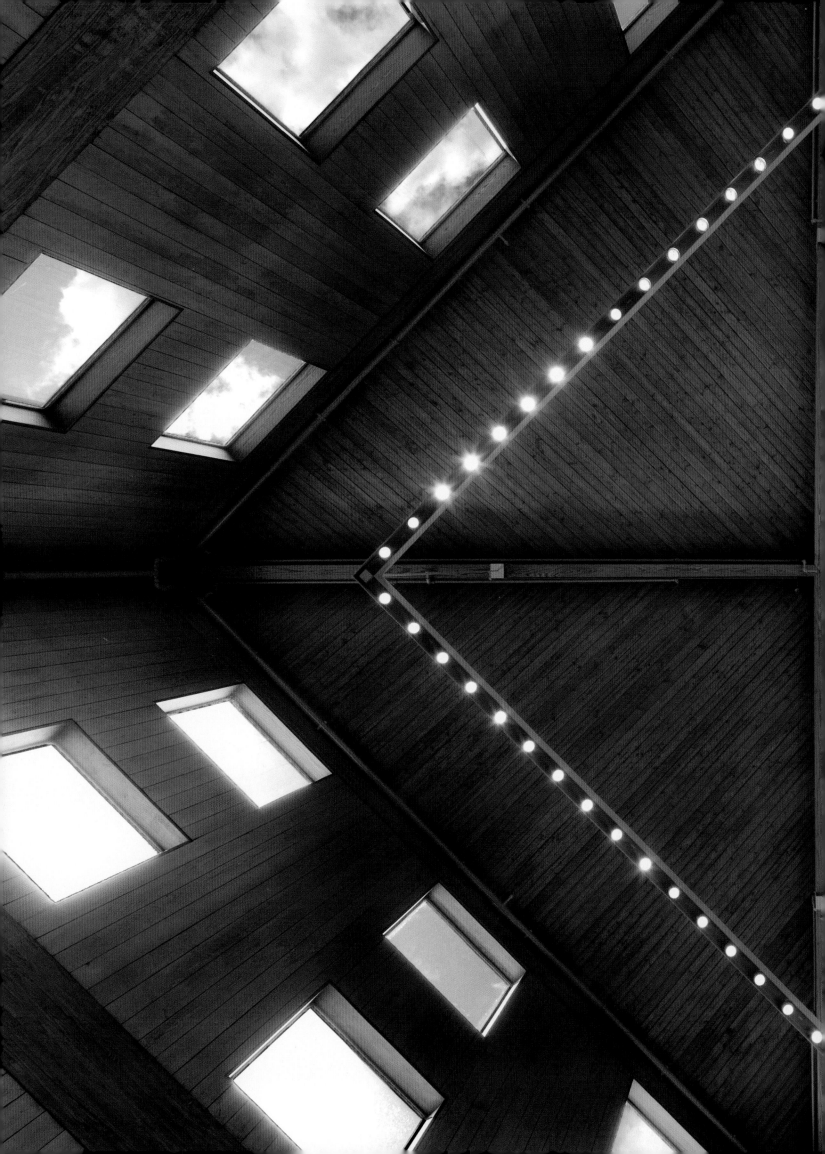

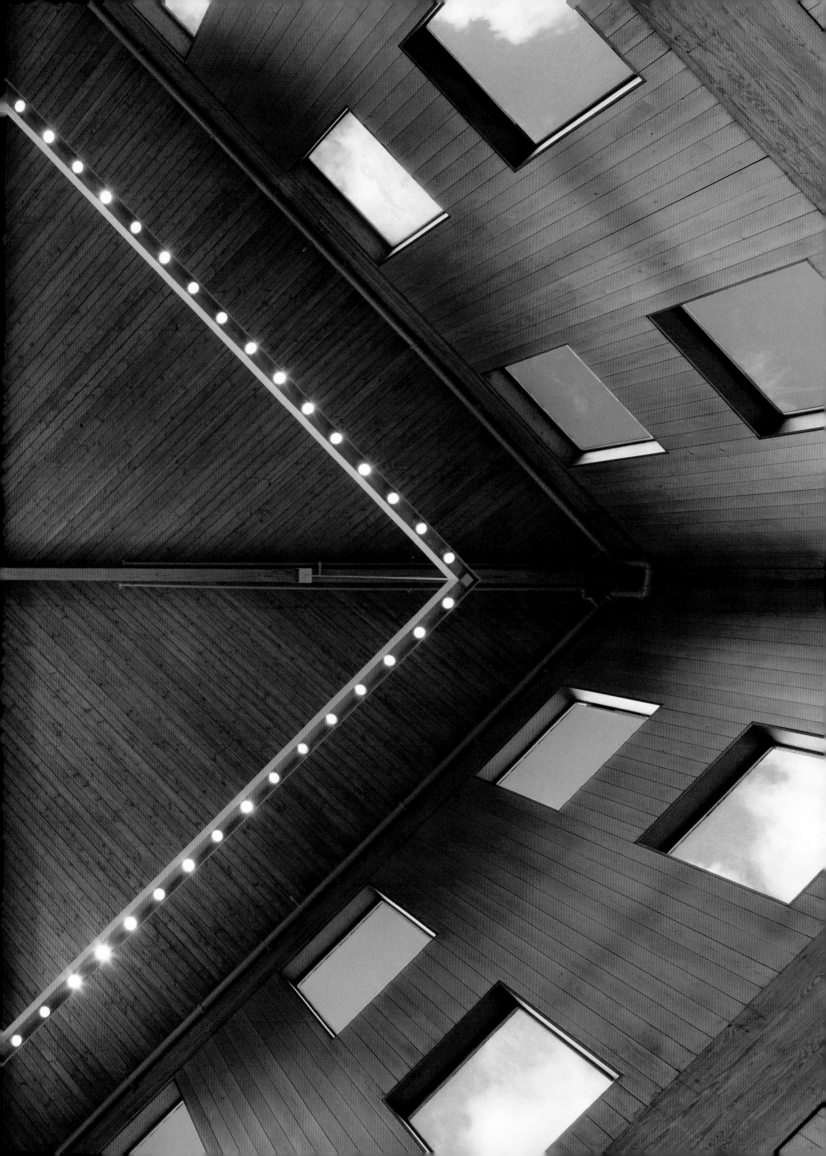

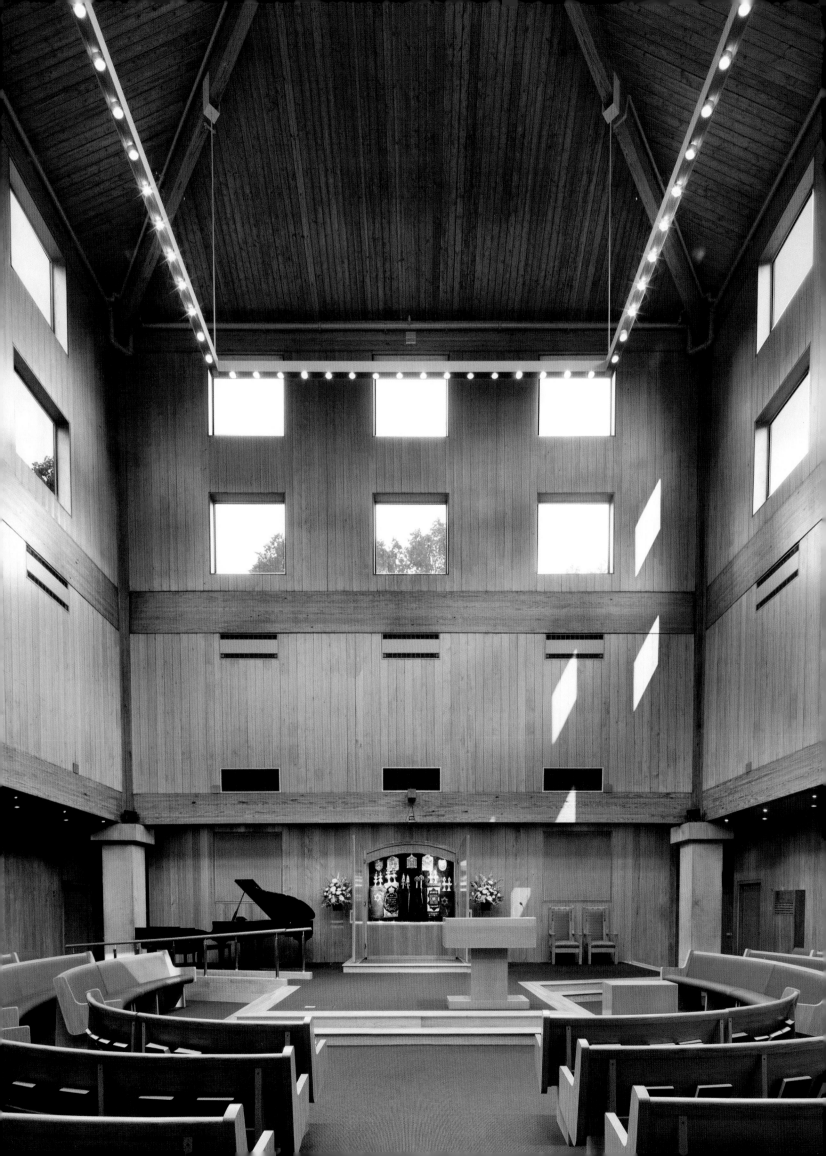

after, in 1572. Through his radical teachings, disseminated by his students, he revolutionized Kabbalah. Luria deals with the time before the first lines of *Genesis*, and posits the answer to the question: If God is everywhere, how can there be room for creation? Before, there was *Ein-Sof*, the infinite. Then, rather than an active gesture of creation, God contracts within himself in an action called the *Tzimtzum*. This withdrawal creates a vacuum into which a single ray of light can enter. The light refracts into the ten *Sefirot*, and then flows into a series of vessels of light, which dramatically shatter because the light that they receive is too intense. This catastrophic event—*Sh'virat Ha-Kelim*, the Breaking of the Vessels—symbolizes the disorder of the universe. The shards that have fallen still retain some of the Divine light. *Tikkun* is the idea that it is mankind's obligation to repair the world by "raising the sparks" through good deeds and study of the Torah.

For almost 300 years, Kabbalah became the heart of Judaism, with its blend of the mystical and the everyday. It was not until the Enlightenment and the liberation of Jews from ostracism that the influence of Kabbalah began to wane. The idea that Jews could become fully accepted members of the culture they lived in, and even assimilate completely, was dissonant with the intricate, transcendent world of the *Sefirot*. Historians of Judaism such as Heinrich Graetz dismissed Kabbalah as folk superstition. With the rise of Reform Judaism and its rationalist bent, large segments of Jews were further distanced from their mystical tradition.

Within the Christian world, beginning with the late Renaissance, there was great interest in the Kabbalah. This helped to circulate images and ideas that eventually found their way into occult circles in the late nineteenth century. These included the Theosophical Society, of which Dutch painter Piet Mondrian was a member, the Irish poet W.B. Yeats, and the Order of the Golden Dawn, as well as the Russian mystic Georgi Gurdjieff

PREVIOUS PAGES AND OPPOSITE The interior of Temple Beth El of North Westchester, designed by Louis Kahn in 1972 and added to and renovated by Alexander Gorlin, is an elevated cube of wood, which Kahn called a "baldacchino" in his sketches. Light enters through 24 square windows and the overall effect is an interpretation of the Polish wooded synagogues that were destroyed by the Nazis. During the renovation, a new square ring of light was installed at a higher elevation than the original, allowing space to have more breadth. The sanctuary recalls the instructions from a later part of the *Zohar*, the Ra'aya Meheimna: "A sanctuary must have windows, as Daniel had in his upper chamber where he prayed, corresponding to the 'windows' in heaven."

OVERLEAF The new glass entrance by Alexander Gorlin Architects mediates between the original Sanctuary by Louis Kahn on the left, and the new social hall and classrooms on the right. The entire plan of the old and new building was organized on the diagram of the *sefirot* with the Kahn building as the crown, the *keter*, of the composition, and the nursery school and playground appropriately under the auspices of *Malkhut*, or the *Shekhinah*, the feminine aspect of God. The glass cube of the entrance was used so that it could glow as a vessel of light, a beacon symbolizing the restoration and reinvigoration of the congregation.

and his pupil, Olgivanna Wright, the third (and final) wife of Frank Lloyd Wright.

It is this lineage that explains why the architectural implications of Kabbalah have long been suppressed. Modern architecture triumphed through the rationalist philosophy of the *Neue Sachlichkeit* or New Objectivity, functionalism, and American architect Philip Johnson's International Style reign at the Museum of Modern Art in New York. Le Corbusier's "machine for living" ruled the roost, leaving no room for the spiritual, the mythic, or the irrational.

Although the mystical and irrational in art has a long and respected tradition, from African masks and Surrealism to Mondrian's association with Theosophy, the Kabbalah itself has been highly marginal. Especially after World War II, many Jewish artists chose to distance themselves for fear of being pigeonholed as Jewish, rather than as mainstream artists. Even when the painter Barnett Newman used explicit Kabbalistic themes in the 1950s and 1960s, the critic Harold Rosenberg took pains to dissociate him from it. Little had changed when, thirty years later in 1996, the critic Arie Graafland wrote that "neither Libeskind nor Newman can be related to Kabbalic or Talmudic mysticism," and then goes on to discuss these topics at length!

Finally, for myself, the Kabbalah as outlined by Rabbi Luria is not only a mystical system of the cosmos, but is a metaphor for the psychology of architectural creation. The rhythm of *Tzimtzum*, withdrawal, vessels of light, the breaking of the vessels, and *tikkun*, restoration, is a concise diagram of the manner in which architecture is made.

Often, the architects or artists must withdraw and create a space around themselves in order to focus and concentrate their energy, making their own *Tzimtzum* for that matter. Within that space of isolation, an illumination can occur: the "vessel of light," the concept, the motivating idea in the fullness of glowing form. This recalls Frank Lloyd Wright's story of how he came up with the idea for Unity Temple in Oak Park, Illinois, in 1904. He stayed up all night, and while drawing, listened to Beethoven for inspiration. To maintain the "vessel of light" is the goal, pushing through the limitations of reality to maintain the architectural thought is essential. The "breaking of the vessels" connotes confronting the idea with reality in the form of budgets, schedules, and the client, sometimes accepting compromise. *Tikkun* implies that a synthesis is possible, a restoration of the original idea, as architecture emerges into reality.

This all recalls Louis Kahn's mysterious musings on the nature of architecture: "A great building, in my opinion, must begin with the immeasurable, must go through measurable means when it is being designed, and in the end be immeasurable. The design, the making of things, is a measurable act. In fact, at that point, you are like physical nature itself because in physical nature everything is measurable, even that which is yet unmeasured, like the most distant stars, which we can assume will be eventually measured. But what is immeasurable is the psychic spirit...I think a rose wants to be a rose."

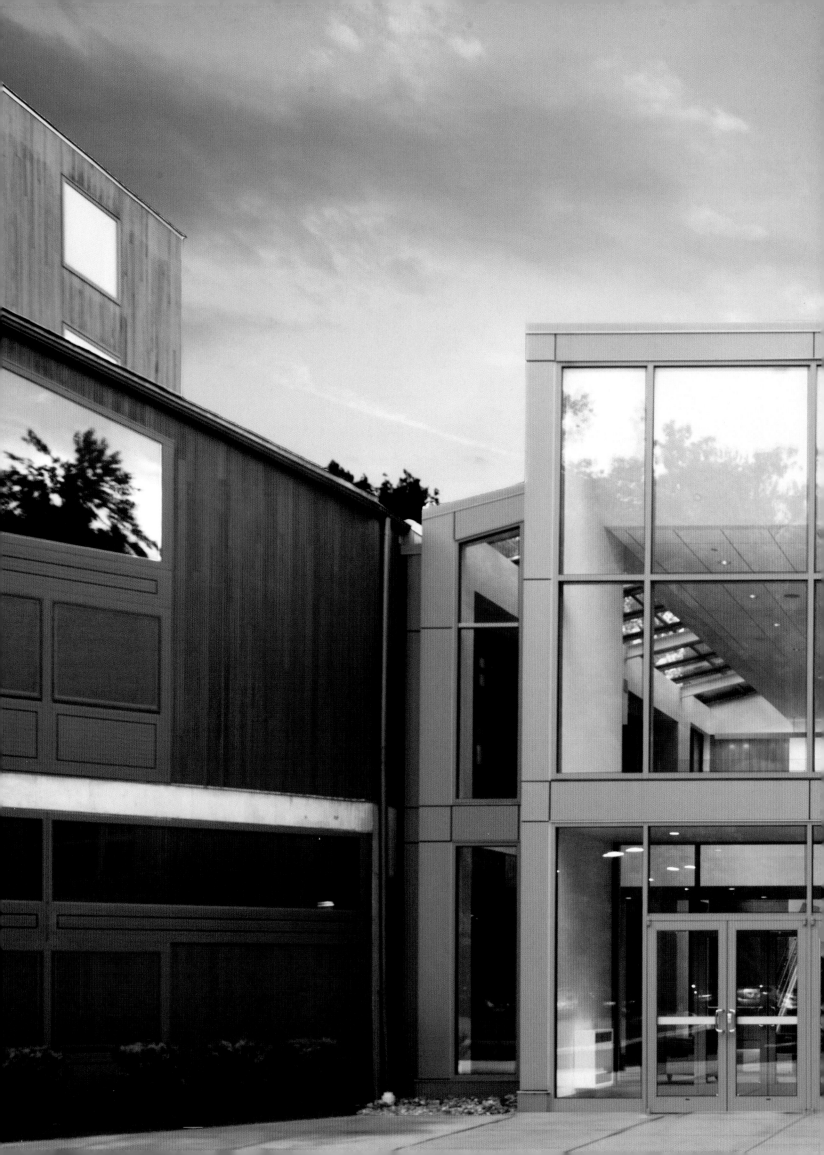

The Ark, the Tent, and the Temple | תבה, משכן, בית המקדש

Tevah, Mishkan, Beit Ha'Mikdash

According to the Kabbalah, the visible world is only a part of the fabric of the universe. There are multiple worlds in a hierarchy from mankind to the angels, and finally to God. The idea of this world as a microcosm of the heavenly realm is essential to an understanding of the architectural projects in the Five Books of Moses. God, as the Creator of the universe, is the author of the books, which exist only as textual artifacts, with a plethora of detail that nonetheless still leaves them ambiguous. In particular, descriptions are characterized by precise dimensions and numbers. The underlying theme is that geometry orders the universe, and these projects partake of that heavenly order. In contrast, the Tower of Babel, as a challenge to the Divine, is presented without any kind of geometric basis, therefore without a heavenly counterpart and, in that way, can disappear without a trace.

The first of the three sacred structures recounted is Noah's Ark. It is described as an elongated rectangular box that preserved the distilled pairs of life on earth from the scourge of the Flood. As a temporary structure, the Ark is constructed of "gofer" wood and covered with tar for waterproofing, with a skylight in its roof to let daylight into the interior. After the flood, a rainbow—a semi-circular geometric sign—is engraved in the sky as God's covenant with humanity that a similar catastrophe will not occur again.

Both the Tabernacle, or Dwelling—or Tent—in the desert, and the Temple in Jerusalem were places for the presence of God's spirit, the *Shekhinah*, and held the Ark of the Covenant with the tablets of the Ten Commandments. The Temple was at the heart of the priestly cult, and the focus of religious worship in ancient Israel. In the Kabbalah, the portable Tent in the desert and the permanent Temple are microcosms of their heavenly counterparts, as described in the *Zohar*: "When the First Temple was built, another Temple was erected throughout all worlds, illuminating all worlds. The Temple below had its counterpart in the Temple above."

All these structures are simple geometries of squares and double squares, and have whole number proportions. They are sacred enclosures that were simple to build in the desert by the wandering Israelite tribe. Surrounding the Tabernacle and holding the Ark was an outer fence covered by layers of colorful animal hides, and the interior of the Tent had multicolored curtains marking increasing precincts of sacredness. The Tent was demountable, suitable for the nomadic tribe until they could reach the Promised Land. The *Zohar* selected the colors of the curtains—blue, purple, and crimson—as indicative and symbolic of the different nodal points of the emanations, or the *Sefirot*. Color thus plays a central part in the Kabbalah.

The Temple in Jerusalem was considered, as with most holy shrines of its time, as the *axis mundi*, or the center of the world and the connective link between earth and heaven: "The land of Israel sits in the center of the world, Jerusalem in the center of the land of Israel, the Temple in the center of Jerusalem, the nave in the center of the Temple, the Ark in the center of the nave, and in front of the Ark, the Foundation Stone, from which the world was founded. This is the Foundation Stone, centric point of the entire universe, upon which stands the Holy of Holies." The Temple is described in the *Book of Kings*, in *Chronicles*, and more completely, in the *Book of Ezekiel*, as a series of concentric courts surrounding a main edifice that held the Ark. As the Tabernacle and both the First and Second Temples have been destroyed, only the biblical text remains. The architectural void at the heart of Judaism is a reality that is mourned yearly on the holiday of Tisha B'Av. Over the centuries, numerous imaginative reconstructions of these structures have been drawn, and the images of those, such as the ones by Villalpando, Bernard Lamy, and Fischer von Erlach, have become objects in themselves and as influential as the actual texts.

OPPOSITE This illumination of *God the Architect of the Universe* from the *Bible Moralisée* of c.1250 captures the powerful image of the Creator as the Architect of the Universe. Utilizing the instruments of the medieval architect to portray the initial act of creation, God "set his circle on the face of the deep," as it is said in the *Book of Proverbs*. Imposing order on the amorphous shape of the "unformed void," the image demonstrates the important Kabbalistic concept of this world as a microcosm of the Divine world above.

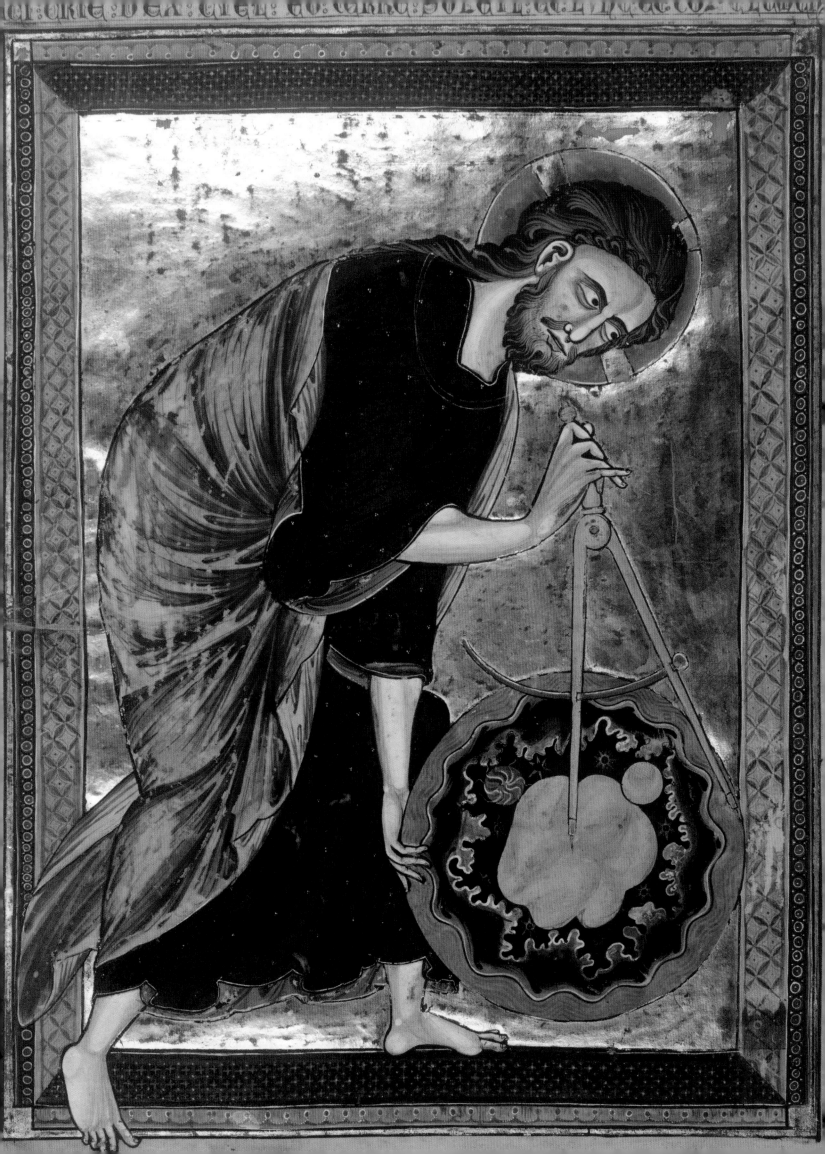

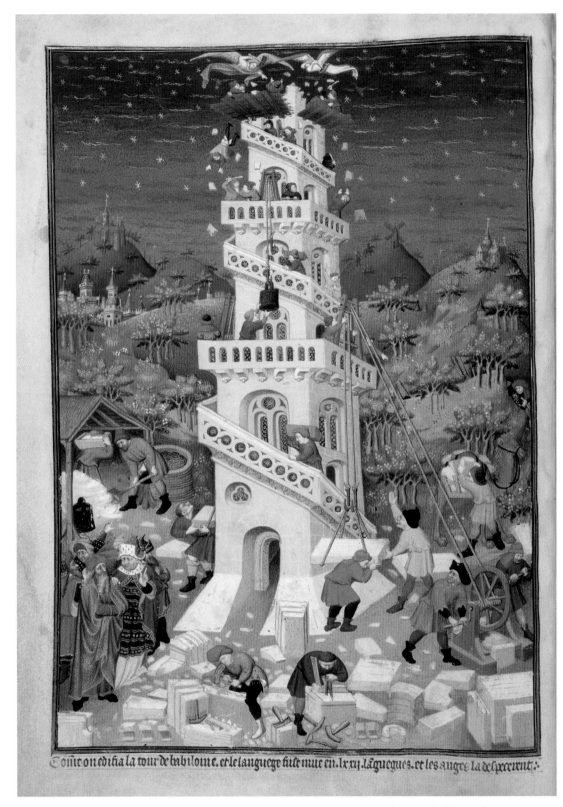

Conic on edifia la tour de babiloine, et le langage fut mue en lxxij. languaguies. et les anges la despeirint.

They said, "Go to, let us build ourselves a city and a tower whose top may reach unto heaven, and we shall make us a name for ourselves."
—Genesis 11:4

LEFT An illuminated French manuscript, *The Bedford Book of Hours*, from 1423, depicts the Towel of Babel as a rectangular structure ringed by a series of ramps that rise to its summit. Angels hover above in the night sky trying to stop this mad project of King Nimrod, the "mighty hunter before God."

OPPOSITE Athanasius Kircher's 1679 engraving, with its finely arcaded ramps that rise far above the flat plains, is the most elegant of the Tower of Babel illustrations. The ziggurat-like structure recalls Mesopotamian prototypes, although the tower displays evidence of abandonment, with shrubs and trees growing at the top.

OVERLEAF This eighteenth-century engraving by Dutch artists Jan Goeree and Jan Baptist, from *Historie des Ouden en Nieuwen Testaments* by David Martin, depicts one of the first of the projects in the Five Books of Moses, whose specifications are straight from God's mouth to Noah's ears: "Make yourself an Ark of gofer wood, with reeds make an Ark, and cover it within and without with a covering of pitch." The ark is a geometric construction floating in the flooded world of evil. It is a temporary structure to preserve pairs of male and female species for the future repopulation of the world. This engraving emphasizes the tradition of the construction of the ark with details of the siding, beams, and animal pens.

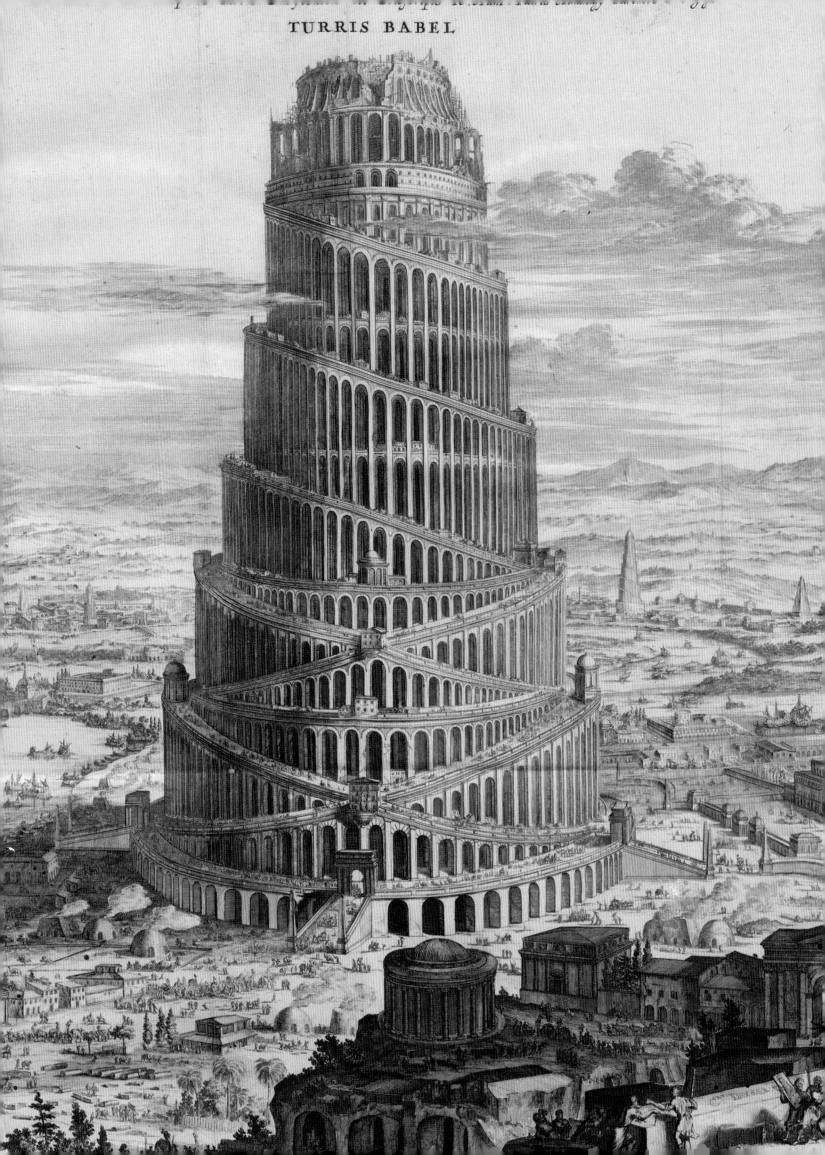

TURRIS BABEL

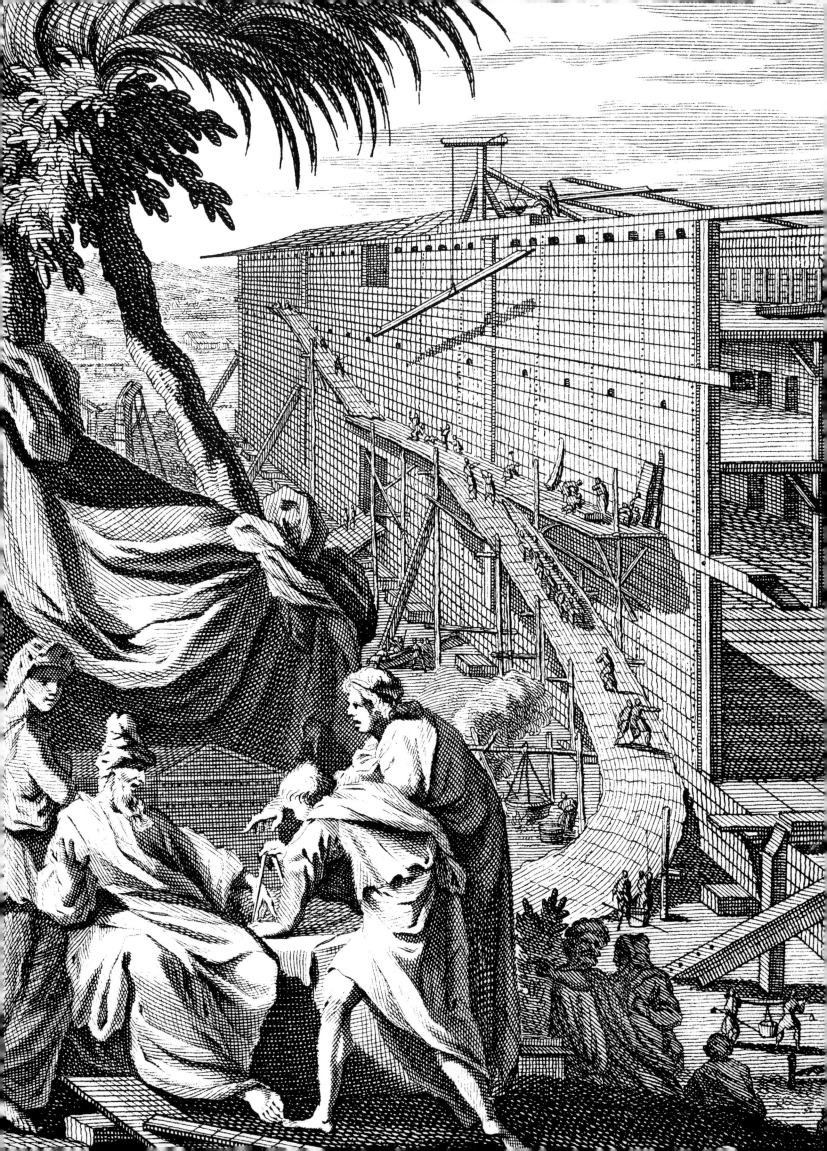

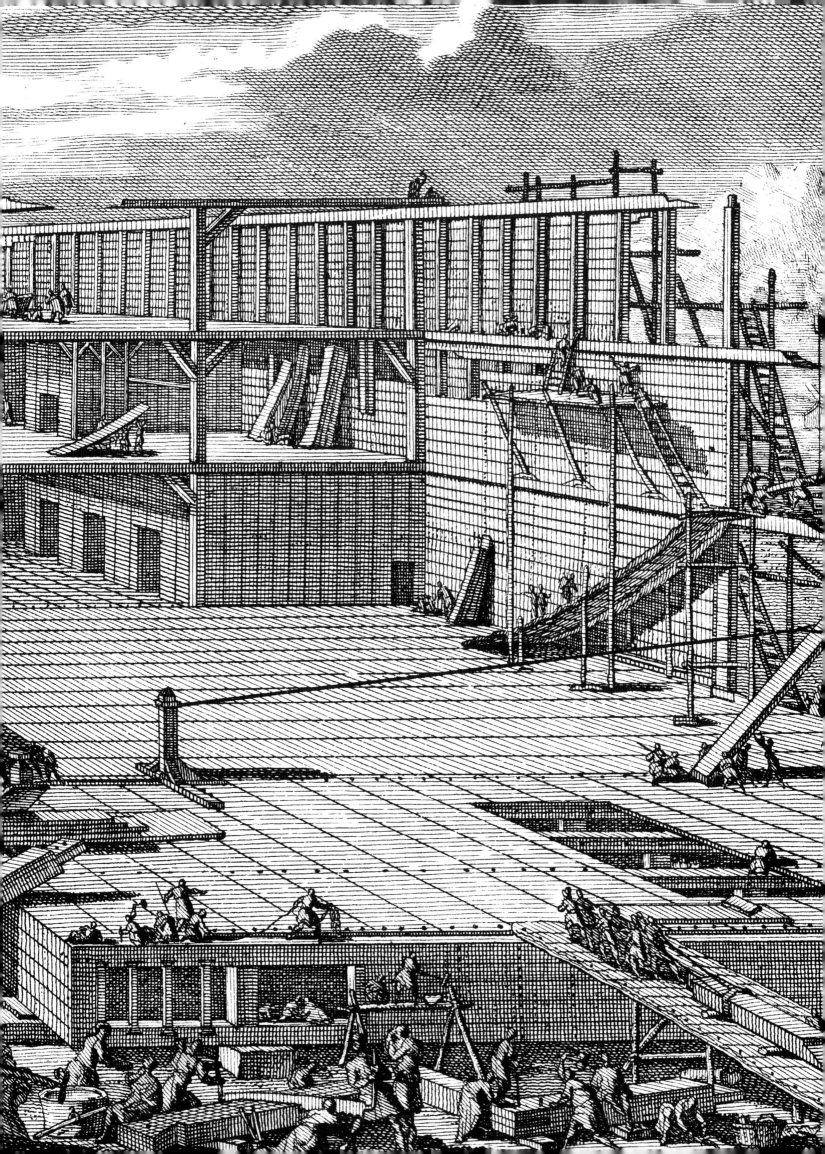

RIGHT The Tabernacle or Dwelling—seen here in a 1728 engraving by Bernard Lamy—was the tent that held the tablets of the Ten Commandments, and was carried through the desert until the Israelites entered the land of Canaan. In the *Book of Exodus*, Moses describes the details to Bezalel, the architect who executed the work. The tent was built of wood, then covered with brightly colored curtains of animal skins that are the springboard into the fantastic realms of the Zoharic tales. In the Kabbalah, our visible reality is but a veil to other dimensions and worlds as in *Zohar 2:127a*: "By this mystery, the Dwelling was formed and constructed, being in the image of the world above and in the image of the world below."

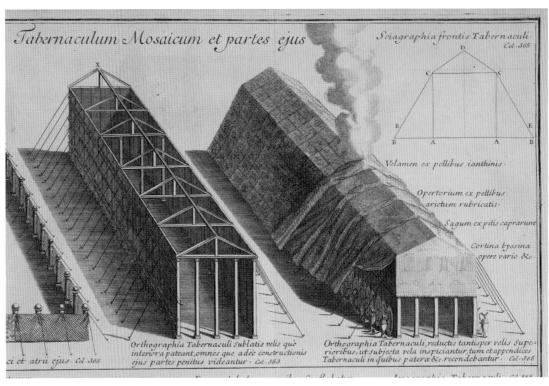

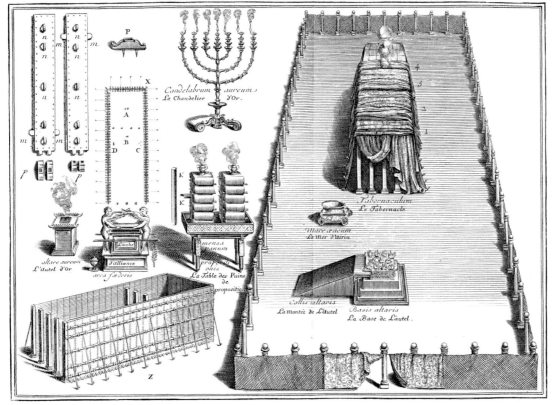

OPPOSITE The precinct of the Dwelling was a series of concentric zones of sacred enclosures, whose plan was a double square. The Tabernacle, shown here from The Luther Bible of 1534, was finished according to a passage in *Exodus*, with a dizzying array of materials: "gold, sliver, and bronze, blue-violet, purple and scarlet, fine linen, and goat's hair, rams' skins dyed red, tanned–leather skins, acacia wood." In the Kabbalah, these literal descriptions are just the beginning for an excursion into the symbolism of the higher worlds: "The making of the Dwelling resembled the pattern above, one corresponding to the other."

"Curtains of the Dwelling, which we have mentioned, are supernal mysteries of mystery of heaven, as has been established, for it is written: Spreading the heavens like a curtain."—**Psalms 104:2**

ABOVE The engraving, also by Bernard Lamy, depicts the tabernacle with its accoutrements, as in *Exodus 25*. Each item is described, from the "table made of acacia wood, two cubits long, one cubit wide, and a half high," to the "lampstand of pure gold... [and the] six branches going out of its sides," to the "mercy-seat of pure gold" and its cherubim on either side, which "shall spread out their wings above, overshadowing the mercy seat." If all these parameters are met, then God will meet with Moses at the mercy-seat and "will deliver to [him] all my commands for the Israelites." The descriptions illustrate a number of Kabbalistic points: The detail implies the whole, and the holy instruments embody the holiness of the Temple itself. Another is that the literal description is the beginning of a symbolic flowering of meaning, so that these holy vessels are microcosms of the world above, in model form, of the world below.

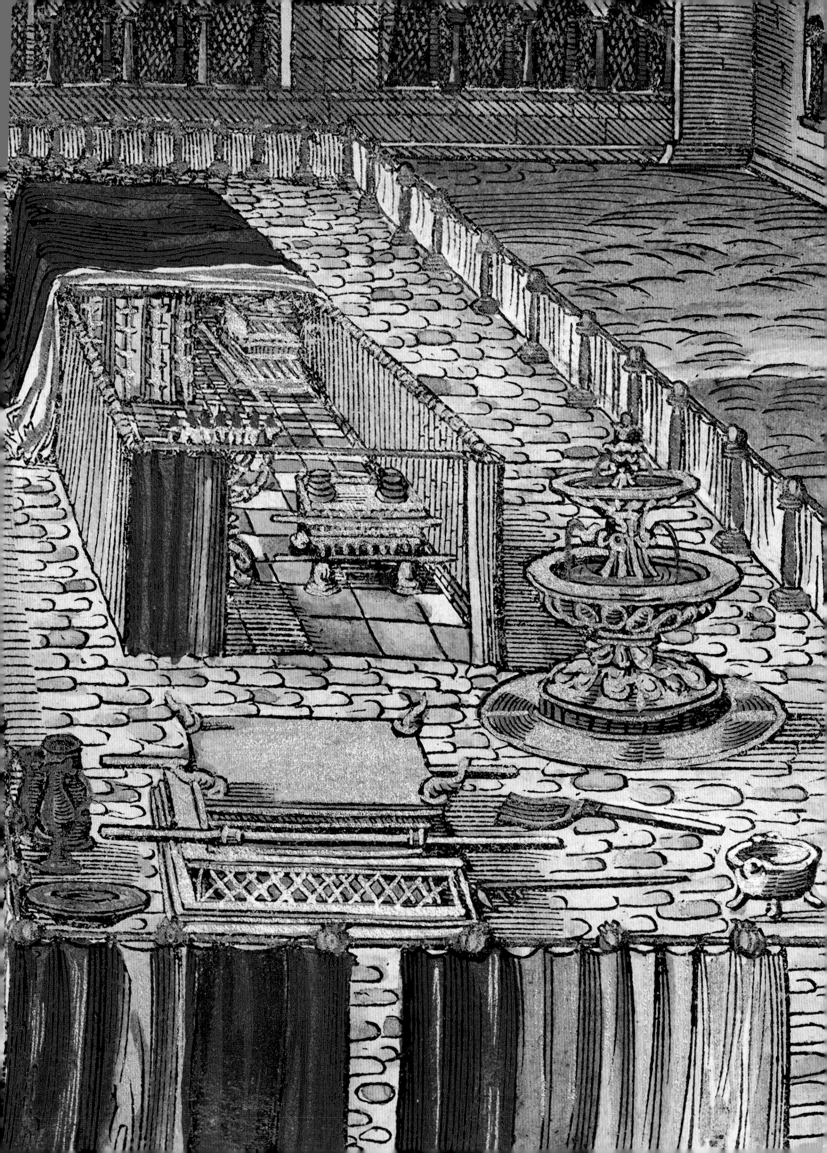

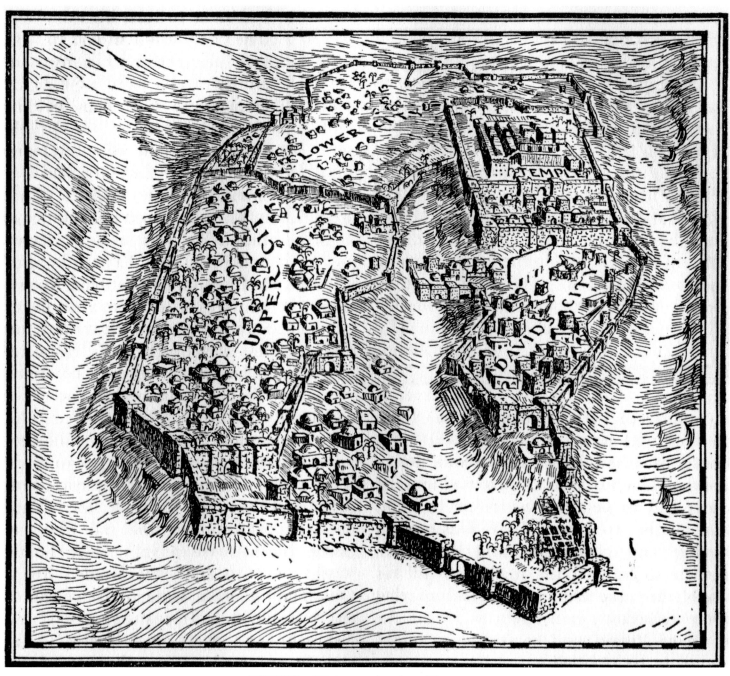

ABOVE The little-known drawing of the Temple in Jerusalem by the Russian-born painter Mark Rothko is for his 1928 illustrations from *The Graphic Bible* by Rabbi Lewis Browne. Rothko, whose signature abstract paintings were to appear twenty years later, demonstrated an intricate knowledge of Jewish tradition and history, laying the basis for both, and their possible presence and persistence in his remarkable paintings of radiant light.

"The first expansion is the Temple, with all those chambers and courts, all its array, and Jerusalem, the entire city within the wall. The second expansion is the whole land of Israel, sanctified in its holiness. The third expansion is all the rest of the earth, the habitation of other peoples; and the ocean surrounds all."—Zohar 2:222b

OPPOSITE In Bernard Lamy's 1728 engraving, the Temple is portrayed as a massive cube rising above the plateau of Jerusalem, accessible by winding ramps and an arcaded aqueduct. The concentric courts of the Temple compound are clearly visible. In the Kabbalah, the Temple in Jerusalem was the center of the world and a copy of the heavenly Temple made manifest on earth. There are a number of descriptions of the Temple in the *Book of Kings* and *Chronicles*, as well as in Ezekiel's vision of the future Third Temple. Since both the first Temple, built by King Solomon in 953 B.C.E., and the second, renovated by King Herod, were destroyed, only the written texts survive to recount the details of these glorious edifices.

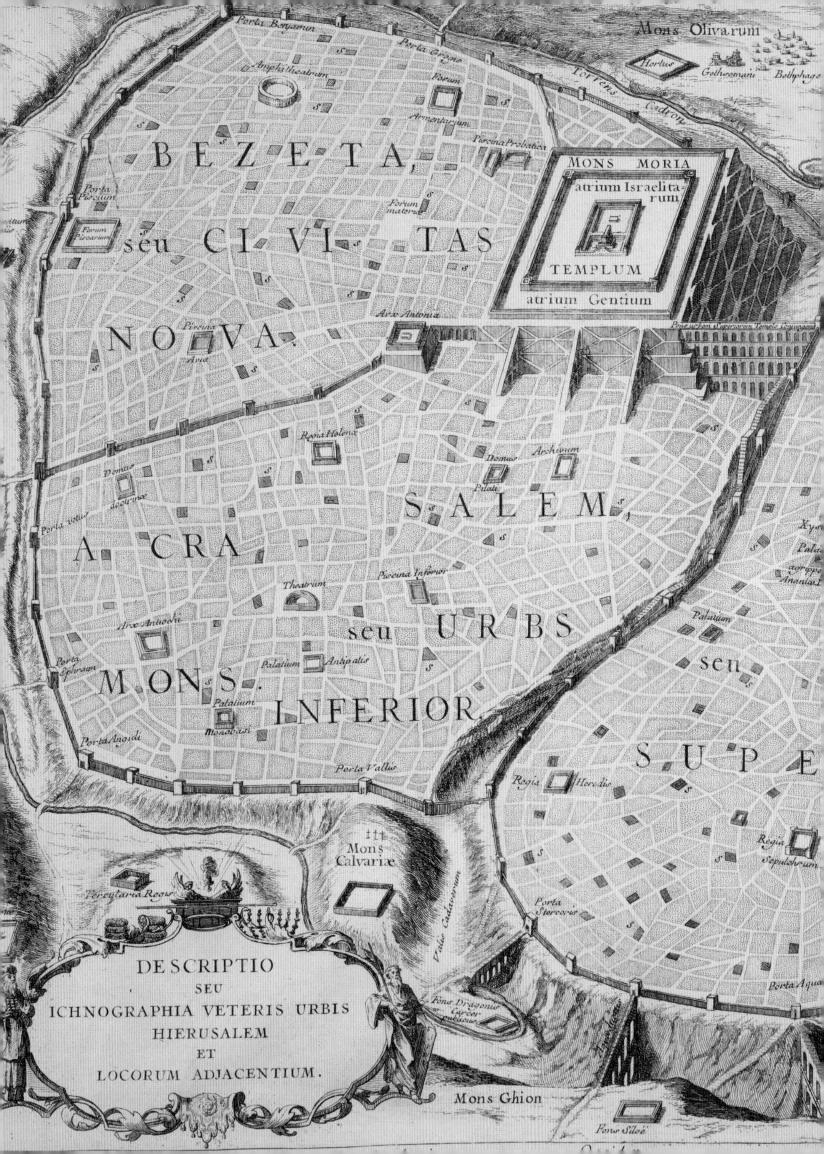

Mons Olivarum

Porta Borgorum

Porta Gregis

Hortus Gethsemani Bethphage

Torrens

Cedron

Amphitheatrum

Forum

Armentarium

Piscina Probatica

MONS MORIA

atrium Israelita-rum

Porta Piscium

Forum matorus

TEMPLUM

Forum Piscarium

seu CI VI TAS

atrium Gentium

Piscina

N O V A.

Avis

Arx Antonia

Pons uchem Superiorem Templo Regium

Regia Helena

Domus

Domus

Archivum

doctrine

Pilati

S. SALEM,

Xy

Pala

A CRA

aorupp

Ananias

Piscina Inferior

Theatrum

seu URBS

Palatium

Arx Antiochi

Porta
Ephraim

Palatium Antipatis

S

seu

M ON S.

Palatium

INFERIOR.

Porta Anguli

Monobasi

Regia

SUPÆ

Porta Vallis

Regia Herodis

Mons
Calvariæ

Regia
Sepulchrum

Porta
Stercoris

Pereytaria Regis

Vallis Cadaverum

DESCRIPTIO

SEU

ICHNOGRAPHIA VETERIS URBIS

HIERUSALEM

ET

LOCORUM ADJACENTIUM.

Fons Dragonis
Carcer
publicus

Porta Aqua

Mons Ghion

Fons Siloé

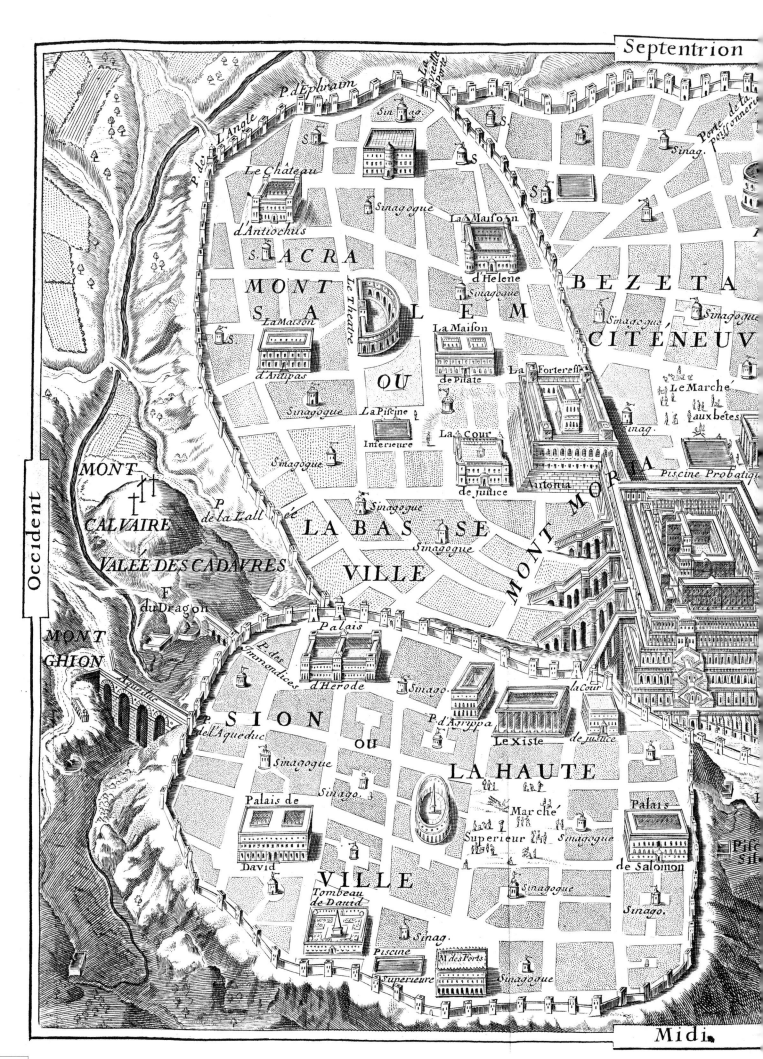

Septentrion

Occident

P. de la Vieille Porte

P. d'Ephraim

P. de L'Angle

Sin ao.

S.

Sinagogue

S.

S.

S.

Porte de la poissonnerie

Sinag.

S.

Le Château

d'Antiochus

La Maison

d'Helene

Sinagogue

BEZETA

Sinagogue

S ACRA

MONT

SA

Sinagogue

CITÉ NEUV

LEM

La Maison

Le Theatre

OU

La Maison

de Pilate

La Forteresse

Le Marché

La Maison

d'Antipas

Sinagogue

aux bêtes

Sinag.

La Piscine

Inferieure

La Cour

Sinagogue

MONT MORIA

Antonia

de justice

Piscine Probatiqu

MONT

CALVAIRE

P. de la Vall'ée

Sinagogue

Sinagogue

LA BAS SE

VALÉE DES CADAVRES

Sinagogue

VILLE

F.

du Dragon

MONT

GHION

Palais

P. des

Immondices

d'Herode

Sinago.

la Cour

de justice

Aqueduc

P. del'Aqueduc

SION

OU

Sinago.

P. d'Agrippa

Le Xiste

LA HAUTE

Sinagogue

Palais

Sinago.

Palais de

Marché

Palais

David

Superieur

Sinagogue

de Salomon

VILLE

Tombeau

de Dauid

Sinagogue

Sinag.

Piscine

M. des Forts

Superieure

Sinagogue

Midi.

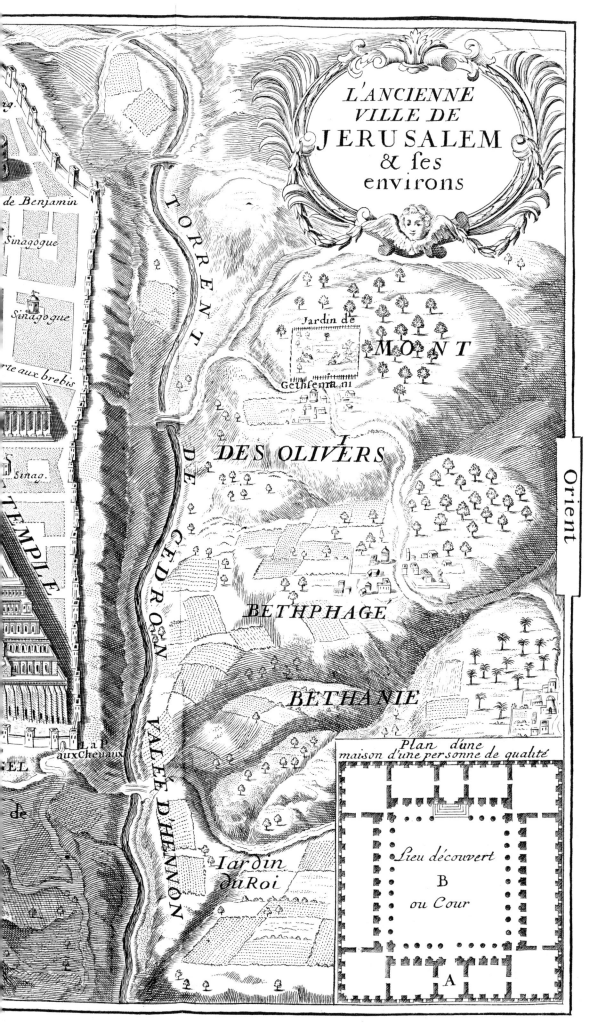

L'ANCIENNE VILLE DE JERUSALEM & ſes environs

de Benjamin

Sinagogue

Sinagogue

rte aux brebis

Sinag.

TEMPLE

TORRENT DE CEDRON

Jardin de

MONT

Gethſemani

DES OLIVERS

Orient

BETHPHAGE

BETHANIE

la
auxCheuaux

EL

de

VALÉE D'HENNON

Jardin
duRoi

Plan d'une
maison d'une perſonne de qualité

Lieu découvert

B

ou Cour

A

"The land of Israel sits in the center of the world, Jerusalem in the center of the land of Israel, the Temple in the center of Jerusalem, the Sanctuary in the center of the Temple, the ark in the center of the Sanctuary, and in front of the Ark, the Foundation Stone, from which the world was founded. This is the Foundation Stone, centric point of the entire universe, upon which stands the Holy of Holies."—Zohar VI, p. 273

LEFT An engraving of Jerusalem, Palestine, by the British geographer George Rollos that dates from 1757, shows the Temple of Herod on the right at the edge of the Valley of Cedron and across from the Mount of Olives. Various Roman palaces, theaters, and monuments are included, some of which are drawn as fanciful inventions. The large size of the Temple is clear in relationship to the rest of the ancient city.

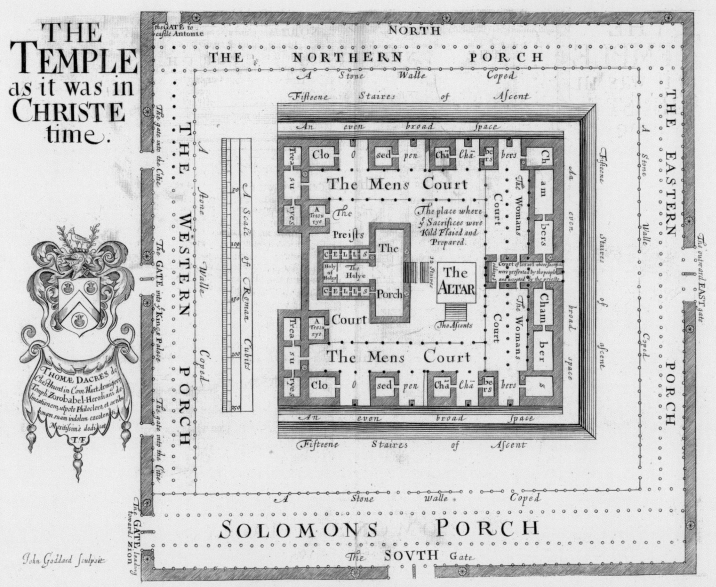

THE TEMPLE as it was in CHRISTE time.

The following labels appear within the engraving:

NORTH

THE NORTHERN PORCH

the GATE to castle Antonie

A Stone Walle Coped

Fifteene Staires of Ascent

An even broad Space

THE WESTERN PORCH

THE EASTERN PORCH

A Stone Walle Coped

The gate unto the Citie

The GATE into y Kings Palace

The gate into the Citie

A Scale of Roman Cubits

Treasuryes

Clo O sed pen Chã Chã be bers

The Mens Court

A Tresurye

The Preists Court

CELLS
Holy of Holye The Holye
CELLS

The Porch

The place where y Sacrifices were Kild Flaied and Prepared.

The ALTAR

The Ascents

Court of Israel where sacrifices were presented to y people and accepted by the preists

The Womans Court

Chambers

The Womans Court

Chamber

A Tresurye

The Mens Court

Clo O sed pen Chã Chã be rs bers

An even broad Space

Fifteene Staires of Ascent

A Stone Walle Coped

SOLOMONS PORCH

The SOVTH Gate

The GATE leading towards ZION

The outward EAST gate

Fifteene Staires of ascent

An even broad space

THOMÆ DACRES de Che Hunt in Com Hart Armiger. Templ Zorobabel-Herodiani delineationem, utpote Philoclero, et architecton suam indolem excolenti, Meritissime dedicat. T F

John Goddard Sculpsit

ABOVE This 1650 engraving by the seventeenth century British historian Thomas Fuller shows the temple in Jerusalem at the time of Jesus. It was an enhanced version of the Second Temple that was rebuilt on a much larger scale by King Herod of Roman Judea, from 22-4 B.C.E. The Talmud states: "Whoever has not seen Herod's temple has not seen a beautiful building." The plan of the temple is square set within a larger square courtyard. A gate facing east led up to the 150-foot high main court of the altar that is visible today. The broad, symmetrical porch created a new façade that increased the apparent size of the temple, masking the smaller dimensions of the Solomonic structure in the rear.

OPPOSITE One of the most important reconstructions of the temple was the one by Juan Bautista Villalpando, a Spanish Catholic priest. Bernard Lamy's version of Villalpando's reconstruction was published posthumously in *De Tabernaculo Foederis De Sancta Civitate Jerusalem Et De Templo* in 1720. The plan is a nine-square grid with the outer court of the people, the inner court of the priests, and the wide loggias that marked the connecting passageways between the precincts. Facing the central court was the temple itself, which was framed by two pillars of brass named Jachin and Boaz. The interior was divided into two parts: an outer chamber, and the inner Holy of Holies, which was exactly one cube of space, equal in length, breadth, and height, and completely covered with gold. Within this chamber was the Ark of the Covenant, surmounted by sculptures of two cherubim with outstretched wings that barely touched.

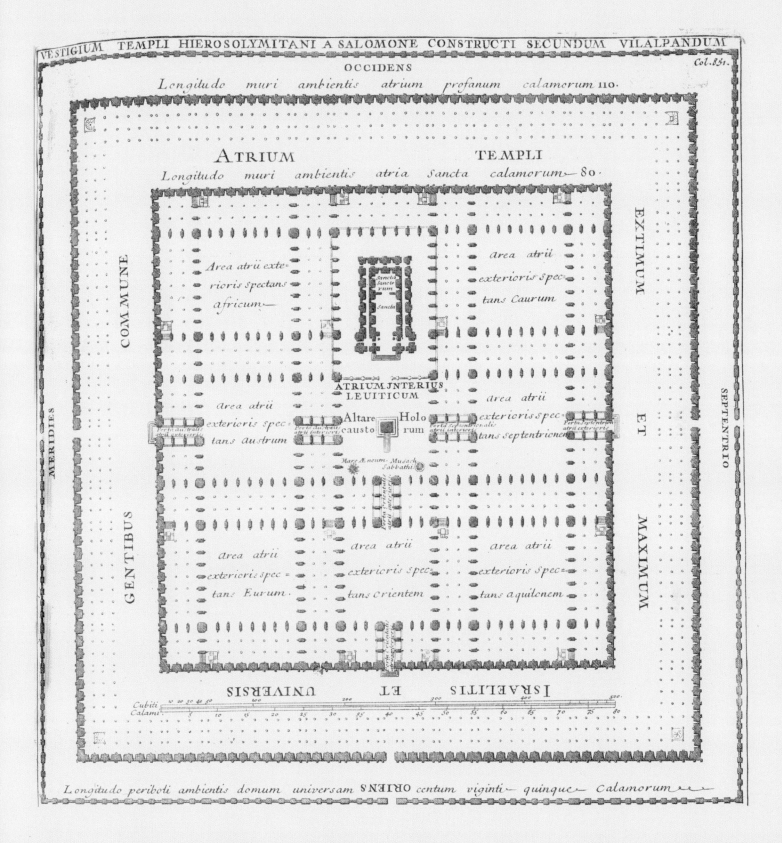

VESTIGIUM TEMPLI HIEROSOLYMITANI A SALOMONE CONSTRUCTI SECUNDUM VILALPANDUM

Col. 831.

OCCIDENS

Longitudo muri ambientis atrium profanum calamorum 110.

ATRIUM TEMPLI

Longitudo muri ambientis atria sancta calamorum 80.

COMMUNE

*Area atrii exte-
rioris spectans
africum*

*Area atrii
exterioris spec-
tans Caurum*

Sancta
Sancto-
rum

Sancta

ATRIUM INTERIUS
LEUITICUM

*area atrii
exterioris spec-
tans Austrum*

Altare Holo
causto rum

*area atrii
exterioris spec-
tans septentrionem*

*Mare Æneum Musach
Sabbathi.*

*area atrii
exterioris spec-
tans Eurum.*

*area atrii
exterioris spec-
tans Orientem*

*area atrii
exterioris spec-
tans aquilonem*

MERIDIES

GENTIBUS

EXTIMUM ET MAXIMUM

SEPTENTRIO

*Cubiti
Calami.*

ISRAELITIS ET UNIVERSIS

Longitudo periboli ambientis domum universam ORIENS *centum viginti quinque Calamorum*

31

Heavenly Palaces and the Throne-Chariot | היכלות, מרכבה

Hekhalot, Merkava

The earliest mystical Jewish themes are derived from the visions of the prophet Ezekiel in his eponymous book, where even in the context of the Bible and its various revelations, it stands out for its drama and otherworldly imagery. Set in Babylonia, where the Jews were in exile after the destruction of the First Temple in 586 B.C.E. The teaching of the Vision, called *merkava*, or throne-chariot, was forbidden by the Kabbalists except to the righteous, and even then, never to more than one person at a time. Ezekiel's vision is characterized by four flying creatures: a man, an ox, a lion, and an eagle, each having four heads facing in four directions. They are floating above a contraption of "wheels within wheels" with multiple eyes in the rims, a surrealistic image crowned by the "appearance of a man"—perhaps God—on a sapphire throne, emerging out of the clouds in flashing colors. The *Merkava* and *Hekhalot*—the Books of the Heavenly Palaces—were the basis of secret Kabbalistic teachings after the destruction of the Second Temple in 70 A.C.E. The *Hekhalot* elaborated upon how an adept man could ascend through the Seven Heavenly Palaces to the throne room of God to experience His presence and learn the secrets of the cosmos. The book *Shiur Komah* was developed to describe the enormous dimensions of God's body. Gigantic angels guarded each gate, and complicated secret passwords were required for admission to the subsequent palaces: "And at the gate of the sixth palace it seemed as though hundreds of thousands and millions of waves of water stormed against him, and yet there was not a drop of water, only the ethereal glitter of the marble plates with which the palace was tessellated." The descent back to earth was considered equally dangerous, so that those who successfully returned were also known, in the Kabbalah, as *yordei merkava*, descenders from the throne.

Although the literal terms for "palace," "gate," and "house" are used, these Hebrew words, as with all of Kabbalah, were to be read on multiple levels of meaning. A palace also represented one of the *Sefirot*, and in the *Zohar*, refers to the most abstract notions of the locus of the original creation. The ascent to the Heavenly Throne was derived in the Bible ultimately from the dream of Jacob's ladder in the *Book of Genesis 28:12*: "And he dreamed, and behold a ladder set up on earth, and the top of it reached unto heaven: And behold the angels of God ascending and descending on it." The trans-cultural idea of the *axis mundi*, the link between earth and heaven, connect Chariot-Throne mysticism to other religious conceptions of reaching the Divine.

The Palaces of Heaven has been a theme explored by numerous artists over the years including William Blake's *Jacob's Ladder*; the luminous baroque bedroom at the end of Stanley Kubrick's *2001: A Space Odyssey;* the endless enfilades of the palaces in the film *Last Year in Marienbad;* contemporary German artist Anselm Kiefer's seven concrete towers, and in his *Hechalot* series of paintings; and German-language author Franz Kafka's short story, "Before the Law." For hundreds of years, artists have sought to bridge the impossible gap between the limits of mankind and a dream of the limitless powers of the idea of God.

OPPOSITE *The Vision of Ezekiel* by the Italian Renaissance artist Raphael from 1518 dramatically portrays the mystical experience of the Biblical prophet in Babylon after the destruction of the Temple of Solomon. This description of the "throne-chariot" is one of the forbidden texts that form the background for the development of Kabbalah. Out of a great storm, Ezekiel views a supernatural four-winged creature, with four faces and four wings: a lion, an ox, an angel, and an eagle. Each is held aloft by wheels within wheels, with multiple eyes on their rims. Suspended above is the throne of God on a sapphire pavement "the color of the terrible crystal," upon which sits a throne with the "appearance of a man" flashing with fire and framed by the rainbow and "the glory of the Lord" *(Ezekiel: 1, 22-28).*

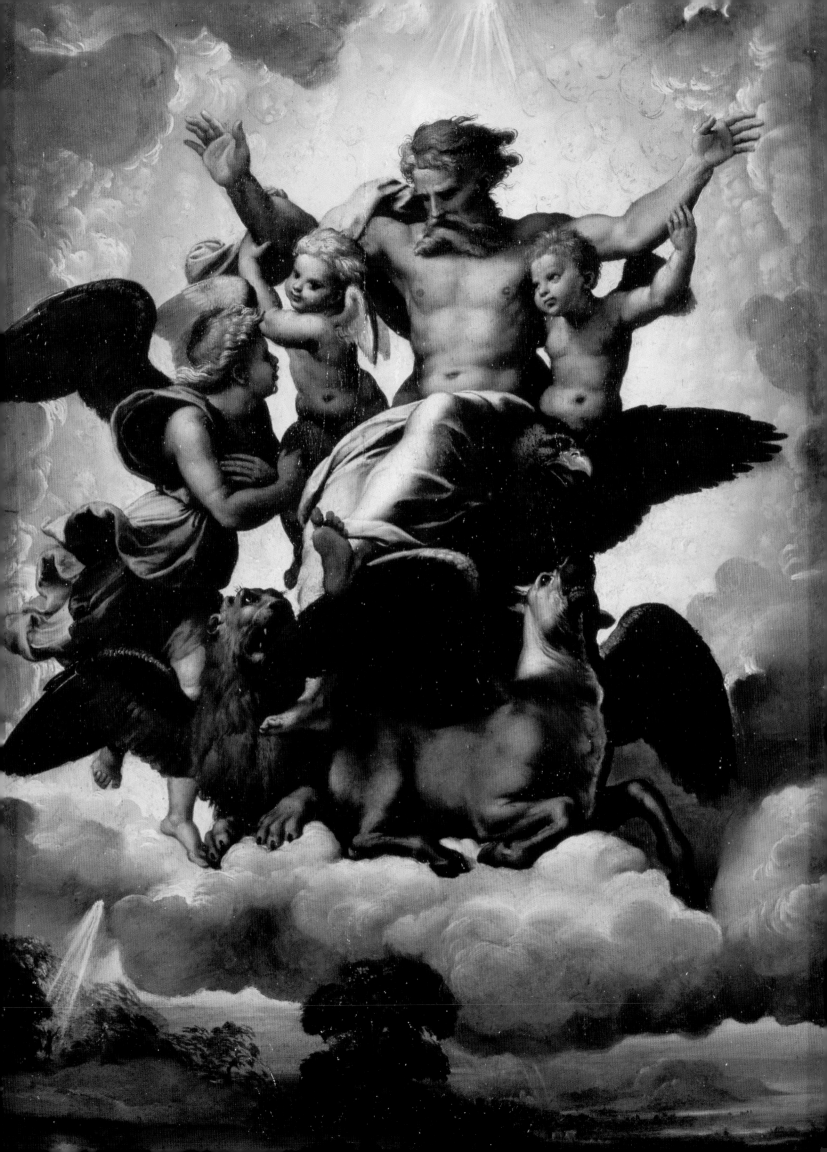

THESE PAGES Artists across the centuries have interpreted Ezekiel's vision through various visual styles. Hans Holbein the Younger's woodcut, *right*, from 1536 imagines the four beasts, the wheels within wheels, with God suspended above. In David Martin's eighteenth-century engraving, *below*, Ezekiel himself is shown experiencing this divine vision emerging from the stormy clouds. *Opposite*, in a more contemporary lithograph by Saul Raskin, from his 1952 book, *Kabbalah in Word and Image*, the chariot, led by God, with its four beasts charging ahead, exudes a fiercer, more urgent tone.

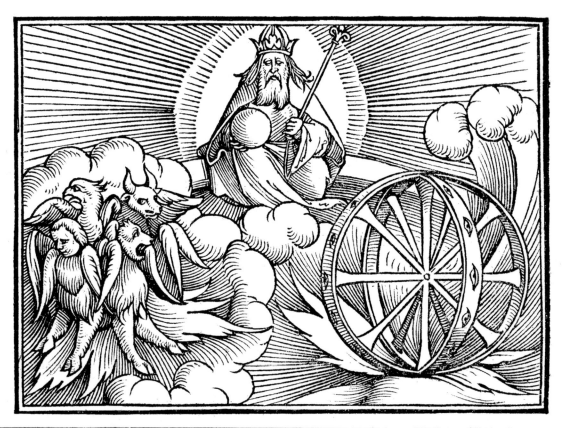

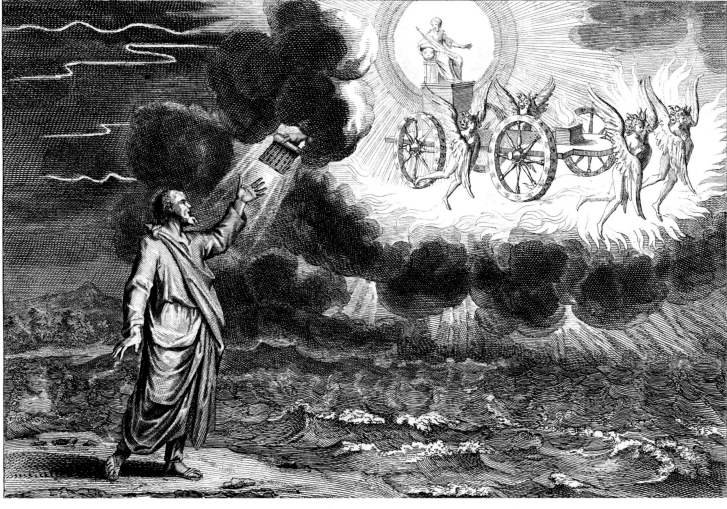

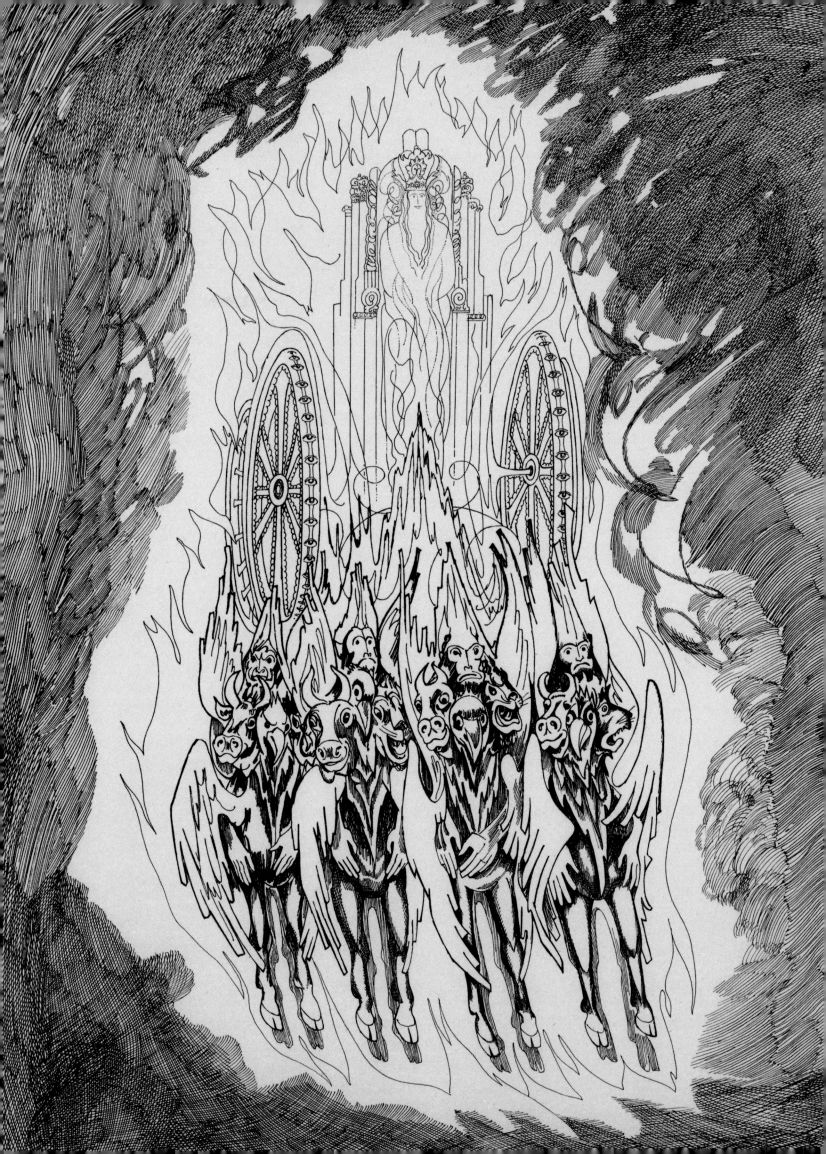

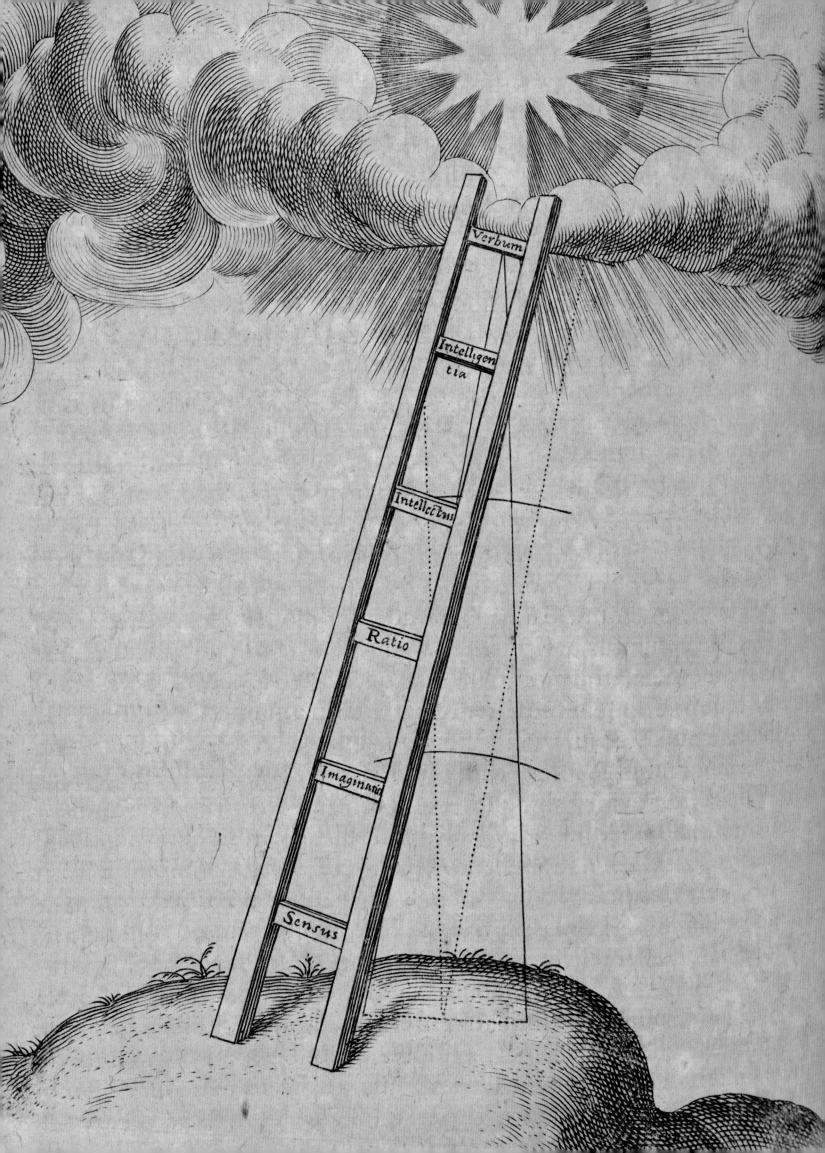

"And he dreamed, and behold a ladder set up on the earth, and the top of it reached unto heaven: And behold the angels of God ascending and descending on it."—Genesis 28:12

OPPOSITE *Jacob's Ladder,* a 1619 engraving by Robert Fludd, an English philosopher, physician, and artist, illustrated Jacob's dream at Beth-El, where angels climbed up and down this link between the two worlds, as described in the *Zohar.* "A ladder is set up on earth, its head reaching unto heaven—moving above, moving below." It is the mythical *axis mundi* that connects heaven and earth, the model for all sacred temples.

RIGHT Contemporary Japanese artist Yayoi Kusama's 2004 *Tender are the Stairs to Heaven,* made of synthetic polymer resin and fibre optic cable, is a luminous, spidery series of rungs, barely capable of holding the angels that tenuously clamber up and down in Jacob's dream. It is a dreamy work that captures the ethereal quality of the Biblical story.

OVERLEAF The Villa Malaparte, fitted into the treacherous cliffs of the Faraglioni rocks overlooking the Mediterranean Sea on the island of Capri, Italy, is the penultimate stairway to heaven. Built in the 1930s by Italian architect Adalberto Libera for the Italian poet Curzio Malaparte, the villa is less about interior space than about the grand triangular stair that rises to a roof terrace, floating between sea and sky—a villa of ascension to the heavenly realm.

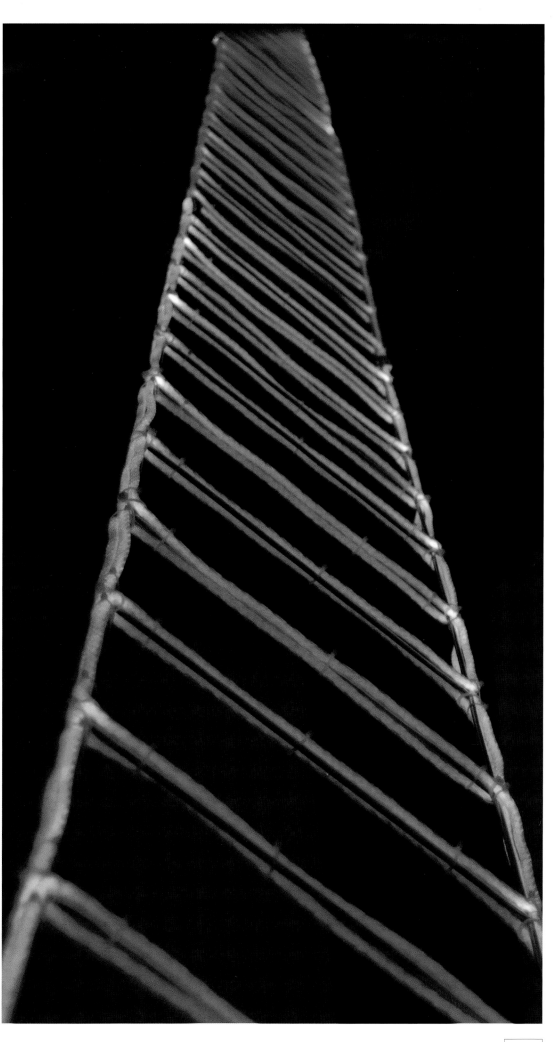

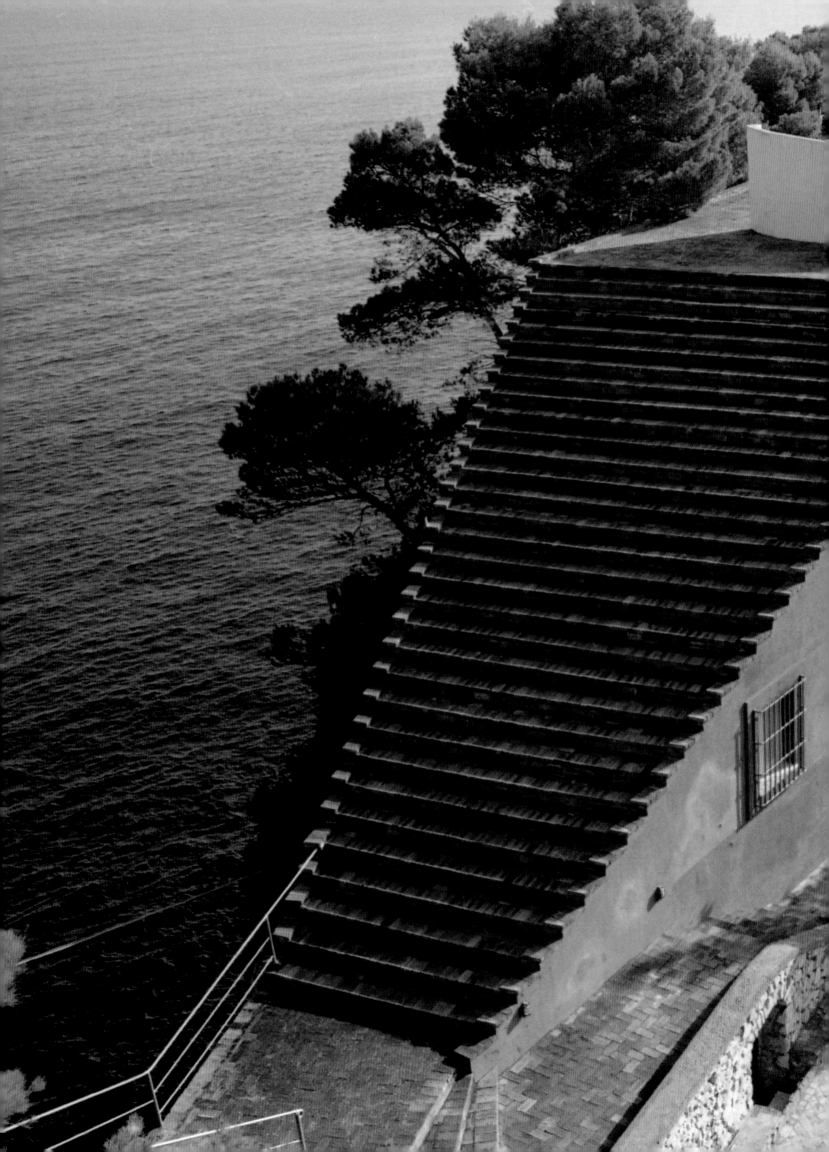

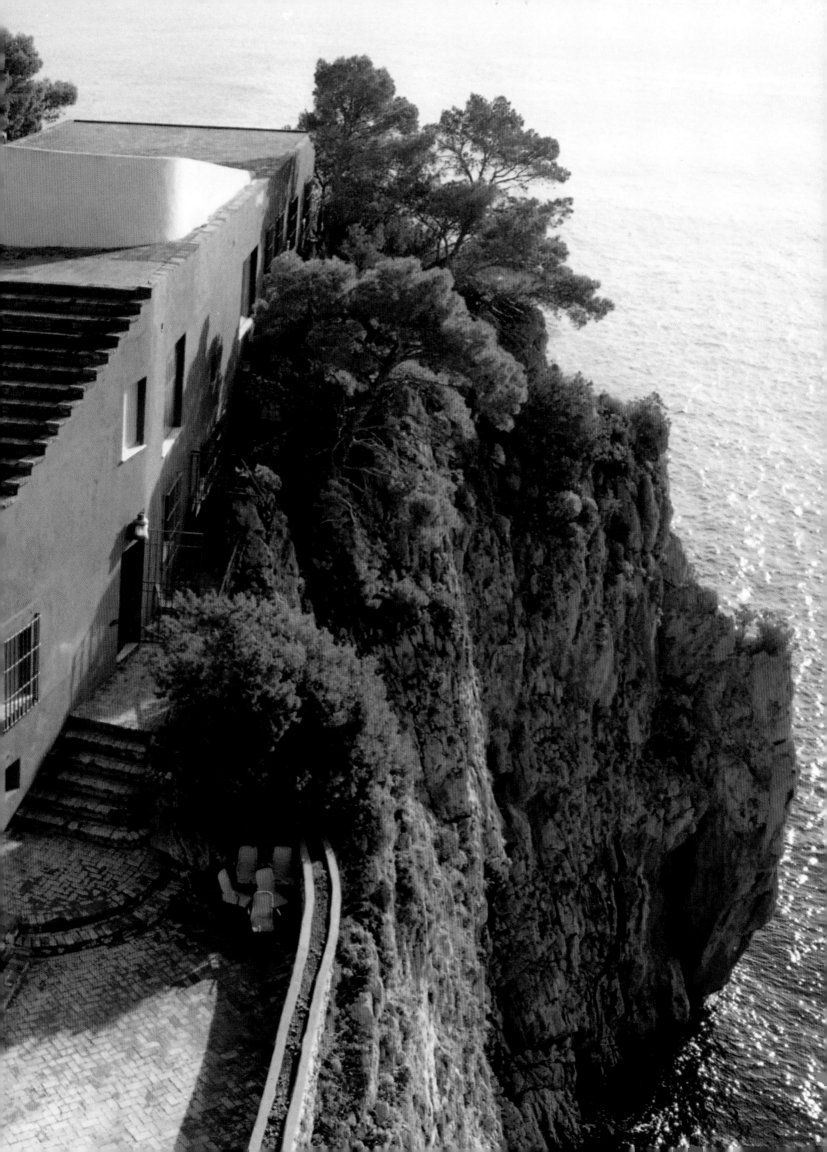

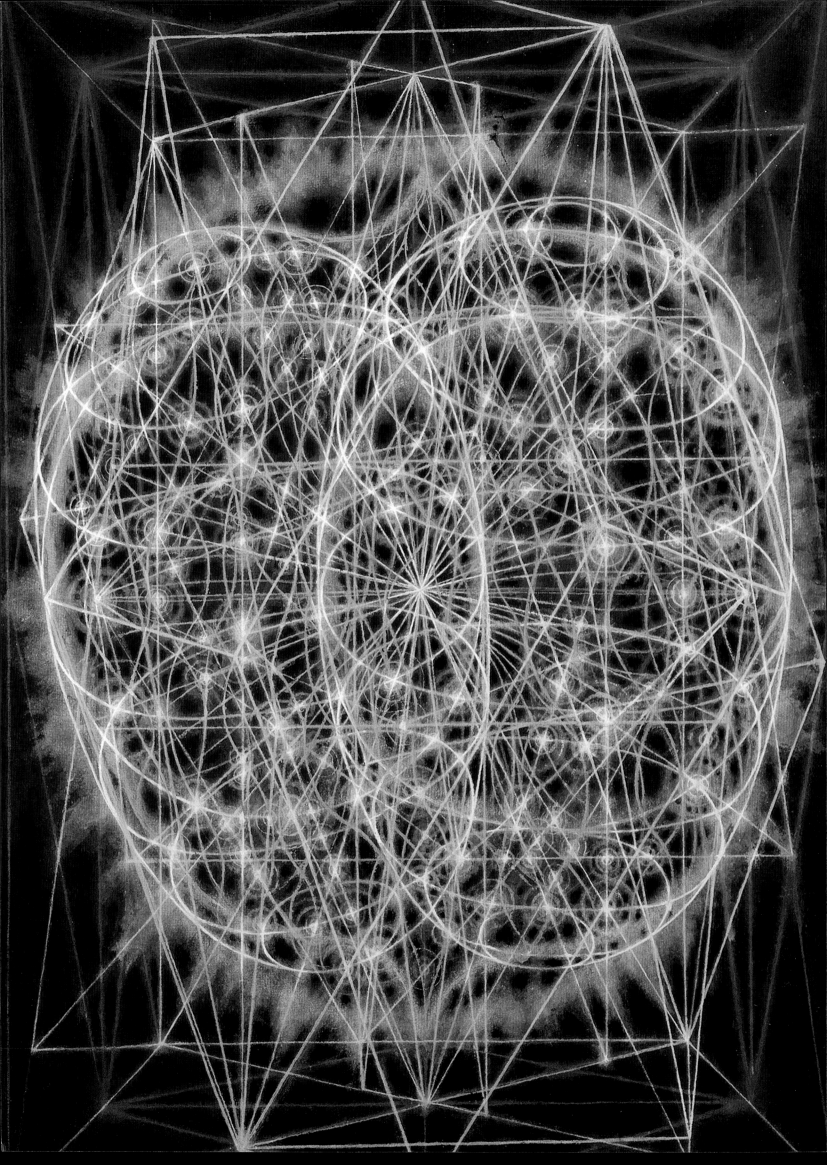

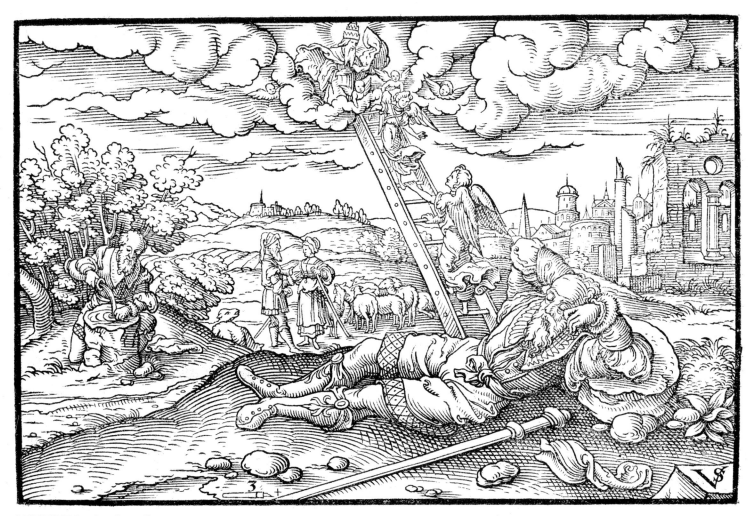

OPPOSITE Russian Surrealist painter and stage designer, Pavel Tchelitchew created this drawing of a network of lines of light and force. Set within a geometrical framework, spiral lines swirl and spin, and when they intersect they glow with points of light. The appearance of mystical wheels in motion recall the *Merkava*, which is why contemporary American poet and artist Brian George entitled this drawing by Tchelitchew *Descent to the Merkavah*, to illustrate one of George's writings.

ABOVE *Jacob's Dream* is a 1560 woodcut by German artist Virgil Solis, whose monogram is visible on the lower right-hand corner. The image depicts the famous scene from *Genesis*, of Jacob's vision of angels both ascending to and descending from heaven.

OVERLEAF The glorious Hall of Mirrors at the Palace of Versailles is the centerpiece of Louis XIV of France—the Sun King's—residence outside Paris. Built in 1690, the gallery is over 200 feet long, and its 357 mirrors reflect not only the magnificent gardens designed by André Le Nôtre, but the golden setting sun, when the room becomes ablaze with light. Perhaps the seventh Palace of Heaven is more fantastic, but the imagination of the mystics would have to start with the Galerie des Glaces.

"Rabbi Akiva said: 'Who may be able to think about the seven palaces and to envision the heavens above the heavens, and to observe the chambers inside the chambers and to claim: I have seen the chamber of God?'"—The Heart and the Fountain, p. 55

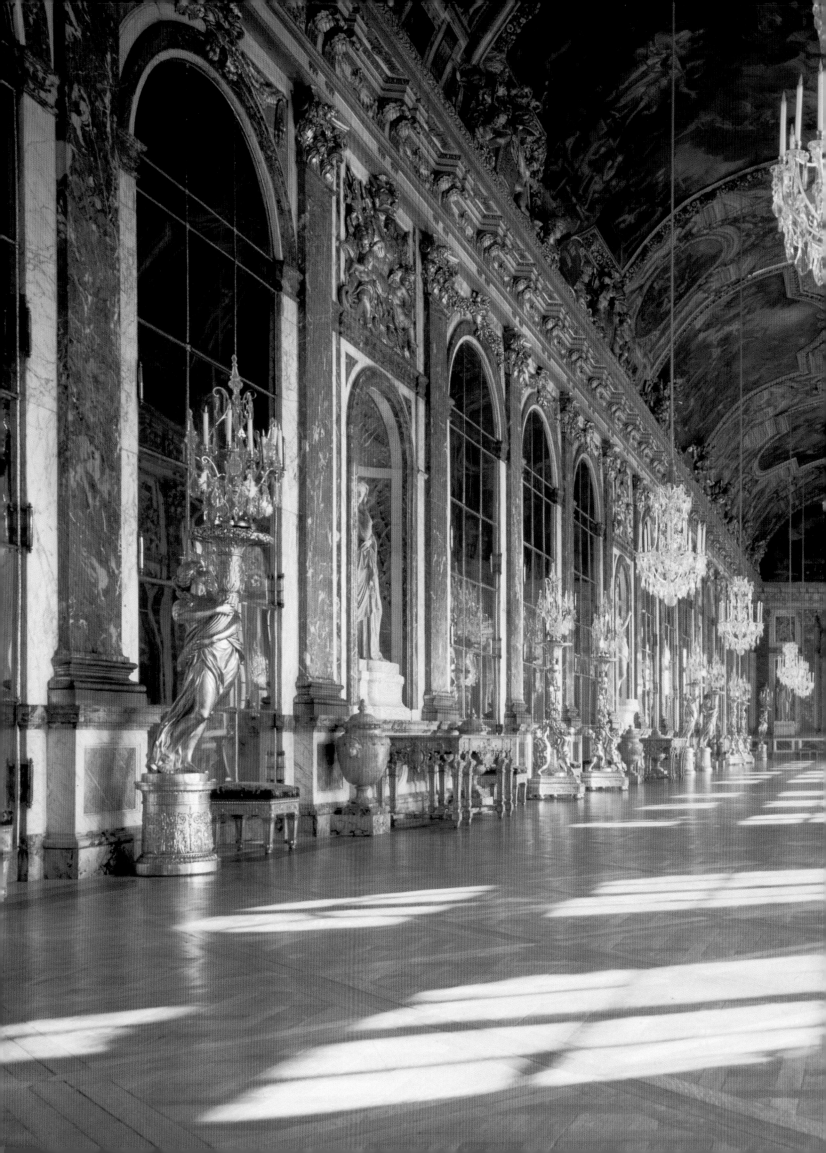

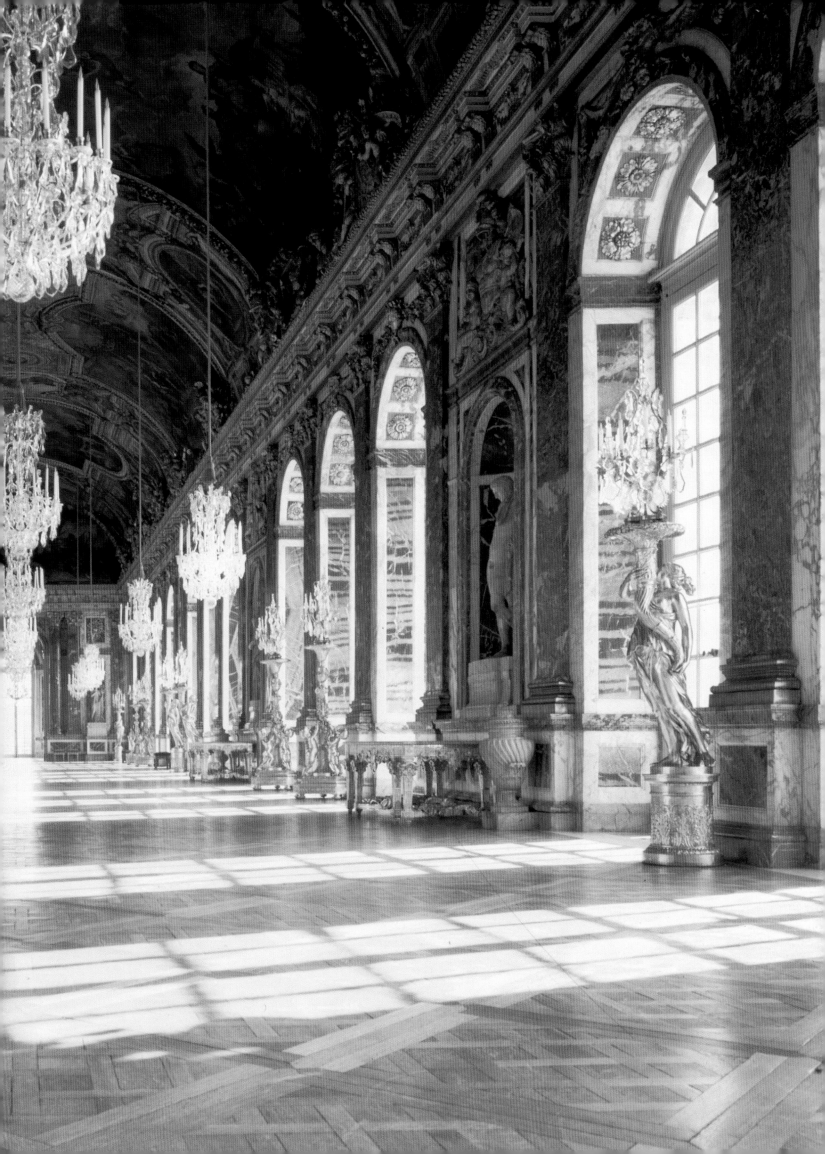

The Void צימצום

Is God an abstract artist? As the American art historian Kirk Varnedoe noted in his book *Pictures of Nothing: Abstract Art Since Pollock,* "abstraction," after all, comes from the Latin *abstractus,* which means to pull or draw away from. It is therefore identical to the concept of *Tzimtzum,* the contraction or withdrawal of God from a point in space in order to make room for the creation of the universe. Profoundly spatial in nature, the definition answers the question, If God is everywhere, how can there be room for the world? The artist Anselm Kiefer wrote: "I have been dealing with Isaac Luria's *Tzimtzum* for 20 years. This is a very abstract process, an intellectually stimulating and intensive process: the idea of a retraction from which something is created."

Of all concepts put forward by the Kabbalah, the *Tzimtzum* is one of the most provocative and pregnant with meaning for artists and architects. The infinite, endless space of God before creation is called *Ein-Sof,* in Hebrew, meaning "without end." *Ein-Sof* is completely beyond human comprehension, and it is only through the manifestation of the world that the Divine is even remotely understandable.

Tzimtzum is the opposite of the active gesture of God in the *Book of Genesis,* where "Let there be light" is a decisive, declarative statement of intent. In contrast, *Tzimtzum* concerns an intentional absence, a taking leave of God from himself, thus creating a vacuum or void in the ether of *Ein-Sof.* This startling scenario was elaborated by Rabbi Isaac Luria of Safed, in Palestine in the late sixteenth century. Gershom Scholem, the great scholar of twentieth-century Kabbalah, connected the idea of *Tzimtzum* to that of exile, writing: "One is tempted to interpret this withdrawal of God into his own Being in terms of Exile, of banishing Himself from His totality into profound seclusion. Regarded this way, the idea of *Tzimtzum* is the deepest symbol of Exile that could be thought of... The first act of all is not an act of revelation but one of limitation."

In Hebrew, *Tzimtzum* refers to the space between the cherubim in the Holy of Holies of the Temple in Jerusalem, where God's essence was focused. The shape of the *Tzimtzum* was a perfect sphere, as the contraction occurred equally on all sides. A single ray of light then entered the void, bouncing around into the pattern of the *Sefirot* and the primordial Man, which is known in the Kabbalah as *Adam Kadmon.* All creation proceeded from that point forward.

As with most Kabbalistic concepts, *Tzimtzum* is at once clear and ambiguous. What is the nature of this void space from which God has withdrawn? In the late medieval period, Rabbi Shem Tov ben Shem Tov explained that the absence of God opened the way for the emergence of evil.

In art and architecture, the void is a powerful primal concept that has motivated the making of form, ranging from Russian Constructivist Kazimir Malevich's rectangular black voids, to the India-born sculptor Anish Kapoor's *Adam.* The American modern artist Barnett Newman entitled his sculpture of the empty space between two folded steel plates *Tzimtzum.* In architecture, the "presence of the absence" has given powerful meaning to the empty spaces of the outdoor room of American architect Louis Kahn's Salk Institute in La Jolla, California, and the voids in between the blocks of Peter Eisenman's Holocaust Memorial in Berlin, Germany. The triumph of the void—empty space with meaning—recalls American architect Frank Lloyd Wright's reference to Father of Taoism, Chinese writer Lao-Tsu that the "space within was the reality," rather than the outward form.

OPPOSITE American artist Barnett Newman's freestanding 1969 sculpture in Cor-Ten steel is a series of two folded walls of metal, each eight feet high and separated by a three-foot space. It is called *Zim Zum* after the Hebrew word for "contraction," the cosmic act by which God makes room for creation. It reinterprets a theme of folded glass walls that he had used in a synagogue project designed for an exhibition at the Jewish Museum in New York in 1963. Walking in the space in between, one can feel the sense of contracted space, the earthly recreation of this divine act. Whether the artist wholly succeeds is less important than the boldness of the cosmic ambition of naming the sculpture *Zim Zum.*

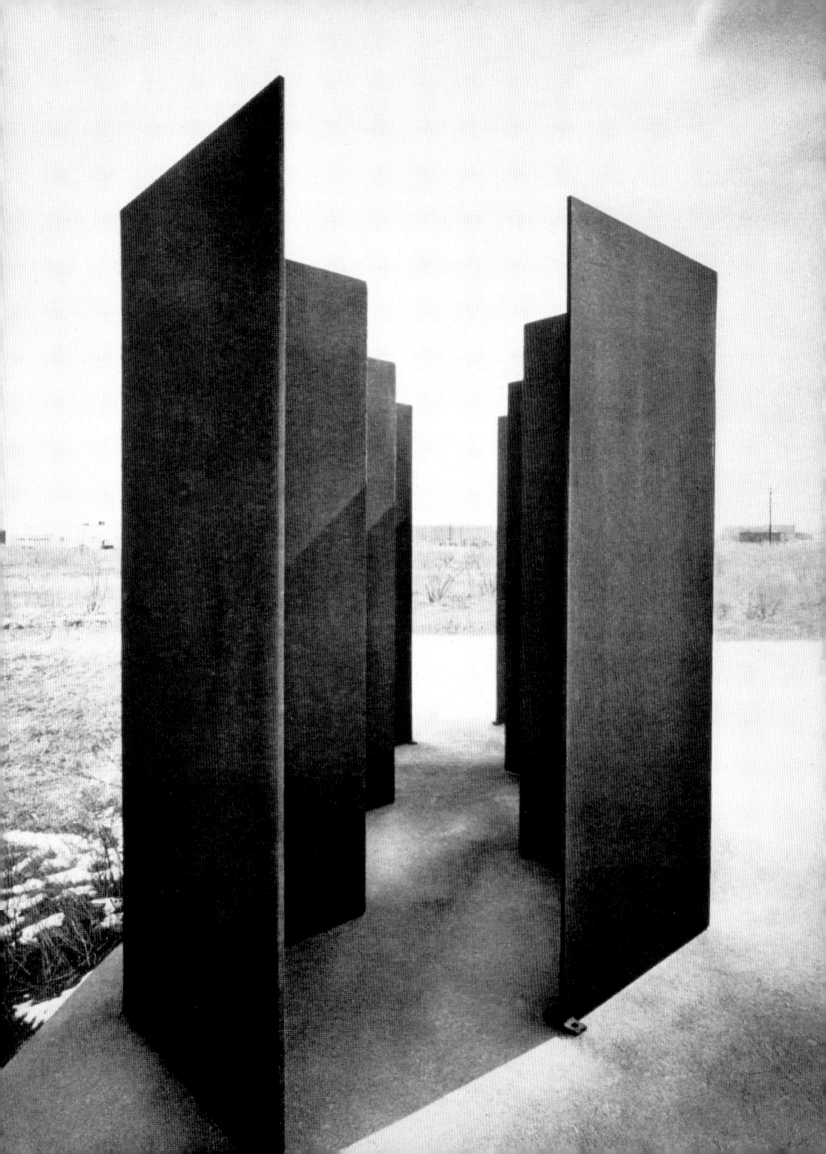

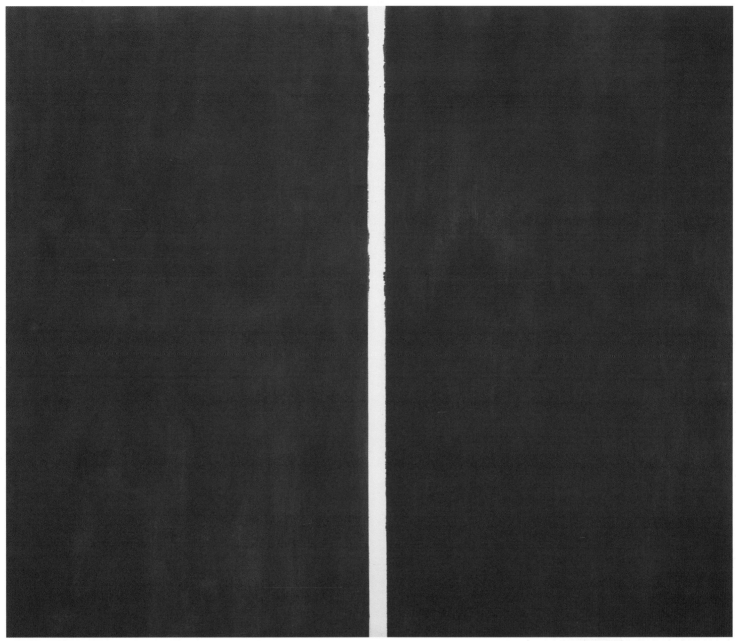

ABOVE Flashing down through the blue ground of Newman's 1953 *Onement IV* is what he calls a "zip"—a luminous slash through the center of the painting. The edges of the zip are either crisp or irregular, implying that light is emerging from the "unformed and void" background, recalling the first moments of creation. Light is making space, pushing out the dark of the boundless infinite, cracking open the void with a ray of light.

OPPOSITE AND OVERLEAF Architects have been known to weep upon viewing the open courtyard of Louis Kahn's 1965 Salk Institute for Biological Studies in La Jolla, California. Mexican architect Luis Barragán said it was a "facade to the sky," and its sublime sense of timelessness marks the experience. A fountain of water issues from the cube of stone in the foreground, cuts through the court, and seamlessly joins the Pacific Ocean. The folded walls of the two laboratories framing the space almost exactly match that of Newman's *Zim Zum* sculpture. As the Tzimtzum creates a void into which flows the first ray of light, Kahn funnels the light into a vessel, recalling the first light of creation.

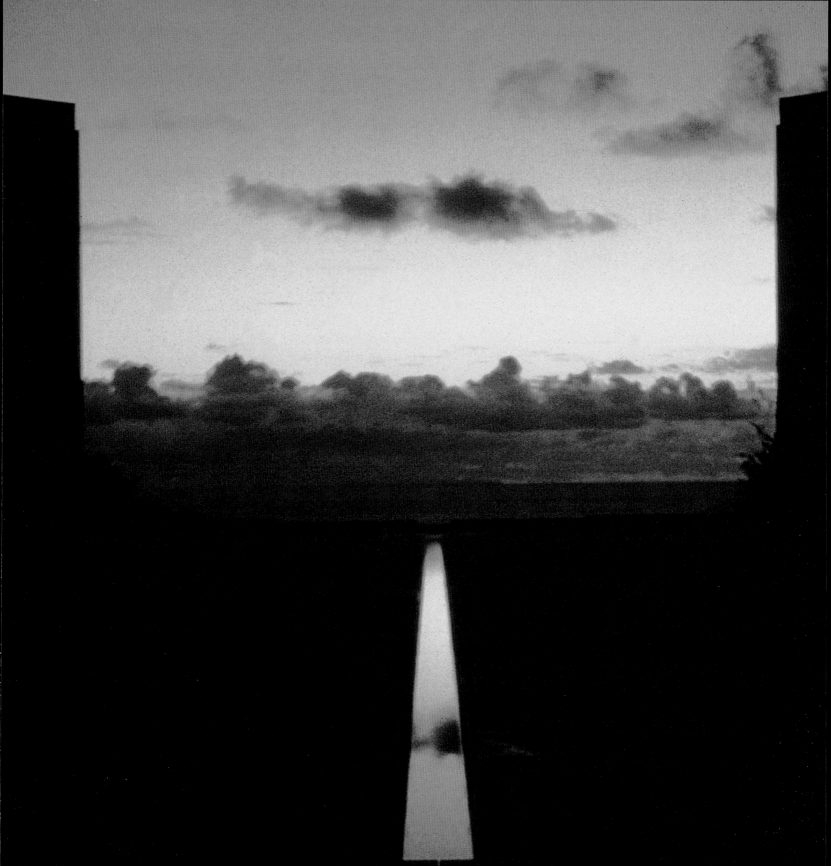

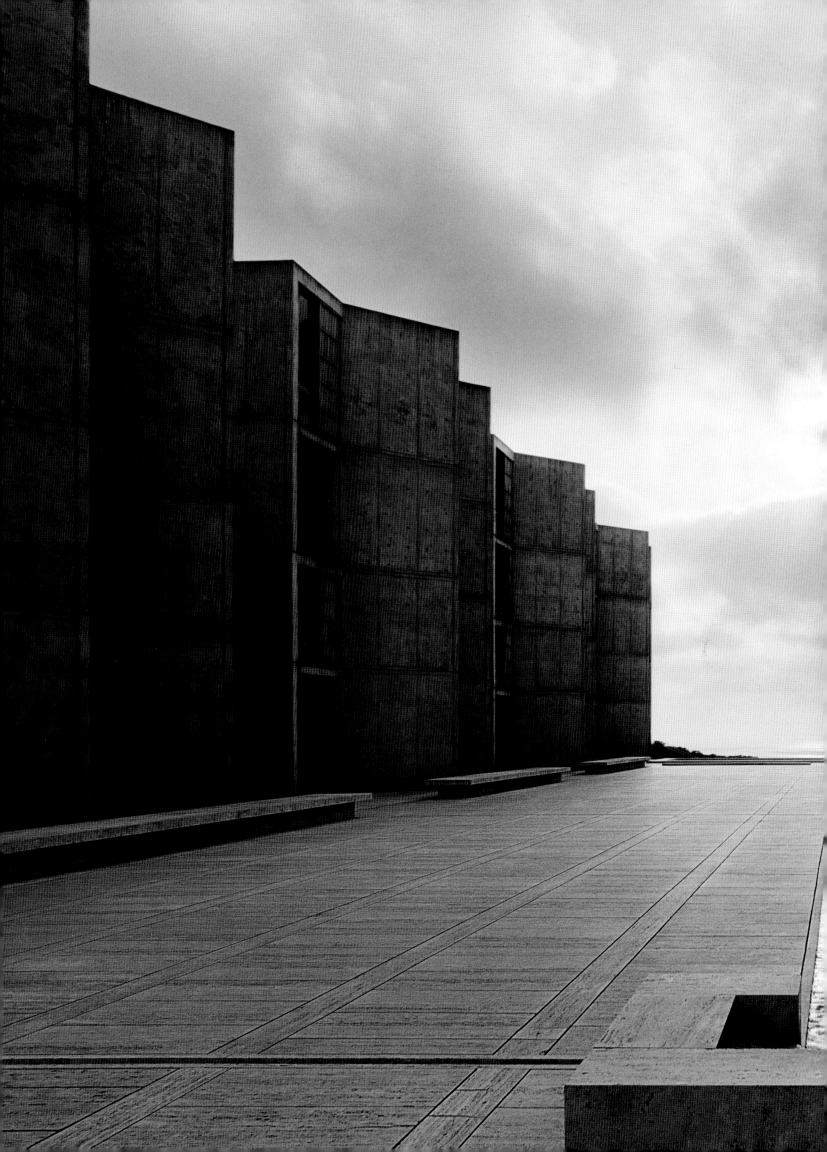

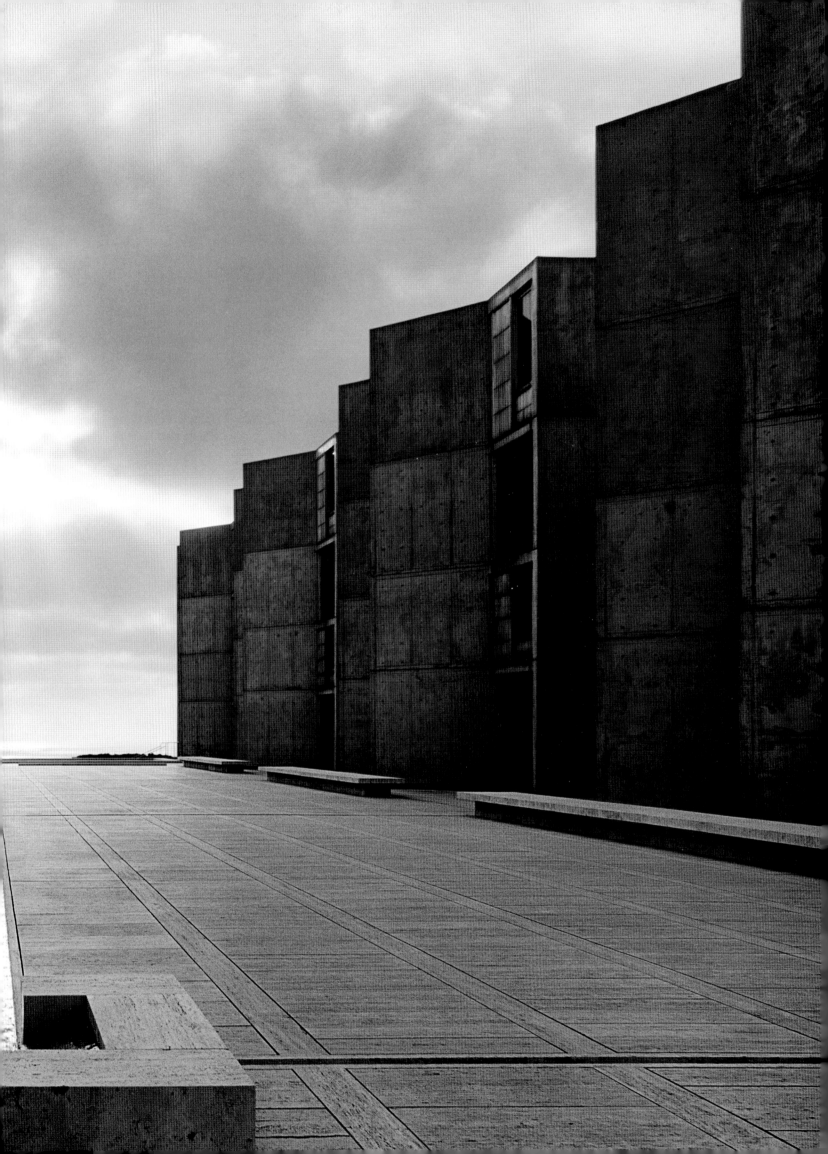

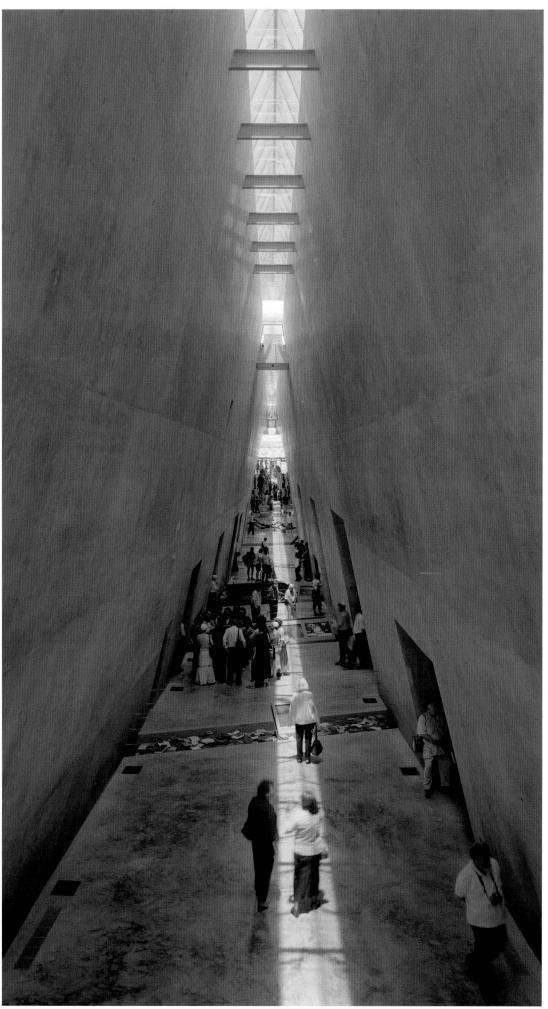

LEFT Israeli architect Moshe Safdie designed the new 1997–2005 *Yad Vashem*, or Hand of God Holocaust Museum in Jerusalem, Israel, with a 600-foot-long gash through Mount Herzl that organizes the experience of the exhibitions. The void is carved in light by the skylight and is a steep isosceles triangle seen in section. As in Daniel Libeskind's Jewish Museum in Berlin, Germany, a visitor zig-zags along the path of the *Tzimtzum*. The long axis is visual, but blocked by cuts in the floor, making people walk into the adjoining galleries and back onto the central path.

OPPOSITE At the far end of the space, after the dreadful memories of the Holocaust are revisited, relief comes in the form of an open view of the surrounding hills through angled walls that splay outwards. As Safdie said: The idea is that "life prevailed. We prevailed." The explosion of the view into the empty sky and the horizon of Jerusalem, the "center of the world" in the Kabbalah, is a powerful experience.

OVERLEAF American multi-media artist Amie Siegel creates work that is haunting and subversive. Such is the case with *Black Moon*, which is comprised of both cinematic and photographic elements. The 2010 Cibachrome print, *Black Moon/ Hole Punch #6*, was created during the process of transferring the 16mm film negative into high definition. During that process, the laboratory punched a hole in each original frame of film, which the artist then turned into prints. The result is a jarring juxtaposition of a typical suburban house blighted by a gaping black hole burning through the scene. The abyssal void home conveys an uneasy critique of reality; the seemingly normal scene masks a vortex about to destroy everything in its path. This *Tzimtzum* contraction perhaps implies the catastrophic destruction that will precede a new creation, recalling the multiple worlds of the Kabbalah that existed before.

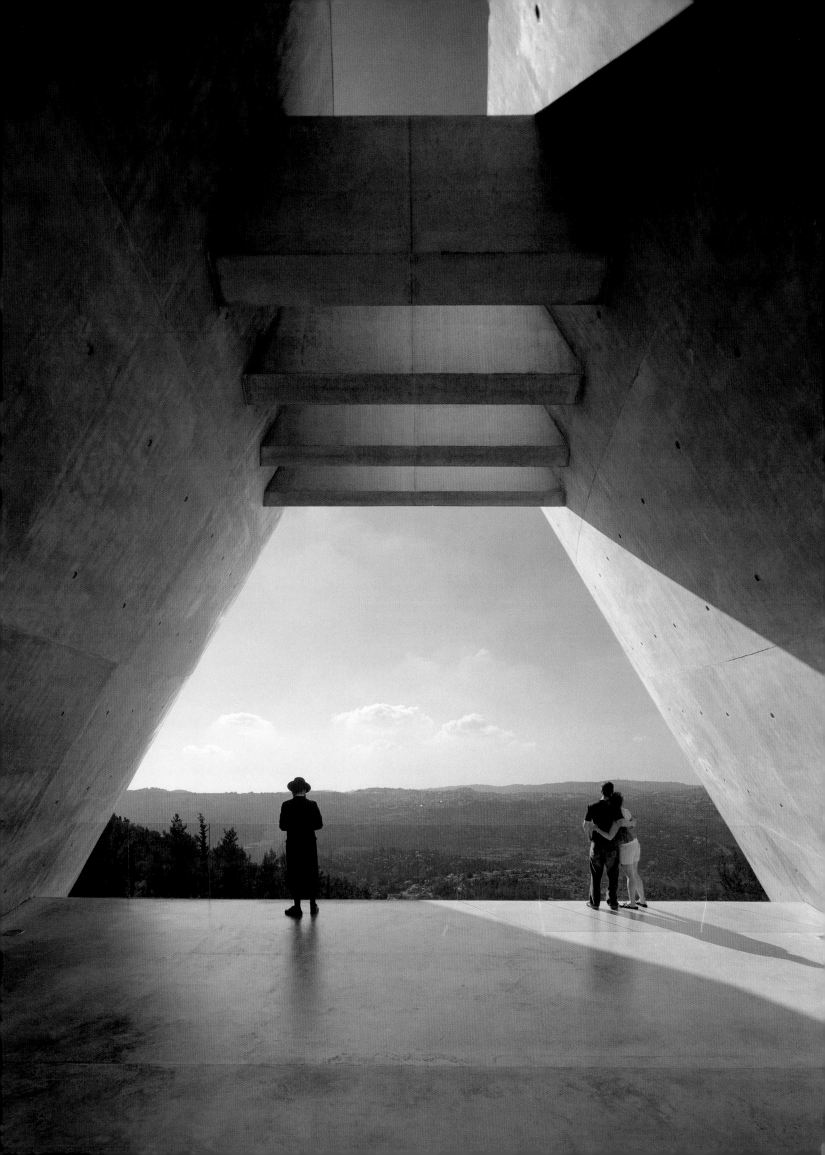

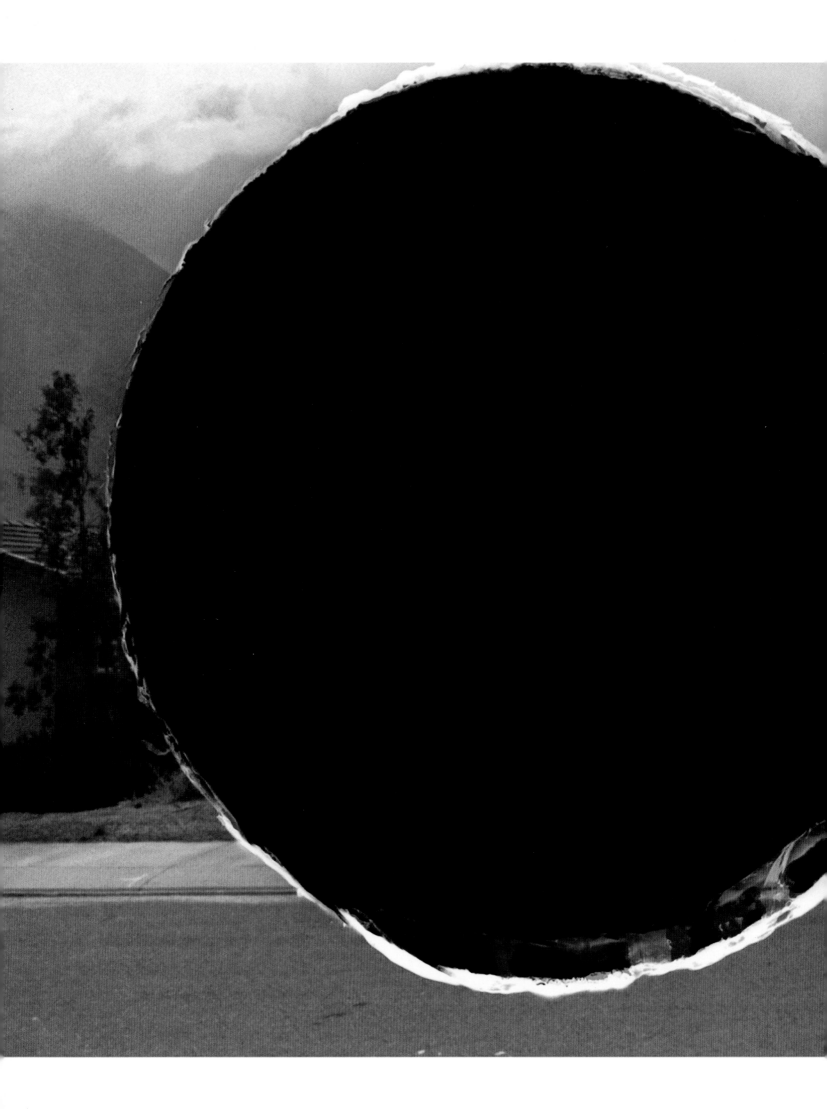

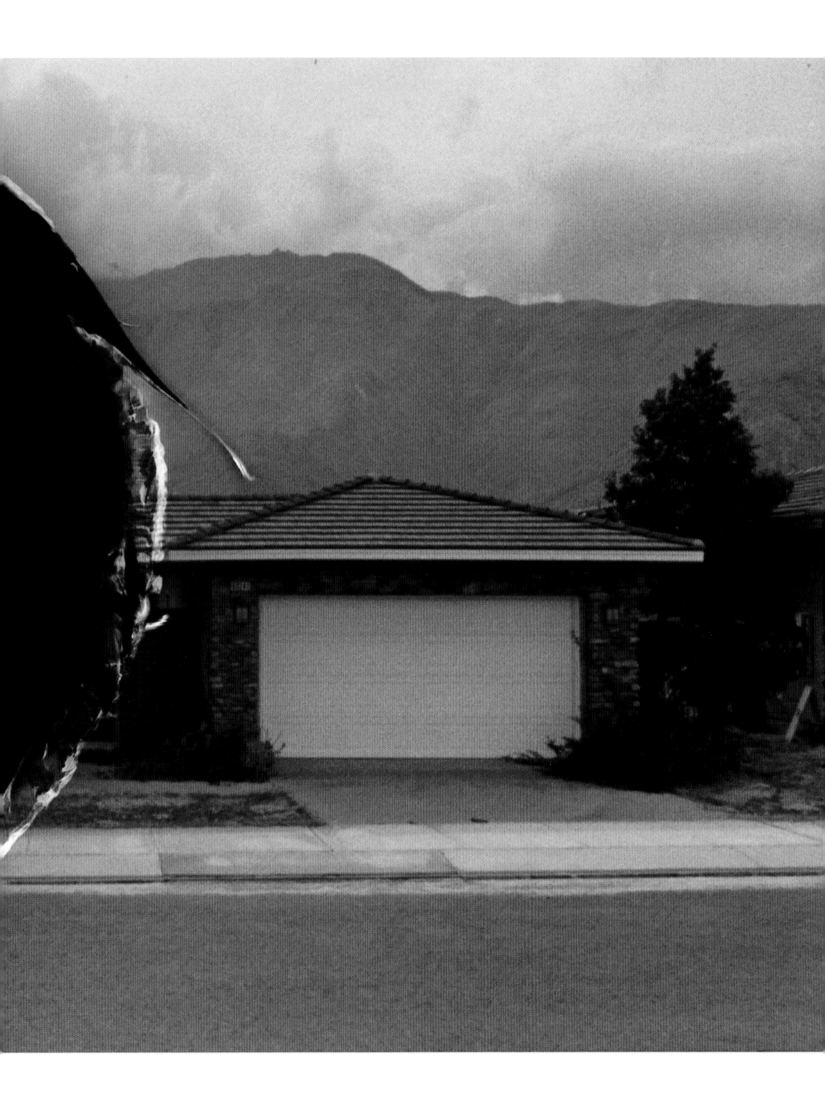

The aspect of the *Tzimtzum* that implies evil in the absence of God is fully realized in American architect Peter Eisenman's Monument to the Murdered Jews of Europe, which was built in 2005 in the heart of Berlin, Germany, near the Brandenburg Gate. One is confronted by a seemingly endless grid of mute concrete blocks that rise from low benches to a height of 15 feet, with paved stone paths in between. Walking in the narrow three-foot-wide space between the pillars is a disorienting and disturbing experience of places not remembered and memories too harsh to recall. The ground gently slopes, and many of the pillars are slightly tilted to further intensify the feeling of being "lost in space," as Eisenman has said. Only the sky is visible above to provide some orientation; otherwise one feels trapped and claustrophobic, and a sense of panic starts to arise. Without any inscription or textual marking, like a graveyard of erased names, the experience is unlike any other memorial in its extreme abstraction. The disturbing effect of a memory encased in concrete is like bodies entombed anonymously in the graves of a Jewish cemetery ruined by the Nazis. The space between the pillars is like the void where God is not, the *Tzimtzum* made concrete. As Eisenman quoted early twentieth-century Austrian architect Adolf Loos: "Architecture is only the monument and the tomb." This memorial is both a place of mystery and of sorrow.

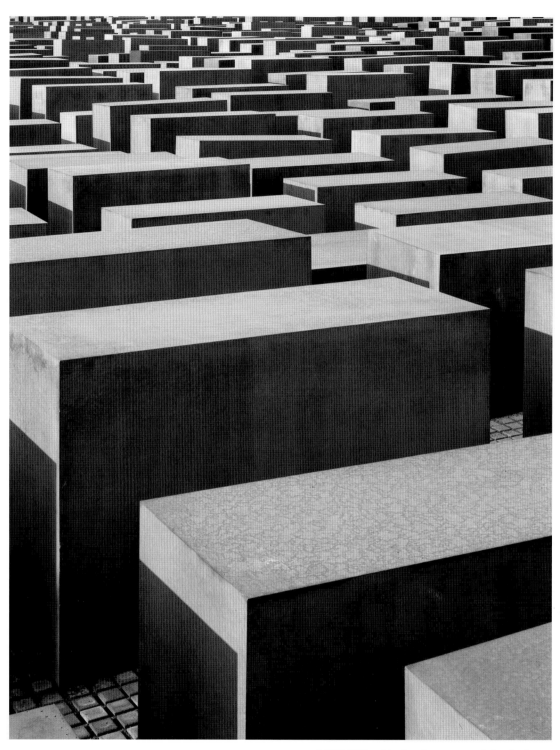

ABOVE The blocks of concrete of the Berlin Holocaust memorial are organized by two grids that create an undulating surface at the top and at the lower level.

OPPOSITE Granite pavers set in gravel provide a path through the rows of blocks. The sense of interminableness and of feeling lost in a cemetery of anonymous gravestones is overwhelming.

OVERLEAF At night, the blocks seem to disappear into the darkness. The numbing sorrow of the millions who were murdered amid the nightmare of the Nazi regime is overpowering amid the sea of menacing concrete.

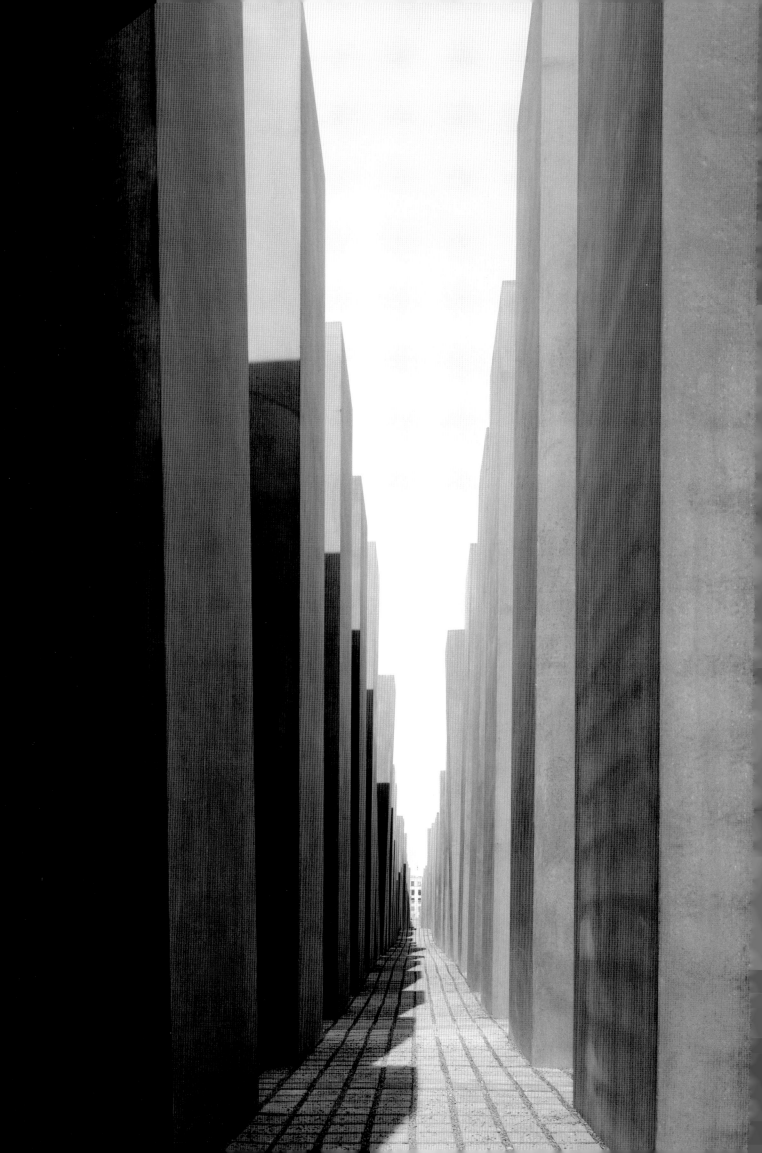

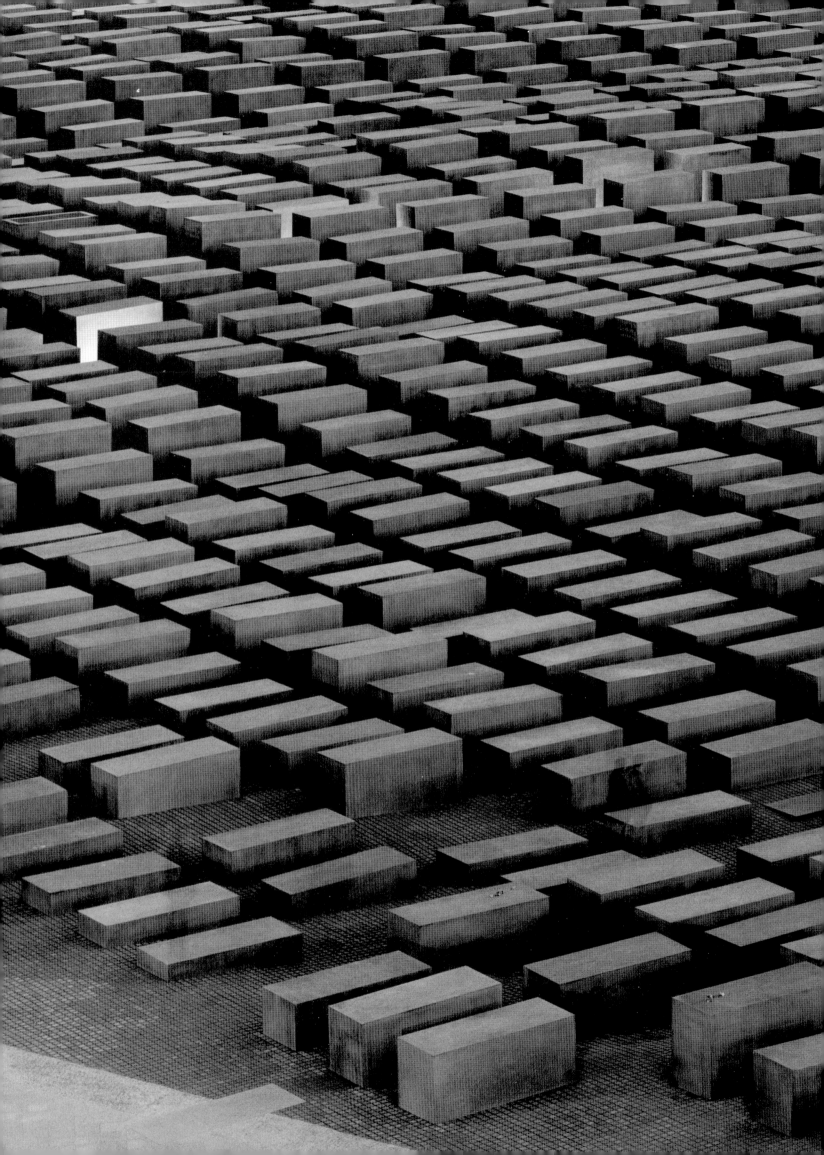

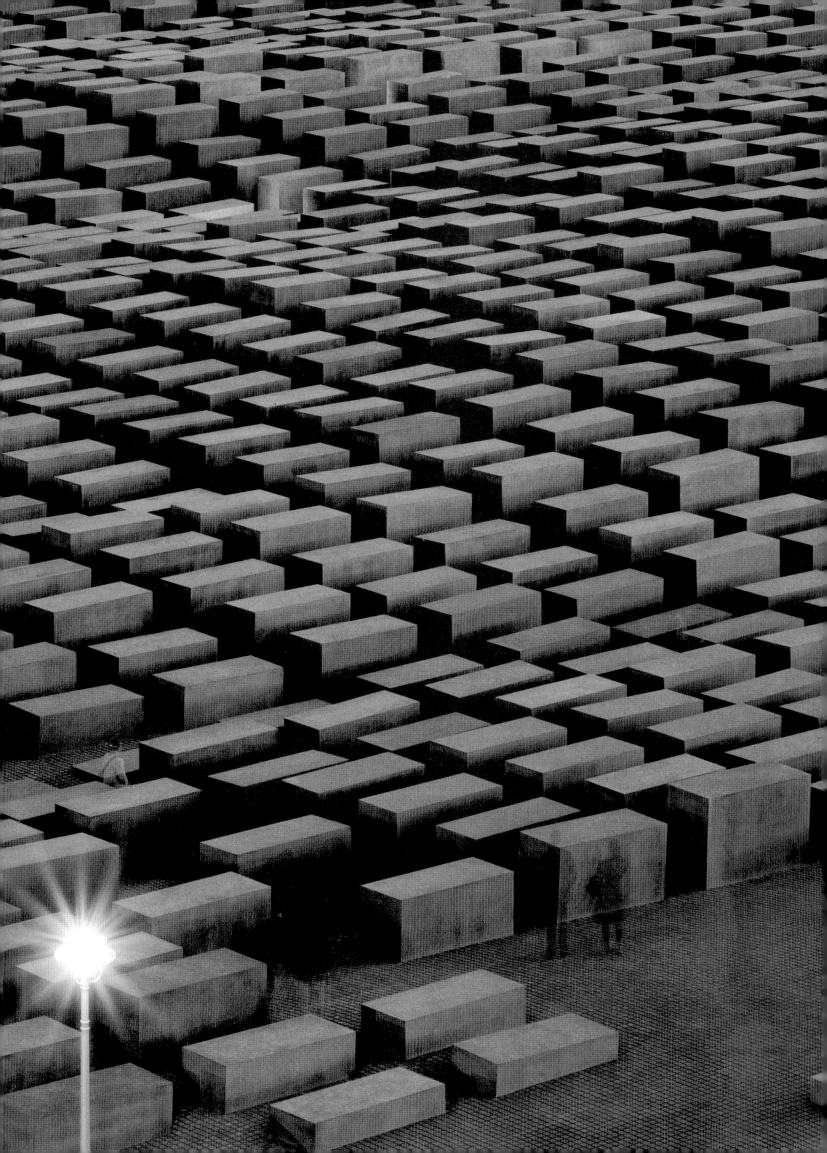

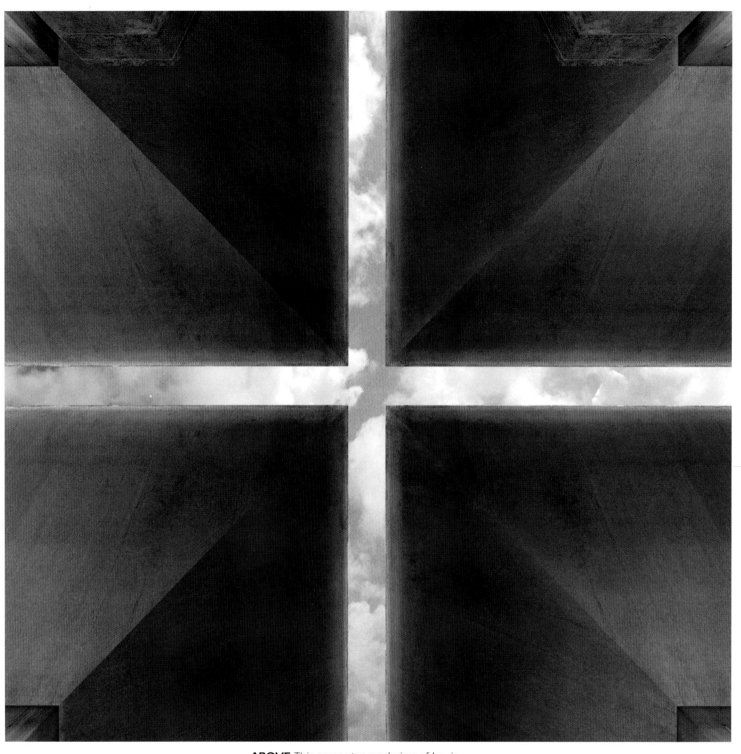

ABOVE This computer rendering of Louis Kahn's unbuilt Hurva Synagogue in Jerusalem, 1967–1974, shows a view of the parasol roof split into four quadrants to let light in. It creates a powerful figural intersection where the four concrete canopies are separated by a gap, allowing them to hover and float miraculously between the lines of light. The void of light that creates structure and space is a perfect metaphor for the *Tzimtzum* as the beginning of creation.

OPPOSITE In Kahn's Yale Center for British Art in New Haven, Connecticut, completed in 1974, light carves space out of the deep concrete beams of the skylights. The powerful four-square figure hovers overhead in the entry atrium. The manner in which the sense of space is created recalls the description in the Kabbalistic text *Sefer Yetzirah,* where the world is "hewed," as if from a solid block of rock, out of the all-encompassing presence of God filling the universe.

"…So too from within that opening in the middle of the Garden issues one light that divides in four directions through the four openings that we have mentioned, where those four inscribed letters exist. That light dividing into four lights, to four sparkling letters, issues from Eden, a radiant place of the Lower Point above."—Zohar 2:210b

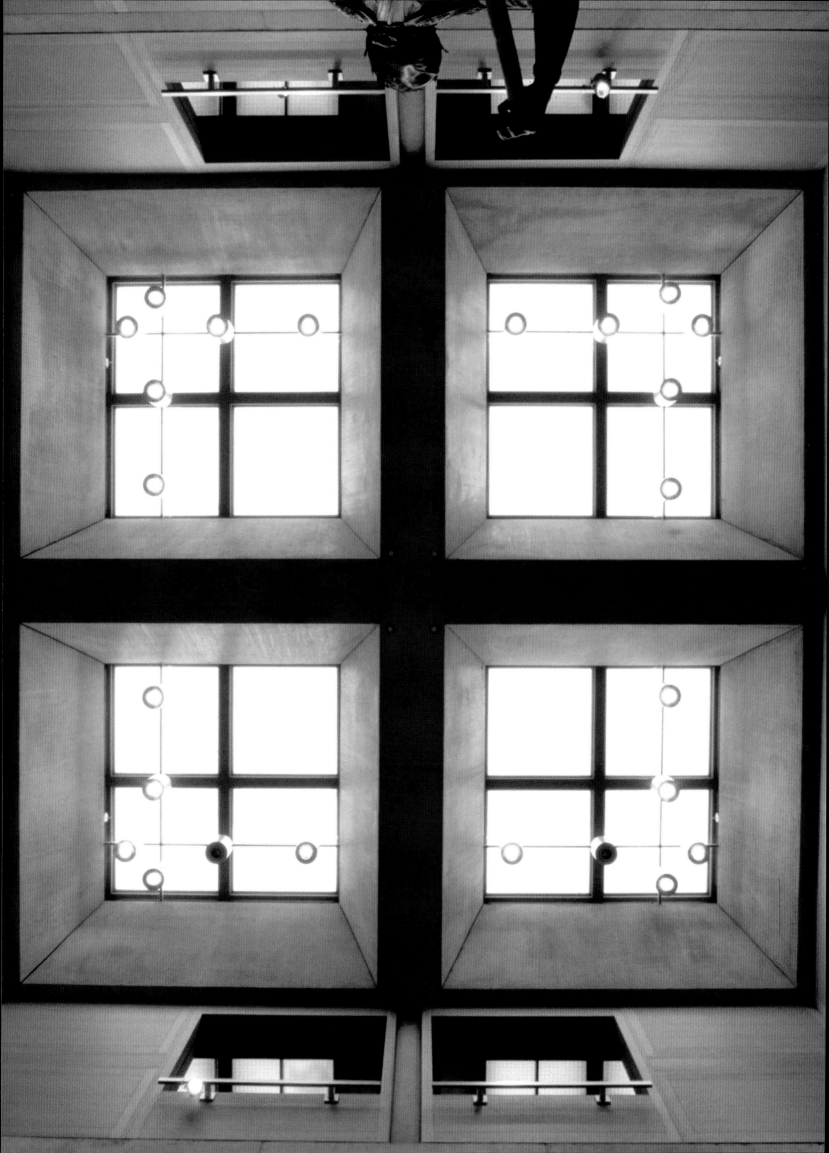

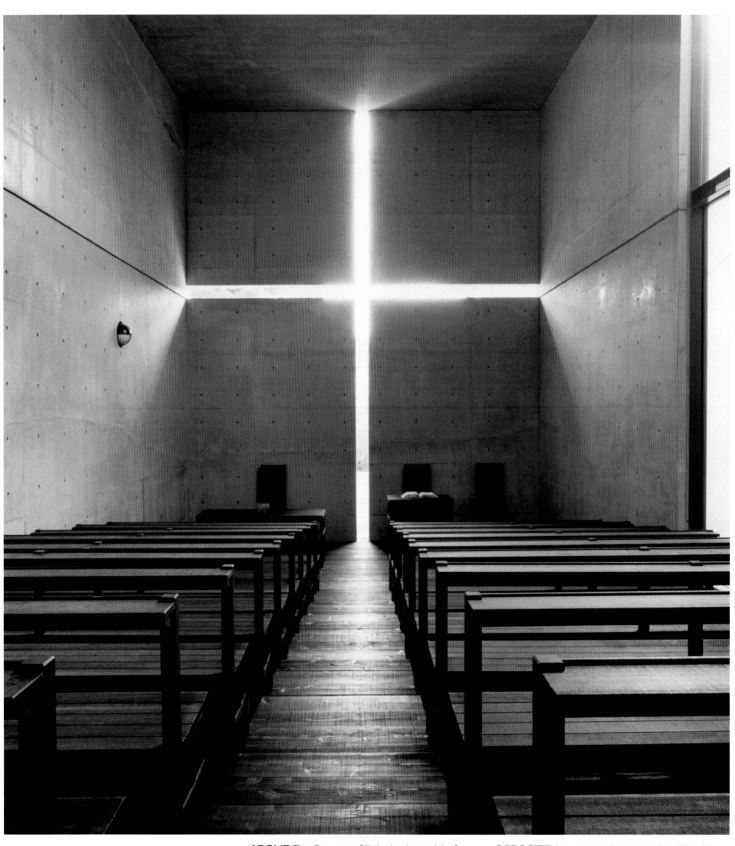

"Look, when Adam was created, he was prepared from the dust of the Temple below, and four directions of the world converged in that place! Those directions of the world joined four aspects that are the foundation of the world: fire and air, water and dust—joining four directions of the world, and from them the blessed Holy One prepared a single body, a supernal array."—Zohar 2:23b

ABOVE The first ray of light in the void of *Tzimtzum* is suggested in the evocative space of Japanese architect Tadao Ando's 1989 Church of the Light in Osaka, Japan. Like Louis Kahn, Ando uses light to carve space out of darkness. Like a laser, light cuts through the concrete walls edge to edge to define a spiritual space within this cubic volume.

OPPOSITE Japanese photographer Hiroshi Sugimoto's 1997 image of the interior of Ando's Church of Light further intensifies the inherent duality of light and dark in the space, distilling the essence of the eerie immanence of the Holy Spirit. The primal light of creation is evoked in the blurry edges of the incandescent cross emerging from the inky void. One also thinks of Isaiah, when the prophet said: "I form the light and create darkness, I make peace, and create evil: I the Lord do all these things."

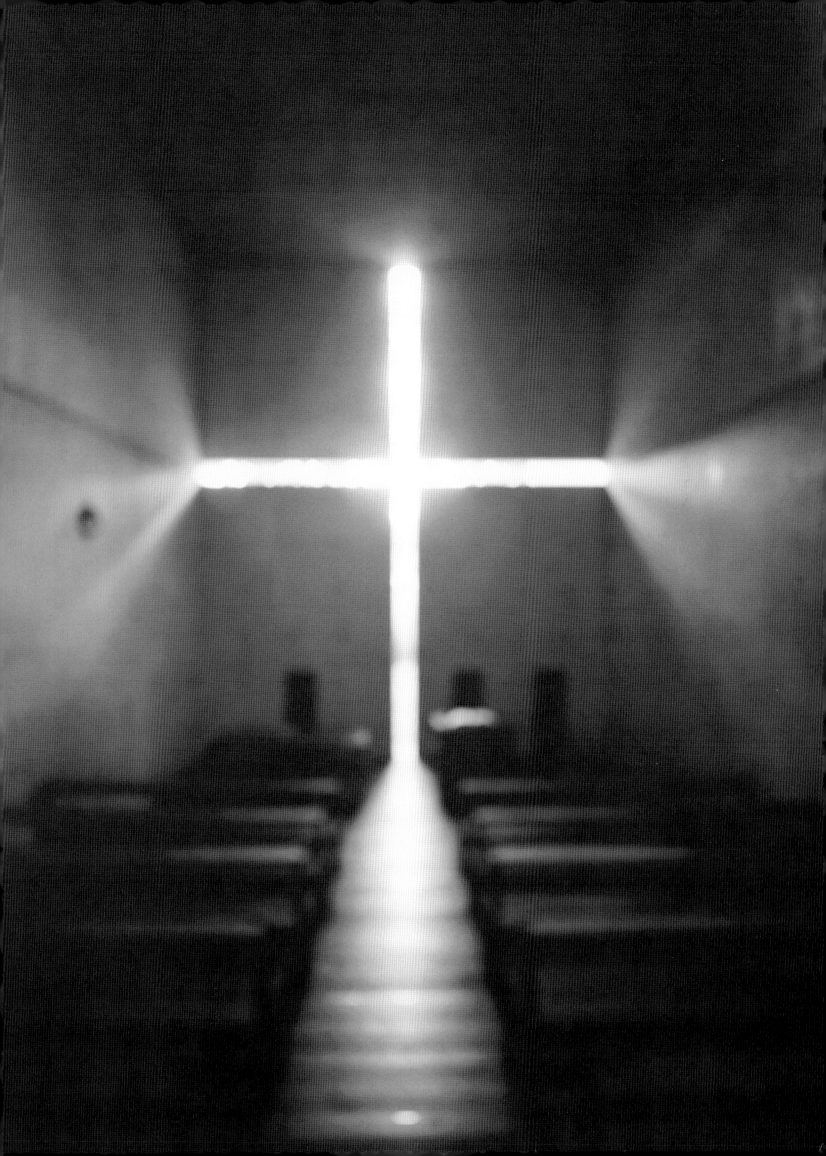

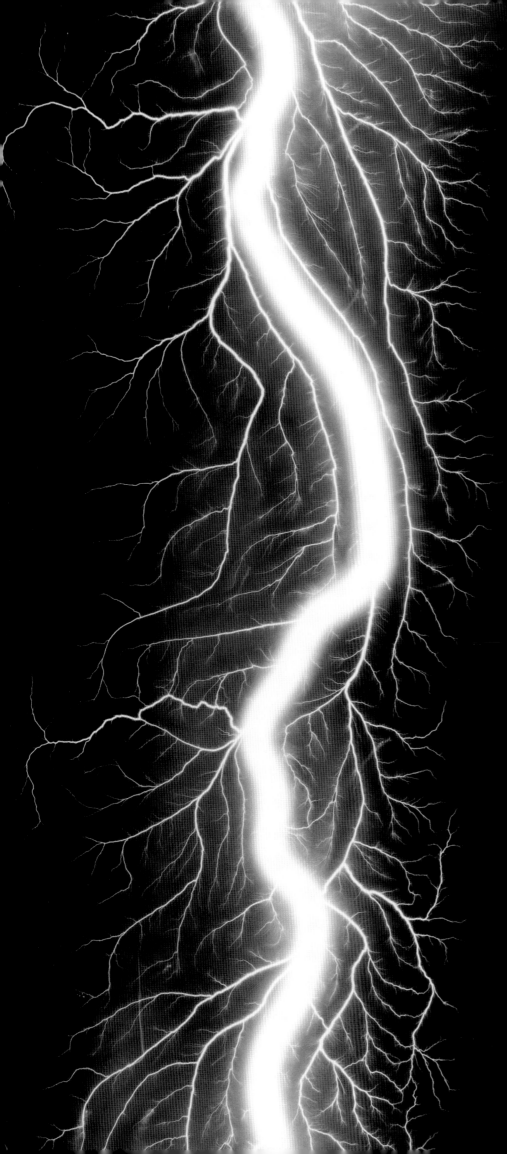

LEFT What appears to be a tremendous bolt of lightning is in fact an electrical device photographed in Sugimoto's studio. In his 2009 photograph *Lightning Fields 220*, the crack of electrical current is remarkable for the enormous range of scales it evokes: from lightning across the sky, to a human brain with branching neurons, to the cosmic Big Bang in the void before creation. All of these interpretations illustrate the Kabbalistic theme of the micro/macrocosm, that the pattern on earth reflects the heavenly model above.

OPPOSITE The absence of the Twin Towers in New York City, as well as the memory of the thousands who died, is a void felt by the millions of people who witnessed or remember the cataclysmic event. The 2002 memorial *Tribute in Light* by John Bennett, Gustavo Bonevardi, Richard Nash Gould, Julian LaVerdiere, and Paul Myoda, with lighting consultant Paul Marantz, is the memorial consisting of two vertical shafts of light that summon the ghostly presence of the towers once a year on the anniversary of the tragedy, on September 11. Perfectly parallel, the shafts of light split the night sky and recall the *Tzimtzum* as an event where the absence of God allows evil to emerge and dominate.

"I form the light and create darkness: I make peace, and create evil: I the Lord do all these things."—Isaiah 45:7

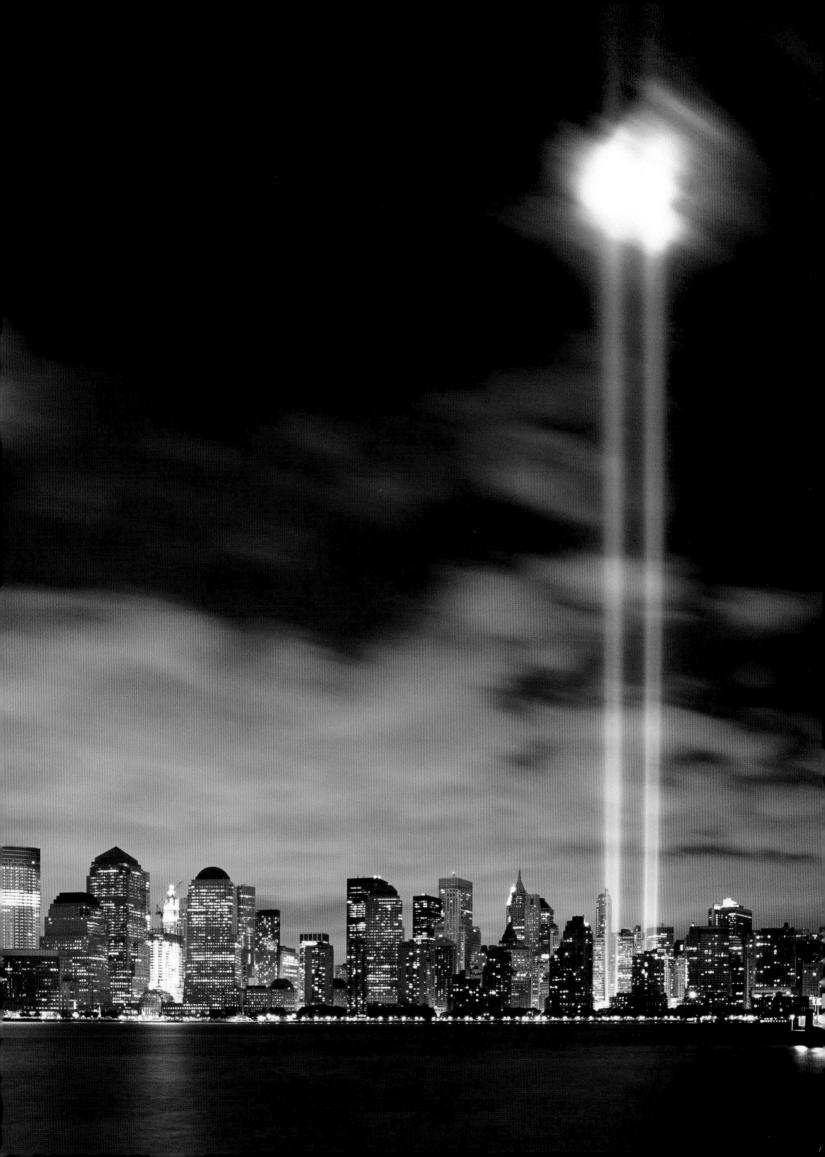

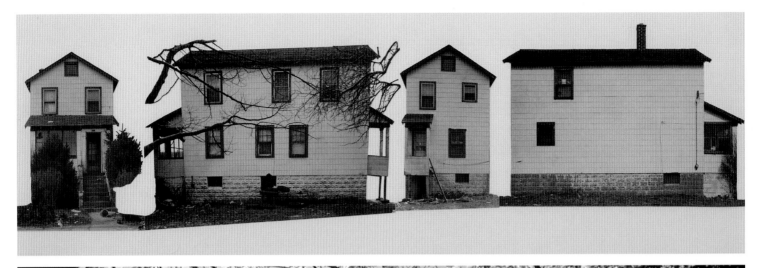

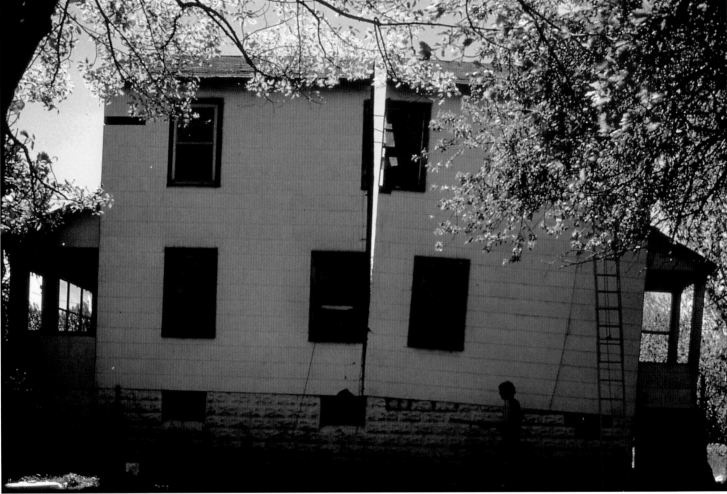

TOP, ABOVE, AND OPPOSITE In a radical experiment called "Splitting" that took place in Englewood Cliffs, New Jersey, in 1974, New York artist Gordon Matta-Clark cut though a house with a chainsaw, exposing the fragility of shelter with a single slice of the knife. Splitting the house completely in two, fracturing walls, ceilings, and floors, the crack threatens to collapse the structure into a pile of rubble. This destabilizing fissure of light is an active void, a narrow portal into another dimension of time and space.

OVERLEAF Rending the fabric of canvases was a violent gesture by Italian artist Lucio Fontana in *Concetto Spaziale* in 1961 that put into question the entire history of painting. Rather than viewing the canvas as a ground upon which paint is spread, Fontana attacked it, slashing its stretched skin to leave scars. The cuts are ambiguous in meaning, as one wonders whether they will pull the canvas apart, or do they represent a wound that is about to heal: Are they rips in the fabric of the universe, or are they in the process of *tikkun*— restoring the torn order of creation?

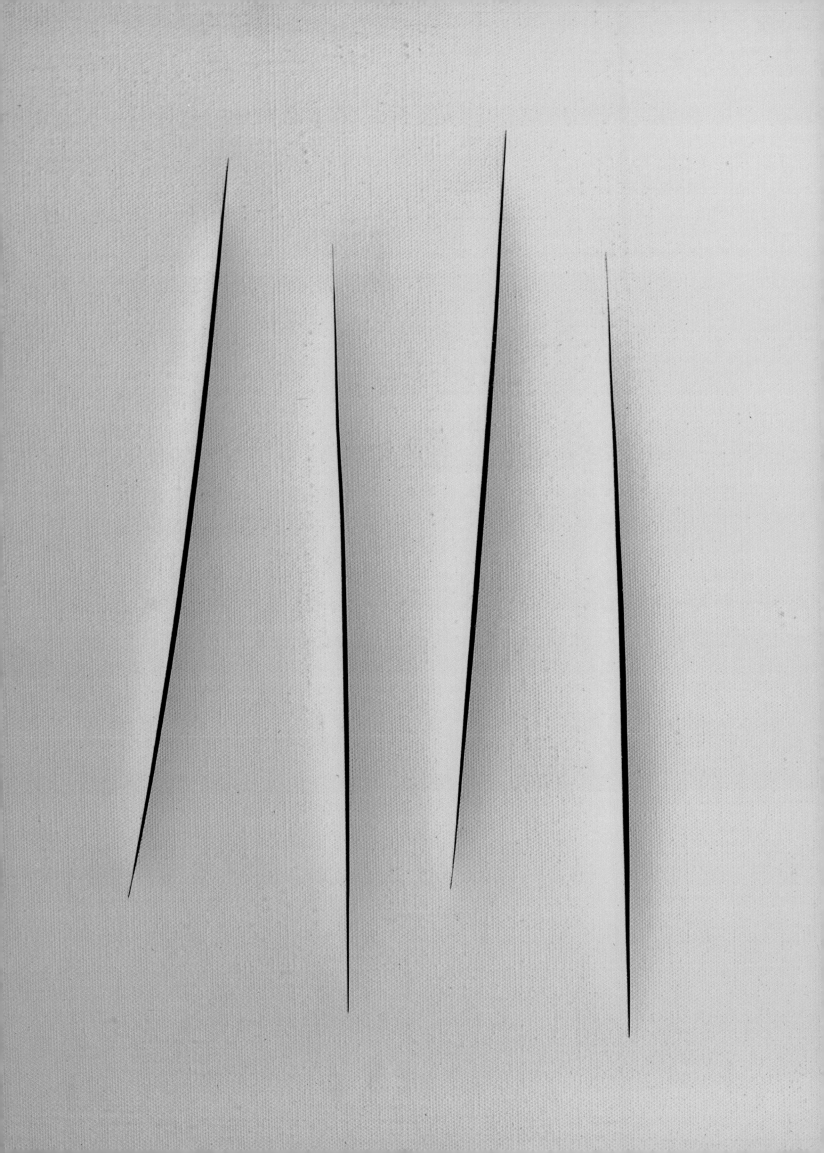

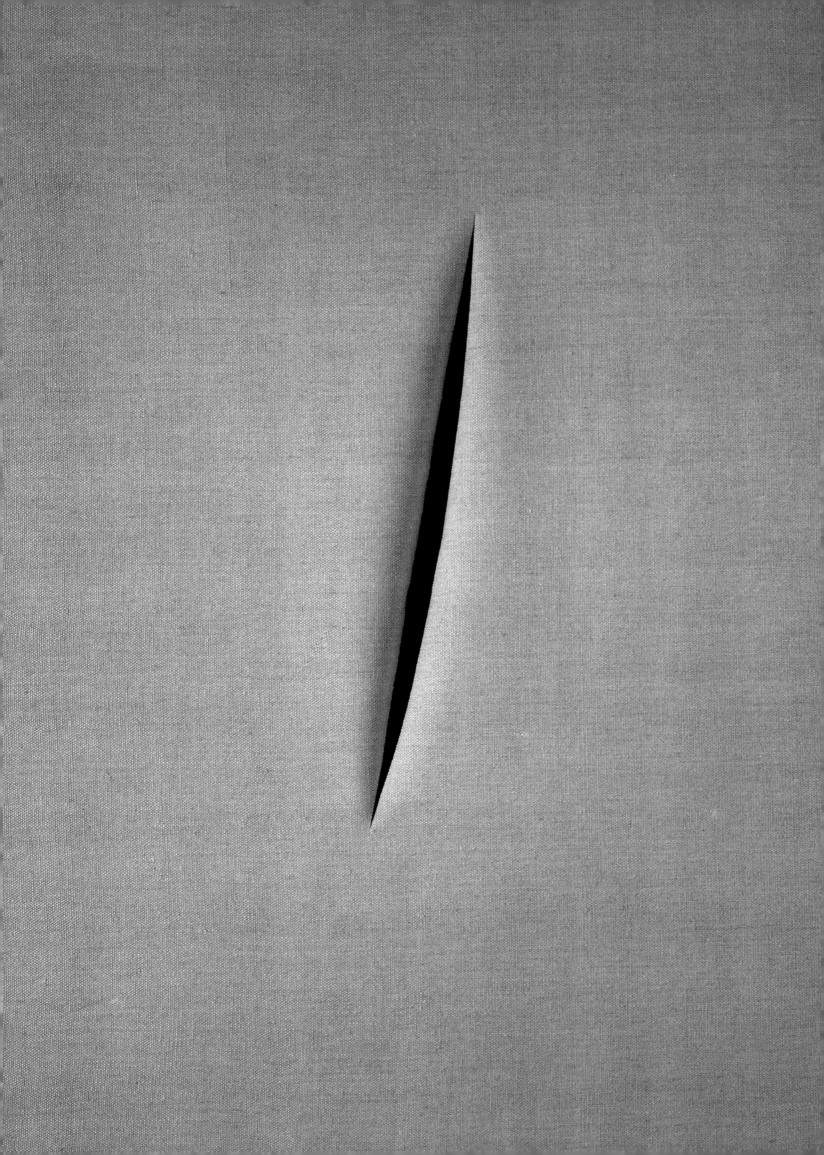

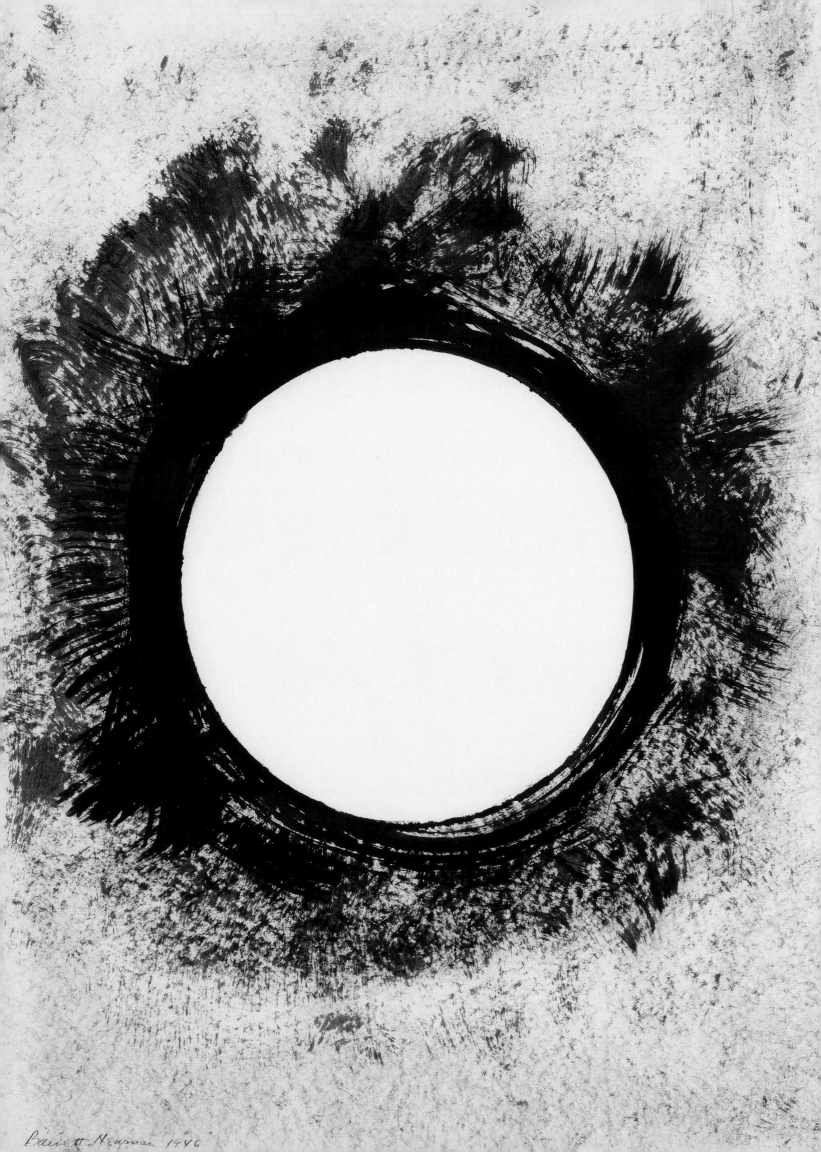

Barnett Newman 1946

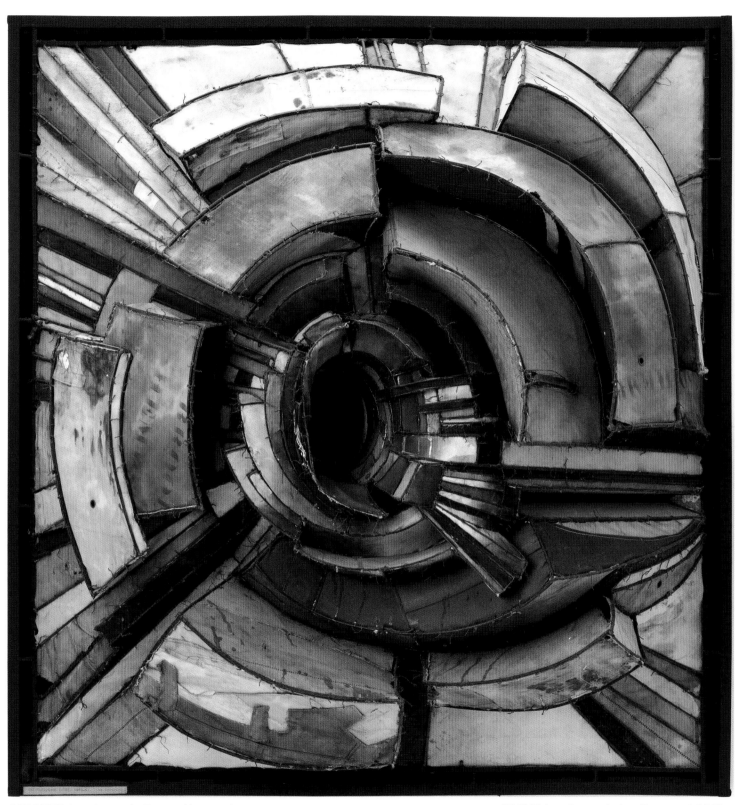

OPPOSITE American artist Barnett Newman's *Untitled—The Void,* 1946 is a circular white space surrounded by an irregular cloud of dark shapes. The substitution of the more usual black void by a white one is unexpected and striking in its contrast between figure and ground.

ABOVE American artist Lee Bontecou's 1962 work, *Untitled,* is a vortex of canvas and wire, a sculpted landscape with a central black hole that draws the eye deep into the frame. The ridges of the concentric rings are cut by four fissures that emphasize the crater-like center. Both centripetal and centrifugal forces are simultaneously at play, pulling in and then away from the center. Like the *Tzimtzum,* the sense of a withdrawal from a point is strongly felt, creating a void of future potentiality.

"Then the immense abyss ascended in darkness, and darkness covered all, until light emanated, split the darkness, and radiated, as it is written: **Revealing depths out of darkness, bringing pitch-blackness to light** *(Job 12:22)."*—Zohar 1:30b

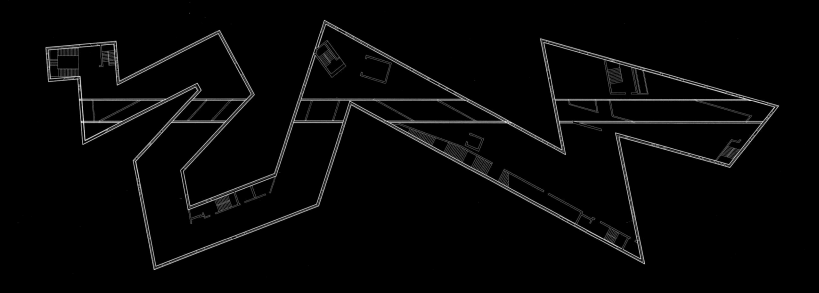

THESE PAGES The American architect Daniel Libeskind's jagged plan for the Jewish Museum in Berlin, Germany, recalls the zig-zag of the *Tzimtzum* in Barnett Newman's synagogue project of 1963. It is a dagger through the heart of Berlin as a vivid monument to the memory of the Holocaust. The linear central area of the museum, cutting through the zigzag, is called the Holocaust Void—a grim and narrow vertical space that recreates the sensation of being trapped, like the Jews in the concentration camps. It is a metaphor for the Holocaust itself, a time when God was absent. The exile of the Divine from himself was a vacuum, which allowed evil to rush in. Claustrophobic and dismally lit from a slit in the roof, the space also brings to mind the misery of Jonah in the whale, "For thou hast cast me into the deep, in the midst of the seas, and the floods compassed me about: All the billows and thy waves passed over me."

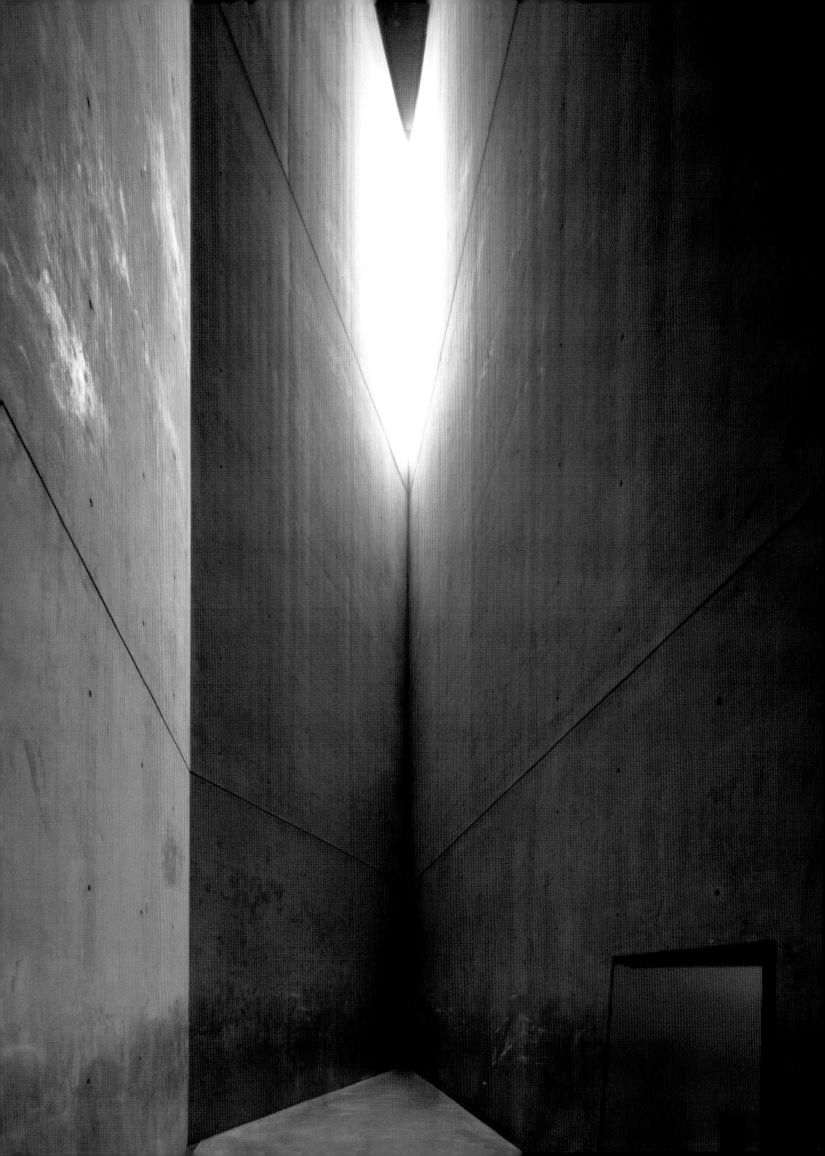

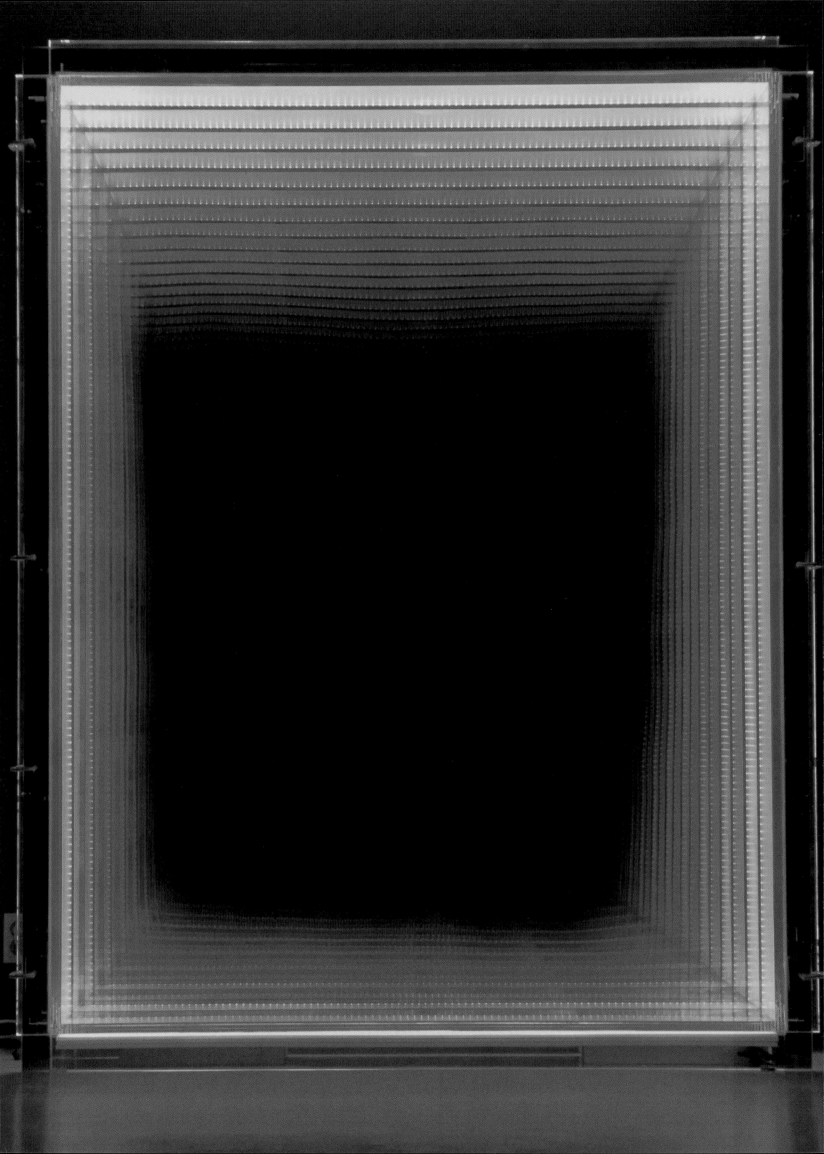

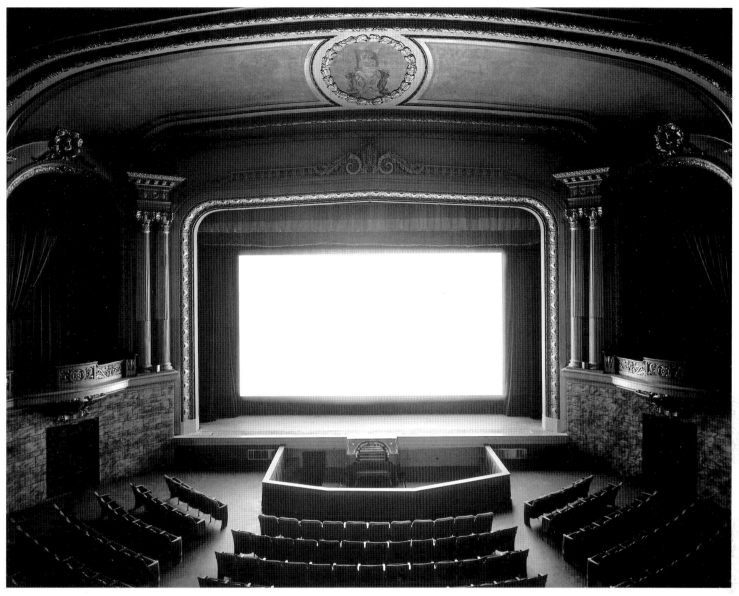

ABOVE By exposing the shutter of the camera for the exact length of the movie in the theater, Japanese artist Hiroshi Sugimoto discovers a void of light. In his 1992 photograph *Grand Lake, Oakland*, all the images of the film have blended together into one luminous, rectangular plane. The eerie light casts a pale glow on the empty seats of the theater, emphasizing the sense of abandonment and anticipation. It is a Zen image of nothingness, or the infinite depth of *Ein-Sof*. It also recalls the strange sensation of static on a television screen, as well as the 1950s science fiction series, *The Twilight Zone*.

OPPOSITE By using fluorescent lights and mirrors, Korean artist Chul Hyun Ahn creates the illusion of a limitless void in the 2011 *Infinite Blue*. Within the fairly small space of a rectangular frame, the illusion of an immense undifferentiated ocean of space is created. Both Zen and Kabbalistic, it conjures the endlessness of *Ein-Sof* that is the prelude to the contraction of the Tzimtzum.

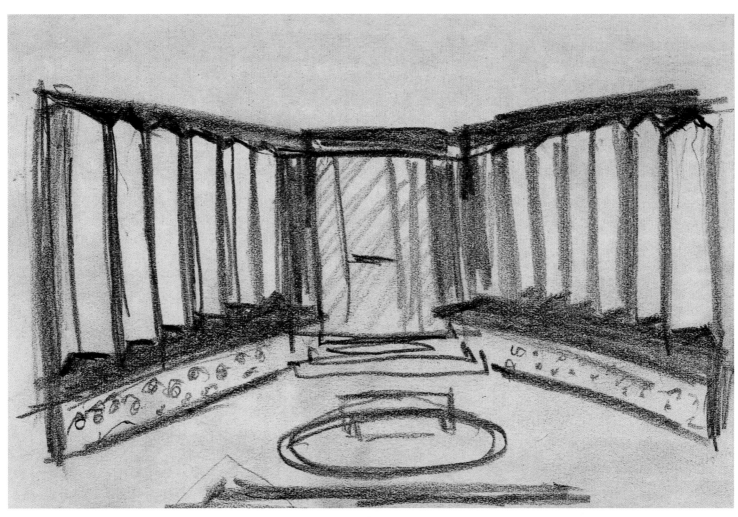

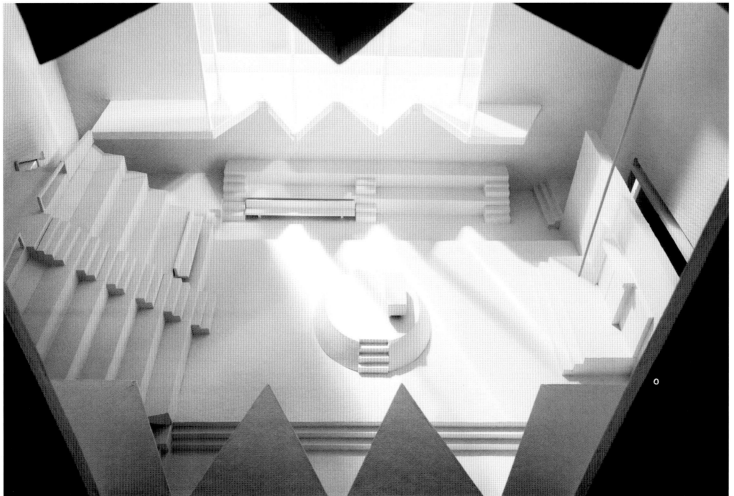

Artist Barnett Newman's sketches and cardboard model for a synagogue project were part of a presentation of *Recent American Synagogue Architecture* at the Jewish Museum in New York in 1963. Newman's idea, presented within an abstract white volume, was to combine two sacred American pastimes that are both communal assembly and individual participation—baseball and religion. Organized like a stadium, the synagogue is a rectangular plan with facing seats for congregants that Newman called "dugouts." The traditional *bimah* from which the Torah scrolls are read is renamed the "pitching mound," where each person gets up to meditate and "stand before the Lord." Like a pitcher before a batter, the solitary individual stands witness before the community and before God. On a mystical note, he called the two folded walls of glass on either side *Tzimtzum*, after the contraction of God to make space for creation. The folded walls became the basis for a future freestanding sculpture. The project is theatrical and dramatic, further emphasized by the artist's use of a quote from the *Book of Isaiah*, written in Hebrew and untranslated, in the sketch that reads: "His trailing robes filling the Temple." Newman's unique combination of popular culture and religious imagery was a groundbreaking project, also unusual for its humor in a distinctly serious field of endeavor.

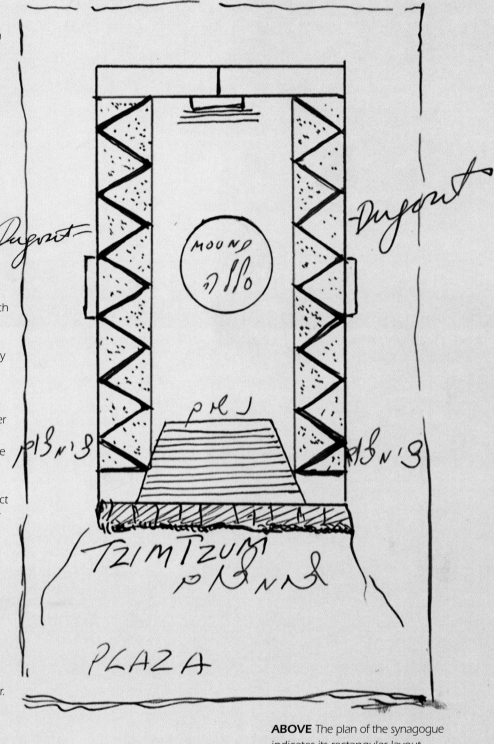

OPPOSITE ABOVE A pencil sketch of the interior of the synagogue shows the folded walls of glass of the *Tzimtzum*, with the ark between the walls and the mound in the center of the space.

OPPOSITE The view of the interior of the model is seen through the folded glass walls of the *Tzimtzum*, displaying the central plan and the stepped seating on three sides. The pitching/Torah mound is at the center, and the ark is on the right.

ABOVE The plan of the synagogue indicates its rectangular layout, with the word "Tzimtzum" repeated three times (in Hebrew).

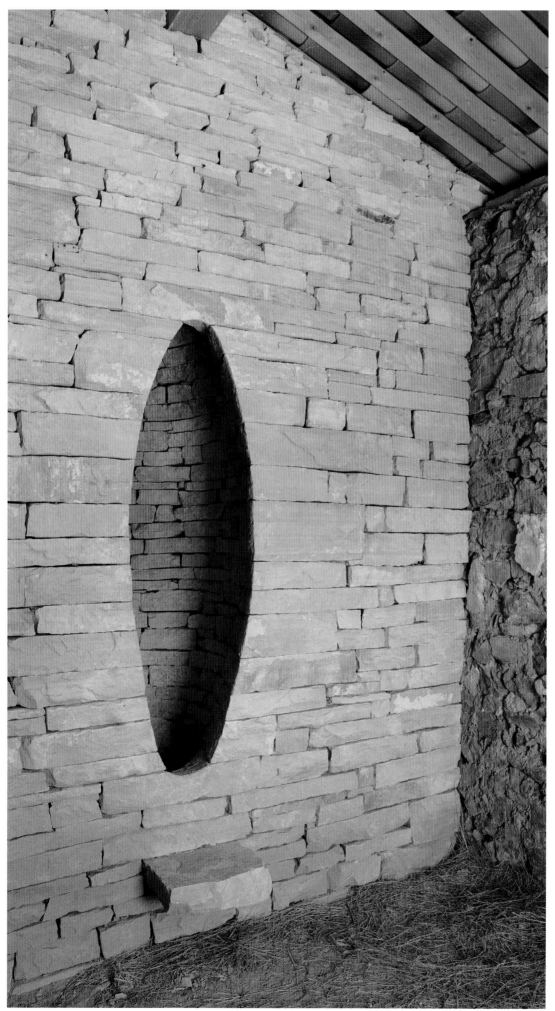

LEFT This 2003 installation in the Romanesque Chapelle Sainte-Madeleine, in Thoard, France, by British sculptor Andy Goldsworthy is a human-scaled, cocoon-shaped indenture in a stone wall. Stepping up to the miniature "cave," one is entirely embraced by its void. The oval shadow envelops one within its dark realm, and, leaving it, one feels somehow "reborn."

OPPOSITE *Adam,* by India-born artist Anish Kapoor, stares intently at us through a deep black rectangle that appears to lie on the surface of the rough stone block, but in fact is cut into its depth. Kapoor's mother is Jewish and the sculpture refers to the *Book of Genesis,* in which the first man was created out of the earth. The interplay between the crisp geometry of the black void against the irregular rock suggests the intelligence of man created in God's image.

OVERLEAF In this great scene toward the end of Brooklyn, New York-born director Stanley Kubrick's 1968 film, *2001: A Space Odyssey,* the aged astronaut, in bed and near death, gestures to the implacable black monolith that has followed man from his early days as an ape. Set within a strange baroque palace with a glowing, gridded floor, the enigmatic monolith is now a frame, a portal into the void beyond. Soon the elderly man will enter the portal and be reborn as the star child, to renew the cosmic cycle of death and rebirth. The scene recalls Czech writer Franz Kafka's short story "Before the Law," in which a man grows old trying to enter the beckoning doorway that has been guarded for years by a gatekeeper who deters him until finally it is too late. In both, the void as a portal into a world of secrets and mystery is symbolic of the Kabbalah, which is open only to the worthy and prepared few.

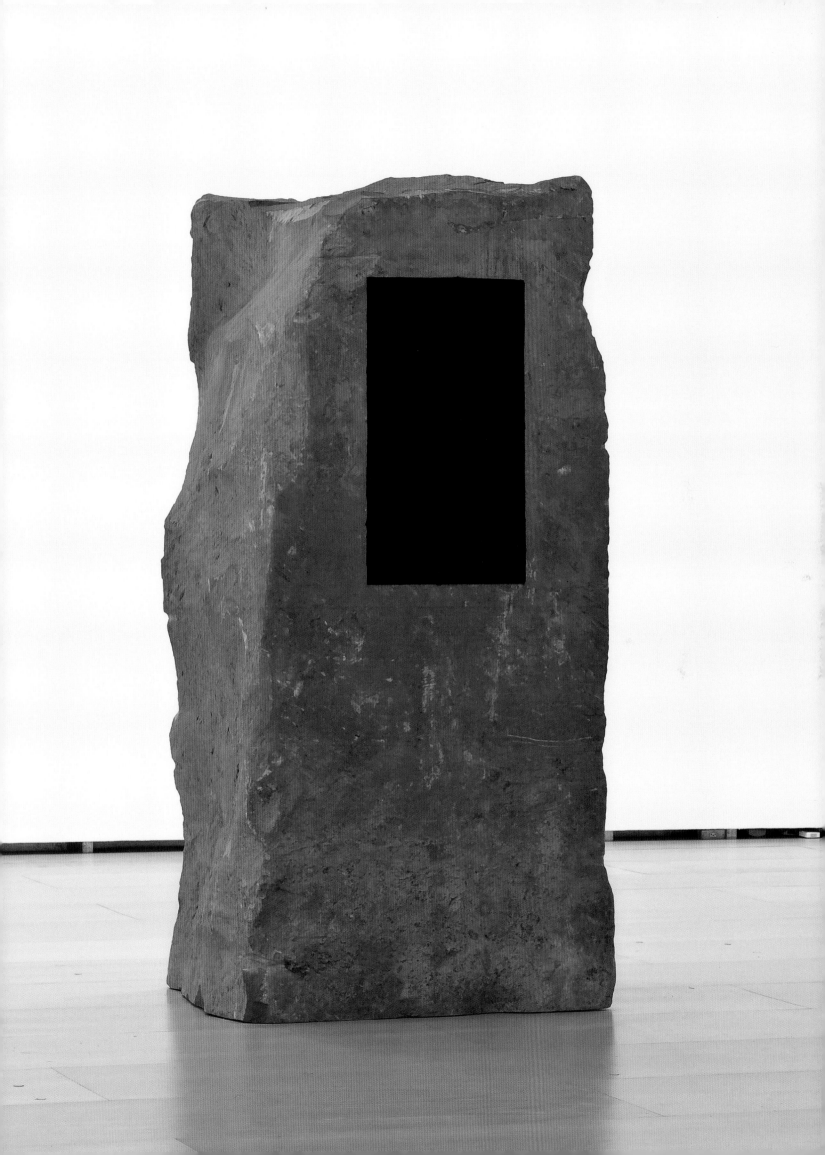

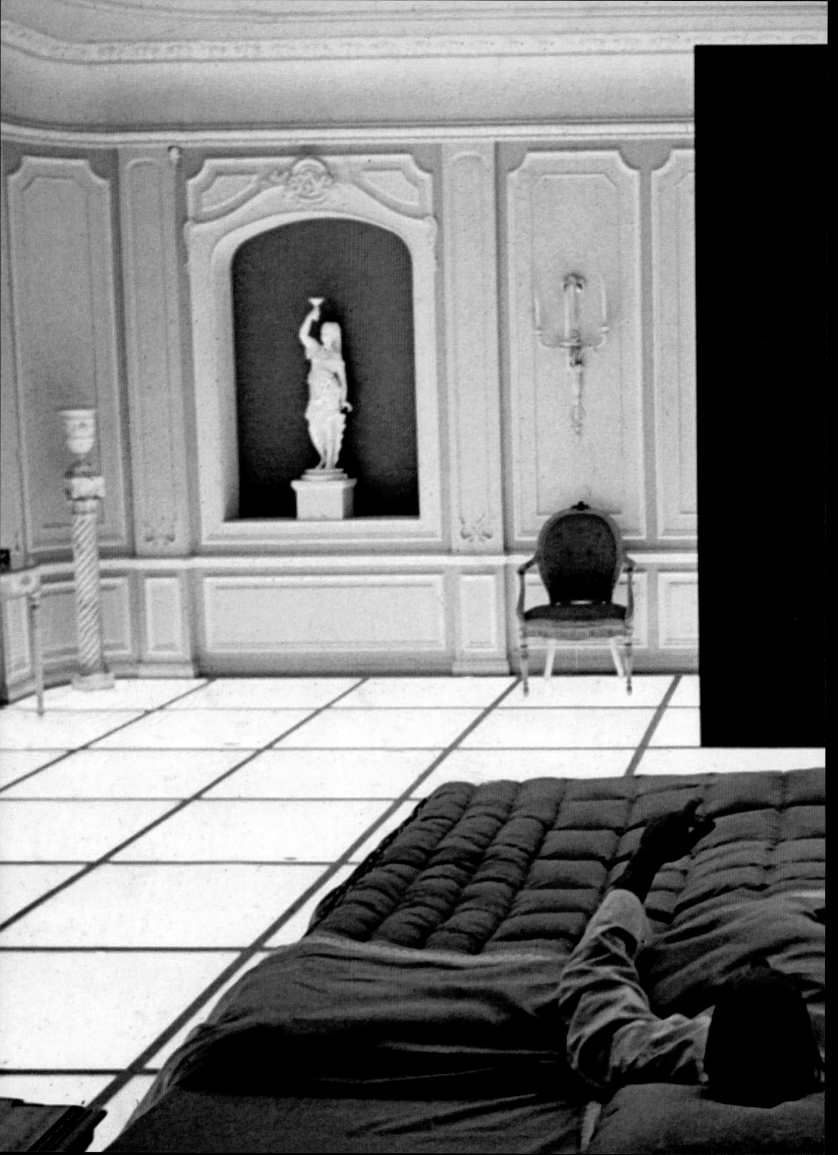

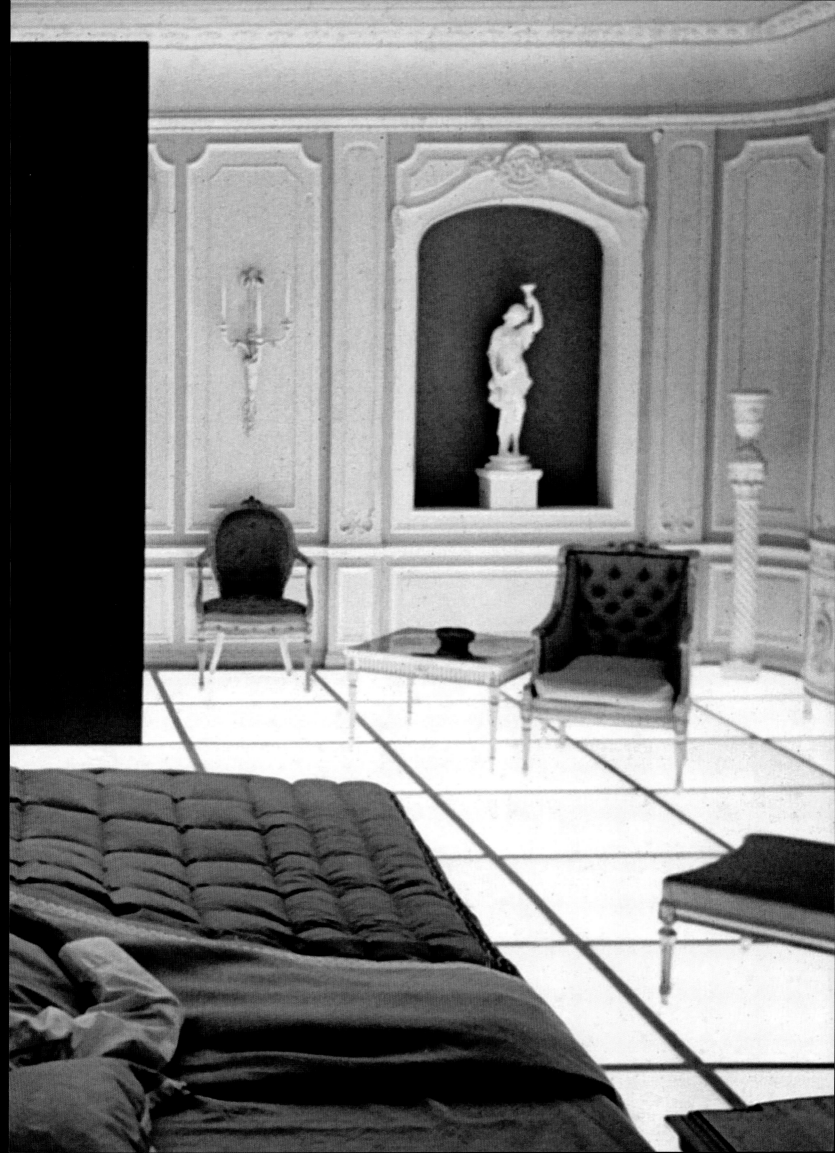

Sefirot ספירות

The concept of the ten *Sefirot* is unique to the Kabbalah. After the contraction of the *Tzimtzum*, the world is manifest through the mechanism of the *Sefirot*, or the emanations of the Divine will and power. In a hierarchy that flows from the infinite *Ein-Sof* into *Keter*, the *Sefirot* unfold in a diagram that is most often portrayed as a tree or a series of concentric circles. In the tree of the *Sefirot*, with its crown in heaven and its roots in the earth, forces are balanced vertically and horizontally. The first three *Sefirot*—*Keter*, crown, *Khokhma*, wisdom, and *Binah*, intelligence—form a triad that combines with the seven lower *Sefirot*.

Of the seven, *Gevurah*, judgment, is balanced by *Hesed*, mercy, and *Netsah*, endurance, by *Hod*, majesty. In the center of these is *Tiferet*, beauty. All of the nine upper *Sefirot* flow into *Yesod*, foundation, which is then directed into *Malkhut*, kingdom, also known as the *Shekhinah*. As the Kabbalah is also a theory of universal correspondence, with the lower worlds a reflection of the upper, and mankind a microcosm of the cosmic order, the *Sefirot* also mirror the human form, with each of the ten points corresponding to different parts of the body. It is similar to Kundalini yoga, with the chakra points charting a course of transcendence to Nirvana. The *Sefirot* deal with gender dualism: the energy of the upper *Sefirot* flows into *Yesod*, the male phallus, and then connects to *Malkhut*, the female presence of God, the *Shekhinah*. There are more subtle gradations and variations within each *Sefirah*, and, as with much of the Kabbalah, there is an intimate relationship presented between God and humanity. Each individual is a microcosm of He who created man "in His image."

The Divine power unfolds in the creation of the universe and emanates his presence into form, recalling the American architect Louis Kahn's words that architecture begins with the "immeasurable" and becomes "measurable." Into the spherical void of the *Tzimtzum*, a single ray of light pierces the darkness to begin the process of emanation. Refracting and zig-zagging, it forms a pattern in the shape of the primordial *Adam Kadmon*. From his eyes, nose, and mouth, light pours out, bouncing back and forth until it takes on the shape of the tree of the *Sefirot*. The *Sefirot*, the channels of Divine light, are in constant flux and flow and are endlessly seeking balance. Colors are associated with each *Sefirah*, but like dye flowing through water, the *Sefirot* remain clear yet take on the color that flows through them.

The ten *Sefirot* and the 22 interconnecting lines of force are the "32 paths of wisdom," the tools of creation from the ancient book *Sefer Yetzirah*. This three-dimensional network must be kept in harmonious balance; otherwise, the universe is out of kilter, which is the general state of affairs.

Another diagram of the *Sefirot* is a series of concentric rings, either in nested squares or in circles that resemble a labyrinth. The outer ring or square corresponds to *Ein-Sof*, and the inner to *Malkhut*. A shortcut through the rings is a single line that directs energy from the outer shell to the inner kernel. One of the metaphors in the *Zohar* is that the world resembles a nut, with a hard shell and an inner essence.

OPPOSITE The Portae Lucis, or *The Gates of Light*, a 1516 engraving by Paulus Riccius from Augsburg, Germany, was used as the title page of the Latin translation of *Gates of Light*, by Joseph Gikatilla, a Kabbalistic sage from the thirteenth century who pre-dated the writing of the *Zohar*. It is a classic presentation of the ten *Sefirot* as a tree of lights, here held aloft by an elderly sage.

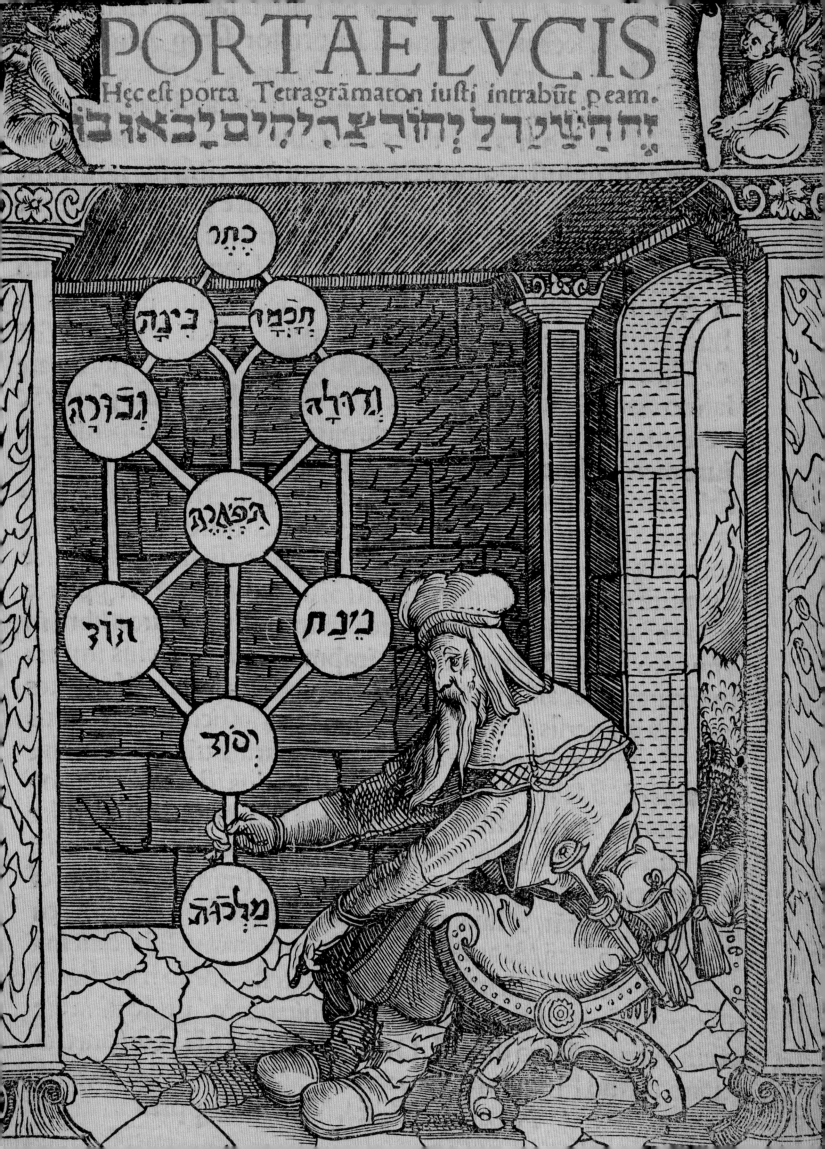

PORTAE LVCIS

Hęc est porta Tetragrāmaton iusti intrabūt p eam.

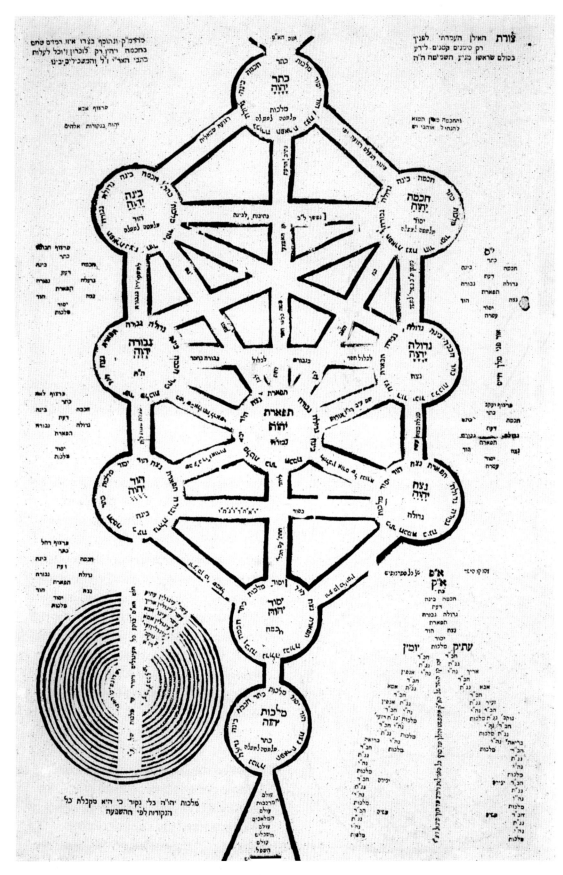

In this engraving from Salonica, Greece, a Sefirotic tree is distinguished by an elaborate Hebrew text.

LEFT In this engraving from Salonica, Greece, which had a large Jewish community until it was destroyed by the Nazis in the Holocaust, a Sefirotic tree is distinguished by an elaborate Hebrew text that connects each of the ten points of the *Sefirot* with each other.

OPPOSITE The Atomium, the symbol of the 1958 World's Fair in Brussels, Belgium, is a 356-foot-high structure that was part sculpture and part building, designed by the Belgian engineer André Waterkeyn. The tinker toy–like structure, made up of nine 54-feet-in-diameter stainless steel spheres, linked by hollow tubes, is a model of an iron atom enlarged to enormous scale. Escalators inside the tubes bring visitors up to the spheres lit by small round windows. The structure was presented as a symbol of the peaceful use of atomic energy. Its similarity to the diagram of the *Sefirot* is unmistakable. Both portray different aspects of the interlocking forces of nature.

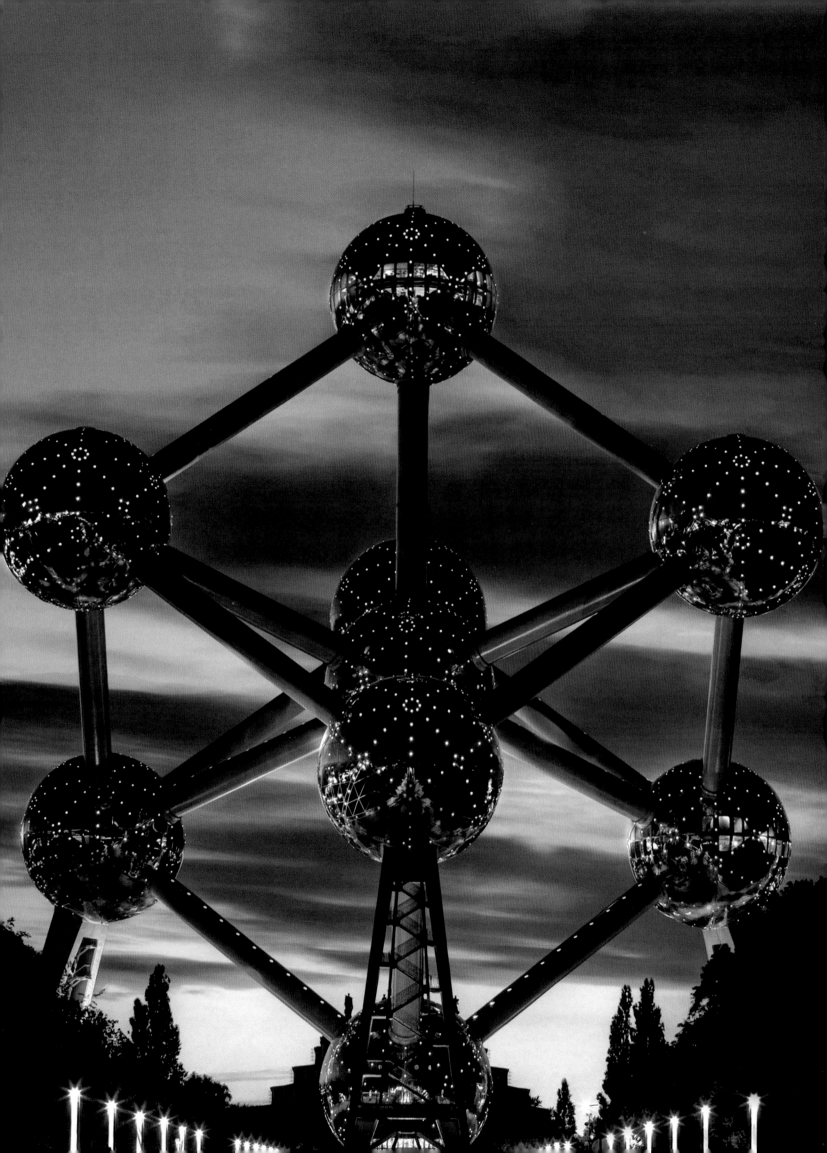

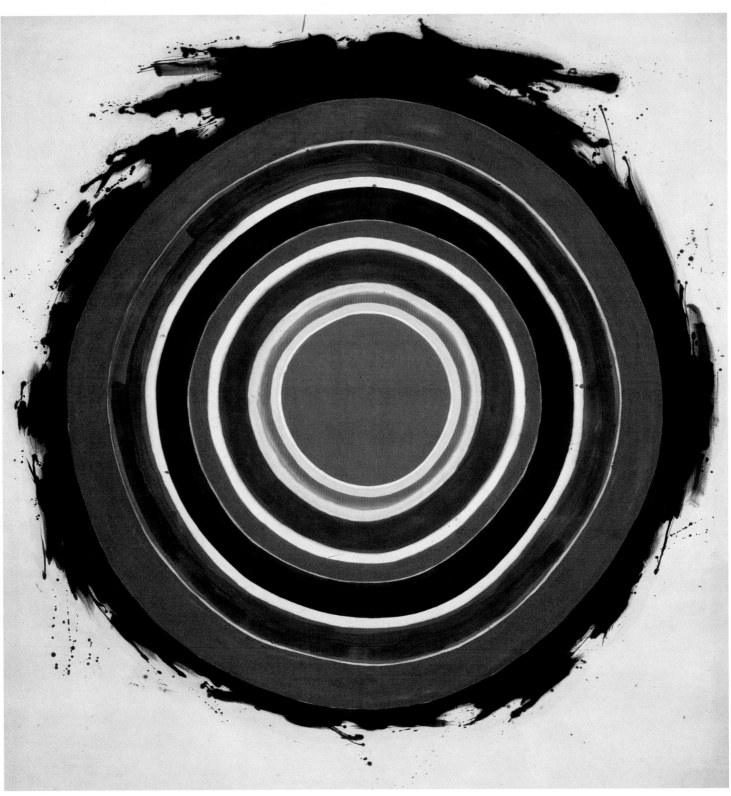

ABOVE American artist Kenneth Noland's 1958 painting *Beginning*, pulsing with energy and color, is a powerful metaphor for the creation of light from the void. Ten rings of color orbit around each other, the same number as the concentric diagram of the *Sefirot*. Both the *Sefirot* and Noland's circular paintings are concerned with the ebb and flow of energy in the universe. In the *Sefirot*, the outer ring is *Ein-Sof*, the infinite, while the inner rings focus on the center of *Malkhut*, the earthly kingdom. Noland's circles appear to recede into deep space, yet simultaneously maintain the picture plane, as was desired by the Abstract Expressionists.

OPPOSITE This diagram of various representations of *Sefirot*, including tree and concentric ring structures, according to Isaac Luria, is from the Silesian Protestant minister Christian Knorr von Rosenroth's *Kabbala Denudata*, "The Kabbalah Uncovered, or the Transcendental, Metaphysical, and Theological Teachings of the Jews," which dates from 1684. Knorr was one of the most authoritative Christian scholars who interpreted the Kabbalah for the Western world.

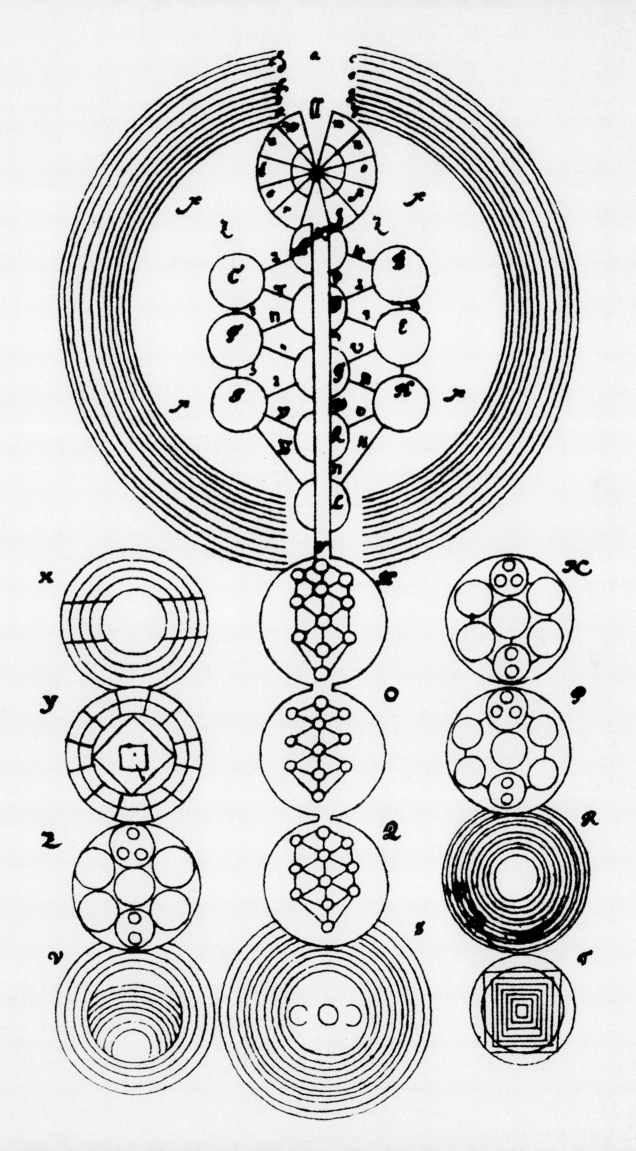

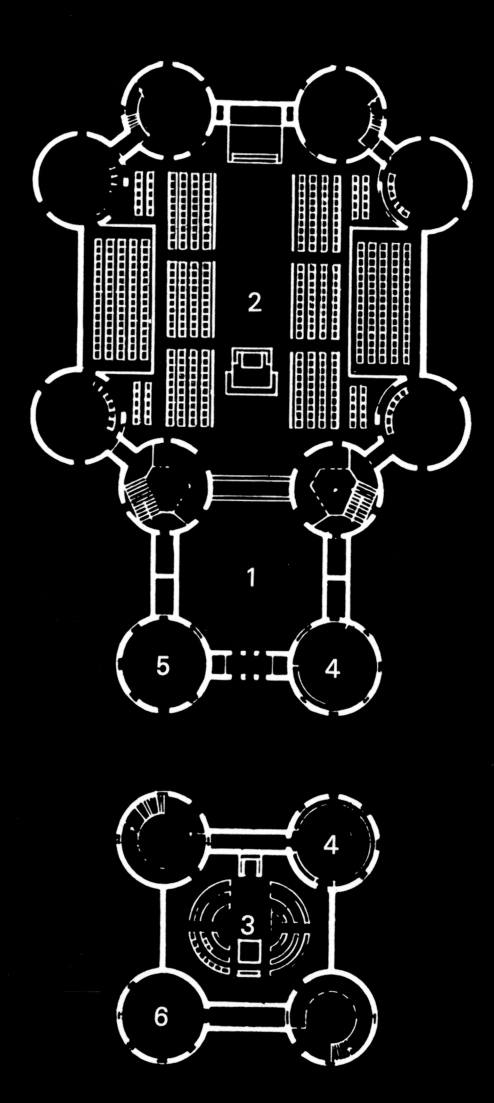

Louis Kahn's 1961-1972 Mikveh Israel synagogue, in Philadelphia, Pennsylvania, was an important project in his career, even though it was never built. The building synthesized the idea of monumentality and the spirit, with a form that recalled a medieval fortress. The central cube-shaped sanctuary was surrounded by ten cylindrical light towers that provided an indirect and mystical light suffusing the central space. Kahn physically separated the sanctuary from the social hall and gymnasium, connecting them all underground.

LEFT The plan remarkably resembles the diagram of the *Sefirot* with its "tree of lights," the Ark in the location corresponding to *Keter,* the crown. The implications of a synagogue plan based on the *Sefirot* were explored by Kahn, even if the architect never explicitly acknowledged the possible source.

OPPOSITE This sketch shows the monumental scale of the interior of Mikveh Israel, with its cylindrical light chambers at the far end of the room. By turning the arches upside down in the cylindrical chamber, Kahn conveys a sense of spiritual separation from the outside world. The diffused light from these chambers would cast a diffused illumination that recreated the sober sense of the original temple in Jerusalem.

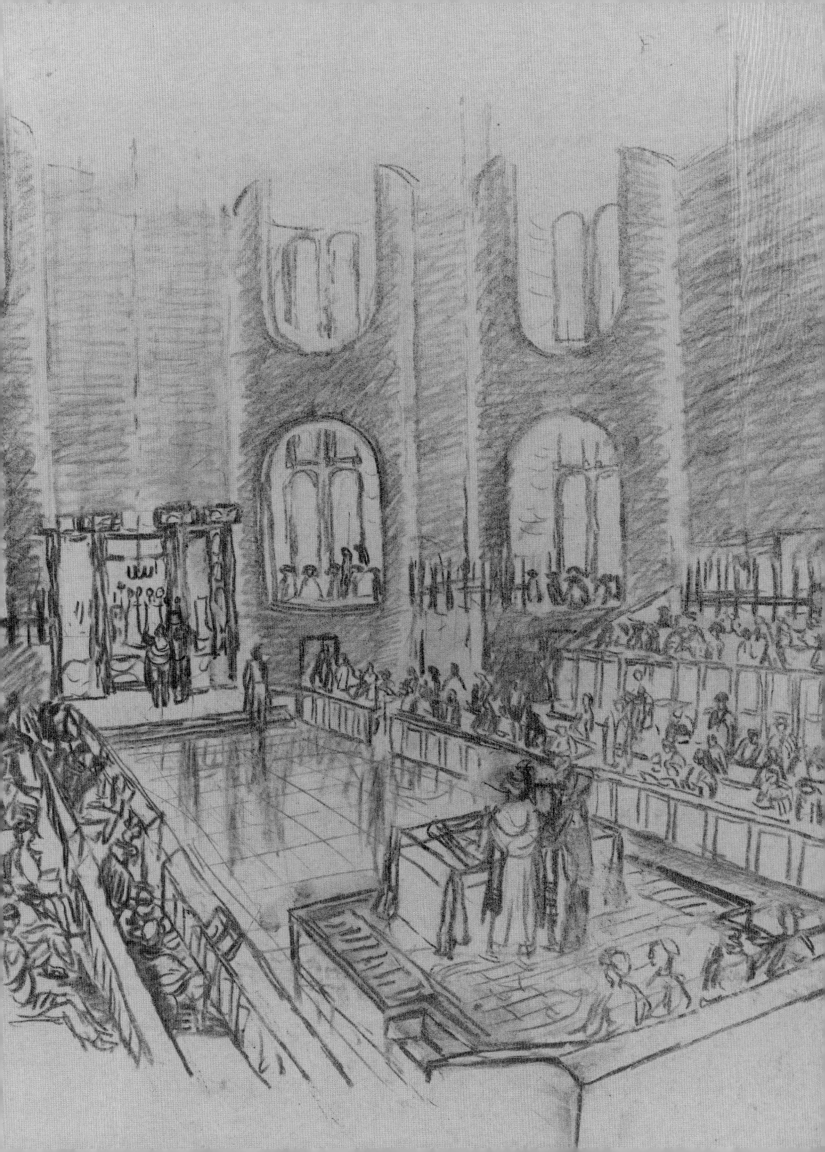

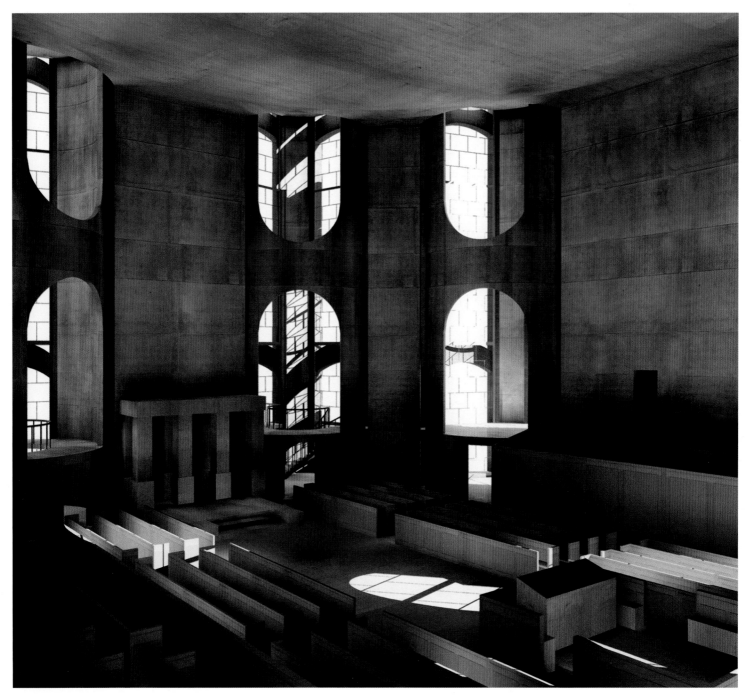

ABOVE The interior of the sanctuary at Mikveh Israel, seen in a computer rendering, offers a view toward the Ark and captures a hint of the illumination from the circular light chambers at the corners of the plan. The ceiling is slightly concave to focus the eye on the hollow corner towers.

OPPOSITE A detail of the light towers from the interior of the sanctuary shows the layers of arched openings. These corner chambers of light served no functional purpose other than to create a spiritual atmosphere in the sanctuary.

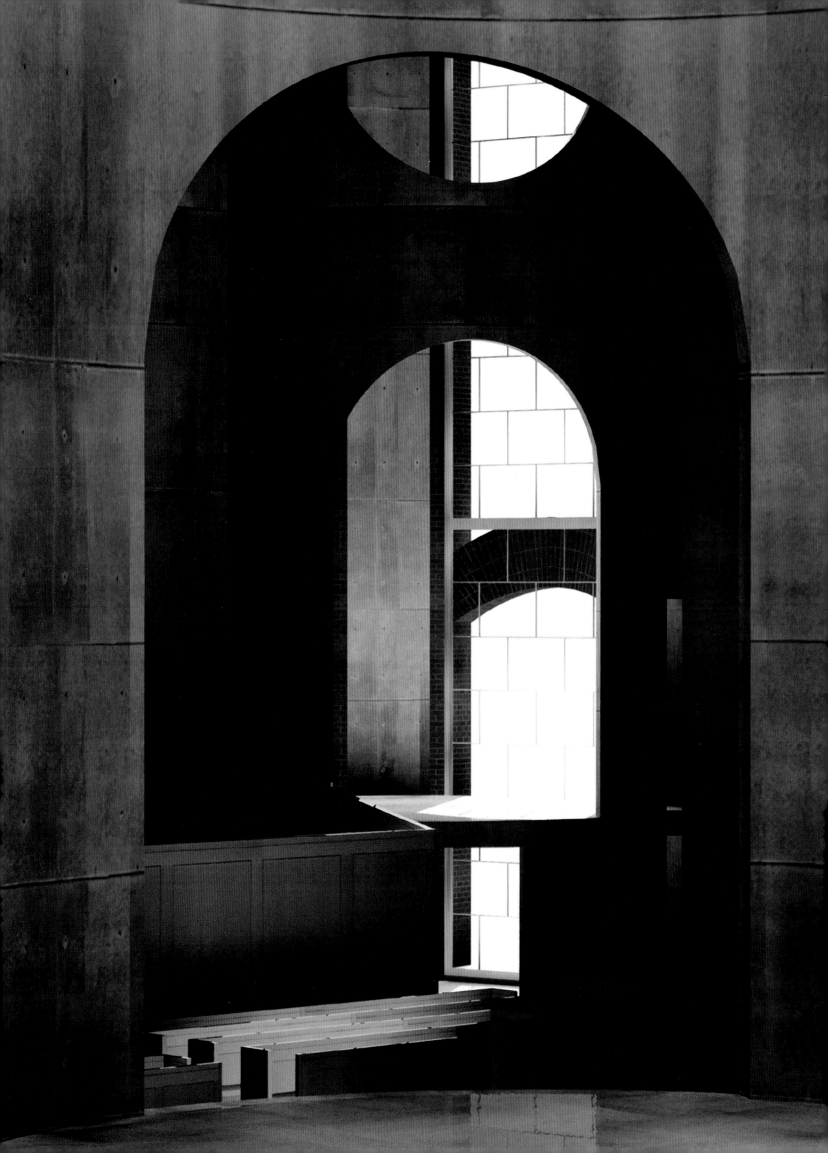

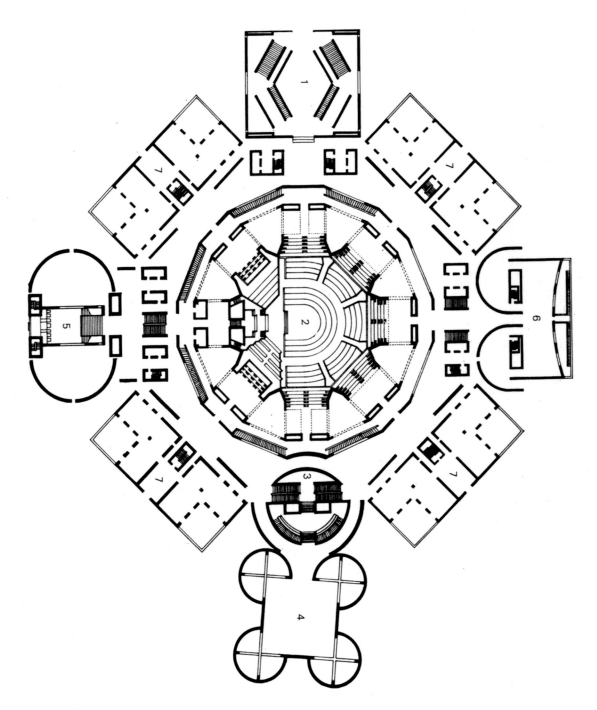

Louis Kahn's National Assembly Building at Dhaka, Bangladesh, 1962-1974, is the largest and most symbolic project of his career. It is a summation of Kahn's thoughts on light and space, matter and construction, as well as the transcendent act of gathering them all together. The monumental National Assembly Building was sited on a flat plane that flooded frequently so that the idea of the buildings as temples floating on lakes became an organizing theme. Included in the huge project were the assembly building, courts, offices, and dormitory spaces for government workers. Kahn received the commission after it was turned down by the Swiss architect Le Corbusier and the Finnish architect Alvar Aalto.

ABOVE The plan of the National Assembly is a series of concentric rings around the central hall that Kahn called a "world within the world." He considered "assembly to be of a transcendent nature" and surrounded the octagonal hall with blocks of offices, a dining hall, and a mosque to further intensify its sacred character. Recalling the concentric diagram of the *Sefirot*, the structure combines the intellectual act of making laws with the earthly ritual of gathering together under a dome-like roof.

OPPOSITE Viewed from above, the National Assembly resembles a lotus floating in a lake, with its center the octagonal legislative chamber. Its petals are different parts of the layout, including an entry hall, a mosque with four round-corner towers, offices, lounges, and a dining hall. The large mass of the building seems deeply hewed and cut from a solid block of rock, alluding to the creation of the world from the *Sefer Yetzirah*, where the world is carved out according to secret geometrical equations.

OVERLEAF The concrete volume of the Assembly Hall, with strips of marble inset to create a gridded pattern on the exterior, rises surreally from a lake "between the waters below and the waters above" *(Genesis)*. The outside is marked by geometrical cutouts of circles, squares, and triangles that recall a verse in the *Book of Proverbs*, "I set my compass on the face of the deep."

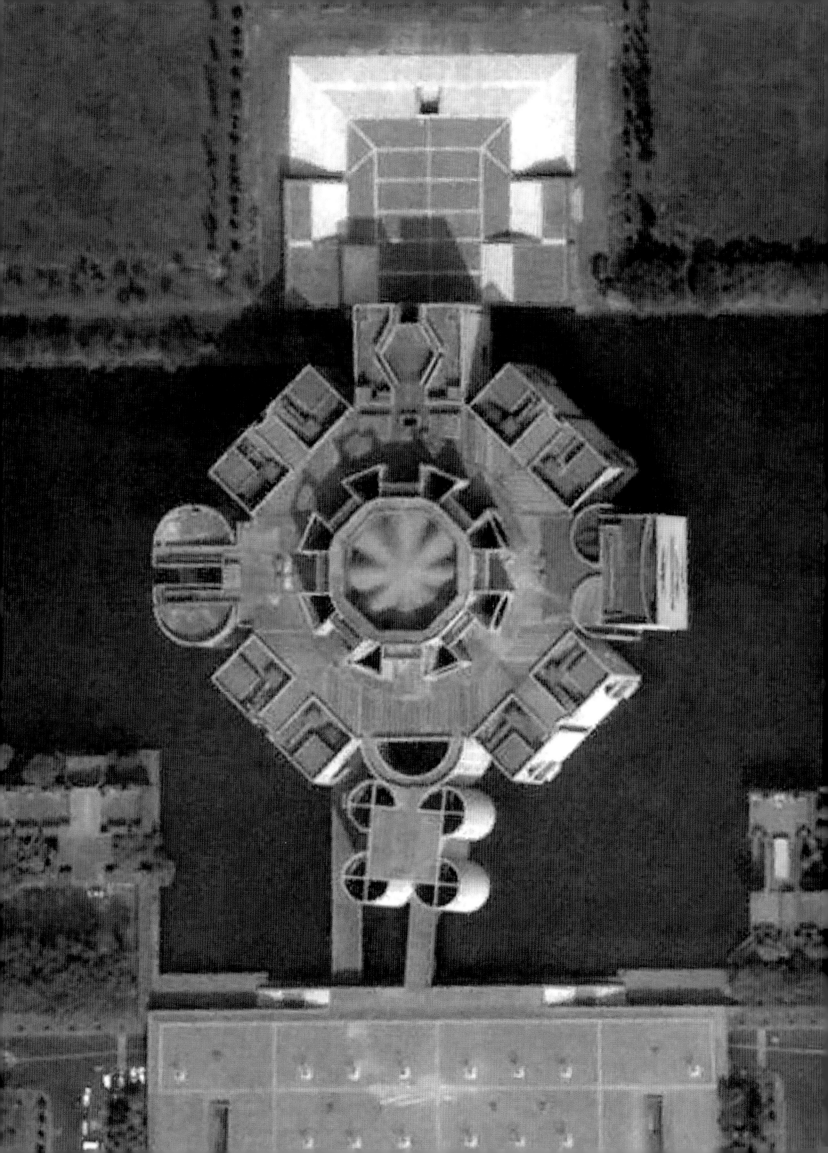

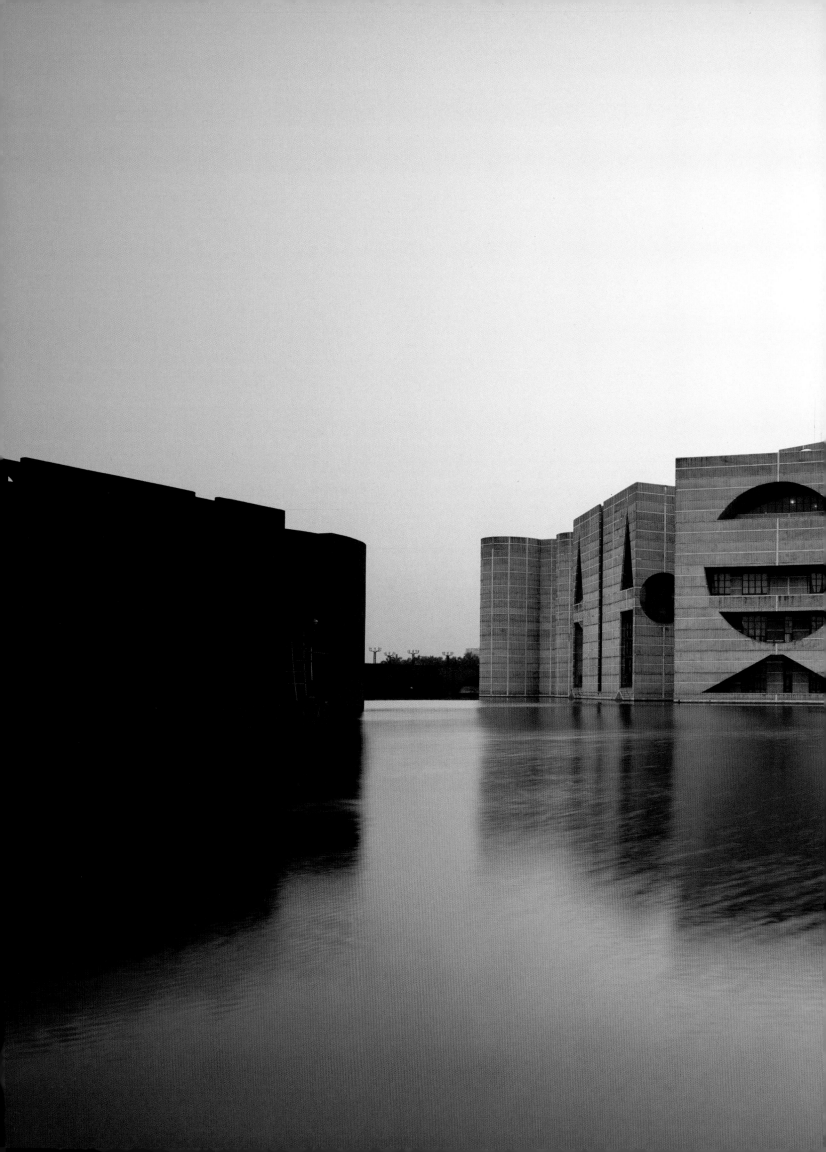

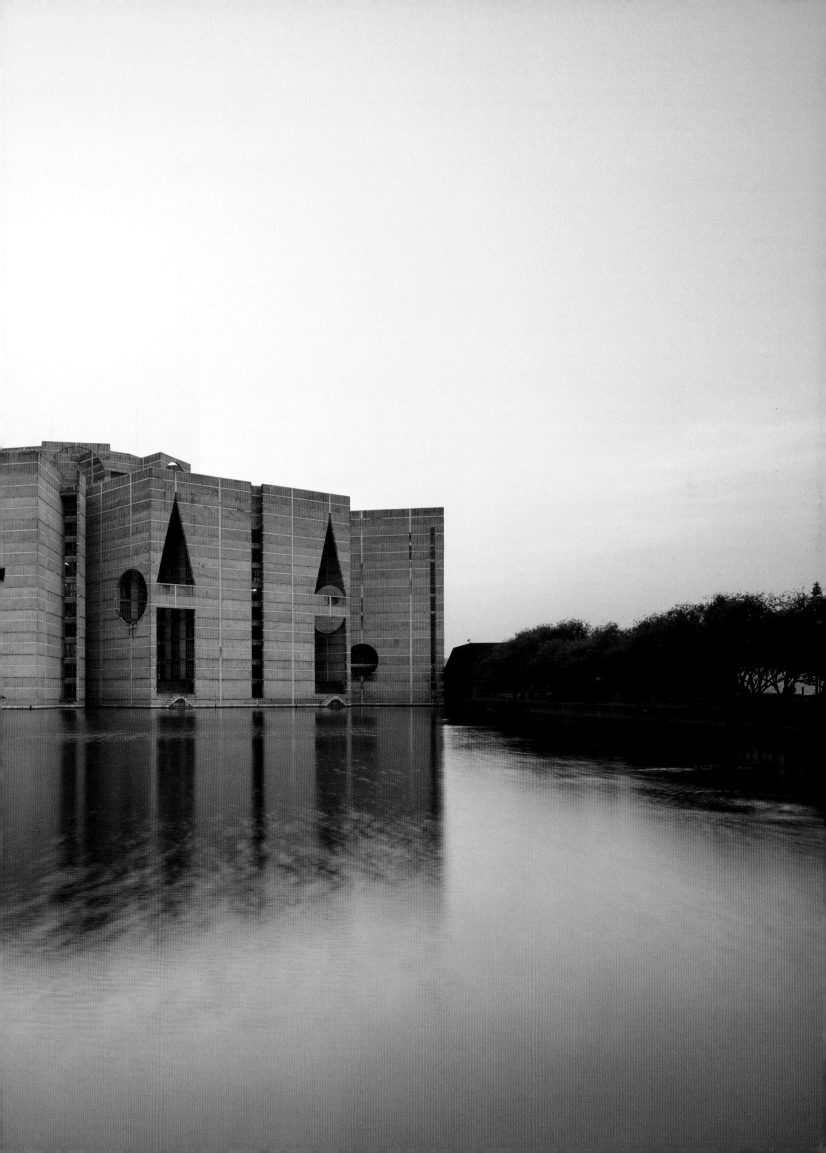

RIGHT A drawing of the section through the 1950 Johnson Wax Research Tower by American architect Frank Lloyd Wright in Racine, Wisconsin, shows the close similarity to a tree, the form that inspired the structure. Wright's belief in organic architecture as deriving from nature was the motivating force behind his design, in which the foundation is a massive root, the central core is a trunk, and the floors cantilever out like branches.

"This house stands in the center of all, countless doors and chambers round and round— supernal sacred sites, where birds of heaven nest, each according to its species. Within emerges an immense, mighty tree, its branches and fruit nourishing all. That tree climbs to the clouds of heaven, is hidden amid three mountains, emerges beneath these mountains, ascending, descending."
—**Zohar 1:172a-1:172b**

OPPOSITE The stained-glass windows by Frank Lloyd Wright for the 1905 Darwin Martin House in Buffalo, New York, are made in the architect's Tree of Life pattern, which was a tribute to nature as an inspiration for his work. The tree is abstracted into rectangular shapes where the lead mullions provide the linear frame for the colored glass panels. The Tree of Life is another term for the *Sefirot*.

Crown

כתר

Keter

Keter, or the crown, is the highest element of the ten *Sefirot*, and the one closest to *Ein-Sof*, or the infinite and hidden God. As it is the intermediary between *Ein-Sof* and the lower *Sefirot*, it is the conduit through which the energy of the Divine is channeled into the world. As the highest crown of God, *Keter Elyon*, it is symbolic of the Tree of Life diagram and the anthropomorphic body of the lower *Sefirot*. Each *Sefirah* itself is crowned with light in numerous passages in the *Zohar*. One of the most dramatic describes the crown of the *Sefirah Malkhut*: "It has been taught about the Mother. At the time of her coronation, there emerges within her crowns one thousand five hundred surfaces with graven ornamentation. When She desires to unite with the King, she is crowned with a diadem of four colors that flash in all four directions, each one three times, making twelve graven areas that then enter into and are joined to twelve others. On the top of the crown, there are four walls facing the four directions, each topped with a tower, as the Scripture says, 'towers of spices.'" (Canticles 5:13)

The crown is the connection between heaven and earth, the mythical *axis mundi* of the world. As with many of the microcosmic ideas of the Kabbalah, the Temple in Jerusalem is its crown and the center of Jerusalem, Israel. In his 1920 book *Die Stadtkrone*, meaning City Crown, German architect Bruno Taut reinterprets the traditional city with its sacred shrine, cathedral, or temple in a modern, secular way. Taut presents, prominent among historical cities, Solomon's Temple in Jerusalem as a prime example of the *Stadtkrone*. For the contemporary city, a civic purpose, such as a museum or performing arts center, replaces the sacred shrine of tall pyramidal buildings as the focus of the urban master plan. Taut was also part of a mystical group called the Glass Chain, which included the German poet Paul Scheerbart, who wrote: "Light seeks to penetrate the whole cosmos," and "colored glass destroys hatred." In the *Zohar*, one reads: "It has been taught: When God revealed himself on Mount Sinai all of Israel saw as one who sees a light in a crystal. From that light each one saw that which Ezekiel the prophet did not see." Along similar lines, the Swiss architect Le Corbusier interpreted the *Stadtkrone* in his plans for the ideal "radiant city," recalling the radiance of the translation of the word *Zohar*. The axial plan culminated in a series of tall glass towers, "rising through the trees like many-faceted crystals." In his plan for the capitol of Chandigarh in India, in 1952, Le Corbusier placed the Governor's Palace at the head of the axis, emphasizing that the palace objectively crowned the city.

More recently, the idea of a crowned "starchitect" designing a monument is ultimately symbolized by American architect Frank Gehry's transcendent Guggenheim Museum, Bilbao, a City Crown *par excellence*. Beyond transforming the city of Bilbao, Spain, and becoming its new secular cathedral, it is a symbol of the power of architecture to elevate mankind's awareness of the world. Equally stupendous is Swiss architects Herzog and de Meuron's spectacular 2008 Olympic Stadium in Beijing, China, nicknamed the Bird's Nest. At the head of the axis of the ancient Forbidden City and the Emperor's Palace, it surprisingly recalls the passage from the *Zohar*: "On that day King Messiah will arise, emerging from the Garden of Eden, from the place called Bird's Nest...There he will reveal himself from the radiance of the Bird's Nest, which will return to its place."

OPPOSITE "At the time when the Temple was built, the blessed Holy One crowned himself with that crown and the King sat with the Bride. And ever since the Temple was destroyed, the blessed Holy One has not been crowned with His crowns, because that *beauty* has been concealed and hidden away" (Zohar IV, p. 306).

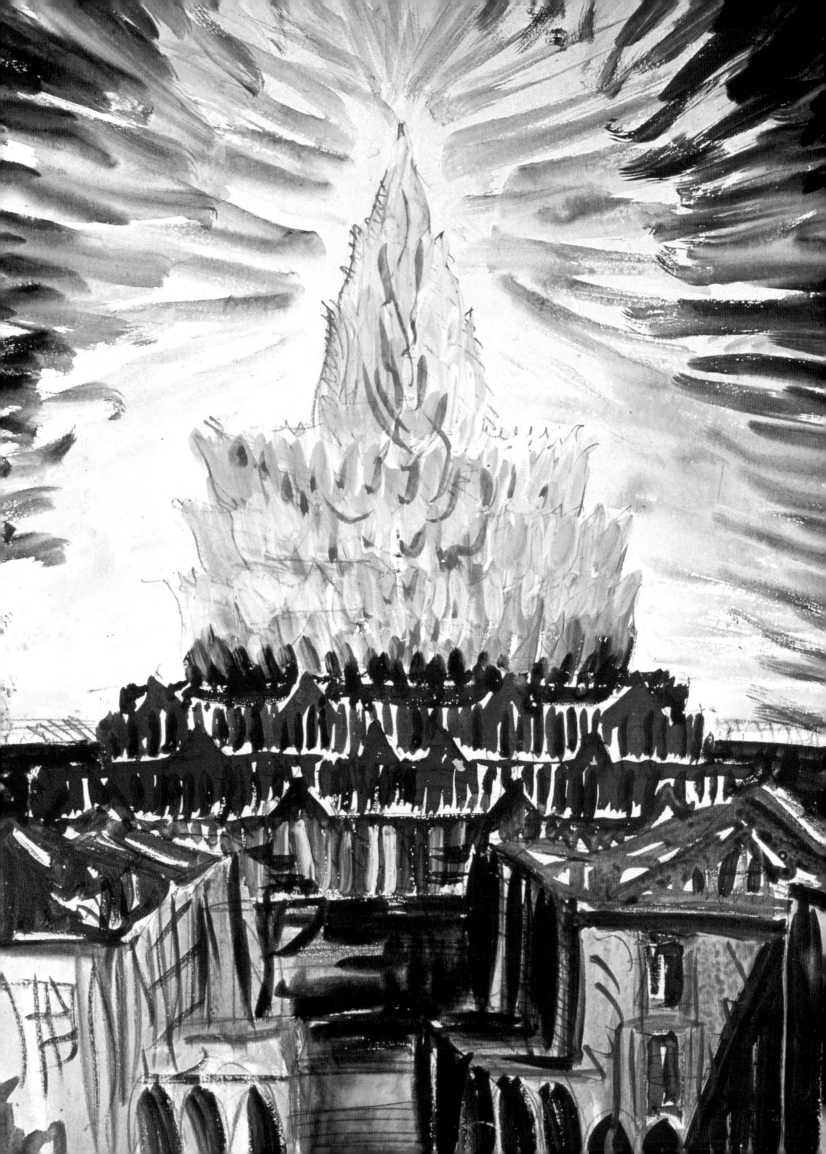

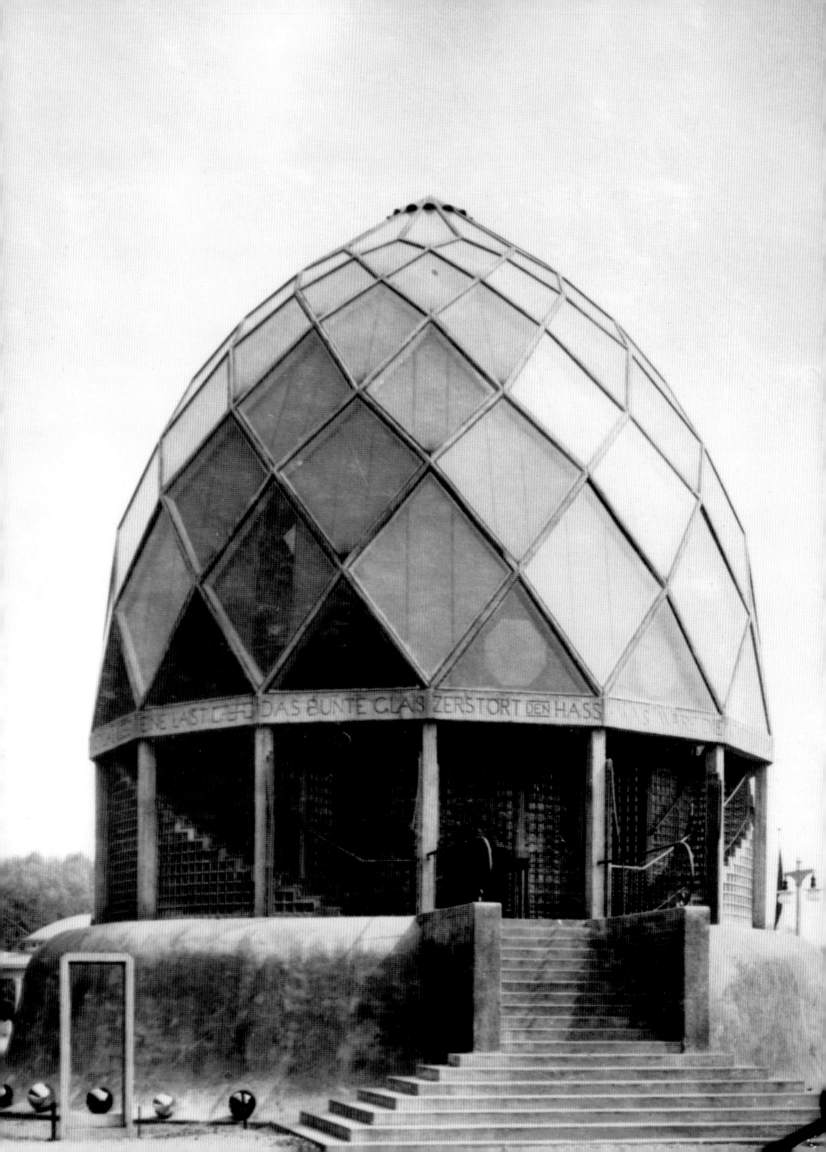

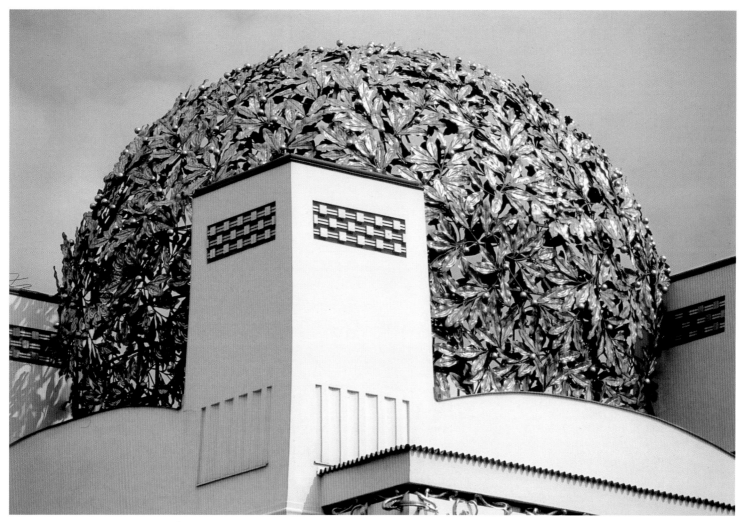

ABOVE Crowning the top of the 1898 Secession building by Austrian architect Joseph Maria Olbrich in Vienna, Austria, is a perforated metal dome of gilded leaves atop a severe masonry structure that has been framed by four pylons. Dedicated to art and the god Apollo, the dome serves a highly symbolic function for the building and for the city of Vienna, as a center of art.

OPPOSITE Early twentieth-century German architect Bruno Taut's Glass Pavilion, shown at the Werkbund Exhibition of 1914 in Cologne, Germany, was constructed to promote the glass industry through presentations of inventive uses of the material. The dome was constructed of glass set in a diagonal frame, culminating in a faceted glass cupola. The pavilion elevated glass to a mystical level through the poems of Paul Scheerbart, whose inscriptions were prominently displayed on both the interior and exterior walls, such as "Light wants crystal," "Glass brings a new era," and "Coloured glass destroys hatred." The Kabbalah scholar Gershom Scholem was a great admirer of Scheerbart and took volumes of his poetry to Jerusalem in 1923.

"Come and see: There are four lights. Three of them are concealed, and one revealed. A shining light. A light of radiance, shining like the heavens in purity. A light of purple, absorbing all lights. A light that does not shine but gazes toward these, receiving them, and they appear in it as in a crystal facing the sun."—Zohar 2:23b

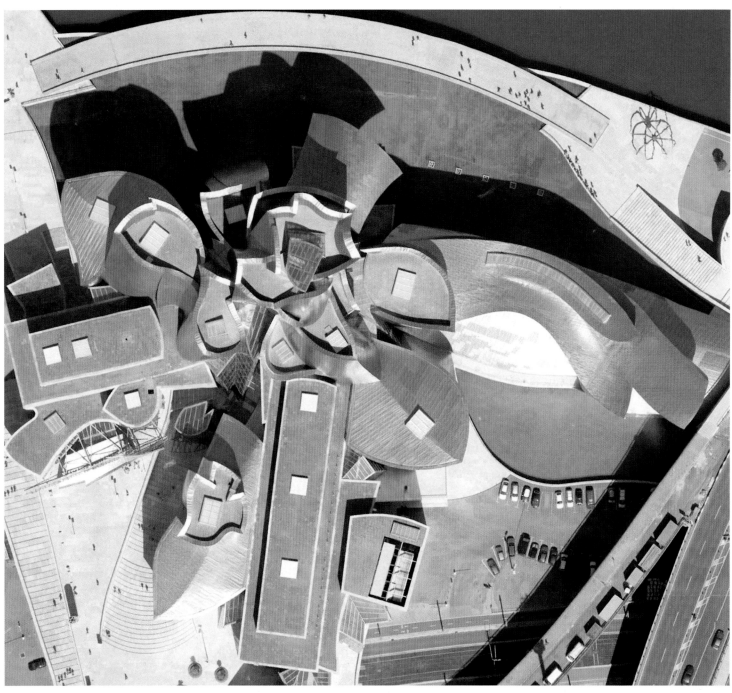

American architect Frank Gehry's 1997 Guggenheim Museum in Bilbao, Spain, captured international attention through its remarkable curvilinear forms that were unlike anything else that had been built up to that time. Its titanium-clad galleries along the Nervión River appear like a strange apparition that has landed from outer space, a vision of an otherworldly jumble of shimmering jewels. The museum has become the City Crown of not only Bilbao, but of the role that cultural institutions of significant architecture can play in revitalizing a city—the so-called "Bilbao effect."

ABOVE From the air, the building resembles the rose of thirteen petals noted at the beginning of the *Zohar*—an evocative motif also in Spanish culture. The flower of museums, the Guggenheim is the new jewel-like crown of the city. The entrance leads to a tall atrium that is the spatial hub of the building. Long galleries at the lower level lead out from the central space, while others spin off on the upper level. They are all lit by skylights in the petal-like rooms.

"Like a rose among thorns, so is my beloved among the maidens"—(Song of Songs 2:2)
"Who is a rose? Assembly of Israel. For there is a rose, and then there is a rose!"
—Zohar 1:1a

OPPOSITE The view of the museum from the south is surrounded by the old city of Bilbao and the hills of the Basque countryside.

OVERLEAF The ziggurat-like massing of the museum of Bilbao belies its modernist sensibility and mounts up four steps to the summit that crowns the atrium. This anchors the composition from which long curvilinear galleries appear to peel off as wings along the Nervión River. The metallic titanium panels reflect the twilight sky with its clouds and the glitter of the water, while still recalling the "thirteen petals" of the rose of the *Zohar*.

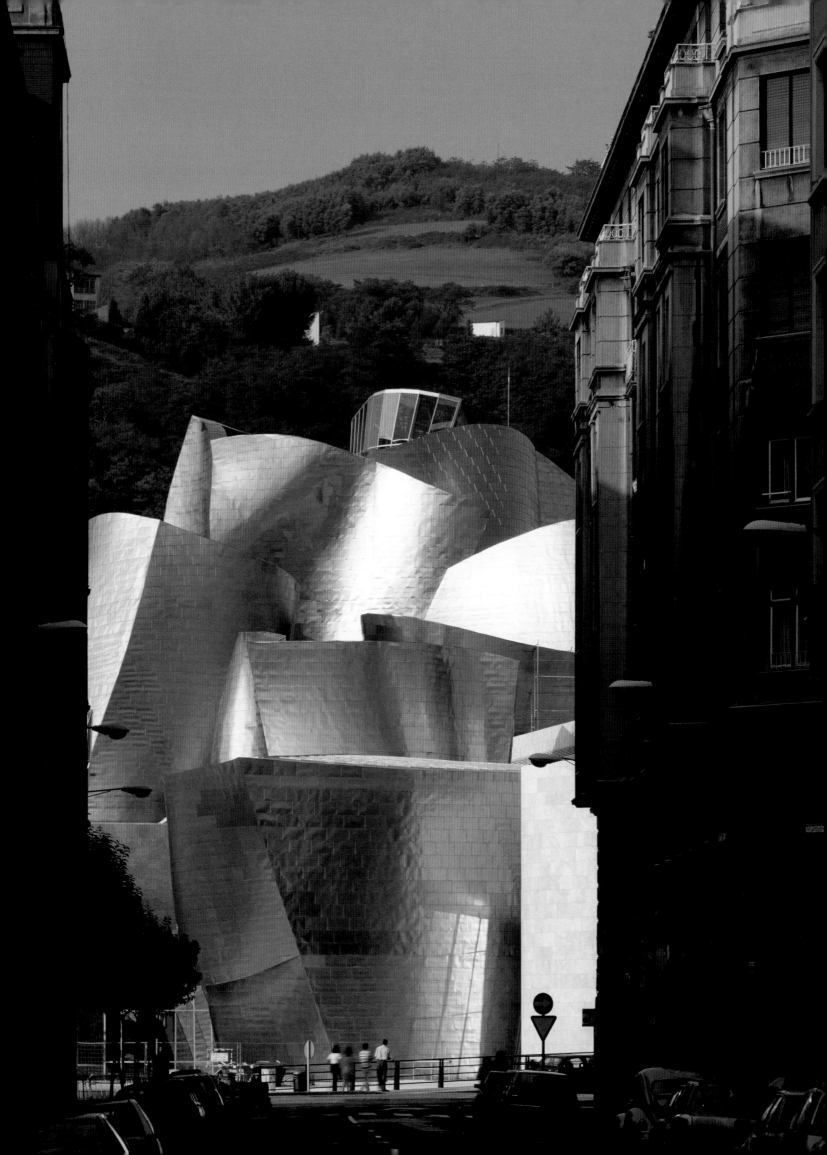

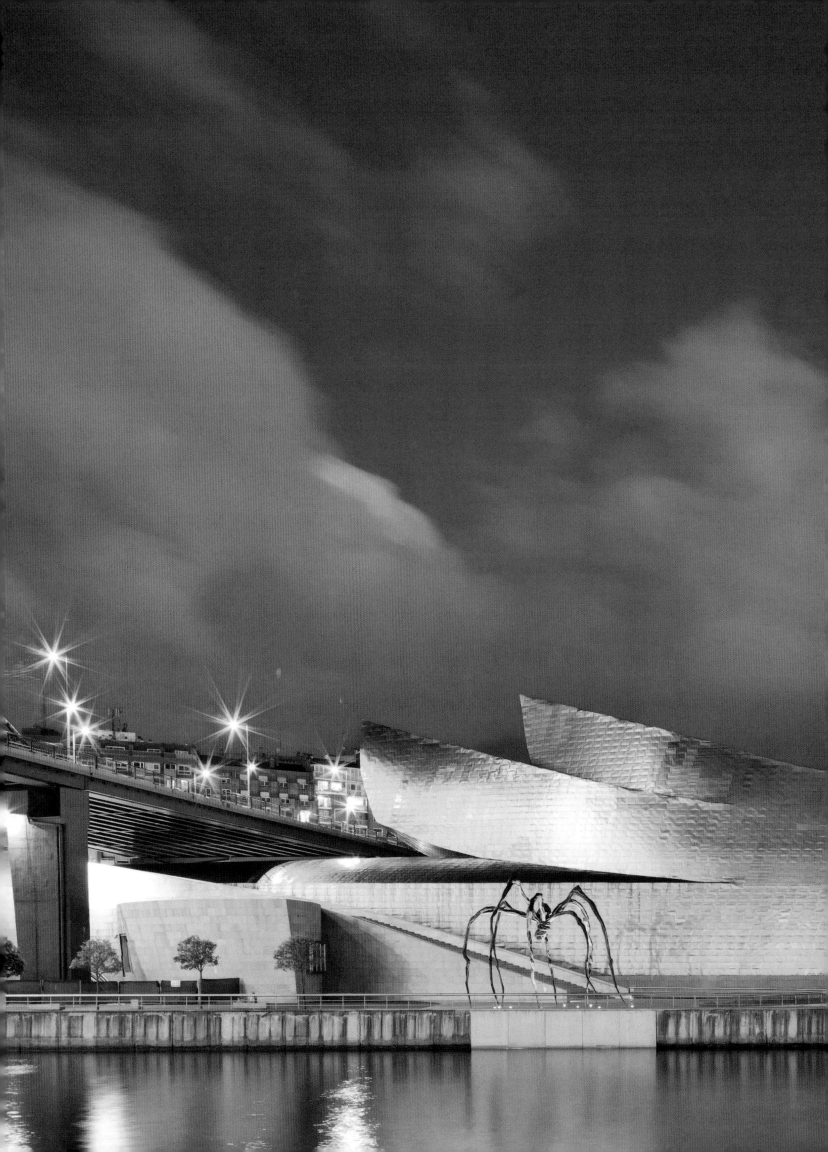

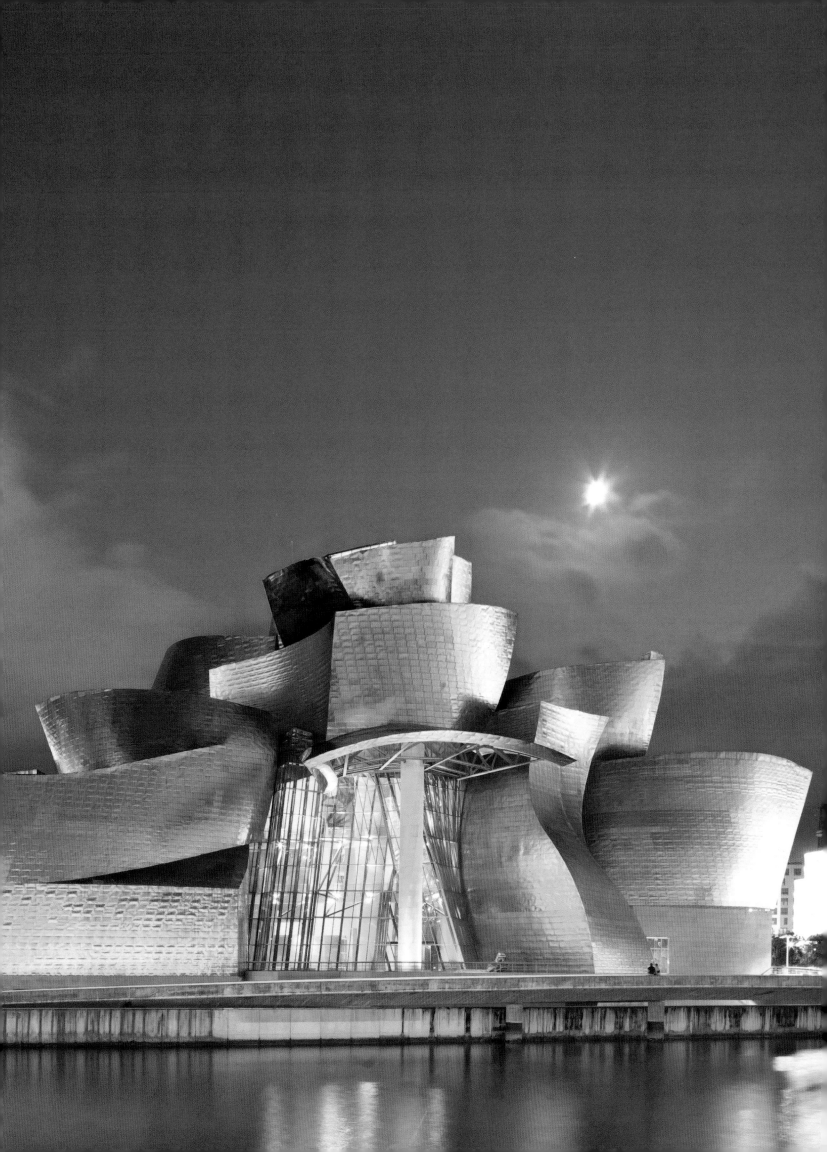

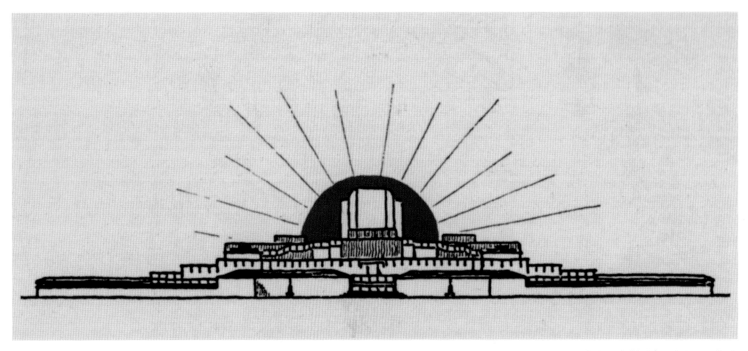

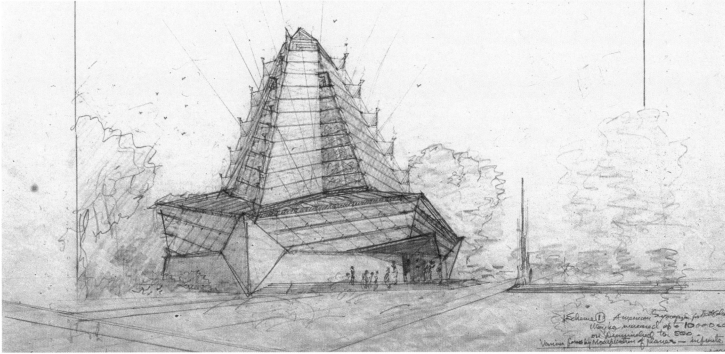

Temple Beth Shalom, built in Elkin Park, Pennsylvania, in 1954, is the only synagogue designed by Frank Lloyd Wright. It was inspired by a theme from Mortimer J. Cohen, its rabbi and the architect's client, of a "traveling Mount Sinai." Wright's triangular mountain of woven glass and plastic panels created a glowing 100-foot-high interior of translucent light. The plan for 1,051 seats was a modified hexagon, and the geometry of the floor angled slightly inward so that congregants, as Wright said, "will feel as if they were resting in the very hands of God." Finally, Rabbi Cohen requested that Wright design the ark and its ornamentation as Isaiah's vision of the throne room of God, with the phrase in Hebrew, "Holy, holy, holy is the Lord of hosts: The whole earth is full of His Glory." Therefore, Wright's synagogue synthesized a number of mystical themes: the vessel of light, *Merkava*, the *Throne-Chariot*, and *Keter*, the crown of the *Sefirot*, in one monumental space.

ABOVE A sketch by Wright of the Beth Shalom synagogue shows the interlocking geometry and the lines of light radiating out from the menorah light "points" along the ridge of the building.

OPPOSITE Beth Shalom is represented here as a radiant Mount Sinai, with light emanating through the translucent structure and making visible the interlocking triangular geometry of the composition.

TOP From a press release to Bruno Taut's book *Die Stadtkrone, The City Crown*, the drawing recalls his 1920 House of Heaven, which he describes as: "The joy of architecture will fill the visitor, emptying his soul of all that is human and making it a vessel for the divine. This building is an image and a salutation of the stars. Its plan is star shaped, and in it the sacred numbers seven and three are united: seven in the great hall, three in the secondary rooms, arrayed like chapels. All the walls, ceilings and floors are of glass."

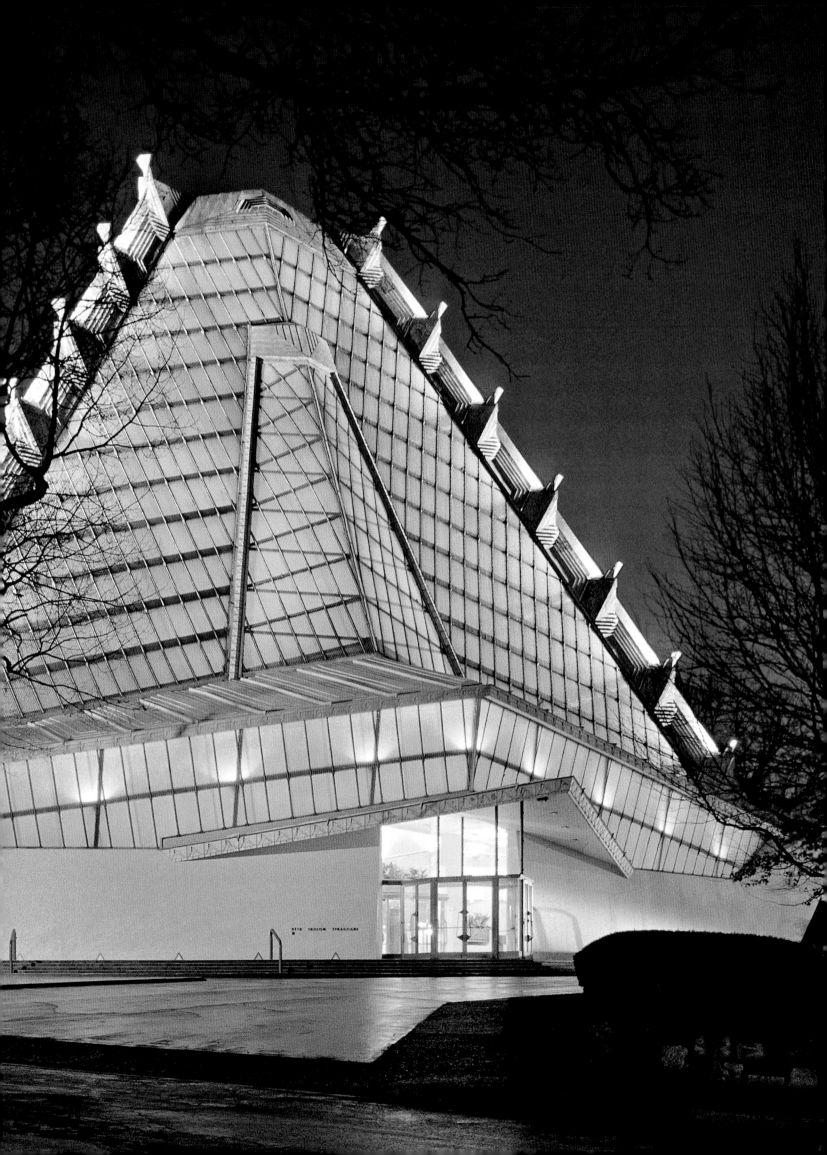

ABOVE In this collage, the plan of Beth Shalom was superimposed over Rabbi Cohen's hands. It explored Wright's concept of the experience of the synagogue as recreating the "feeling of being in the very hands of God."

OPPOSITE The triangular eternal light hovers over the interior of the synagogue, with colors glowing like the *Sefirot*. Its geometry relates to the hexagon, and thus abstractly to the Star of David, without making an overt reference.

OVERLEAF The National Stadium at the 2008 Beijing Olympics was designed by the Swiss architects Herzog & de Meuron in collaboration with the Chinese artist Ai Weiwei. Placed just off the main historical axis of the Forbidden City and the Imperial Palace, the crowning location symbolized the extreme importance the Olympics and the stadium had for the Chinese nation. The exterior is encased in a seemingly random lacework of steel beams that were explained by the architects as a metaphorical "bird's nest." In China, this is a delicacy eaten only on special occasions and the nickname stuck.

"For twelve months He will be hidden in the radiance of the Bird's Nest. After twelve months that radiance will extend between heaven and earth, settling upon the land of Galilee, where Israel's exile began. There he will reveal Himself from the radiance of the Bird's Nest, which will return to its place."
—**Zohar 2:9a**

Vessels of Light

אור הכלים

Ohr Ha'Kelim

The symbolism of light pervades the Kabbalah. The undifferentiated light of *Ein-Sof* preceded creation. One of the earliest texts of the first century A.C.E., the *Bahir,* meaning brilliance, derived from the *Book of Job 37:21*: "And now they do not see light. It is brilliant in the skies." The *Zohar* in Hebrew means radiance. Light creates space out of the darkness of the void, and it is architecture that sculpts light into form. The American architect Louis Kahn wrote: "I turn to light, the giver of all Presences, by will, by law. You can say the light, the giver of all presences, is the maker of a material, and the material was made to cast a shadow, and the shadow belongs to the light." For Swiss architect Le Corbusier, "Architecture is the masterly, correct, and magnificent play of masses brought together in light."

In the *Zohar,* it is written that "As the light shone, its radiance blazed from one end of the universe to the other." Into the *Tzimtzum* flows a single ray of light that bounces around in the vacuum of the Divine absence. At first the lights form a pattern of points *(olam ha'-nekudot)*, then coalesces into circles and straight lines *(iggul ve'yosher)*, recalling the Russian artist Wassily Kandinsky's 1925 book, *From Point and Line to Plane*. It refracts finally into the shape of the first, primordial man, *Adam Kadmon*. Light flows out of the seven orifices of his face, arranging themselves into ten vessels or bowls—the beginning of the *Sefirot*. The bowls themselves, built of a rougher kind of light, are suspended in the infinite void of deep space, like bright stars or galaxies. These vessels are the raw ingredients of every artist or architect concerned with the sensory aspects of light— especially the California Light and Space Movement of the late 1960s that includes James Turrell, Robert Irwin, and Doug Wheeler. American architect Steven Holl's breathtaking St. Ignatius Chapel in Seattle, Washington, and the opus of American architect Richard Meier's work are prime examples of the elevation of light to a mystical level.

"All around you—in every corner and on every side—is light. Turn to your right, and you will find shining light; to your left, splendor, a radiant light. Between them, up above, the light of the Presence. Surrounding that, the light of life. Above it all, a crown of light—crowning the aspirations of thought, illumining the paths of imagination, spreading the radiance of vision. This light is unfathomable and endless."—*Sha'ar Ha-Kavanah*, attributed to Rabbi Azriel of Girona, thirteenth century mystic.

"When it arose in the will of the blessed Holy One to create the world, He issued from the spark of impenetrable darkness a single vaporous cluster, flashing from the dark, lingering in ascension. The darkness descended, gleaming—flaring in a hundred paths, ways, narrow, broad, constructing the house of the world."—Zohar 1:172a

OPPOSITE This page from the Sarajevo *Haggadah* from Barcelona, from about 1350, is characterized by its abstract portrayal of the first four days of creation from the *Book of Genesis*. Beneath a dome-like frame, light is separated from dark, the waters above from the waters below, earth from dry land, and vegetation from the earth.

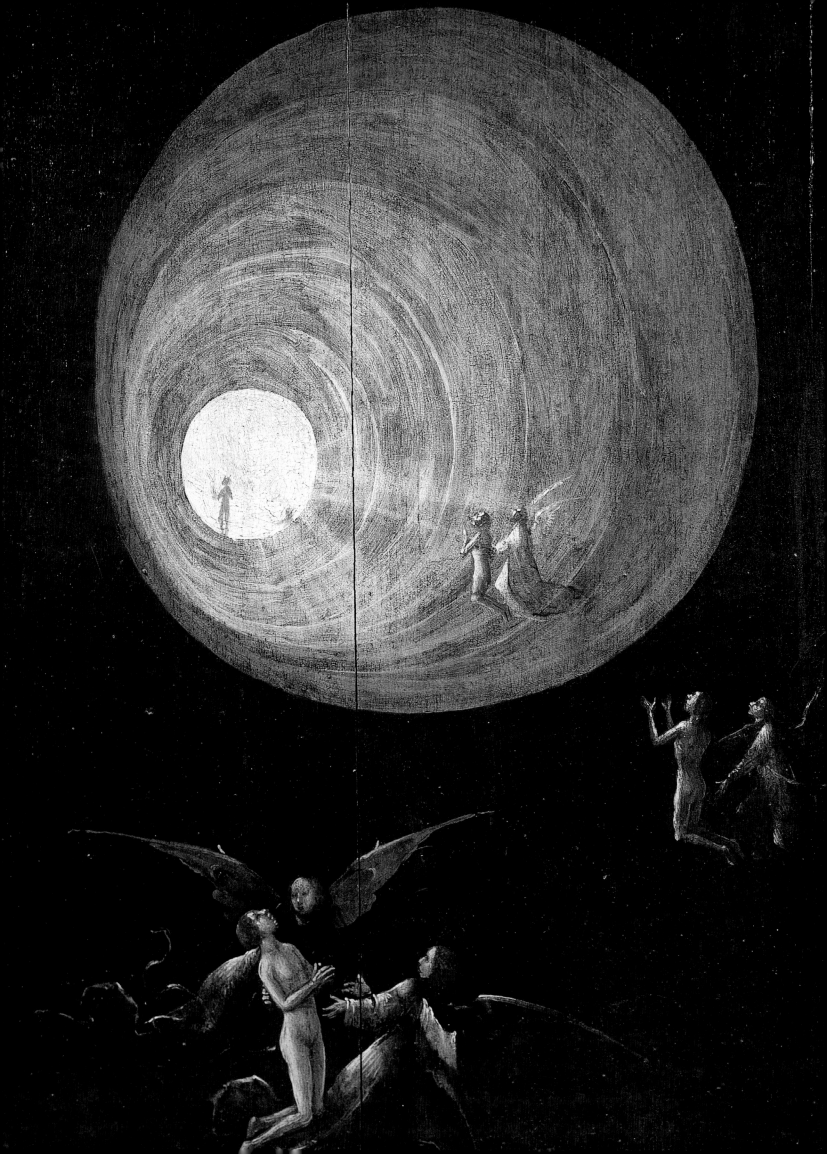

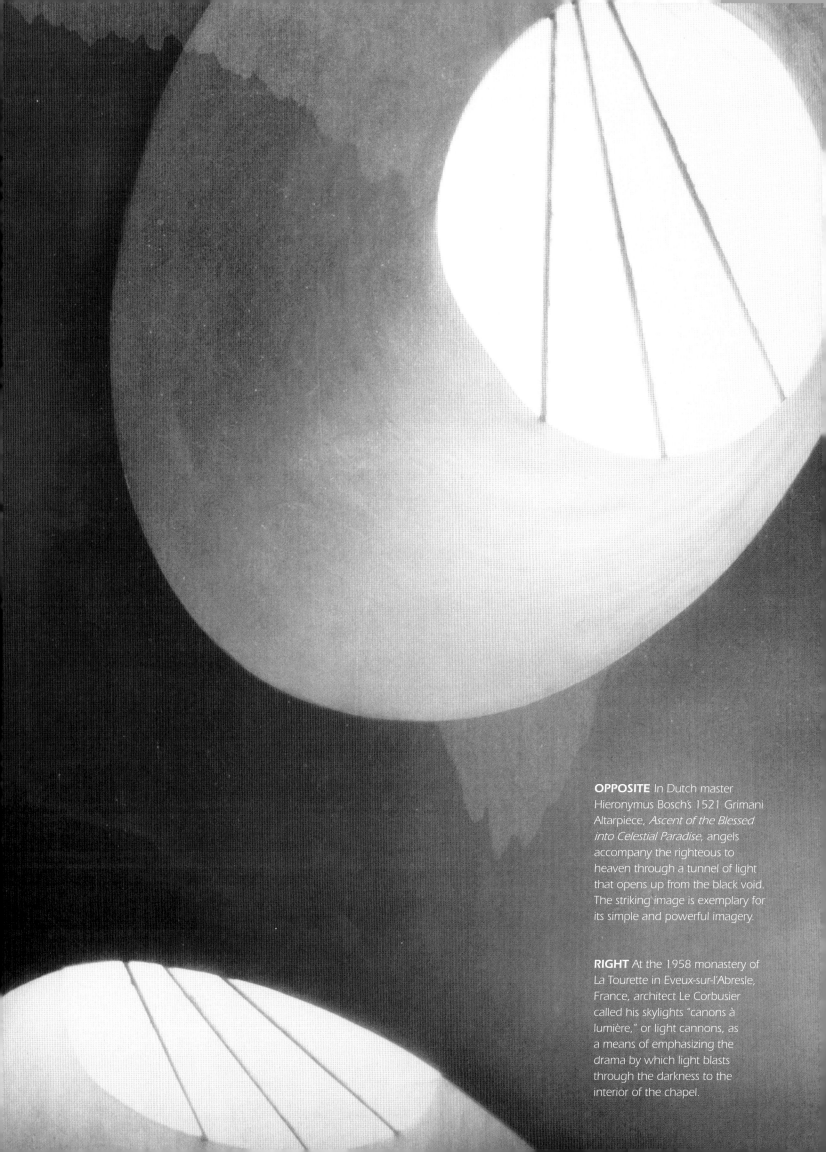

OPPOSITE In Dutch master Hieronymus Bosch's 1521 Grimani Altarpiece, *Ascent of the Blessed into Celestial Paradise*, angels accompany the righteous to heaven through a tunnel of light that opens up from the black void. The striking image is exemplary for its simple and powerful imagery.

RIGHT At the 1958 monastery of La Tourette in Eveux-sur-l'Abresle, France, architect Le Corbusier called his skylights "canons à lumière," or light cannons, as a means of emphasizing the drama by which light blasts through the darkness to the interior of the chapel.

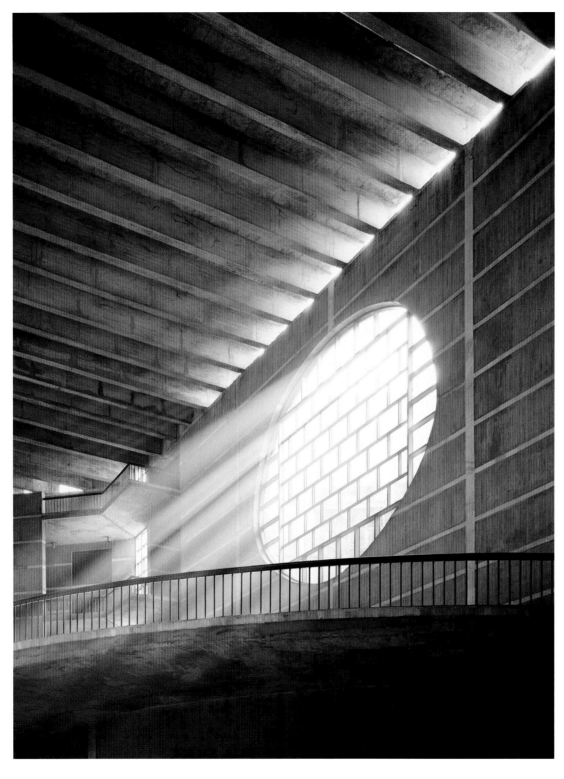

LEFT In Louis Kahn's 1974 National Assembly in Dhaka, Bangladesh, sun streams through a round window and between the roof beams of the ceiling.

OPPOSITE Men are shown at prayer in the mosque of the National Assembly building, with shafts of sunlight coming through the round corner windows that have been cut through the concrete structure. The relationship between the two openings makes the upper circle appear to levitate like a celestial orb of light.

OVERLEAF The 2011 *Perimeter for a Room*, was a site-specific installation at the Lisson Gallery in London by French contemporary artist Daniel Buren. Panels of colored Plexiglas, anchored to the wall, trace a horizontal path along the room's edge. The panels create a feeling of intimacy, as if the ceiling has been lowered. Light from above shines through the colored glass to bathe the lower half of the room in ambient shadows, creating a warm atmosphere of diffused color. The effect recalls the use of color in the Kabbalah, where each *Sefirah* remains clear, but the mystical colors that flow through change our perception of each of the points of light. "*In this quadrisected expanse, all colors are included, four colors seen within, engraved quadruply, higher and lower secrecies inscribed in four engravings. When the colors of these four scatter, they total twelve: green, red, white, and a color blended of all colors, as it is written: Like the appearance of the rainbow allusion in the cloud on a rainy day, so was the appearance of the surrounding radiance.*"—Zohar 1:71b

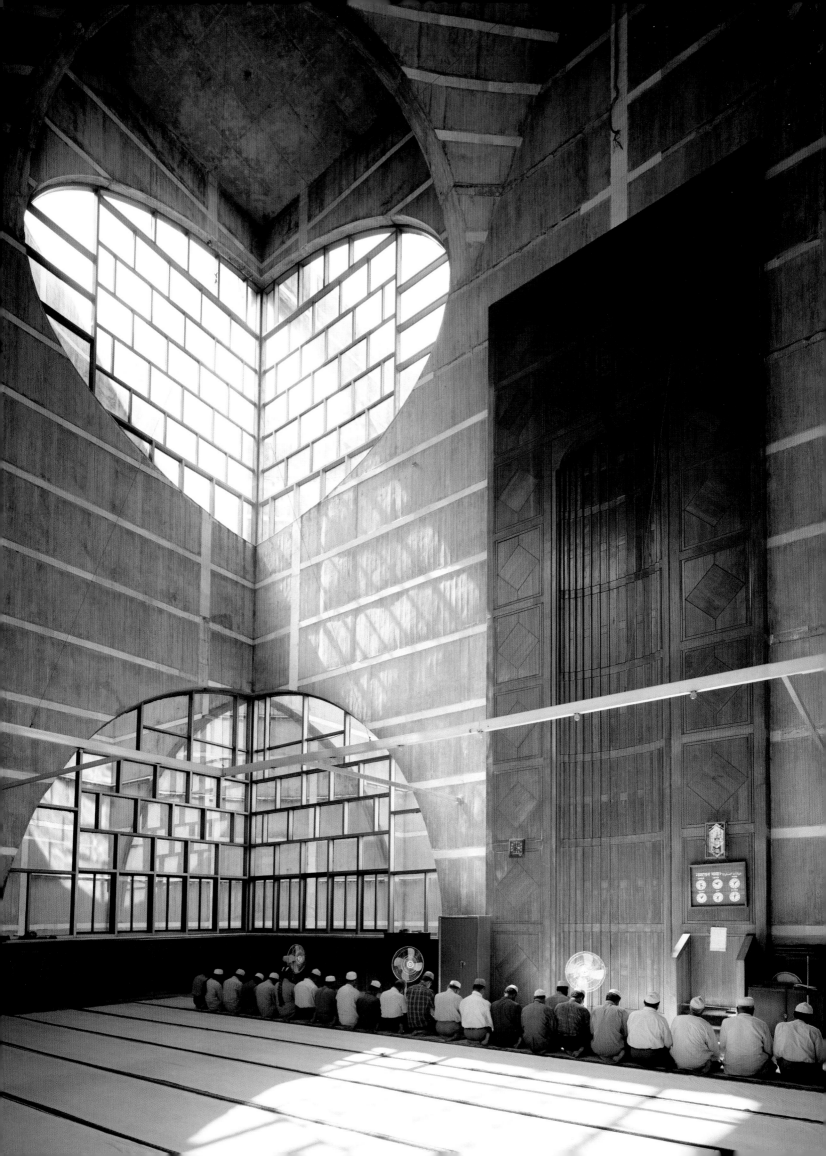

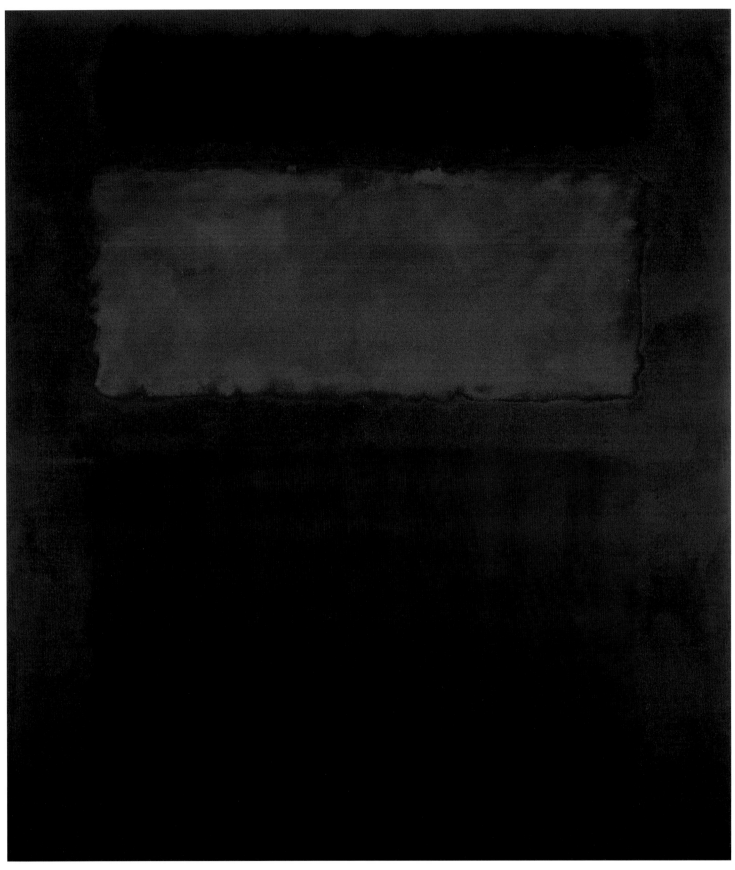

"This blue on the second day was tinged with other colors: red and black. Blue (Exodus 25:4)—red comes to it from the second day itself, corresponding to the color of fire, and this is Elohim. It inherits the color gold, for all is one color. Blue emerges from that color red. When it descends, the red plunges deep into the place that is the sea and is dyed blue; that red enters the sea and its hue is diluted and turns blue, and this is Elohim, though not as harsh as the first one."—Zohar 2:149b

ABOVE The red band in this 1960 painting, *Untitled,* by the Russian-born American artist Mark Rothko catches our attention because of its brilliance, and especially as it contrasts with the deep-blue field and dark black and brown bands. Looking at the edges of the rectangles, a man's profile emerges on the left side of the red band—a possible allusion to Rothko's earlier figurative, mythological themes. The anthropomorphic image is surprising because of the abstract elements. In the *Zohar,* colors associated with the *Sefirot* are animated. They ascend, descend, and emerge from each other in a way similar to Rothko's use of color and form.

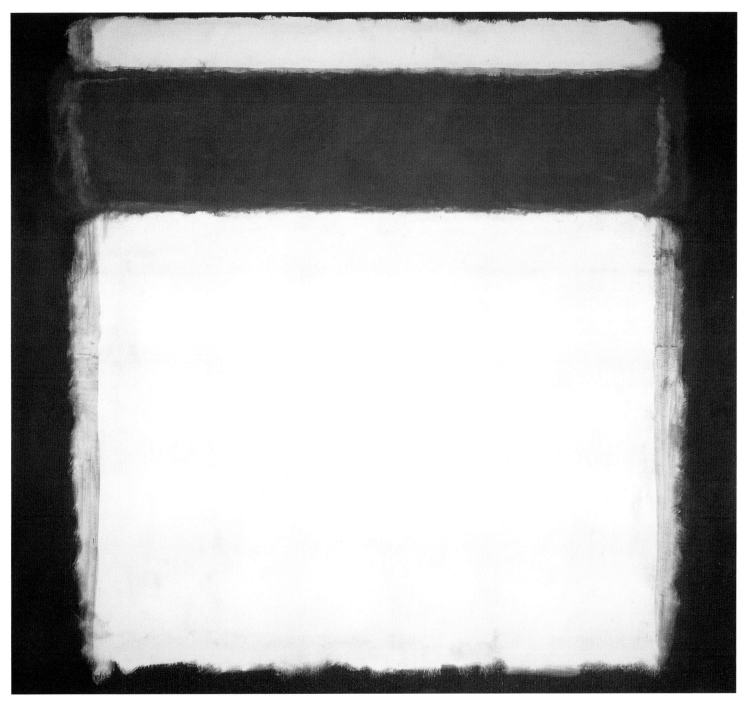

ABOVE As the art historian Dore Ashton has pointed out, despite his disclaimers, Rothko was a mystic of color and light, related in spirit to the *Zohar*. In the 1957 painting *Light Area Over Red*, a whitish band appears to float above and emerge from a red background. Rothko treated the space of the painted canvas like "plates of jelly," and also conjured the weight of air itself at 15 pounds per square inch. In *Number 16*, the dynamic composition is an oscillating play between white and red, with both struggling for alternate dominance as foreground or background. The red band near the top appears to be pulled tensely across the white field that at first seems to be receding, but then flips to the surface and the red slips back to the rear plane.

"One color, the one ascending, emerges, and that color is the color of white, whiter than another. It enters that flame and is tinged yet not tinged, and it rests above on top of that chamber…"—Zohar 2:128b

"In the upper chamber are three modes of color, flashing in one flame—that flame darting from the side of the south, which is right. Those colors diverge in three directions: one ascending above, one descending below, one appearing and hidden when the sun shines."—Zohar 2:128b

RIGHT Designed by American architect Steven Holl, the 2007 Bloch Building at the Nelson-Atkins Museum in Kansas City, Missouri, is a vessel of light that glows alongside the original classical stone museum of 1933. Five frosted glass plank pavilions cascade down the lawn on the side of the old museum and gigantic skylights illuminate the bulk of the addition that lies underground. The largest one, the entry to the new addition, is reflected in a pool with mysterious discs of light that seem to float in the depth of the water, but are actually skylights into the below-ground parking garage. The pool, entitled *One Sun/34 Moons*, was conceived by artist Walter De Maria in collaboration with Holl. The image recalls the passage from the *Zohar, 1:52a*, "Seven lights ascend and descend on seven sides. Seven supernal lights enter the sea—six radiating from one supreme. As the sea receives, so it disperses Its waters to all those seas, all those rivers." Holl has made light into a palpable and visceral presence on the vast American prairie under the dark sky of the night.

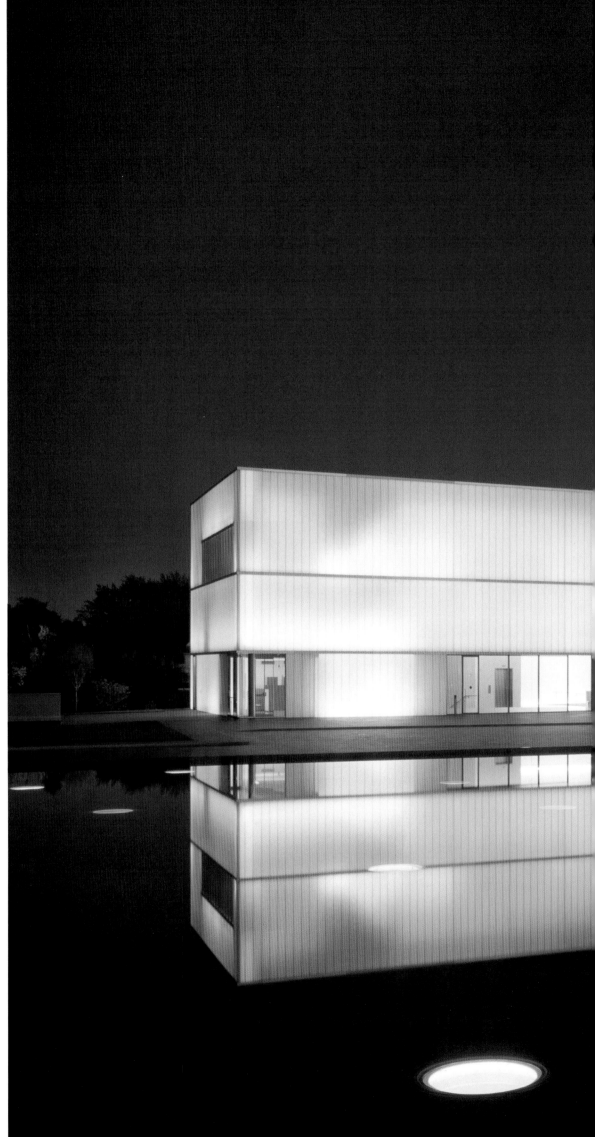

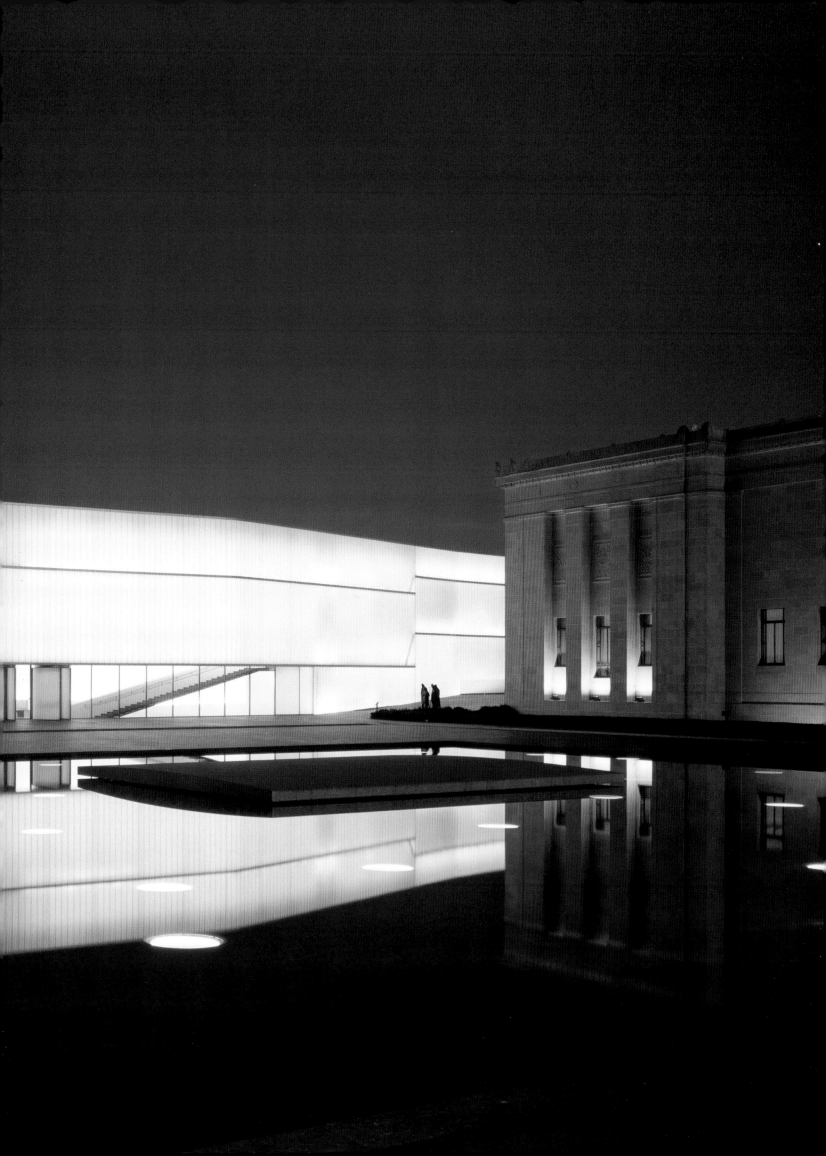

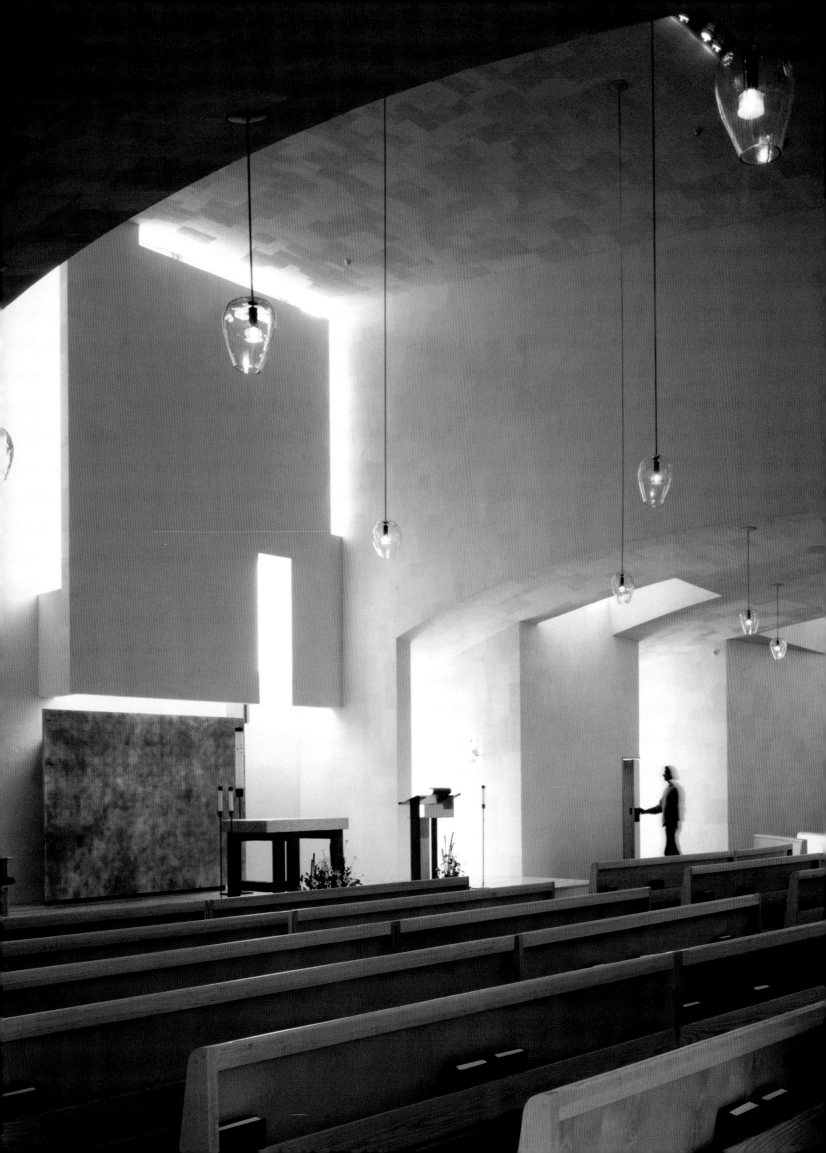

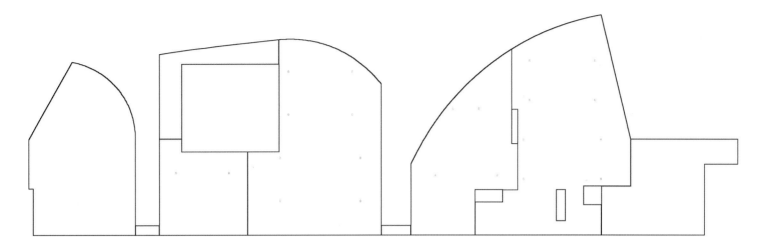

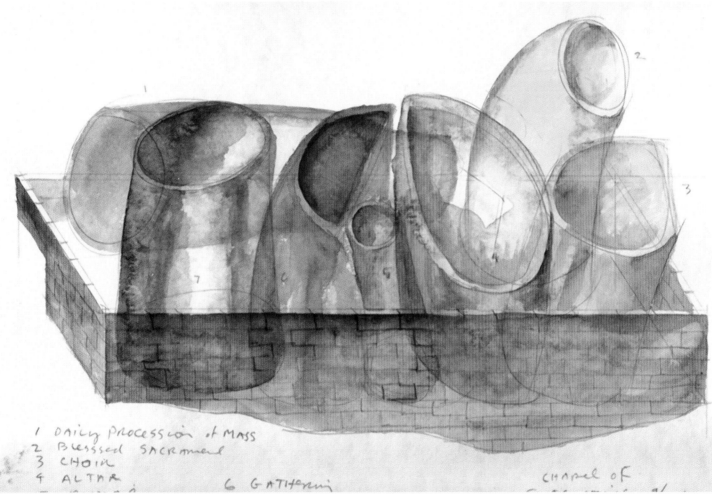

1 DAILY PROCESSION of MASS
2 BLESSED SACRAMENT
3 CHOIR
4 ALTAR
6 GATHERING
CHAPEL OF

American architect Steven Holl's Chapel of St. Ignatius of 2007 at Seattle University, in Seattle, Washington, was conceived, he says, as a "collection of light vessels." Holl confessed that although it was a Catholic chapel, he in fact consulted the Kabbalah scholar Gershom Scholem's books on the theme of vessels of light during the design phase. In the interior, light emerges from unseen sources and is suffused with a sense of luminous divinity.

OPPOSITE In the interior of Holl's St. Ignatius Chapel, a series of indirectly lit spaces recall the "bottles of light" set in a box, as described by the architect.

TOP A line drawing of the elevation of the exterior of the chapel shows the articulation of the skylights.

ABOVE The conceptual watercolor sketch of the Chapel of St. Ignatius was entitled *Seven Bottles of Light in a Stone Box.*

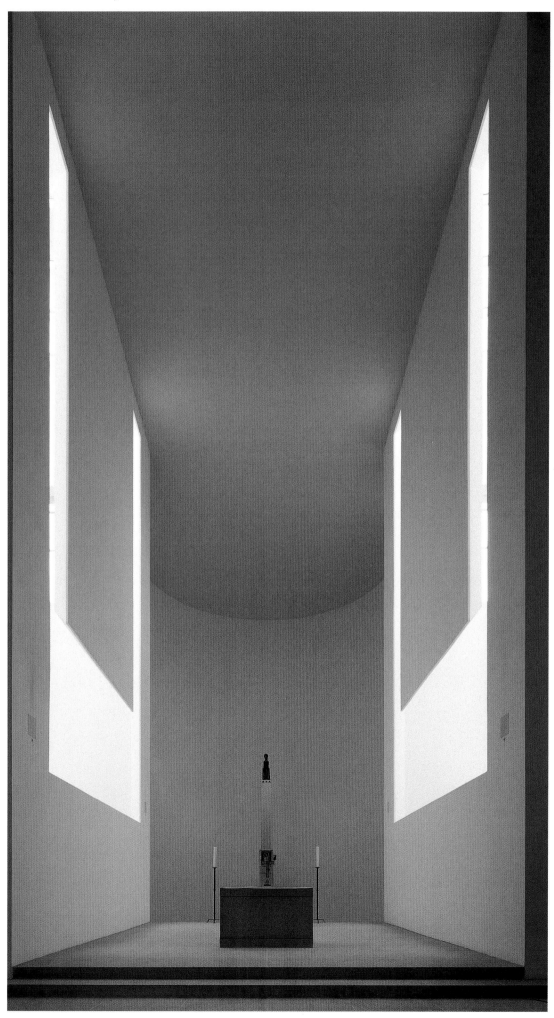

LEFT John Pawson's 2004 Cistercian Nový Dvúr Monastery in the Czech Republic culminates in the high altar, a perfect chalice of light, with two glowing cup-like shapes "inscribed" on the walls. They are actually baffles that bounce light indirectly off the deep walls to create the illusion of the Holy Grail, first recounted by a Cistercian monk in the thirteenth century. The *Zohar* also refers to the seven celestial windows of the highest heaven, where "the fourth window is a window called Goblet."

Le Corbusier's 1955 Chapel of Nôtre-Dame-du-Haut, in Ronchamp, France, replaced a previous mountaintop pilgrimage chapel that was destroyed during World War II. Literally built out of the rubble, the chapel celebrated the survival of a statue of Mary that was untouched by the German bombs. Signaling a new direction in his work, Le Corbusier's contrapuntal opposition of sweeping curves is a radical departure from the Swiss architects rational geometry. The chapel is a Bach fugue of light and dark, a vision of the throne of God's heavenly palace.

OPPOSITE In the side chapel, with the altar bathed in light from a hidden skylight, the plan and section are curved to form one seamless whole.

OVERLEAF Bursting with light, the interior of Ronchamp is an asymmetrical composition of large and small windows in a thick, fortress-like wall. Some angle inward, so that light bounces off the sides, while others splay out toward the exterior. The light of the wall recalls a passage from the *Zohar*: "*In that firmament are one hundred window openings, some on the east and some on the south, and in every single window one star. When the sun traverses those windows and openings in the firmament, it sparkles…*"—Zohar 2:172a

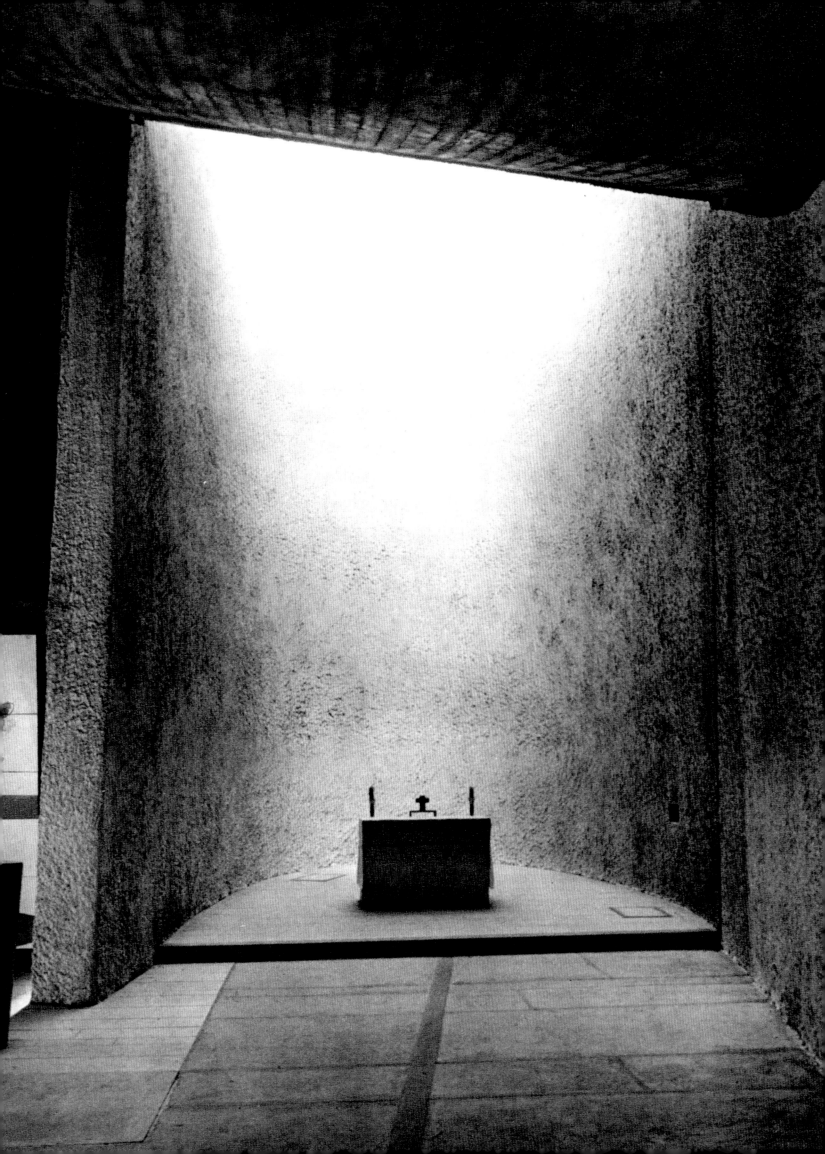

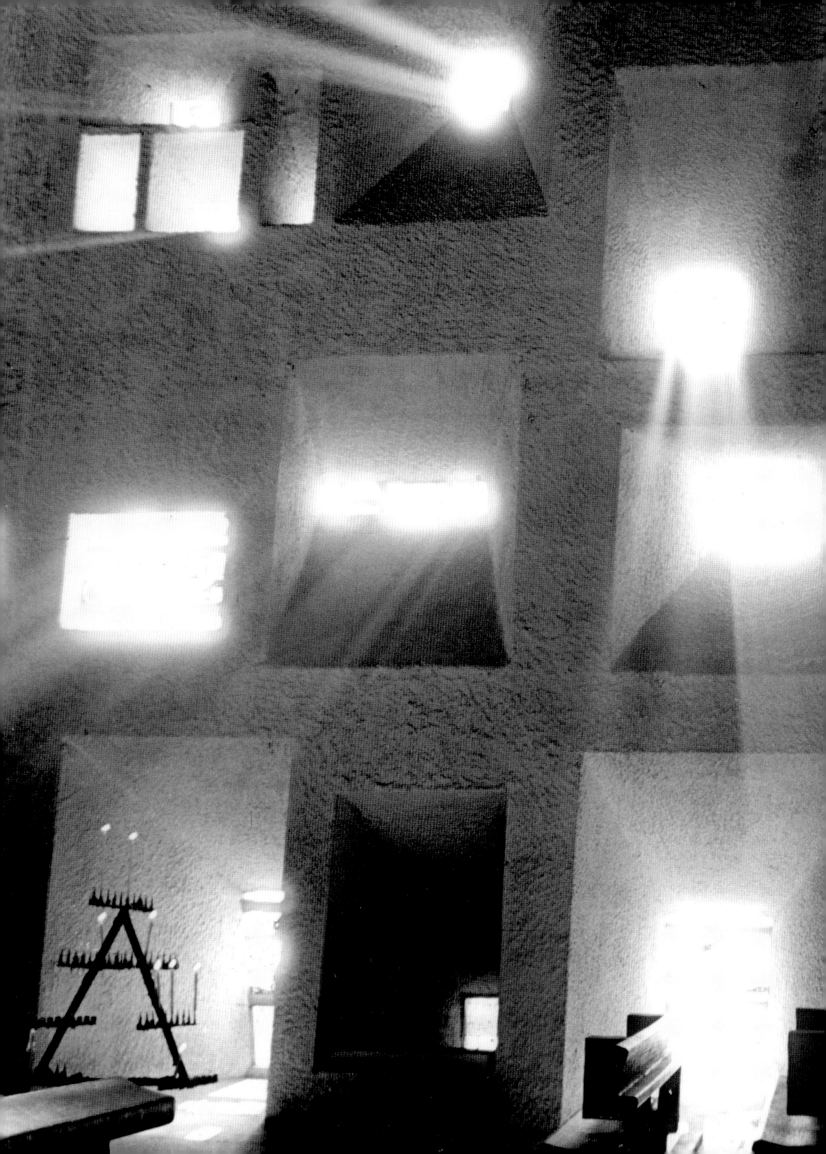

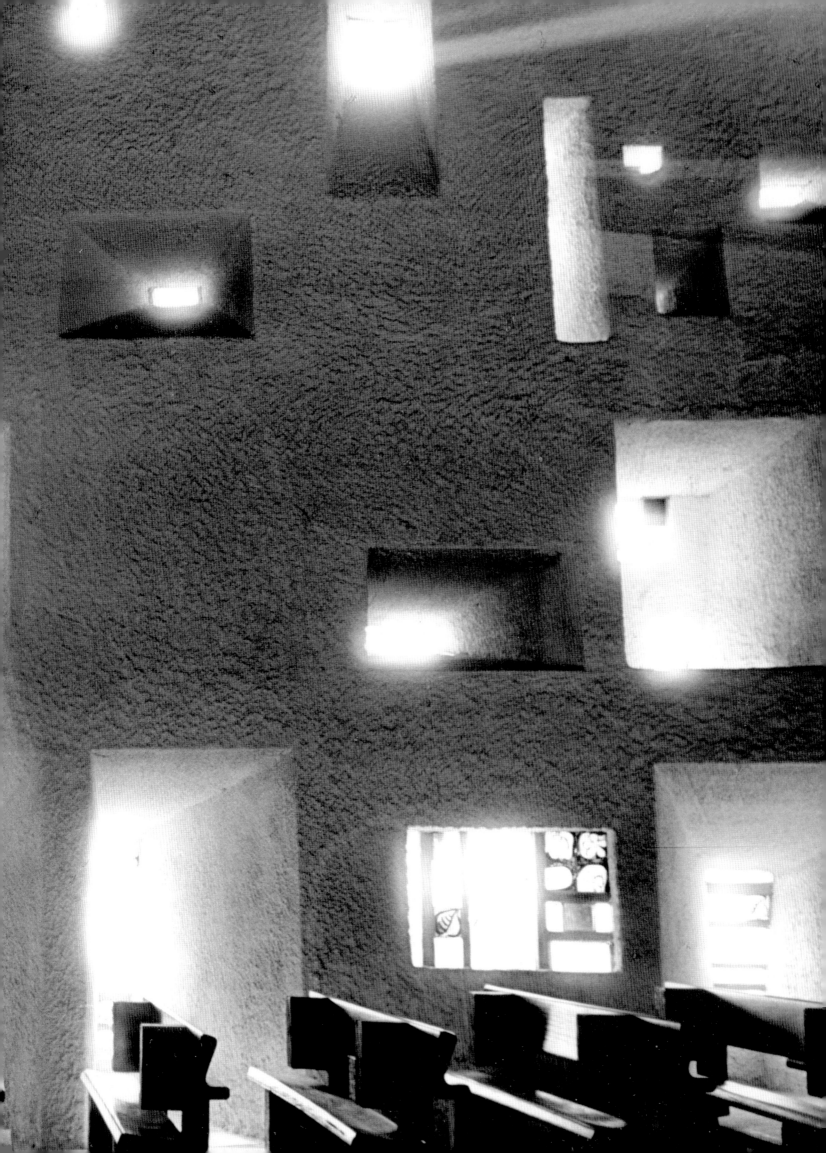

OPPOSITE The synagogue entrance is between the half circle and the cube of the social hall, through the arcade that leads to a grand stair toward the main sanctuary.

TOP AND ABOVE This 2008 synagogue, Congregation Beth Shalom, by South African architect Stanley Saitowitz of Natoma Architects in San Francisco, is composed of three parts: a cubic volume containing the social hall, a plinth of offices, and a curving shape clad in Jerusalem stone that contains the sanctuary, described as a "sacred vessel." From the outside, the abstract bowl is precariously balanced, and gives no hint of the luminous interior space.

OVERLEAF The interior of the sanctuary is lit entirely from above, from a narrow skylight that cuts the ceiling in two, the light culminating in the ark and the eternal light. Congregants pray within the metaphorical *Tzimtzum*, in a vessel of light, seated on both sides of this cosmic drama.

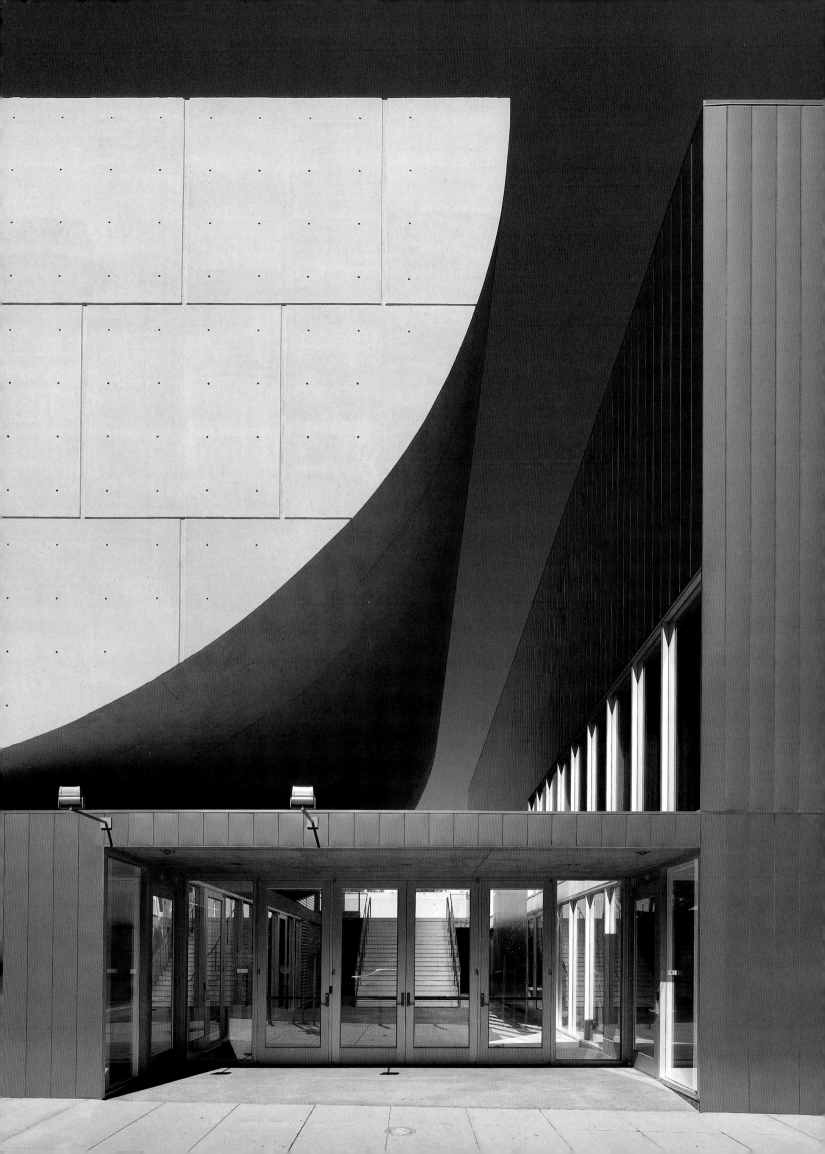

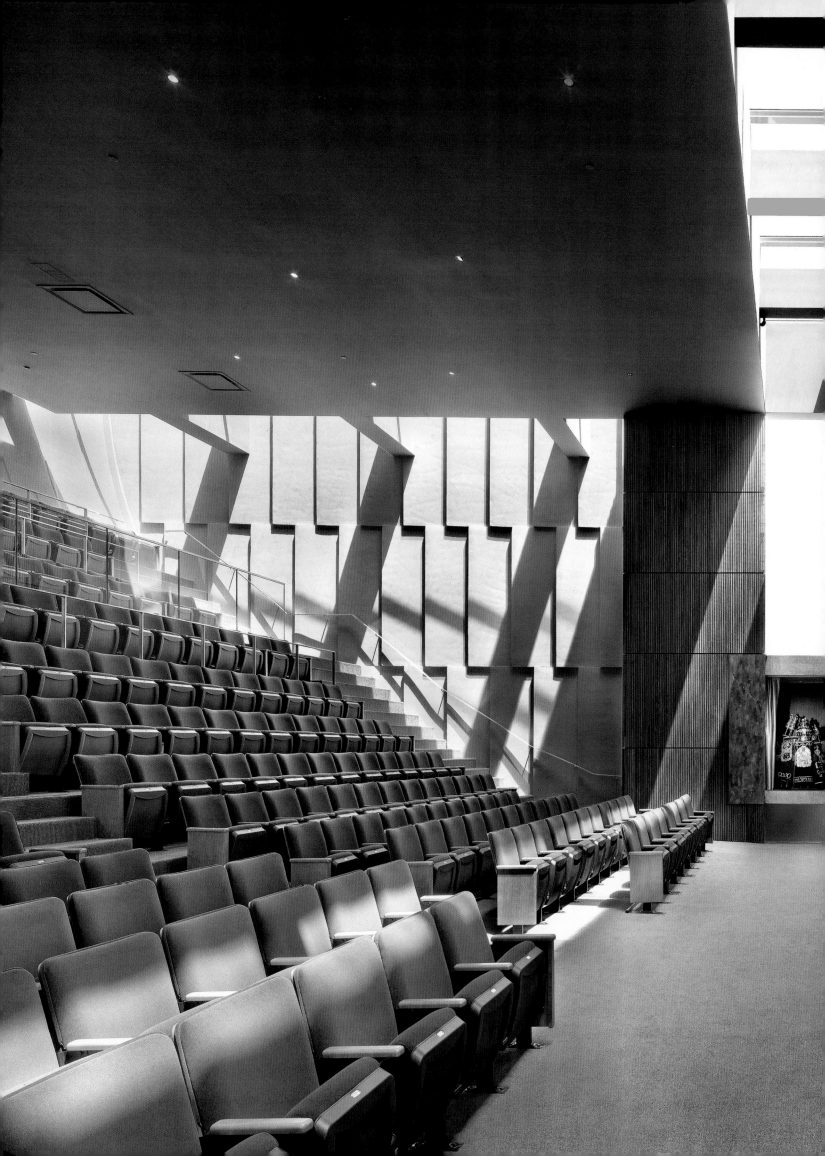

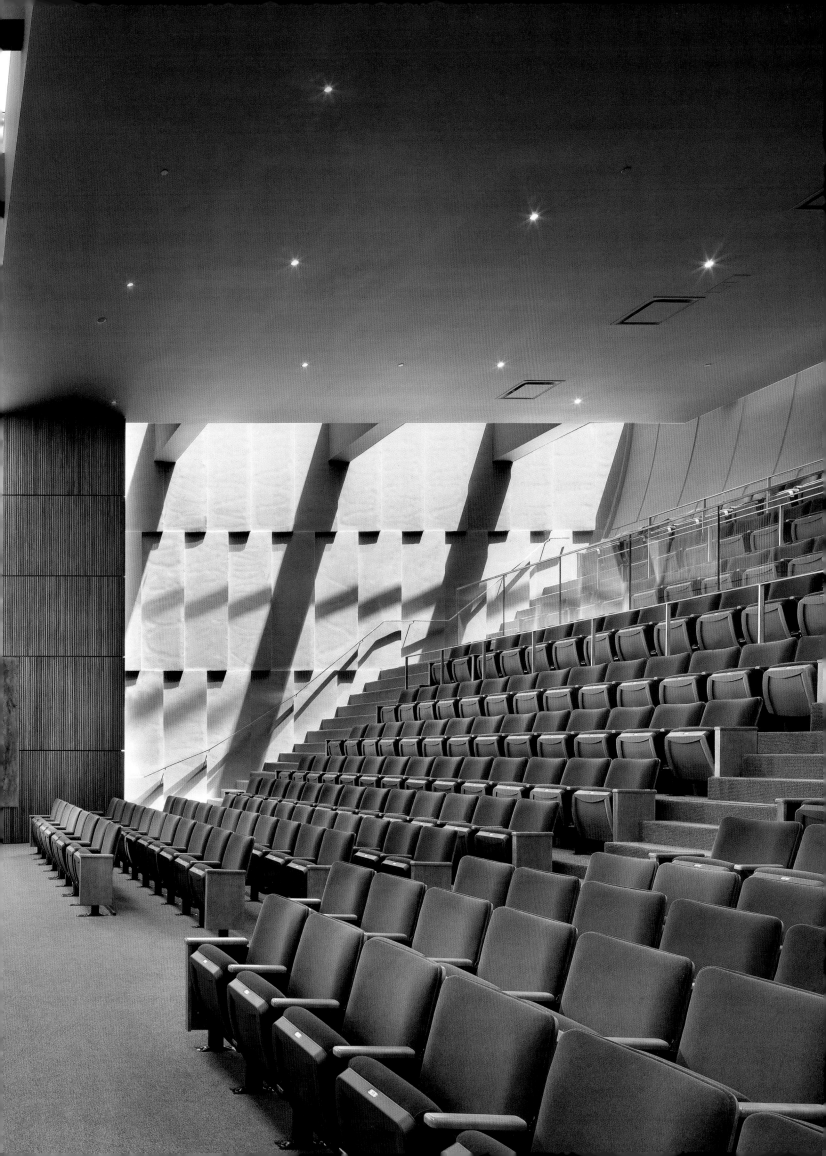

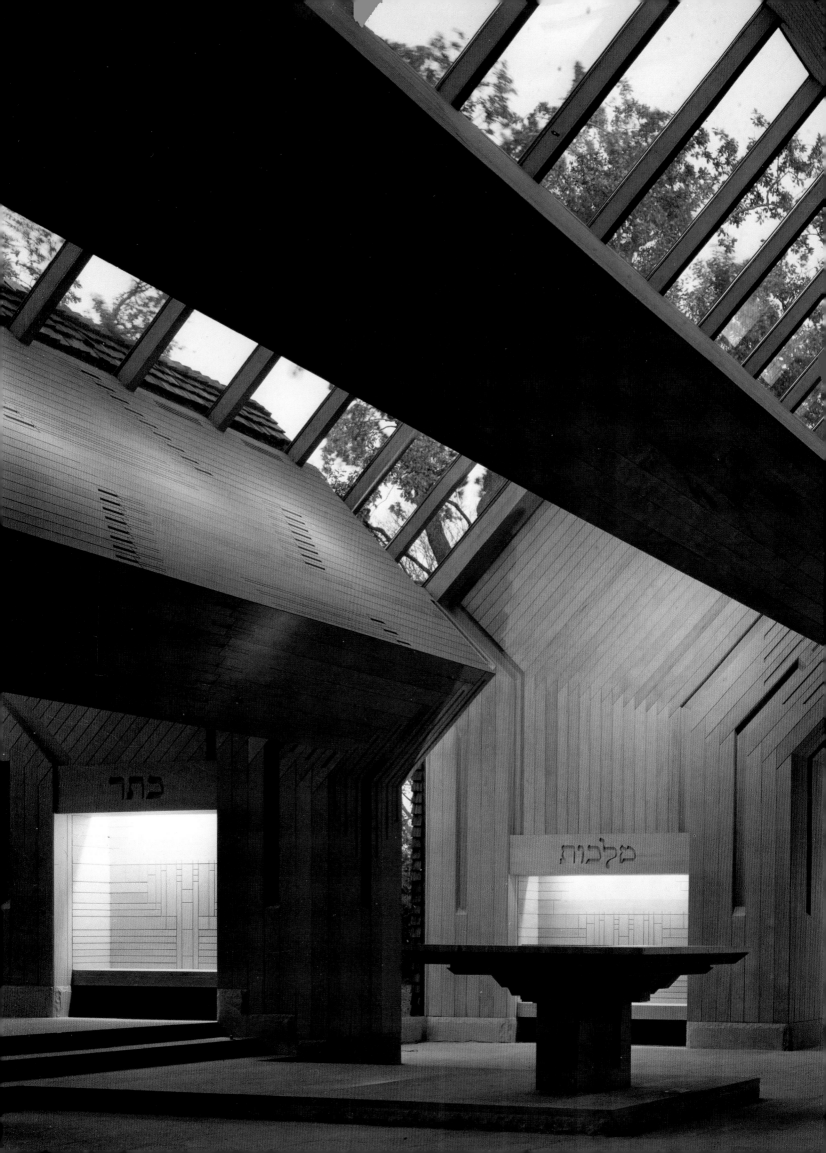

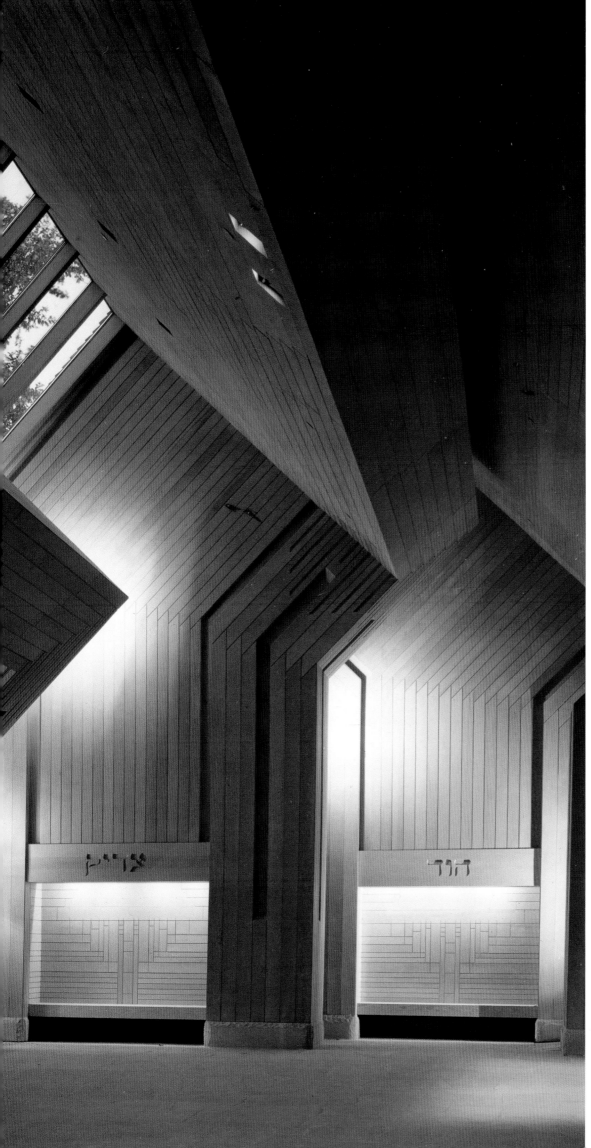

LEFT American architect Norman Jaffe's 1987 Gates of the Grove Synagogue, in East Hampton, New York, now known as the Jewish Center of the Hamptons, referred explicitly to a number of concepts from the Kabbalah, especially the use of the sacred number ten. There are ten windows and ten prayer niches with the names of the *Sefirot* inscribed in Hebrew above each one. The interior is clad in cedar, the wood of Solomon's Temple. The roof trusses are shaped like the Hebrew letter *yud*, the first letter of the Tetragrammaton, the sacred four-letter name of God. The space is bathed in natural light, with the authenticity and intimacy of the wooden synagogues of Poland that were destroyed by the Nazis during the Holocaust.

OVERLEAF German artist Sigmar Polke's extraordinary windows for the Grossmünster in Zürich, installed in 2008, include slices of agate arrayed within the existing stone frames. There had been talk of creating new windows for the church since 1851. Polke's agate windows are sections of stone that reveal patterns like fertilized cells or living organs. In fact, the biomorphic shape in the medieval illumination of God the Architect, giving order to the universe, was an inspiration for the artist. The agates also recall Ezekiel's vision of the "wheels within wheels, with rings full of eyes on the rims." These windows bring together a number of mystical Kabbalistic themes frozen in colorful stones of light. The large lunette window, facing north, is the last one visible inside the Grossmünster before leaving the church to join the outside world.

"The universe diffracts into forty-five hues of colored light. Seven disperse into seven abysses, each one striking its own abyss, stones gyrating. The light penetrates those stones, piercing them, and water issues from them, each one sinking within an abyss, covering both sides."—Zohar 1:51b

A masterpiece of modern domestic architecture, the Maison de Verre in Paris, by French interior designer Pierre Chareau and Dutch architect Bernard Bijvoet, is a comprehensive renovation of a French hôtel particulièr. It is a sensuous combination of technology and residential accommodation, with an intricate use of glass, wood, rubber, and steel. The main living room is entirely sheathed in a translucent glass block, each square with a circular lens at the center. The house combined living quarters and the offices for Dr. Jean Dalsace, a gynecologist, and his wife, Annie. Completed in 1932, it has never been surpassed in its details and faith in the dream of modernism as a vision of the future.

RIGHT During both day and night, the house is a cocoon of light, with hundreds of circles gazing out, like the eyes of Ezekiel's vision. The house recalls Austrian architect Adolf Loos' dictum to Le Corbusier: "A civilized man does not look out the window; his window is a ground glass, it is there only to let light in, not to let the gaze pass through." Chareau, who was Jewish, created this unique work of architecture that was both ancient and modern.

LEFT On a granite cliff overlooking the Atlantic Ocean, this house in Nova Scotia, Canada, by the New York firm Alexander Gorlin Architects, and completed in 2012, is divided into six pavilions of concrete, glass, and steel that express the individual rooms of the residence. Each one is focused in a different direction, offering views of a lighthouse, a World War II bunker, and the shipping lanes to Halifax. At twilight, there is an ethereal quality to the light emitted from the pavilions—or vessels of the house—due in part to the curving zinc roofs that appear to float above the structure.

"The house ascends and is placed between two sides, while hymns are chanted and praises rise. Then the one who enters, enters silently, and the house glows with six lights lustering in every direction."—Zohar 1:172b

The Breaking of the Vessels | שבירת הכלים

Sh'virat Ha-Kelim

In an effort to explain the apparent disorder and chaos of the world, great Kabbalist Rabbi Isaac Luria of Safed, Israel, proposed in 1570 a dramatic concept equal to the *Tzimtzum: Sh'virat Ha-Kelim*, or the "breaking of the vessels." The ten glowing vessels in the void eventually cannot contain the Divine light flowing into them, so they explode, breaking into myriad shards. In the Kabbalah, the shattering of the vessels is part of the cycle of creation and destruction that began long before this universe. In a famous *Midrash*, a first-century commentary on the Torah, Rabbi Abahu wrote: "The blessed Holy One created and destroyed worlds before he created these, saying: 'These please me. Those did not please me.'" In Judaism there is a long history of broken things, such as Moses breaking the first set of Ten Commandments and the destruction of the first and second Temples. In the *Book of Isaiah*, it was written: "And he shall break it as the breaking of the potter's vessel that is broken in pieces; he shall not spare: so that there shall not be found in the bursting of it a shard to take fire from the hearth, or to take water with out of the pit."

Like the Big Bang theory of the beginning of the universe, these containers shattered, and their contents spilled helter-skelter into the void. One Kabbalistic theory is that the light of the vessels was unstable, combining good and evil in a volatile mixture that blew up. This idea contends that the first emanation of the Divine light was a means for God to purify himself of the evil that was mixed in with the good. Evil is therefore construed to be an original part of the Divine, and was released when the vessels broke. In the *Book of Isaiah 45:7*, God says: "I form the light, and create darkness: I make peace, and create evil: I the Lord do all these things."

As with everything in the Kabbalah, nothing is simple, so of the ten vessels of light, which correspond to the ten *Sefirot*, the upper three, being stronger, did not break. The lower seven bowls were completely shattered. Clinging to the broken shards, *klipot*, are sparks of the light left over from inside the bowls. These precious sparks are to be gathered and restored to their original place, higher in the cosmos. A broken world that must be repaired, or *tikkun*, is a Kabbalistic theme that that has reverberated throughout the centuries. And it is especially current today.

The Breaking of the Vessels is an idea that is both conceptual and visual, and is close to the recent Deconstructivist Movement in architecture that sought to mirror the fragmentary nature of contemporary culture in three-dimensional form. It was based on the literary theory of interpretation, which dissected multiple meanings of a text. Jacques Derrida, the twentieth century philosopher, was one of the foremost proponents of Deconstructionism. His views were adopted by the American architect Peter Eisenman, who even collaborated on an architectural project with him. I met Derrida, who was Jewish, at a lecture he gave at the Cooper Union School of Architecture in New York, where I asked him about whether his ideas had any relevance to synagogue design. He answered: "Are they still building synagogues?"

Even today, few ideas express the mood of contemporary architecture and art so much as fragmentary form: Polish-born architect Daniel Libeskind's Imperial War Museum in Manchester, England, has a design based on the fragments of a broken globe; German artist Anselm Kiefer made a series of paintings called *Ha-Kelim* (the vessels), which were shown in Paris in 2000; British sculptor Cornelia Parker's 1991. *Cold Dark Matter* at the Tate Gallery in London was an exploded shack; and Italian architect Renzo Piano's tower, the tallest in London and finished in 2012, has been named the Shard.

OPPOSITE Versions of contemporary Italian sculptor Arnaldo Pomodoro's 1960s *Sfera con Sfera*, or *Sphere within Sphere*, have been installed in a number of locations around the world, including the Cortile della Pigna in the Vatican in 1996, as well as in Dublin, at the United Nations in New York, in Tel Aviv, and in Teheran, Iran. The piece consists of a polished bronze globe that has been fractured to reveal another sphere within it, with what appear to be strange mechanical details just under the surface. One meaning certainly alludes to the breaking of the vessels in the Kabbalah, that moment when the initial order of the universe is rent asunder, with the obligation left to mankind to mend the resulting mess.

American architect Daniel Libeskind's 2001 Imperial War Museum, in Manchester, England, was described by the architect as "that of a globe that has been shattered into fragments and reassembled. The building's form is the interlocking of three of these fragments, or shards, that represent earth, air, and water." This poetic Kabbalistic concept takes the idea of the broken vessel as a metaphor for the destruction of war, and their healing reconstitution as an illustration of *Tikkun*.

TOP AND ABOVE The hand-drawn sketches of the concept of the museum as a series of fragments that have been recombined is captured in a drawing by Libeskind that appears to be almost Japanese calligraphy, *top*, and the shattered globe as the basis for the design of the museum, *above*.

OPPOSITE The entry to the museum is between the vertical Air shard and the horizontal Earth shard, both covered with stainless steel panels. The direction of the panels is in contrast to the orientation of the shards, so that there is tension set up between the structure and the skin. This sets up a slightly disorienting sense appropriate to the meaning of the museum as a place to emphasize peace, as opposed to its ostensible name as a War Museum. One enters in the gaps between these fragments of the original globe that has shattered through the violence of mankind.

OVERLEAF Libeskind describes the nature of his design for the museum. "The building is a constellation composed of three interlocking shards. The Earth shard forms the generous and flexible museum space. It signifies the open, earthly realm of conflict and war. The Air shard, with its projected images, observatory and education spaces, serves as a dramatic entry into the museum. The Water shard forms the platform for viewing the Canal with its restaurant, café, deck and performance space." Of course this is the literal description of functions that are a springboard into the symbolic realm of interpretation, not unlike the four levels of meaning from the literal *(P'shat)* to the secret *(Sod)* meaning in the Kabbalah.

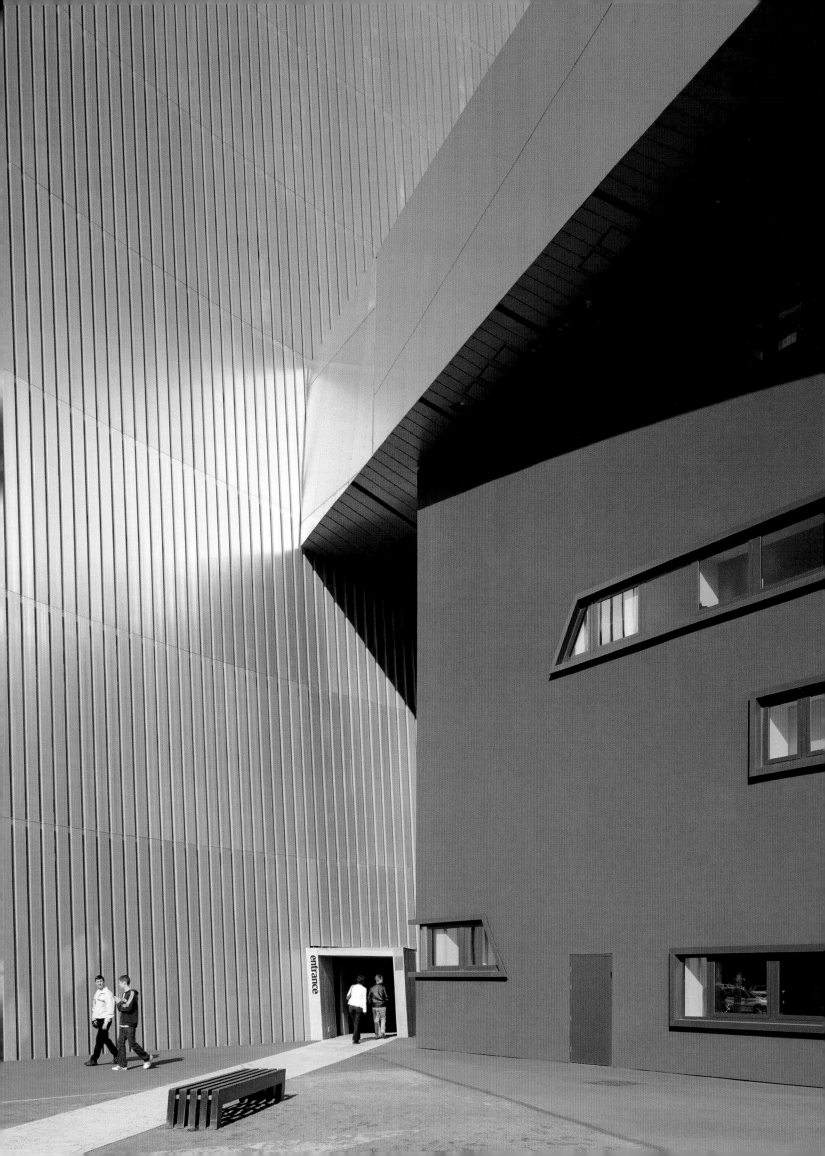

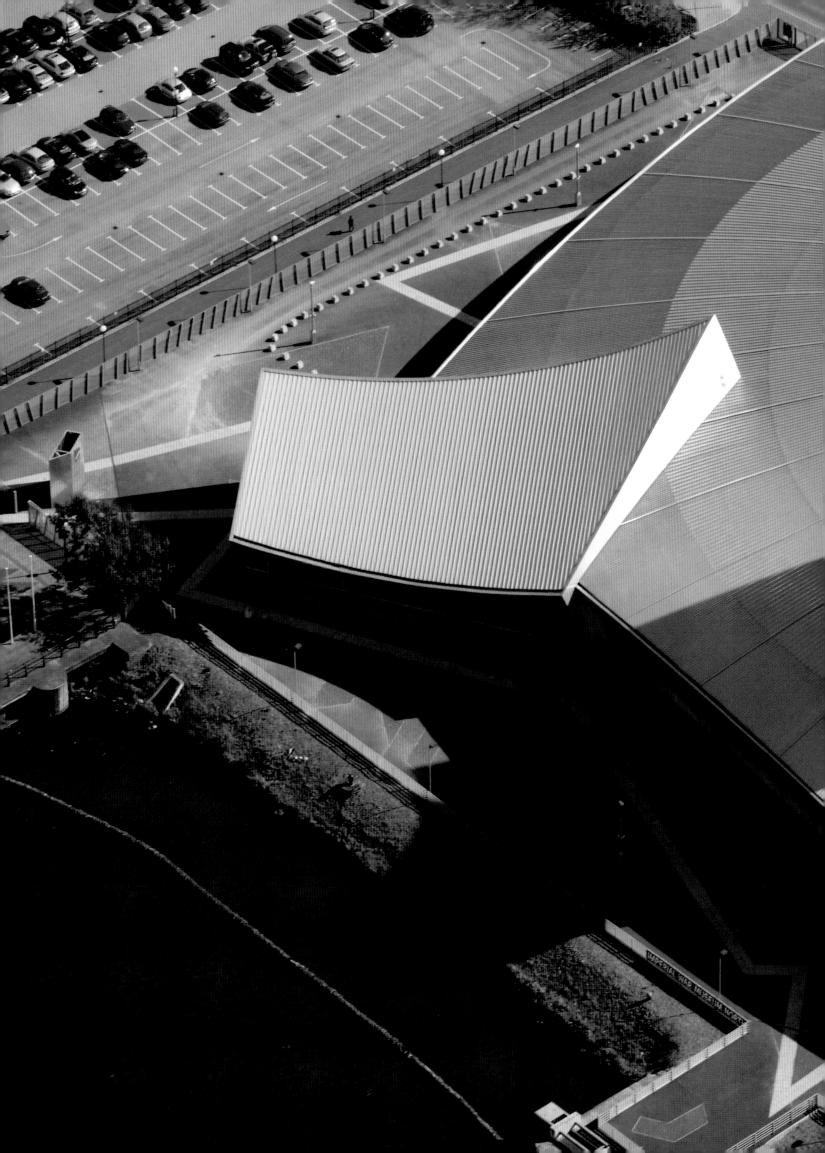

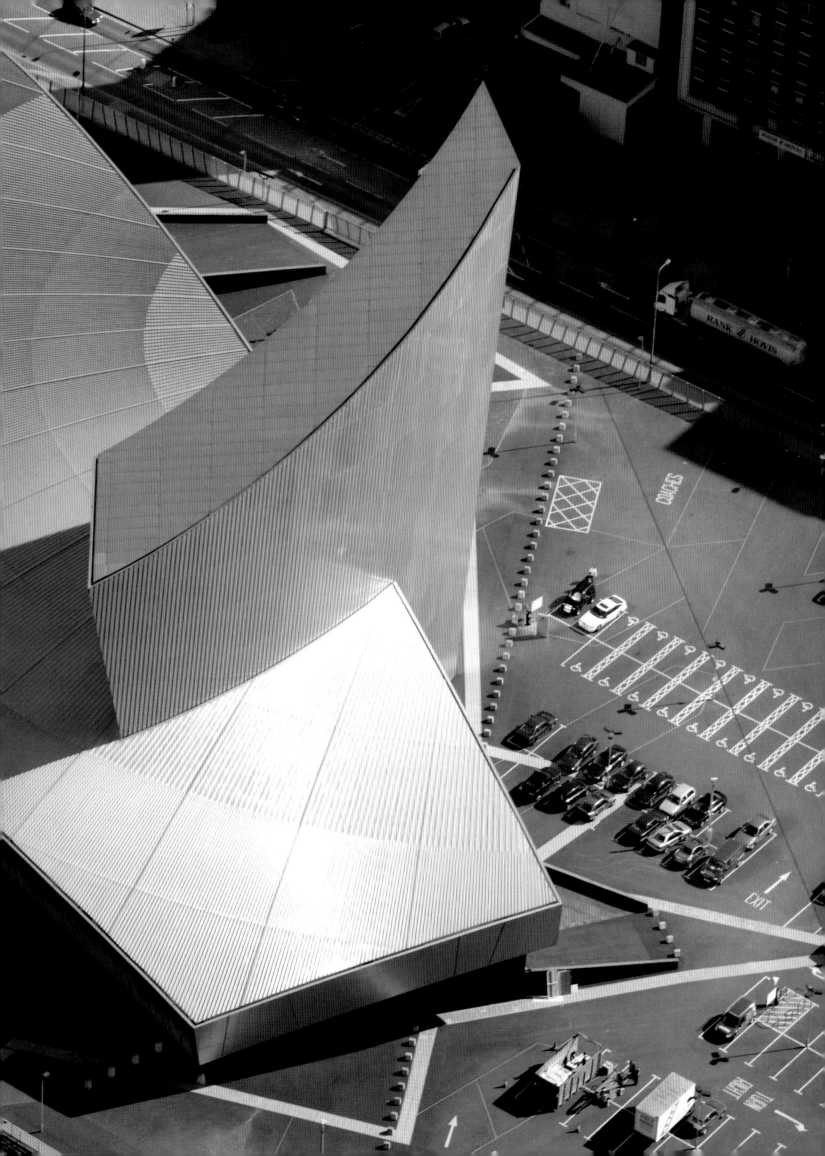

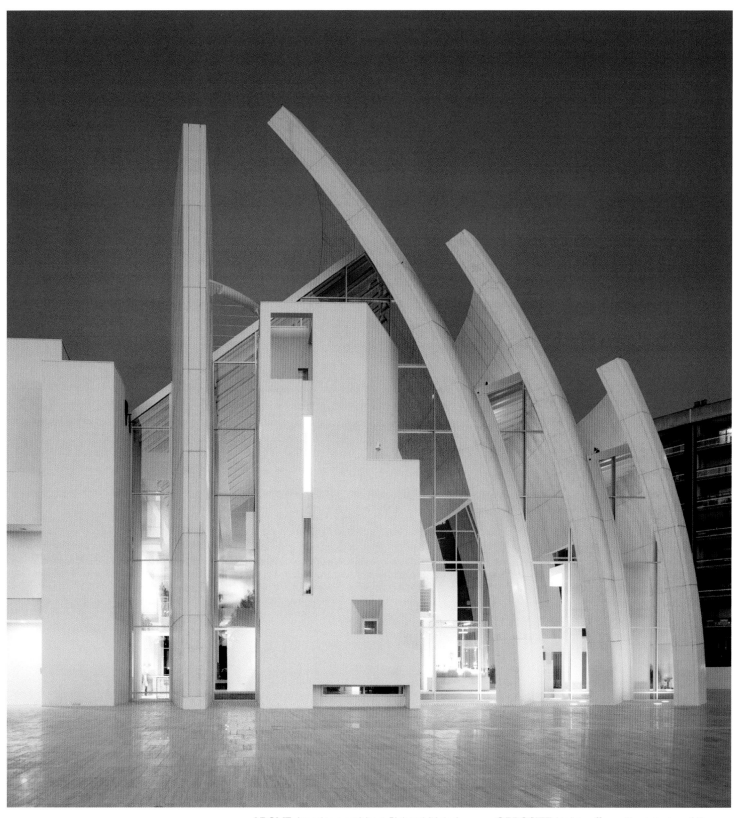

ABOVE American architect Richard Meier's 2003 Jubilee Church in Rome, Italy, is composed of "three large shell-wall planes." These represent fragments of a single broken sphere that soars up to capture the light. Meier explained that, "regardless of my Jewish religion, I was honored beyond measure to be chosen as architect of the Jubilee Church." The architect has always used light in a quasi-mystical sense, with its transcendent quality that is adaptable to the Judeo-Christian tradition of religious spaces.

OPPOSITE Light suffuses the interior of the Jubilee Church from in between the concrete shells, and through both the vertical spans of glass and the large skylights.

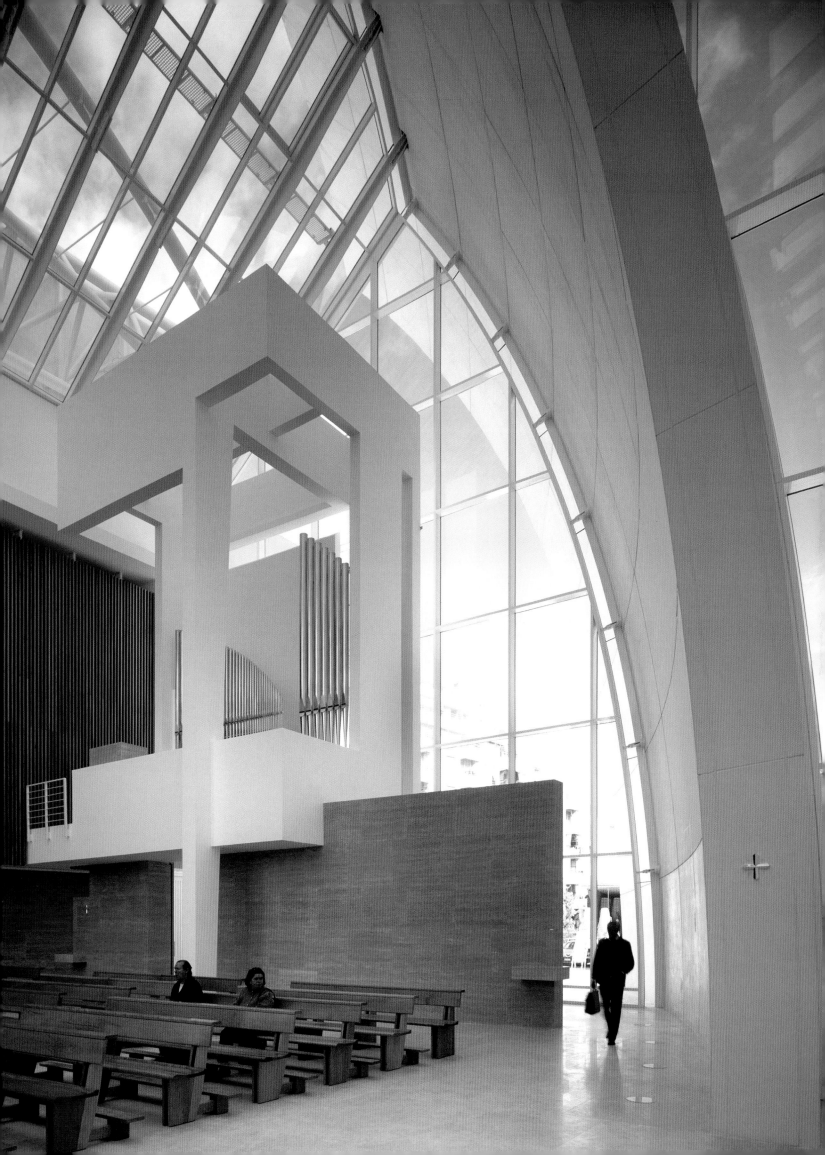

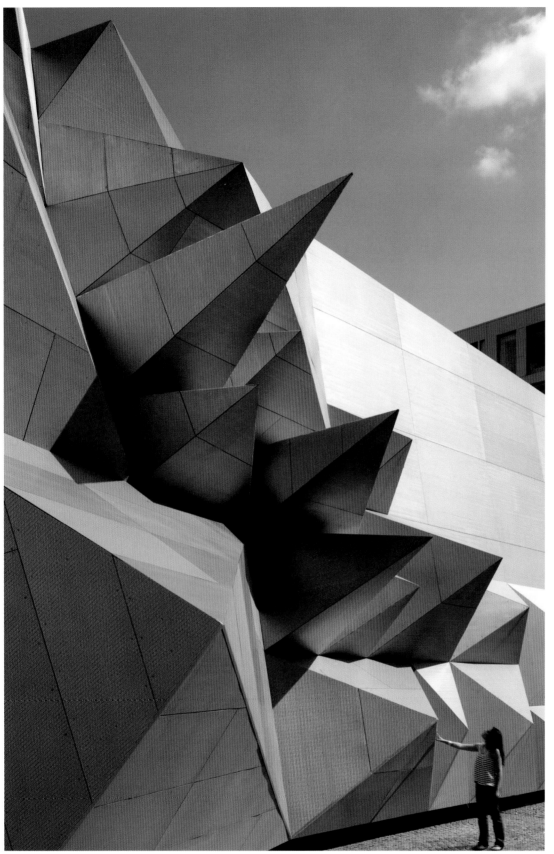

The Austrian architectural firm of Coop Himmelblau's 2010 temporary mobile pavilion for the Bavarian State Opera in Munich, Germany, is composed of a series of acoustical "shards," whose purpose, in the interior, is to enhance the sound, and on the exterior, to shield the noise of the street from the audience.

LEFT Built of aluminum, the Bavarian State Opera House appears more dangerous than it is in reality, as the "points" are for the most part beyond reach. In the Kabbalah, these metaphorical "shards" from the broken vessels would be hiding "sparks" of the original light that need to be returned to their divine source.

OPPOSITE German artist Caspar David Friedrich's 1824 *Das Eismeer*, or Sea of Ice, is an evocative portrayal of the romantic notion of the malevolent forces of nature wreaking havoc on the puny creations and dreams of man. Inspired by the true story of a shipwreck in 1820, the barely visible remains of the boat have been absorbed by the monumentally jagged blocks of upturned ice. The crushing forces that have "broken the vessel" of the ship have destroyed the predictable order of the universe on which the ship previously set sail.

OVERLEAF British artist Cornelia Parker's 1991 *Cold Dark Matter: an Exploded View* in the Tate Gallery in London, England, is made of the remains of a garden shed blown up at the artist's request by the British Army. Parker collected the pieces, hung them strategically in the Tate, and lit the ensemble with a single light bulb to enhance the sense of explosion. Violence and chaos in a state of suspended animation characterizes many of Parker's works.

"And He shall break it as the breaking of the potter's vessel that is broken in pieces; he shall not spare...So that there shall not be found in the bursting of it a shard to take fire from the hearth."—Isaiah 30:14

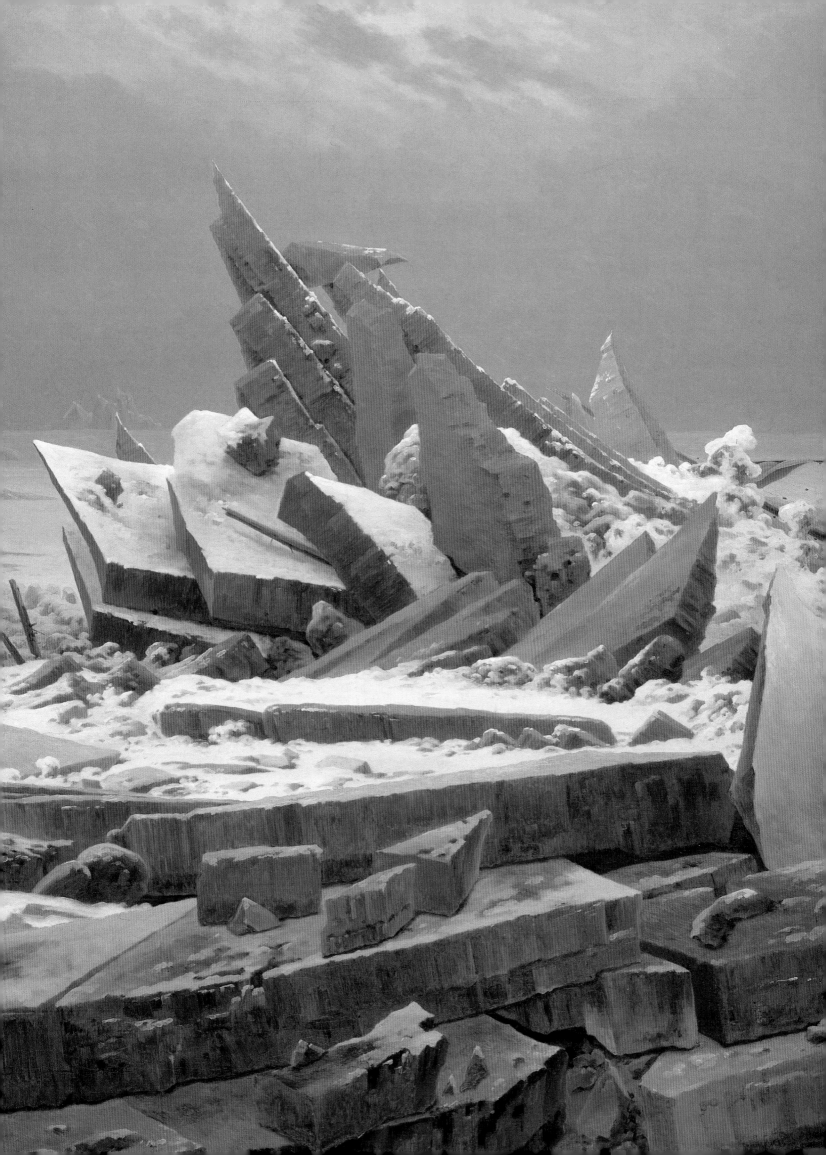

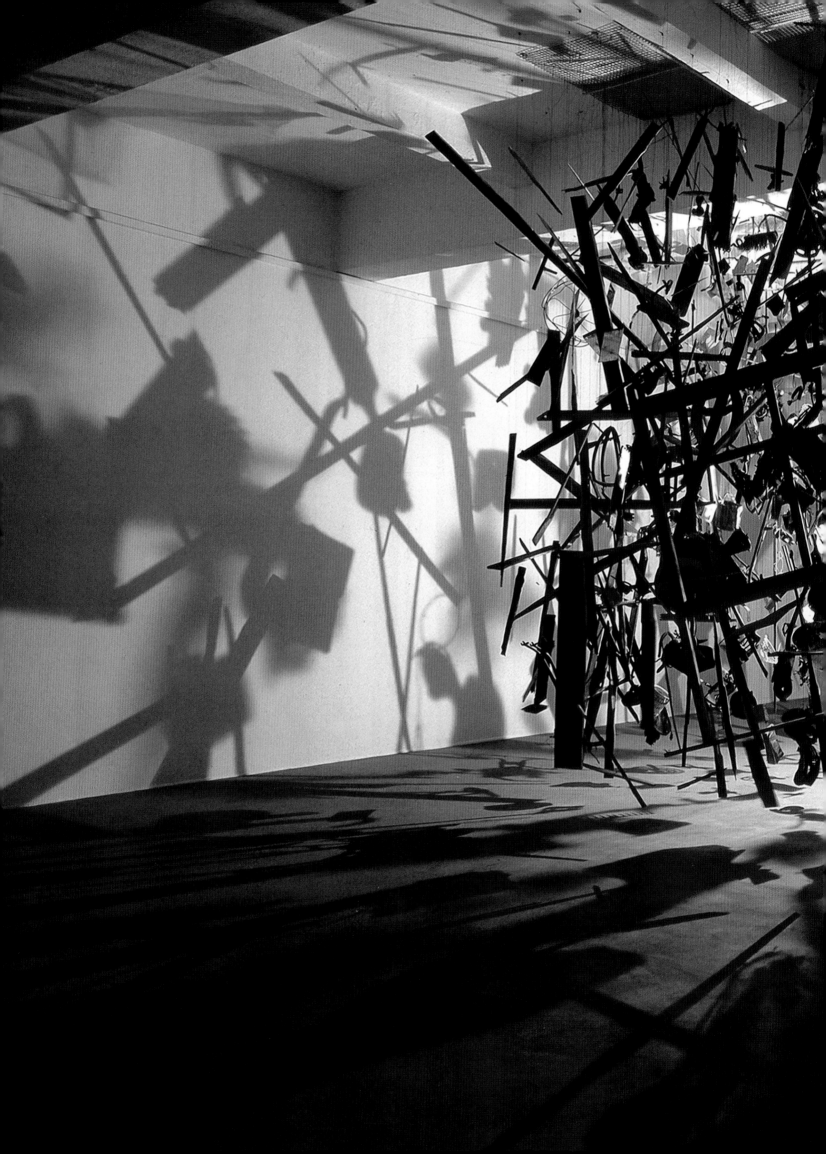

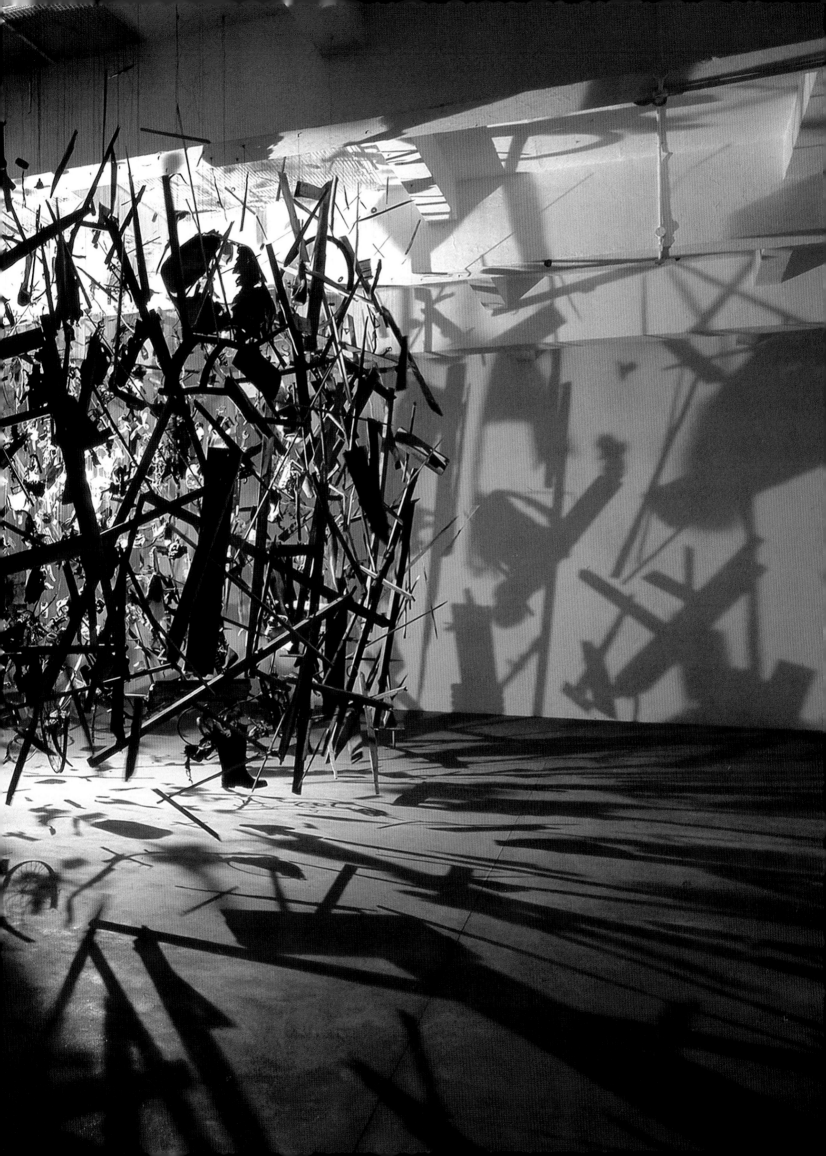

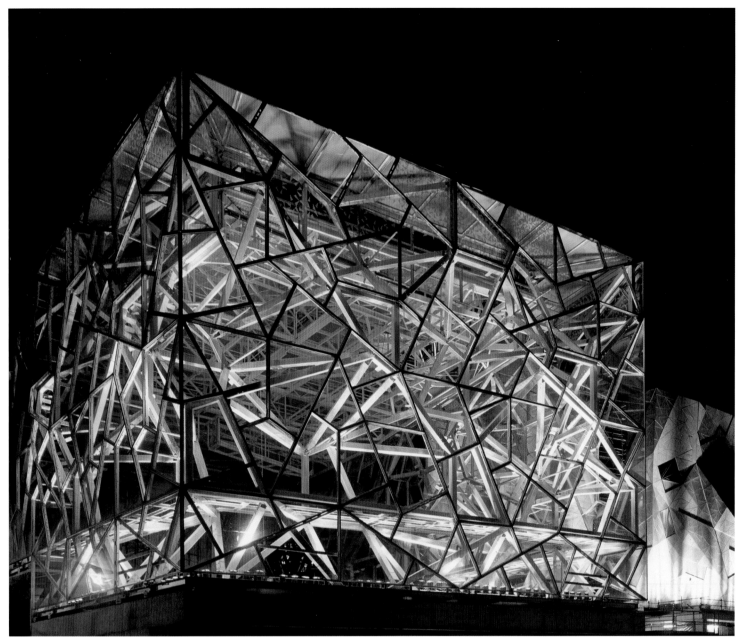

ABOVE The 2003 Federation Square building in Melbourne, Australia, by Lab Architecture, an Australian firm, is a radical experiment in fractal geometry. It is an all-glass structure that appears as if about to shatter into a thousand pieces. Based on a triangular module that is repeated in larger panels based on the number five, it relates to the all-important number ten of the *Sefirot*.

OPPOSITE The interior of the performance space has a double glazing of fractal geometry on the walls and ceiling that acoustically enhances the perception of the sound by breaking up the surfaces.

OVERLEAF *Bang Boom* is a light fixture by the German designer Ingo Maurer that re-enacts the initial cosmic explosion in miniature, with a sense of humor that references the American Pop Art artists of the 1960s.

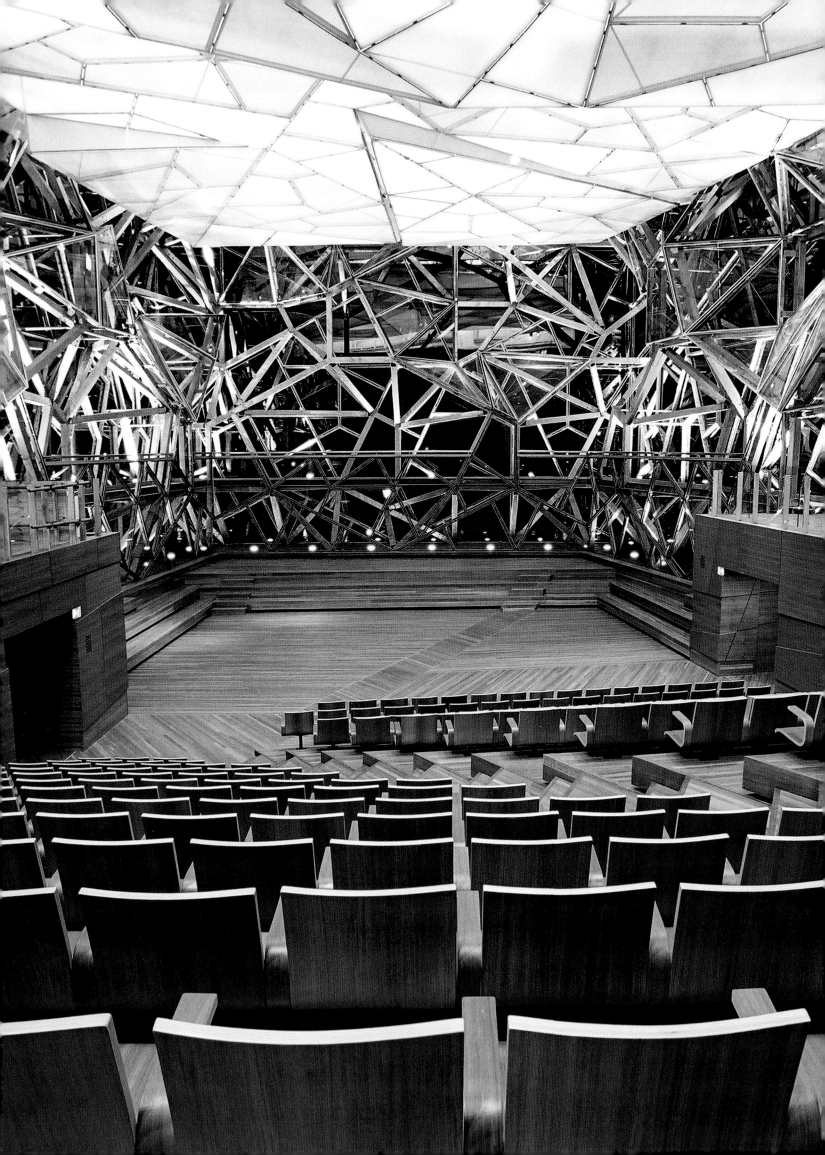

Repair תיקון

Tikkun Olam, which means "repair of the world," are words that have become prevalent in contemporary Judaism, in referring to any charitable or social action that helps individuals or adds to the betterment of society. However, the phrase has its roots in the Kabbalah, where it refers to the situation after the catastrophe of the broken vessels of creation. As Rabbi Luria recounted in the sixteenth century, 288 sparks of the original primordial light were lodged within the shards, *klipot*, that fell to earth. These sparks sustained the fragments and gave power to the evil that has been unleashed on the world. Much of the original divine light ascended back to its source, but what remained needed to be returned to restore the balance of the cosmos. Luria advanced a radical concept that it is mankind's obligation to find and return the sparks, rather than waiting for God to pick up the pieces. To put Humpty Dumpty back together again, each individual has a task that eventually will lead to the repair of the world and the return of the Messiah, when they, as it is said in the *Book of Isaiah*, "shall beat their swords onto plowshares." Since no one knows when that last spark will be reunited on high, each person is essential in the process of restoration. Since the Kabbalah is basically conservative with regard to Orthodox Judaism, the path to *tikkun* involves the observance of the 613 commandments, *mitzvot*, leading an ethical life, and study of the Torah. *Tikkun* is expressed as a "theurgy, a complete reorganization of the relationship of God to mankind, which is now a full partner in the restoration of the cosmos." God literally needs mankind to help redress the imbalance in the universe. In the *Zohar* it says: "The impulse from below calls forth that from above." The sparks are also within each person, so that it is an internal struggle to raise them as well.

WHEN? WHO? Rav Abraham Isaac Kook commented on *tikkun:* "We constantly aspire to raise the holy sparks. We know that the potent energy of the divine ideal—the splendor at the root of existence—has not yet been revealed and actualized in the world around us. Yet the entire momentum of being approaches that ideal."

Since the idea of *tikkun* refers to an abstract cosmic action, it is an appropriate metaphor for the physical world of architecture. A good example of architecture as *tikkun* is American architect Louis Kahn's design for the Hurva Synagogue in Jerusalem, Israel, which was begun in 1967, after the Six Day War. Hurva, which means ruin, was built in the eighteenth century, then destroyed, then rebuilt in the nineteenth century, only to be demolished by the Jordanians after the 1948 Israeli War of Independence. Shortly after the Israelis regained the Old City of Jerusalem, Kahn was commissioned to build a new synagogue, adjacent to the ruins of the original, the two connected by a garden. With its cubic form and buttresses, and its plan as a series of concentric squares similar to the rings of the *Sefirot*, it was designed to recall Solomon's Temple. Unfortunately, the synagogue was never built. Kahn's design is a restoration, a physical and spiritual repair of the broken husk of the original synagogue.

Certainly controversial, but perhaps necessary examples exist in Germany, where architecture is used as a cultural means to restoring a broken past. The restoration of the Reichstag in Berlin after the reunification of Germany is a creative reconstruction. Its open glass dome, a modern reinterpretation of the original, is where the public now has direct visual access to the proceedings of the legislative chamber. The architects preserved relics and inscriptions from the Allied soldiers, so that the new Reichstag becomes a memorial to them, as well as to the Holocaust, and a living monument to the revival of German democracy.

OPPOSITE The interior of the glass dome atop the Reichstag features helical ramps that are open to the public.

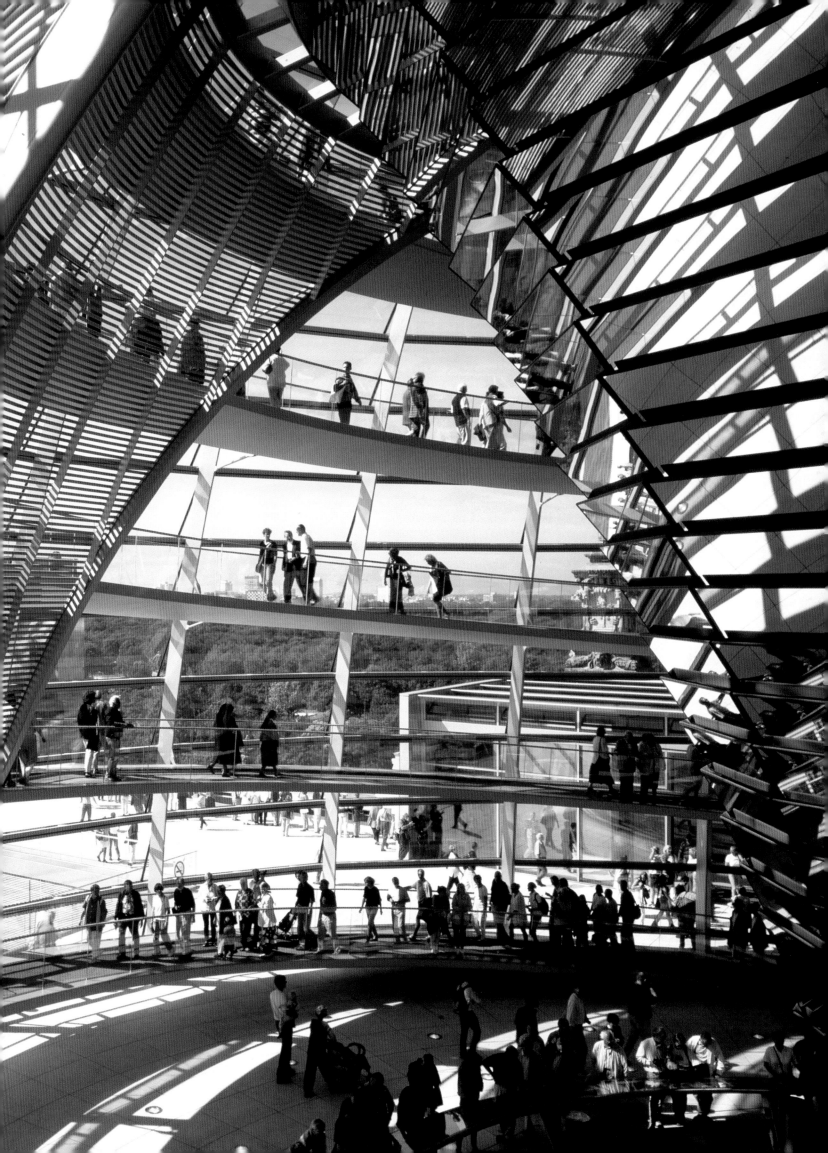

The Reichstag building in Berlin, Germany, that dates from the late nineteenth century (1894), housed the parliament until it was severely damaged in a fire in 1933. The structure had long symbolized democracy standing against tyranny—its significance made evident as it was burned by Adolf Hitler as a symbolic way for the dictator to seize power. After the reunification of Berlin on October 3, 1990, the half-ruined building became the home of the New German Parliament. British architect Norman Foster's 1992-1999 renovation and additions to the Reichstag are a masterful example of architecture as *tikkun*, using the term as a metaphor for a building that has been repaired and restored while still retaining traces of its history. As Foster wrote, "these scars are preserved, and historical layers articulated." A new glass dome is a reinterpretation of the original one. And now, with its helical ramps, the public can see directly into the parliamentary chamber. The synthesis of old and new, in a way that elevates and extends the original, is truly a "repair of the world" that has a special meaning in this highly charged place.

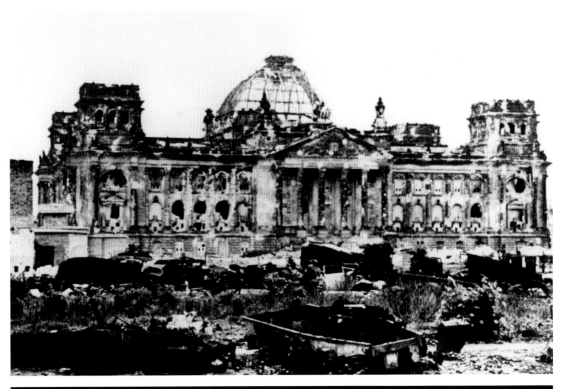

ABOVE RIGHT The burning of the Reichstag in 1933 destroyed most of the building, though its structure remained intact.

RIGHT The Reichstag, after its renovation by Norman Foster, is illuminated at night.

OPPOSITE The solar reflector of the glass dome at the top of the Reichstag is visible from within the structure.

German architect Manuel Herz created the synagogue and Jewish community center in Mainz, Germany, between 2000 and 2010, on the site of a former synagogue that was destroyed on *Kristallnacht*, literally, "Night of Crystal," which is often referred to as the "Night of Broken Glass," the violent anti-Jewish pogroms that took place on November 9 and 10, 1938, in Germany, parts of Austria, and Czechoslovakia, which had recently been occupied by German troops.

RIGHT The profile of the building takes its shape by abstracting the Hebrew word *kedusha* meaning holiness. Herz wrote: "In its history, Judaism has never developed a strong tradition of building. Nor has it developed architectural styles that, as is the case in other religions, try to translate certain values and credos into built space. Instead, writing could be seen as a replacement for spatial production in Judaism." As in the Kabbalah, Hebrew words and letters have magical powers to create, and Herz uses them as the large scale of the building and as the actual surface of the walls in the sanctuary. The exterior is covered with a ribbed ceramic tile that imparts the sense that the building is engraved, as in the esoteric fourth century *Sefer Yetzirah* or Book of Creation.

OVERLEAF This interior of the Mainz synagogue is like a series of broken shards that have come to life, illustrating the concept of *tikkun* as a kind of cosmic repair. The fragmented triangular forms are luminous, set at different angles to emphasize their individual yet similar characters. In our era, no event has been as catastrophic as the Holocaust for the Jewish people. To build a new synagogue on the site of the ruins of the original one in Germany, to restore a once-decimated Jewish community, is an extraordinary act of optimism and reconciliation, and of *tikkun*.

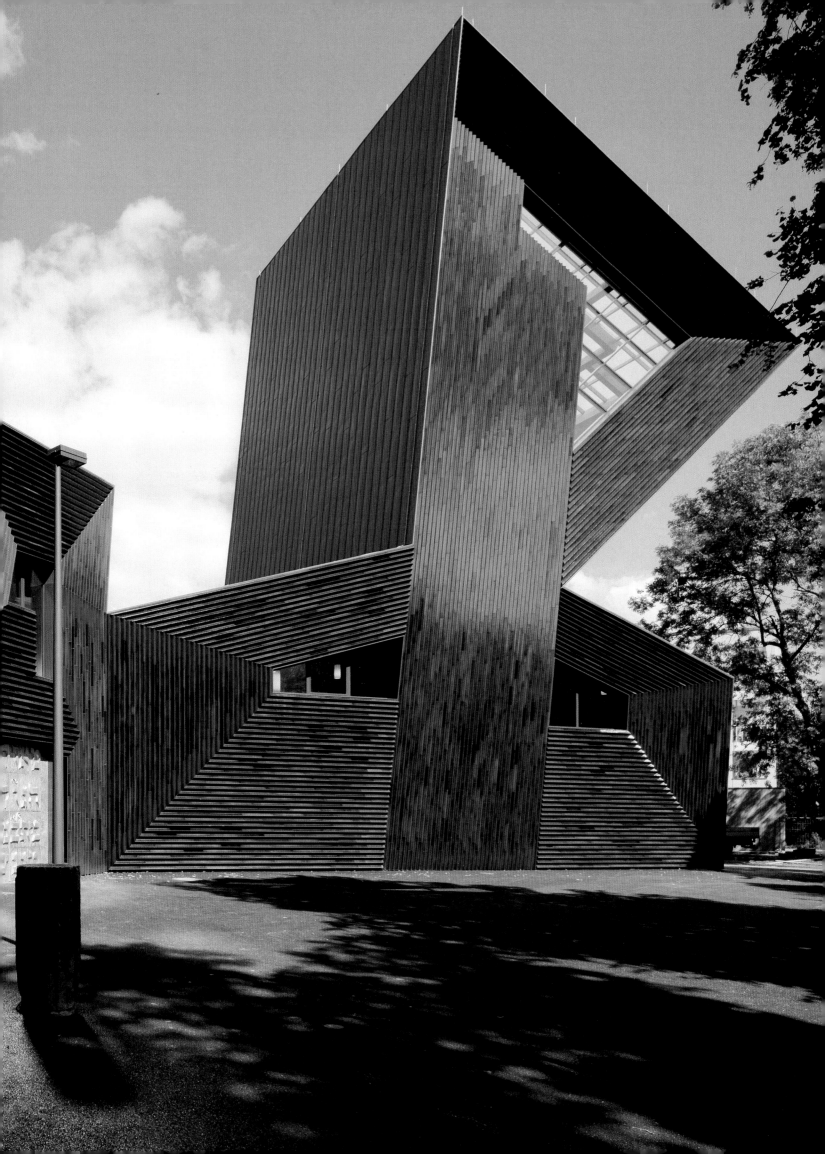

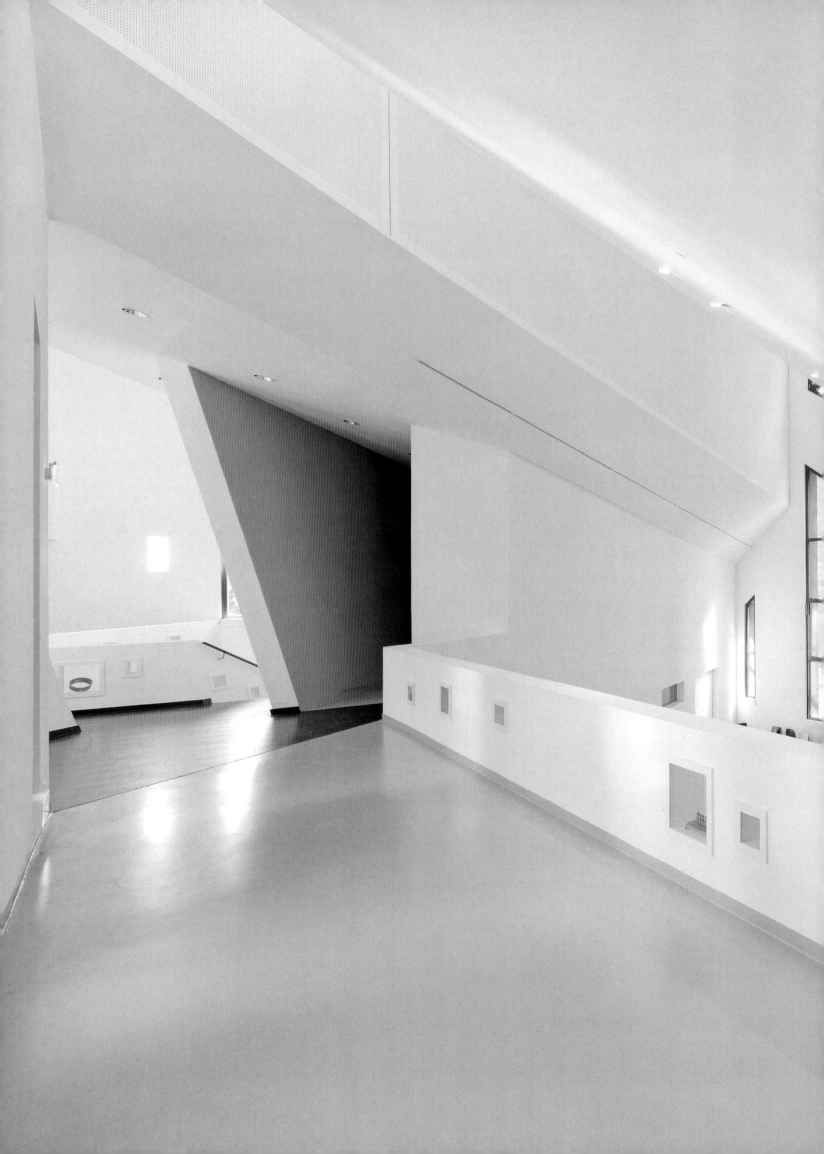

RIGHT This square, concentric interpretation of the *Sefirot* is composed of the first letters of the ten *Sefirot* encircling each other, with *Keter* (crown), on the outside, and *Malkhut* (kingdom) at the center. Resembling a labyrinth, it is from Moses Cordovero's post-humous book, *Pardes Rimonim* (pomegranate orchard), from Cracow, 1592. The pomegranate is a metaphor for the tiers of meaning of the world; within the deceptively simple exterior is a center filled with myriad seeds of interpretation. It derives from the decoration on the two pillars in front of Solomon's Temple, which were carved with pomegranates. As noted before, since the Temple on earth mirrors the Temple above, the pomegranate represents the celestial mysteries hidden within the literal appearance of the world.

BELOW RIGHT The 1967-1974 Hurva Synagogue in Jerusalem by Louis Kahn was meant to replace the original one that was destroyed by the Jordanians after the 1948 War of Israeli Independence. Inspired in part by historical engravings of Solomon's Temple, Kahn proposed a massive cubic volume, surrounded by massive buttresses containing prayer chapels, which were separated by narrow slots of space to let light into the interior. Kahn's plan included a series of nested squares, with seating within the inner zone facing a massive stone ark. Four open-plan columns mark the central space, from which rise four parasol-shaped columns that become the roof of the sanctuary. The concentric plan recalls both the original temple as well as one of the alternate diagrams of the *Sefirot*.

OPPOSITE This computer rendering of the interior of the Hurva Synagogue shows the view from the upper level toward the central space of the sanctuary. Strips of light in the roof are visible where the concrete-parasol roofs do not quite touch each other.

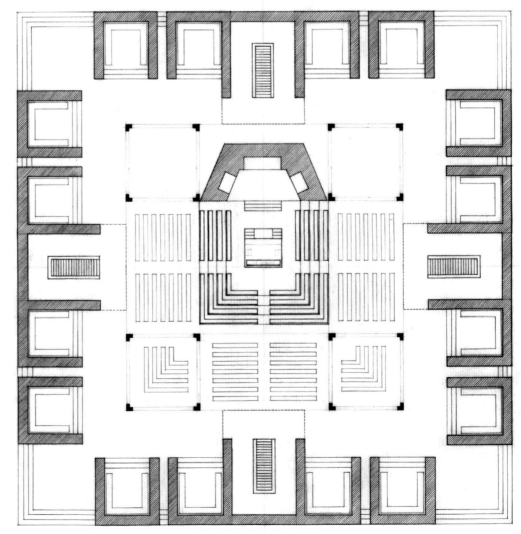

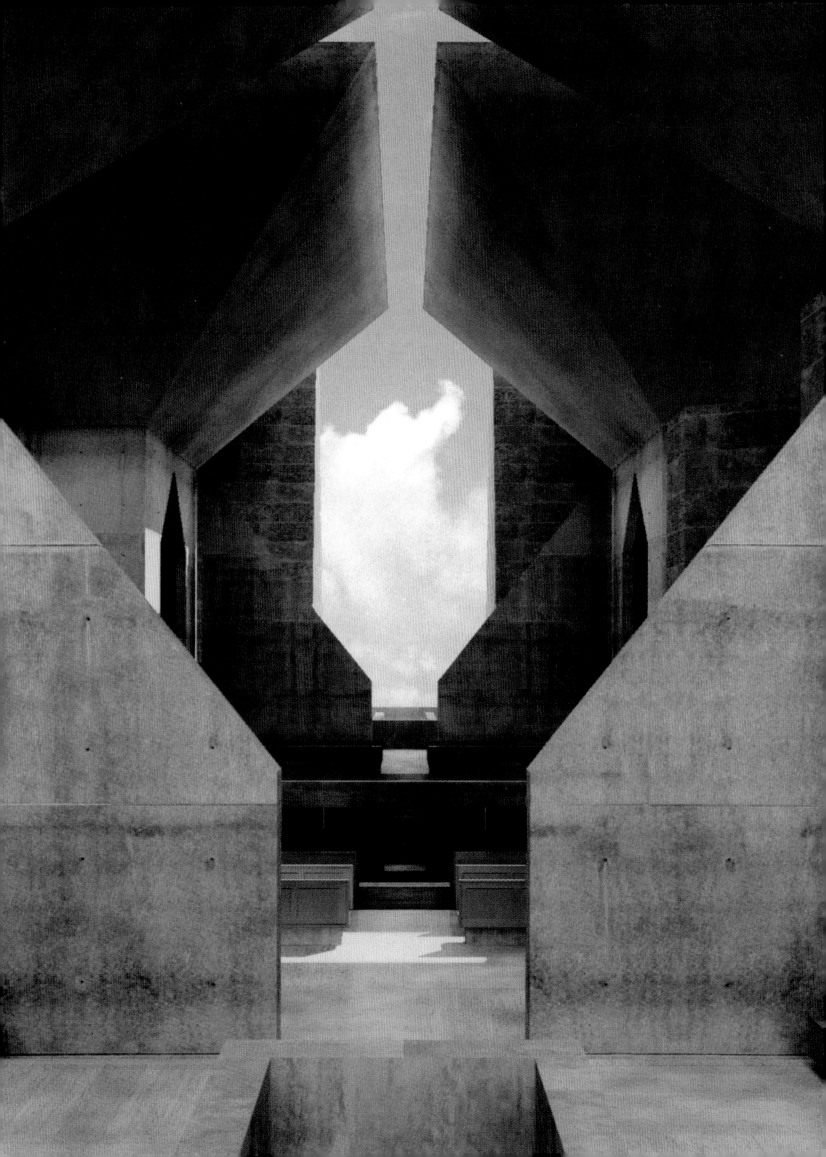

British architectural firm David Chipperfield Architects, with Julian Harrap's 2010 renovation of the Neues Museum in Berlin, has revived a museum that was in ruins for almost 70 years, since it was bombed in World War II. Designed by the Prussian architect Friedrich August Stüler between 1843 and 1859, the neo-classical spaces have been, according to the architectural critic Suzanne Stephens, "conserved, rehabilitated, reconstructed, and remodeled" in a most sensitive manner, exposing the historical record of the building while reimagining its new life. The juxtaposition of old and new creates a poignant reminder of the scars of the past, yet reinvigorates the institution both for the present and the future.

ABOVE During World War II, the entry hall of the Neues Museum was nearly completely destroyed.

OPPOSITE A new stair, in contrasting white concrete, is part of the renovation of the entry hall of the Neues Museum.

OVERLEAF Modern Swiss architect Peter Zumthor's Kolumba Museum, the art house of the Archdiocese of Cologne, Germany, incorporates 2,000 years of occidental architecture within the body of the building. The remains of Roman, Gothic, and Medieval ruins are visible below the museum, which has been raised on 40-foot-high concrete columns to preserve the archeological site. Dappled light enters the area from an open brickwork pattern, with walkways through the site. Religious art from the past 2,000 years is the theme of the Kolumba collection. The idea of elevating the shards of the ruins, repairing the broken fabric of the archeological fragments, and synthesizing them with new galleries is an example of the architecture of *tikkun*.

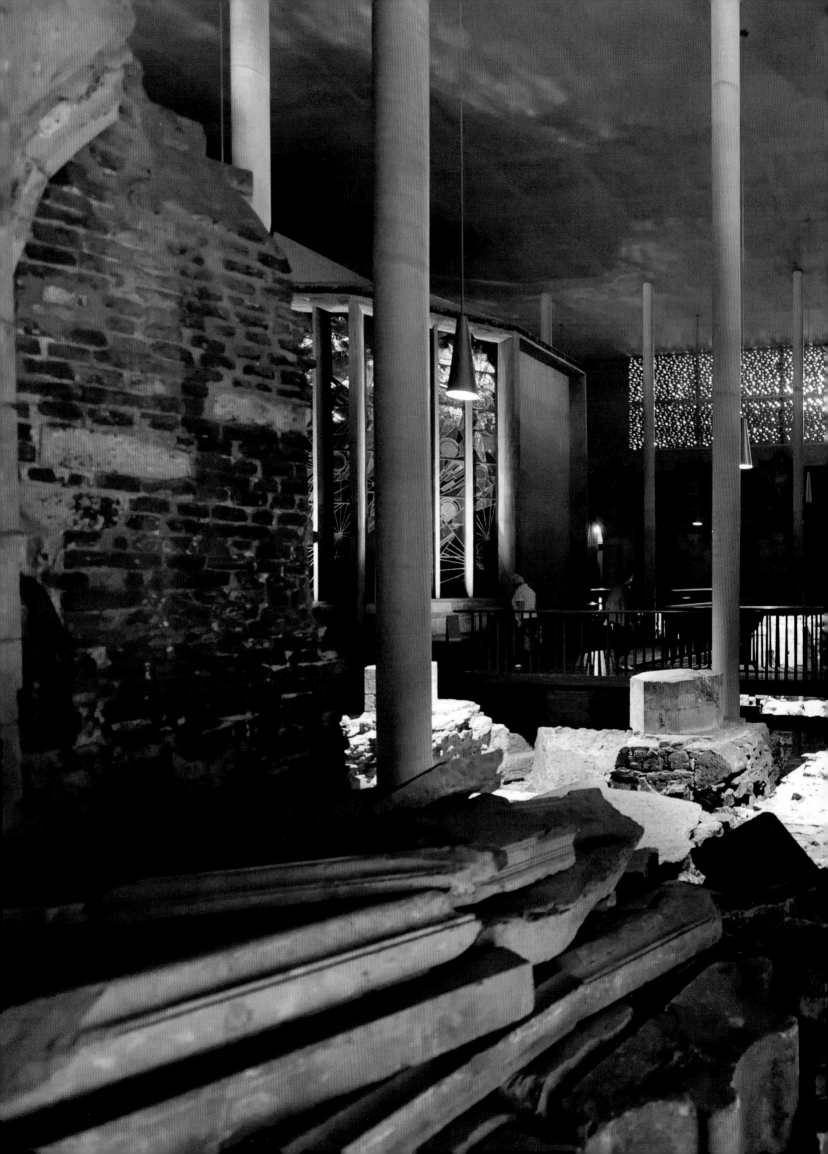

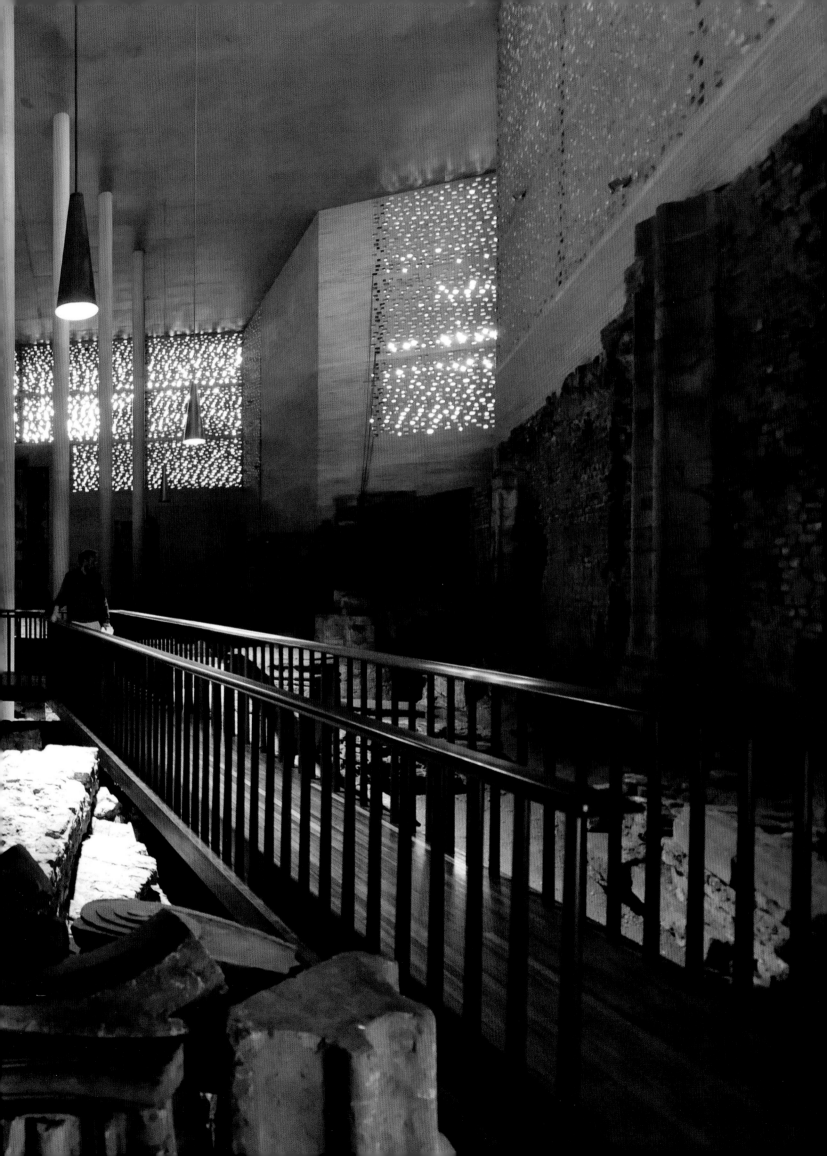

Golem גולם

The idea of mankind acting like God and creating a living being has, throughout history, been a theme in myth and literature. In the Kabbalah, this idea is elaborated as an extension of the power of language and letters to animate lifeless matter. Kabbalah scholar Gershom Scholem defined the Golem succinctly: "The Golem is a creature, particularly a human being, made in an artificial way by virtue of a magic act, through the use of holy names." The word only appears once in the Old Testament, in *Psalms 139:15-16*: "My bone was not hidden from Thee, when I was made in secret. And formed the lowest part of the earth. Thy eyes did see my *Golem*: For in Thy book all things are written: the days also in which they are to be fashioned and for it too there was one of them." In the Talmud, there is a passage that relates how "Rava created a man and sent him to Rabbi Zera. The Rabbi spoke to him but he did not answer." In the *Sefer Yetzirah*, The Book of Creation, of the early third or sixth centuries A.C.E., obscure techniques are described to combine and transpose Hebrew letters with the secret Divine names of God. Medieval Kabbalists referred to these techniques as a means of making a Golem. Actual recipes were described such as that of important Kabbalist Abraham Abulafia: "Afterwards let him take a cup full of pure water and a small spoon, and fill it with dust. He should be acquainted with the weight of all the dust before he begins to stir it, and also with the size of the spoon which serves him to measure. And after he will fill it, he shall pour it in the water, and he will gently blow during his pouring onto the surface of the water. And when he begins to blow on the first spoonful, he should recite loudly a letter of the divine name with one breath, until his spirit will go out, it will be exhausted by his breathing, his face being turned to the earth."

The most famous Golem was ostensibly created by Rabbi Yehuda Loew of Prague in the sixteenth century. In this legend, the Golem is activated by inscribing the Hebrew word *emet*, or truth, on his face. When the first letter, *aleph*, is removed, the word then spells *met*, or death, and the Golem dies. In one version of the story, which became the basis for the 1920 silent horror film *The Golem*, written and directed by Paul Wegener, the Golem is created to save the Jews of the Prague ghetto from being killed. At first he does his job, but then, as with most Golem stories, becomes uncontrollable and must be deactivated.

As the great Yiddish writer, Isaac Bashevis Singer, wrote: "The golem-maker was, essentially, an artist." The artist basically creates something out of nothing, taking raw materials and miraculously creating a world where there was none. Art has been obsessed with the illusion of life—in painting and sculpture in the Pygmalion myth, or in Michelangelo's David, where the artist "saw" the figure in the block of marble before "releasing" him. On the Sistine Chapel, Michelangelo's Adam is brought to life across the gap between God's finger and the hand of the first man.

The Cuban-American sculptor Ana Mendieta reinterpreted the Golem in its feminine form in her 1973-1980 *Silueta Series*. The series involved Mendieta creating female silhouettes made of mud, which appear to be incipiently alive, and conflates the *Shekhinah* and the Golem myths.

In architecture, it would appear to be more difficult to create a Golem, but not surprisingly, the American architect Frank Gehry has succeeded in his building the Dancing House in Prague, completed in 1996, and nicknamed "Fred and Ginger" after the famous American performers Fred Astaire and Ginger Rogers; the two "dancers" are literally frozen together in time. As the Swiss architect Le Corbusier wrote: "Passion creates drama out of inert stone."

OPPOSITE The great painting, *The Creation of Adam* (1508-1512) in the Sistine Chapel in Rome, by the Florentine master Michelangelo Buonarroti, focuses on the gap between God and Adam's outstretched hand that is about to receive the spark of life. Until this point, Adam is a "Golem," a lifeless lump of clay, as described in the *Book of Genesis 2:7*, "and formed of the dust of the earth." Nevertheless, Michelangelo emphasized the similarity of Adam to God, who created man "in his own image, in the image of God created he him, male and female" (*Genesis 1:26*).

OPPOSITE Cuban-American artist Ana Mendieta's work is concerned with the intimate connection between the human body and nature and especially the ancient fertility rites associated with the female form. In her 1976 work the *Tree of Life*, Mendieta is entirely covered with mud, virtually blending into a tree in Iowa. Merging into the earth, Mendieta becomes Eve, the progenitor of human life. She is also, in her inanimate pose, like the Golem, awaiting activation by the word from the divine.

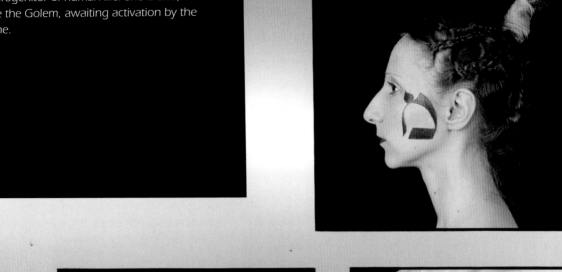

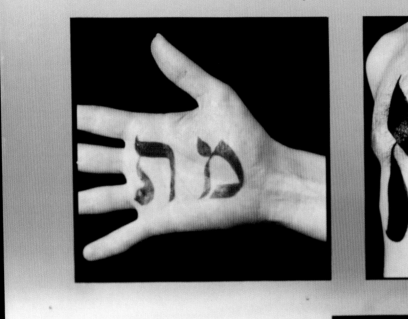

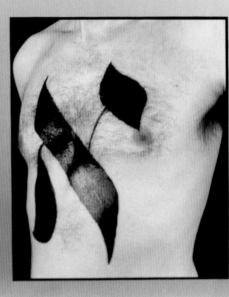

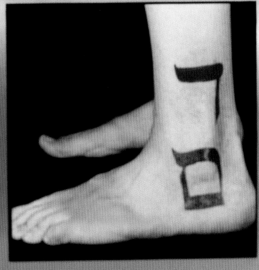

RIGHT Three artists collaborated on the 1987 work entitled *Golem II*—the Russians Rimma Gerlovina and Valeriy Gerlovin, and the American Mark Berghash—for an exhibition at the Jewish Museum in New York in 1988 called *Golem! Danger, Deliverance and Art*. The work consists of color photographic prints of fragments of the human body emblazoned with the Hebrew letters associated with the Golem, which have been mounted on aluminum. Starting with the *aleph* on the chest, the word across the hand spells out *emet*, meaning truth, and is supposed to activate the creature. But the removal of the initial *aleph* spells *met*, or death, to deactivate it. The acrostic on the ankle and foot spells either *adam*, which refers to both earth and the first man, or without the *aleph*, reads *dam*, meaning blood. This work symbolizes the magical power of Hebrew letters and words to both create life and take it away.

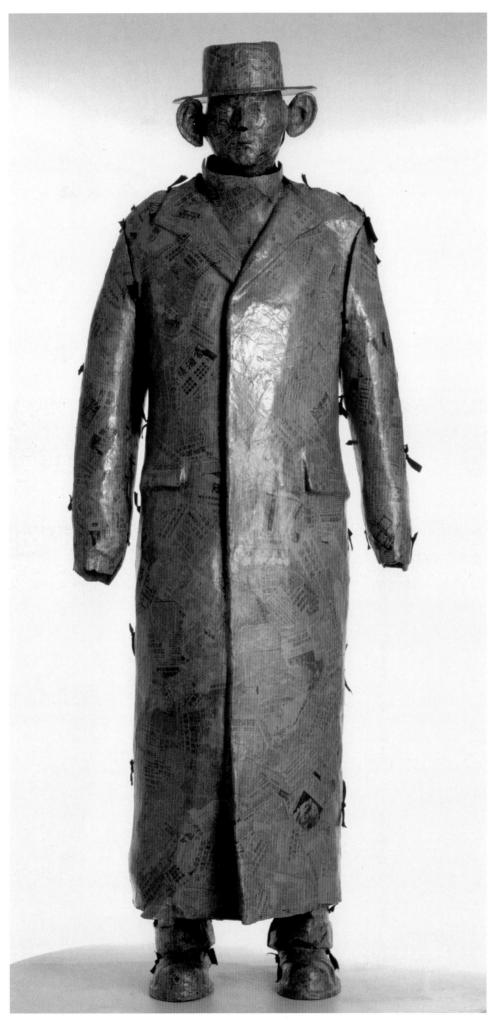

LEFT American artist Robert Wilson and German costume designer Moidele Bickel created the Golem with Chinese and Japanese newspapers for Wilson's 1987 performance of *Death, Destruction, and Detroit II* at the Schaubühne in Berlin, Germany. Another character in the play, dressed as a rabbi, cut open the Golem's costume to reveal an actor wearing the black clothes that are traditional for Eastern European Jews. In this way, the Golem represents the mystery of the conception of human life from dust and the magical nature of creation in art and life.

The German director Paul Wegener's 1920 film *The Golem* tells the story of the artificial being created by Rabbi Loew in Prague, in the Czech Republic, to defend the Jewish ghetto against the malevolent intentions of corrupt city officials. The Golem is an ancient legend that attributes the power to create life from the magical incantations of Hebrew letters and words. In the film, the Golem fulfills his mission but then runs amok, endangering the town, so Rabbi Loew must deactivate him to save the Jews from their initial savior.

OPPOSITE At the end of *The Golem*, a young girl offers the Golem an apple as a token of friendship. After causing havoc in the town, he picks her up in a moment of weakness, and then beauty kills the beast. She innocently grabs what appears to her to be a button on his chest and detaches it, causing him to return to his inanimate state, thus saving the town.

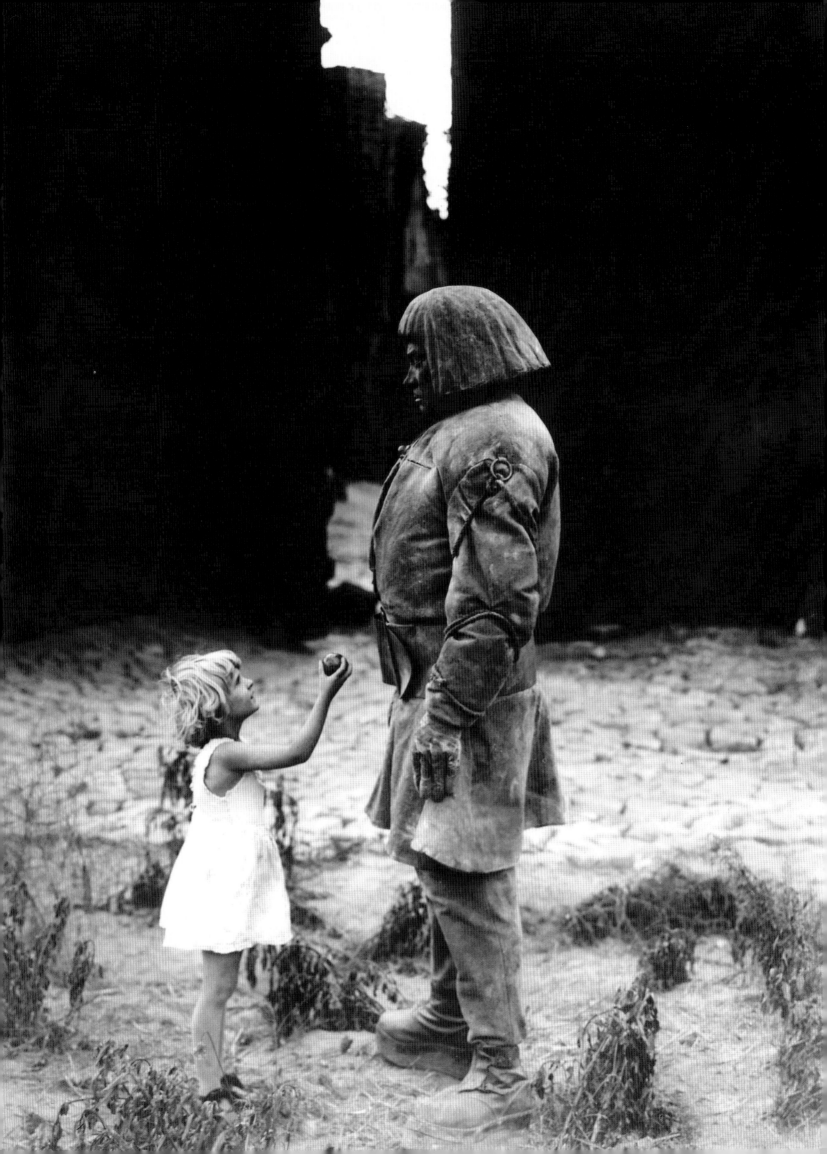

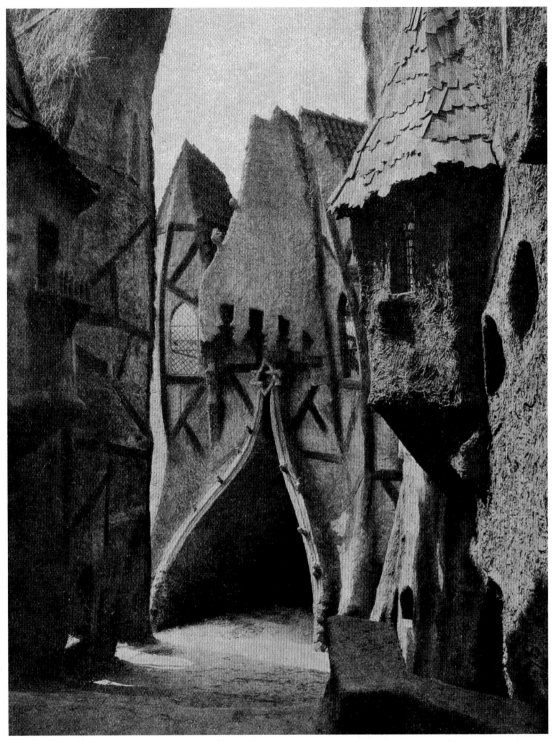

In 1920, German architect Hans Poelzig created an entire town of 54 houses made of reinforced plaster on the Tempelhof Airport field in Berlin. The architecture of the "town" was an Expressionist vision of Gothic mud huts, with curving walls and drooping rooflines that exude a strange and exotic atmosphere. In Poelzig's fantasy of an Eastern European shtetl, the buildings are made of the same clay from which the Golem himself is sculpted. This brilliant invention intimately connects the town with the inanimate material that Rabbi Loew's magic conjures into a living man, who must save the Jews from the threatened pogrom. "It is not Prague that my friend, the architect Poelzig, has erected. Rather it is a poem of a city, a dream, an architectural paraphrase of the Golem theme. These alleys and squares should not call to mind anything real; they should create the atmosphere in which the golem breathes," according to Paul Wegener, the director of the film *The Golem*.

THESE PAGES AND OVERLEAF

The houses in the film *The Golem* are halfway between living creatures and shelters for the Jews in the ghetto. They appear, like the Golem, to be on the verge of becoming animated themselves. The sets perhaps unintentionally also express the lack of an authentic architectural style for the Jewish religion. Jews were either confined to ghettos, or were poor and, unable to develop their own architecture, were often expelled or massacred over the centuries since the destruction of the Second Temple, by the Romans, in 70 A.C.E.

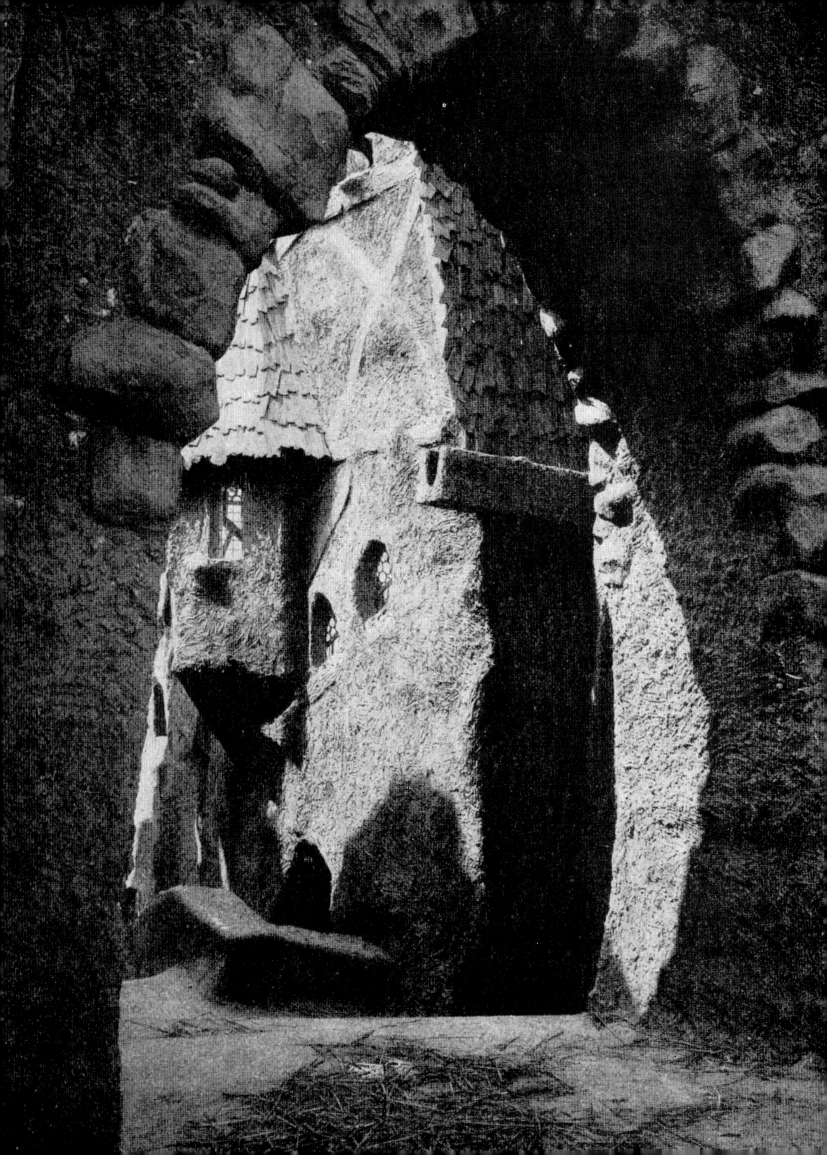

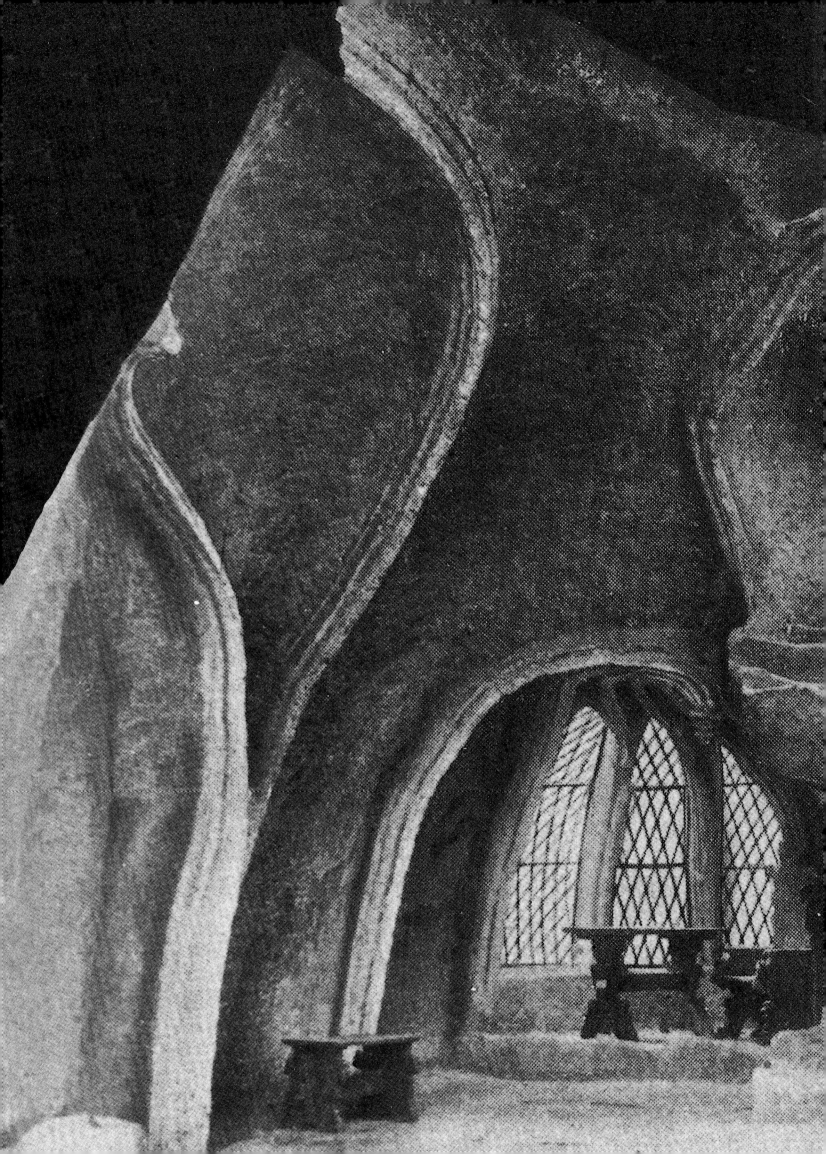

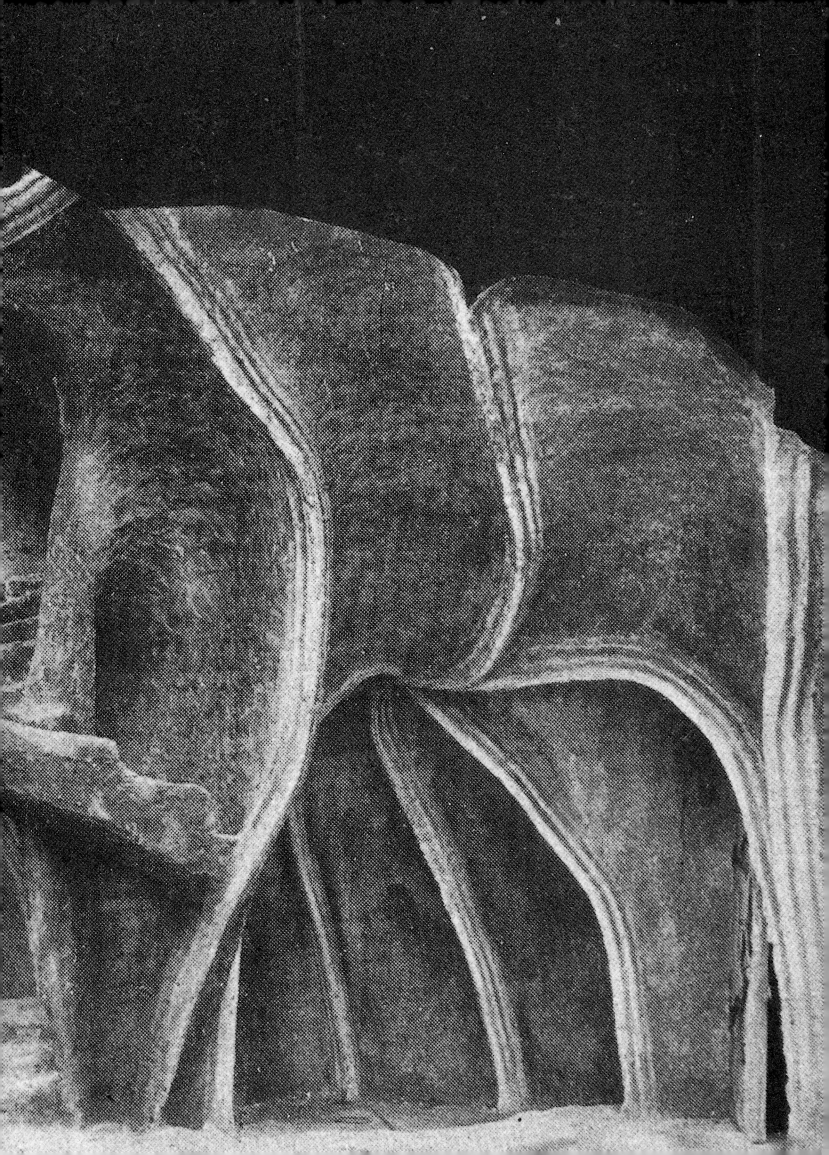

ABOVE The series of three drawings that date from 1995, by the American architect John Hejduk, are of imaginary houses or towers that appear to be alive and walking on truss-like legs. Each tower is like an animated character with different patterns on its surface. One, in a maroon red color, is tall, with diagonal stripes and a vine-like pattern. Another is black with curving yellow stripes, and attached conical protrusions. A third is a green pyramid with smaller pyramidal-shaped arms. And the last one is blue, purple, and ochre. They march and prance and follow each other around like people in a circus troop. Of course, architecture that is alive is part of the Golem "family" of matter, where a spark electrifies lifeless wood and steel into robots with minds of their own.

OPPOSITE Dancing House is the nickname given to this 1996 office building in Prague, in the Czech Republic, designed by the American architect Frank Gehry. For the Nationale-Nederlanden building, the façade along the Vltava River was divided into the appearance of two towers, one a solid cylinder with offset windows, or Fred, and the other, an expressive glass structure that appears to lean into the neighboring tower, or Ginger. Together, Fred and Ginger, named after the famous dancing couple Fred Astaire and Ginger Rogers, are an animated pair that recalls the very Czech idea of the Golem, a creature brought to life by magical means. The shapes of the towers are similar in fact to the curving forms of the village designed by Hans Poelzig for the 1920 movie The Golem, which was also set in Prague.

Anselm Kiefer

Anselm Kiefer is a contemporary German artist who has explicitly acknowledged the Kabbalah as an inspiration for his work. He has said: "In the mid-1980s, I went to Jerusalem and began to read the books of Gershom Scholem. Beside the fact that Kabbalistic stories and interpretations are very interesting, I think my attraction has something to do with the way that I work." Kiefer was initially known for his grim commentary on the post-World War II period in Germany, flagrantly outing the suppressed guilty memories of the Nazi period. For more than the past twenty years, he has overlaid and paralleled these themes, relentlessly using Kabbalistic words and concepts to create a deeply unsettling nether world of religion and art.

Like French artist Marcel Duchamp, there is a certain irony and dislocation between the title and the content. Kiefer's *Seven Heavenly Palaces, Merkabah* are seven towers of ribbed, concrete slabs, precariously built in an aircraft hangar in Milan, Italy, on the plan of the *Sefirot*. Rather than crystalline, palatial constructions, they are narrow, tall, and uninhabitable. In 2000, in the Chapelle de la Salpêtrière in Paris, Kiefer hung six large lead paintings in the chapel's arches, entitled *Shevirat Ha-Kelim*, or *Breaking of the Vessels*, with ceramic pots attached in the pattern of the *Sefirot*, some of which were broken. Certainly hell, not heaven, has been a more conspicuous condition of our time. While God was apparently absent during the Holocaust, the faithful nevertheless believe in His ultimate mystery. Kiefer brings the German and Jewish experiences together in a completely unexpected and disturbing way, for the religious. Perhaps calling his expression blasphemy would be an understatement. Of course, art is the contemporary religion and Kiefer's rendition of the *Shekhinah* as a wedding dress, with embedded glass shards and a sculpture of the *Sefirot* growing out of it, is a moving experience.

The artist's recent exhibition in 2010–2011, at the Gagosian Gallery in New York, entitled *Next Year in Jerusalem*, is a grating play on the promise at the end of each Passover seder. During the Holocaust, there was no next year for the six million Jews who were murdered. Kiefer paints the Hebrew titles on the glass vitrines—*shekhinah, tikkun die sefiroth*—that turn the traditional meaning of these words inside out. A ruined fuselage of a fighter plane, perhaps a Messerschmitt, is ironically entitled *Merkaba*. Kiefer has said "I have been dealing with Isaac Luria's *Tzimtzum* for 20 years. This is a very abstract process, an intellectually stimulating and intensive process: the idea of a retraction, from which something is created." The artist has enlisted contemporary interpreters of the Kabbalah, such as Harold Bloom and Melinda Davis, to advise him, establishing the Kabbalah as instrumental in the creation of his art. These evocative themes comment on the contemporary condition of mankind, which is suspended between faith and disbelief. Kiefer explained: "I have always been fascinated by Jewish mysticism. All letters in the alphabet are considered holy. No matter how arbitrarily we line them up, the letters come from God, and always formulate a meaning—even if it is only revealed thousands of years later."

OPPOSITE Included in the 2011 exhibition *Next Year in Jerusalem* at the Gagosian Gallery in New York, the 2010 sculpture in a large glass case, entitled *Sefiroth*, is of a plaster cast of a wedding dress penetrated by broken glass shards, out of which emerges, in the place of a head, a diagram with the enumerated discs of the *Sefirot*. This striking image combines the theme of the *Shekhinah*, the female aspect of God, in her location exactly at the bottom of the tree of the *Sefirot*. Kiefer included the shards of the broken vessels to further dramatize the connection between these Kabbalistic concepts that were here made absolutely explicit.

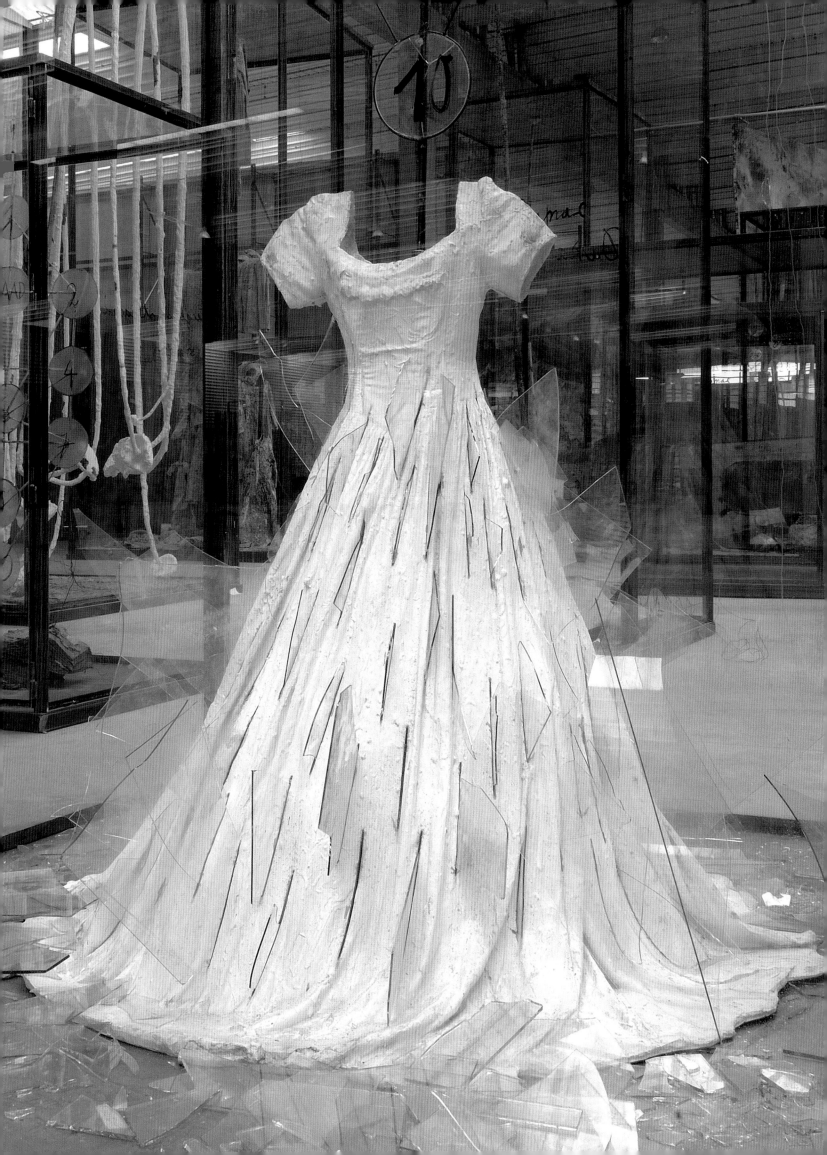

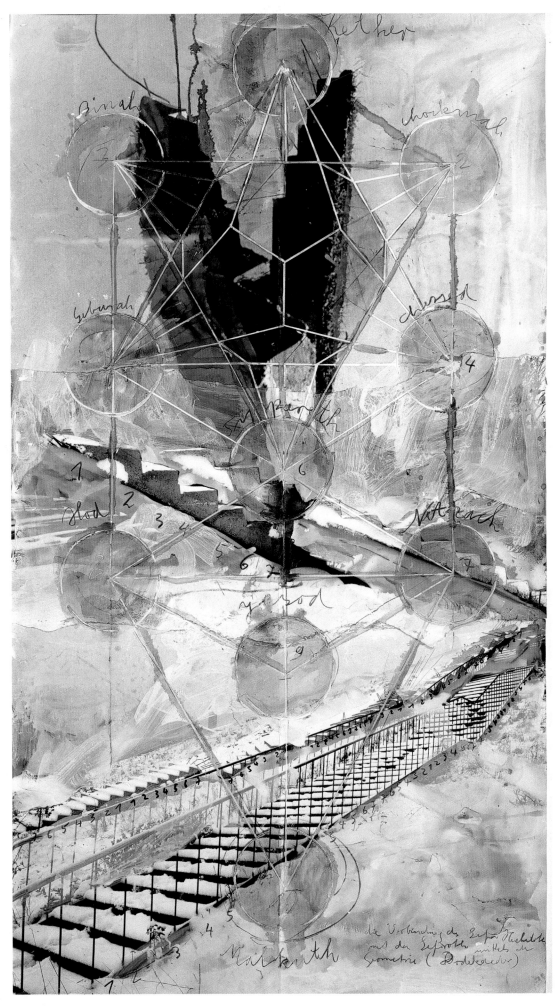

LEFT German artist Anselm Kiefer's 2002 painting *Sefiroth* presents the diagram of the emanations, with the Hebrew words for each *Sefirah* superimposed over an apparently snowy scene of ascending stairways. The handwritten inscription at the lower right reads: "connection between the *Sefer Hechaloth*, or the Book of the Heavenly Palaces, and the *Sefiroth* through the geometry of the Dodecahedron." This is the artist's explanation of the relationship between these two mystical concepts. Mysticism by definition must remain mysterious, so Kiefer's painting is a puzzle without a solution.

OPPOSITE Kiefer's 2002 *Merkaba* continues the artist's interest in Kabbalistic titles that contrast with the actual visual content of the image. Here, a photograph of fragments of concrete stairs at his vast studio in Barjac, France, has been painted over and collaged with strips of lead. On top, the word *Merkaba*, or the mystical throne-chariot of God, is written in paint. The faded grey image is as grim as can be, the opposite of the gleaming celestial chariot. On another level, in the Kabbalah, there are four ascending worlds and levels of interpretation—so that, like the Messiah, who has been predicted to arrive on a lowly donkey, the transcendent meaning may be hiding in plain sight.

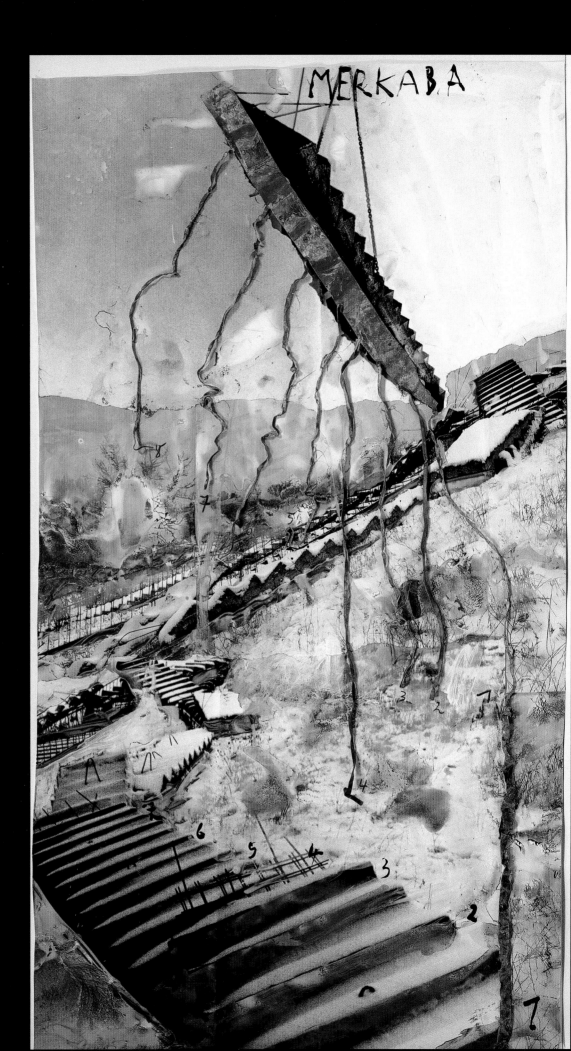

OPPOSITE From 1993 to 2002 in Barjac, France, Kiefer turned La Ribotte, an old silkworm nursery near Barjak, into a vast installation of his worldview, intertwining towers, fragments of sculpture, stepped pyramidal constructions, and underground connecting tunnels. In the cavernous excavation, fragments of the clay pots from the 2000 Kabbalistic series *Sh'virat Ha-Kelim*, or Breaking of the Vessels, have fallen in the twilight darkness of this silent place.

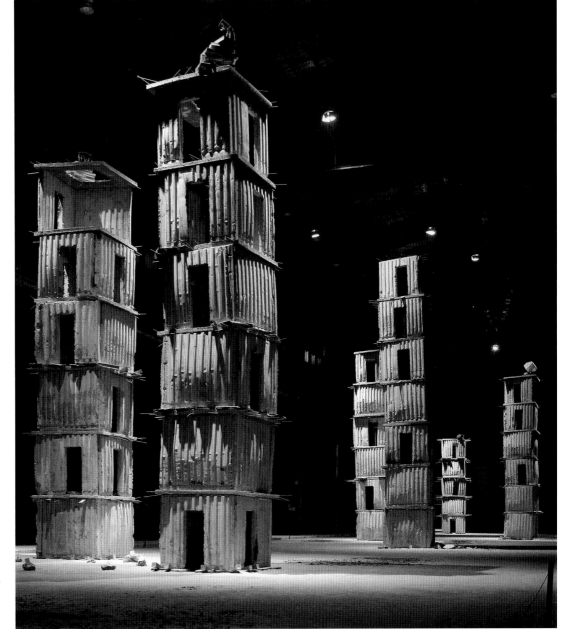

ABOVE The *Seven Heavenly Palaces* were a 2004 site-specific installation in the Bicocca Hangar in Milan, Italy, of seven concrete and lead towers. The title is based on the *Book of Hechalot*, or Heavenly Palaces of pre-Kabbalistic lore. The structures were set on a plan of seven of the lower ten *Sefirot*. There is nothing heavenly about these towers. The ironic title seems to mock the precarious state of construction, and the towers recall the ruins of post-war Germany of Kiefer's childhood. Between the reality of the built towers and the evocation of the mystical title, the *Seven Heavenly Palaces* are an evocation of the ancient past into the present.

Arbel, Vita Daphna. *Beholders of Divine Secrets: Mysticism and Myth in the Hekhalot and Merkavah Literature.* New York: State University of New York Press, 2003.

Ashton, Dore. *About Rothko.* Cambridge: Da Capo Press, 2003.

Auping, Michael, ed. *Anselm Kiefer: Heaven and Earth.* Fort Worth: Modern Art Museum of Fort Worth, 2005.

Battistini, Matilde. *Astrology, Magic, and Alchemy in Art.* Trans. Rosanna M. Giammanco Frongia. Los Angeles: The J. Paul Getty Museum, 2007.

Benson, Timothy O. *Expressionist Utopias.* Los Angeles: University of California Press, 2001.

Biale, David. *Gershom Scholem: Kabbalah and Counter-History.* 2nd ed. Cambridge: Harvard University Press, 1982.

Bilski, Emily D. *Golem! Danger, Deliverance, and Art.* New York: The Jewish Museum, 1988.

Bletter, Rosemarie Haag. "The Interpretation of the Glass Dream—Expressionist Architecture and the History of the Crystal Metaphor." *Journal of the Society of Architectural Historians* 40.1 (1981), 20-43.

Bletter, Rosemarie Haag. "Paul Scheerbart's Architectural Fantasies." *Journal of the Society of Architectural Historians* 34.2 (1975), 83-97.

Bloom, Harold. *Kabbalah and Criticism.* New York: Continuum, 1993.

Borges, Jorge Luis. *Collected Fictions.* Trans. Andrew Hurley. New York: Penguin Books, 1998.

Britton, Karla Cavarra, ed. *Constructing the Ineffable: Contemporary Sacred Architecture.* New Haven: Yale University Press, 2011.

Celant, Germano, ed. *Anselm Kiefer.* Milan, Italy: Skira, 2007.

Clearwater, Bonnie. *The Rothko Book.* London: Tate, 2006.

Conrads, Ulrich, ed. *Programs and manifestoes on 20th-century architecture.* Trans. Michael Bullock. Massachusetts: The MIT Press, 1970.

Curl, James Stevens. *The Art and Architecture of Freemasonry.* Woodstock: The Overlook Press, 1993.

Dan, Joseph, ed. *The Heart and the Fountain: An Anthology of Jewish Mystical Experiences.* New York: Oxford University Press, USA, 2003.

———. *Kabbalah: A Very Short Introduction.* New York: Oxford University Press, 2007.

Diserens, Corinne, ed. *Gordon Matta-Clark.* New York: Phaidon Press, 2003.

Elior, Rachel. *Jewish Mysticism: The Infinite Expression of Freedom.* Trans. Yudith Nave and Arthur B. Millman. Portland: The Littman Library of Jewish Civilization, 2007.

———. *The Three Temples: On the Emergence of Jewish Mysticism.* Trans. David Louvish and Batya Stein. Portland, Oregon: The Littman Library of Jewish Civilization, 2004.

Fine, Lawrence. *Physician of the Soul, Healer of the Cosmos: Isaac Luria and His Kabbalistic Fellowship.* Stanford: Stanford University Press, 2003.

Frampton, Kenneth. *Modern Architecture: A Critical History.* New York: Oxford University Press, 1980.

Franck, Adolphe. *The Kabbalah or The Religious Philosophy of the Hebrews.* Trans. I. Sossnitz. 1926. BiblioBazaar, 2008.

Gerson, Felix N. *Rembrandt, the Jews and the Bible.* Trans. Franz Landsberger. Philadelphia: The Jewish Publication Society of America, 1961.

Gikatilla, Rabbi Joseph. *Sha'are Orah: Gates of Light.* Trans. Avi Weinstein. Eds. Kerry Brown and Sima Sharma. 1248. San Francisco: HarperCollins Publishers, 1994.

Godfrey, Mark. *Abstraction and the Holocaust.* New Haven: Yale University Press, 2007.

Graafland, Arie. *Architectural Bodies.* Ed. Michael Speaks. Rotterdam: 010 Publishers, 1996.

Green, Arthur. *Keter: The Crown of God in Early Jewish Mysticism.* New Jersey: Princeton University Press, 1997.

———. *A Guide to the Zohar.* Stanford: Stanford University Press, 2004.

Grözinger, Karl Erich. *Kafka and Kabbalah.* Trans. Susan Hecker Ray. New York: Continuum, 1994.

Halevi, Z'ev ben Shimon. *Kabbalah: Tradition of Hidden Knowledge.* London: Thames & Hudson, 1979.

Idel, Moshe. *Absorbing Perfections: Kabbalah and Interpretation.* New Haven: Yale University Press, 2002.

———. *Ascensions on High in Jewish Mysticism: Pillars, Lines, Ladders.* Budapest: Central European University Press, 2005.

———. *Golem: Jewish Magical and Mystical Traditions on the Artificial Anthropoid.* Albany: State University of New York Press, 1990.

———. *Kabbalah: New Perspectives.* New Haven: Yale University Press, 1988.

Jewish Museum. *Recent American Synagogue Architecture.* Ann Arbor: The University of Michigan, 1963.

Jung, Carl G. *Man and His Symbols.* New York: Laurel Edition, Dell Publishing, 1964.

Kafka, Franz. *The Complete Stories.* Ed. Nahum N. Glatzer. New York: Schocken Books, 1971.

Kahn, Louis. *Louis Kahn: Essential Texts.* Ed. Robert Twombly. New York: W.W. Norton & Co., 2003.

Kandinsky, Wassily. *Concerning the Spiritual in Art.* Trans. Michael T.H. Sadler. New York: Dover Publications, 1977.

Kaplan, Aryeh. *Sefer Yetzirah: The Book of Creation.* Boston: WeiserBooks, 1997.

———. *The Bahir: Illumination.* Boston: WeiserBooks, 1998.

Klein, Minca C. & H. Arthur Klein. *Temple Beyond Time: The Story of the Site of Solomon's Temple at Jerusalem.* New York: Van Nostrand Reinhold, 1970.

Landau, Ellen, ed. *Reading Abstract Expressionism, Context and Critique.* New Haven and London: Yale University Press, 2005.

Landsberger, Franz. *Rembrandt, the Jews and the Bible.* Trans. Felix N. Gerson. 1946. Philadelphia: The Jewish Publication Society of America, 1942.

Lethaby, William R. *Architecture, Mysticism and Myth.* 1891. New York: George Braziller, 1975.

Levy, Mark. *Void In Art.* Bramble Books, 2006.

Liddell, Samuel and Macgregor Mathers. *Kabbala Denudata.* 1912. New York: The Theosophical Publishing Company of New York, 2012.

Los Angeles County Museum of Art. *The Spiritual in Art: Abstract Painting 1890-1985.* New York: Abbeville, 1986.

Lundquist, John M. *The Temple: Meeting Place Between Heaven and Earth.* London: Thames & Hudson, 1993.

MacNulty, W. Kirk. *Freemasonry: A Journey through Ritual and Symbol.* London: Thames & Hudson, 1991.

Mann, Vivian B., Ed. *Jewish Texts on the Visual Arts.* Cambridge University Press, 2000.

Matt, Daniel. *The Essential Kabbalah: The Heart of Jewish Mysticism.* New York: HarperCollins, 1995.

McCarter, Robert. *Louis I. Kahn.* New York: Phaidon, 2006.

McDonough, Michael, ed. *Malaparte: A House Like Me.* New York: Verve Press, 1999.

Mies van der Rohe Foundation. *Mies van der Rohe Award 2011: European Union Prize for Contemporary Architecture.* Barcelona: Actar, 2012.

Ouaknin, Marc-Alain. *Mysteries of the Kabbalah.* Trans. Josephine Bacon. New York: Abbeville Press, 2000.

Otto, Rudolf. *The Idea of the Holy.* Trans. John W. Harvey. New York: Oxford University Press, 1959.

Ponce, Charles. *Kabbalah.* San Francisco: Quest Books, 1983.

Plummer, Henry. *The Architecture of Natural Light.* London: Monacelli Press, Thames & Hudson, 2009.

Reuchlin, Johann. *On the Art of the Kabbalah: De Arte Cabalistica.* Trans. Martin and Sarah Goodman. 1516. Nebraska: University of Nebraska Press, 1993.

Rosenfeld, Gavriel D. *Building After Auschwitz: Jewish Architecture and the Memory of the Holocaust.* New Haven: Yale University Press, 2011.

Rykwert, Joseph. *On Adam's House in Paradise.* New York: The Museum of Modern Art, 1972.

Sachs, Angeli and Edward van Voolen, eds. *Jewish Identity in Contemporary Architecture.* Munich: Prestel, 2004.

Samuel, Gabriella. *The Kabbalah Handbook.* New York: Penguin Group, 2007.

Scheerbart, Paul. *The Gray Cloth.* Trans. John A. Stuart. Cambridge: The MIT Press, 2001.

Scholem, Gershom, ed. *The Correspondence of Walter Benjamin and Gershom Scholem 1932-1940.* Cambridge, Harvard University Press, 1992.

Scholem, Gershom. *Kabbalah.* New York: A Meridian Book, 1978.

———. *Alchemy and Kabbalah.* Trans. Klaus Ottmann. 1977. Putnam: Spring Publications, 2006.

———. *Major Trends in Jewish Mysticism.* New York: Schocken Books, 1995.

———. *On the Kabbalah and its Symbolism.* Trans. Ralph Manheim. New York: Schocken Books, 1969.

———. *On the Mystical Shape of the Godhead.* Trans. Joachim Neugroschel. New York: Schocken Books, 1991.

———. *On the Possibility of Jewish Mysticism in Our Time & Other Essays.* Ed. Avraham Shapira. Trans. Jonathan Chipman. Philadelphia: The Jewish Publication Society, 1997.

———. *Origins of the Kabbalah.* Trans. Allan Arkush. New Jersey: Princeton University Press, 1990.

———. *Walter Benjamin: The Story of a Friendship.* Trans. Harry Zohn. New York: The New York Review of Books, 1981.

Schwarzer, Mitchell, Connie Wolf, and James E. Young. *Daniel Libeskind and the Contemporary Jewish Museum: New Jewish Architecture from Berlin to San Francisco.* New York: Rizzoli, 2008.

Schwarzer, Mitchell. "The Architecture of Talmud." *Journal of the Society of Architectural Historians.* 60.4 (2001): 474–487.

Sherwin, Byron L. *Kabbalah: An Introduction to Jewish Mysticism.* Lanham, Maryland: Rowman & Littlefield Publishers, 2006.

Spector, Sheila A. *"Wonders Divine:" The Development of Blake's Kabbalistic Myth.* Lewisburg: Bucknell University Press, 2001.

Steinsaltz, Adin. *The Thirteen-Petalled Rose: A Discourse on the Essence of Jewish Existence and Belief.* Trans. Yehuda Hanegbi. New York: Basic Books, 2006.

Steinsaltz, Adin. *The Essential Talmud.* Trans. Chaya Galai. New York: Basic Books, 2006.

Taut, Bruno. *Die Stadtkrone.* Berlin: Gebr. Mann Verlag, Berlin, 2002.

Taut, Bruno and his circle. *The Crystal Chain Letters.* Ed. and Trans. by Iain Boyd Whyte. Massachusetts Institute of Technology, 1985.

Taylor, Mark C. *Disfiguring: Art, Architecture, Religion.* Chicago: University of Chicago Press, 1992.

Tigerman, Stanley. *The Architecture of Exile.* New York: Rizzoli, 1988.

Townley, Kevin. *The Cube of Space: Container of Creation.* Colorado: Archive Press, 1993.

Trachtenberg, Joshua. *Jewish Magic and Superstition: A Study in Folk Religion.* Kentucky: Forgotten Books, 2008.

Varnedoe, Kirk. *Pictures of Nothing: Abstract Art Since Pollock.* New Jersey: Princeton University Press, 2006.

Vital, Chayim. *The Tree of Life: The Palace of Adam Kadmon.* Trans. Donald Wilder Menzi and Zwe Padeh. New York: Arizal Publications Inc., 2008.

Wingate, Ealan, ed. *Anselm Kiefer: Merkaba.* New York: Gagosian Gallery, 2002.

Wolfson, Elliot R. *Through a Speculum That Shines: Vision and Imagination in Medieval Jewish Mysticism.* New Jersey: Princeton University Press, 1994.

Young, James E. *The Texture of Memory: Holocaust Memorials and Meaning.* New Haven and London: Yale University Press, 1993.

RELIGIOUS TEXTS:

Ezekiel. Trans. Rabbi Dr. S. Fisch. London: The Soncino Press, 1950.

The Five Books of Moses. Trans. Everett Fox. New York: Schocken Books, 1983.

The King James Bible. National Publishing Company: 1978.

The Zohar. Trans. and commentary Daniel C. Matt. Pritzker Edition. 6 vols. Stanford: Stanford University Press, 2004.

PHOTOGRAPHY CREDITS
Every effort has been made to locate the holders of copyright; any omissions will be corrected in future printings.

Cover: © Yayoi Kusama Studio, Inc / Courtesy Gagosian Gallery; Endpapers: Raymond Meier / Trunk Archive; Opposite half title: © Hans Sautter; 1: Stockbyte /Getty Images; 2: © Sigmar Polke / Grossmünster Zürich (Photo Lorenz Ehrismann) ; 4: The Art Archive / British Museum / Eileen Tweedy; 7, 9, 11: Courtesy Alexander Gorlin Architects ; 12-13, 14, 16-17: Photo by Durston Saylor / Courtesy Alexander Gorlin Architects; 19: Erich Lessing / Art Resource, NY; 20: The Art Archive / British Library; 21: Heidelberg University; 22-23: Courtesy of the Pitts Theology Library, Candler School of Theology, Emory University; 24, top: The Burke Library at Union Theological Seminary, Columbia University Libraries ; 24, bottom: Courtesy of the Pitts Theology Library, Candler School of Theology, Emory University; 25: Klassik Stiftung Weimar, Herzogin Anna Amalia Bibliothek; 26: Public Domain; 27: The Burke Library at Union Theological Seminary, Columbia University Libraries; 28-29: Courtesy of the Pitts Theology Library, Candler School of Theology, Emory University; 30: © The Jewish National and University Library & The Hebrew University of Jerusalem; 31: The Burke Library at Union Theological Seminary, Columbia University Libraries; 33: Scala / Art Resource, NY; 34, top: Courtesy of the Pitts Theology Library, Candler School of Theology, Emory University; 34, bottom: Courtesy of the Richard C. Kessler Reformation Collection, Pitts Theology Library, Candler School of Theology, Emory University; 35, 36: The Burke Library at Union Theological Seminary, Columbia University Libraries; 37: © Yayoi Kusama Studio, Inc. / Image courtesy of the artist and Roslyn Oxley9 Gallery, Sydney; 38-39: © Roberto Schezen / ESTO; 40: Alexander Kuznetsov / Arnoldsche Art Publishers, Stuttgart; 41: Courtesy of the Richard C. Kessler Reformation Collection, Pitts Theology Library, Candler School of Theology, Emory University; 42-43: © RMN-Grand Palais / Art Resource, NY; 45, 46: © 2012 The Barnett Newman Foundation, New York / Artists Rights Society (ARS), NY; 47: Photograph by Jonathan Perlstein; 48-49: Photo by Balthazar Korab; Courtesy The Library of Congress; 50, 51: © Timothy Hursley; 52-53: Courtesy of the artist, Amie Siegel; 54, 55, 56-57: © Hélène Binet; 58: Kent Larson; 59: © Jeff Goldberg / Esto; 60: © Tim Griffith / Esto; 61: © Hiroshi Sugimoto, courtesy Fraenkel Gallery, San Francisco and Pace Gallery, New York; 62: © Hiroshi Sugimoto, courtesy Pace Gallery; 63: ©2010 Robert Vizzini, Exchange Place View #1; 64, 65: © 2012 Estate of Gordon Matta-Clark / Artists Rights Society (ARS), NY; Courtesy The Estate of Gordon Matta-Clark and David Zwirner, New York/London; 66: © 2012 Artists Rights Society (ARS), New York / SIAE, Rome; 67: Tate, London / Art Resource, NY; 68: © 2012 The Barnett Newman Foundation, New York / Artists Rights Society (ARS), NY; 69: Copyright Lee Bontecou; 70: © SDL; 71: © BitterBredt, Courtesy Studio Daniel Libeskind; 72: © Chul Hyun Ahn / Courtesy of C. Grimaldis Gallery; 73: © Hiroshi Sugimoto, courtesy Fraenkel Gallery, San Francisco and Pace Gallery, New York; 74, top: © 2012 The Barnett Newman Foundation, New York / Artists Rights Society (ARS), NY ; 74, bottom: Ezra Stoller © Esto; © 2012 The Barnett Newman Foundation, New York / Artists Rights Society (ARS), NY; 75: © 2012 The Barnett Newman Foundation, New York / Artists Rights Society (ARS), NY; 76: © Chris Hellier / Corbis; 77: Photo by Dave Morgan / Collection of Tate, London; 78-79: MGM / The Kobal Collection / Art Resource; 81: Courtesy of The Library of The Jewish Theological Seminary; 82: Public domain; 83: © www.atomium.be / SABAM 2009 / Maurice Mikkers; 84: © Estate of Kenneth Noland/Licensed by VAGA, New York, NY; 85: Courtesy of The Library of The Jewish Theological Seminary; 86: Louis I. Kahn: Complete Work 1935-74 by Heinz Ronner, Sharad Jhaveri, Assleandro Vasella. Institute for the History and the Theory of Architecture. The Swiss Federal Institute of Technology, Zurich. Courtesy Louis I. Kahn; 87: Digital Image © The Museum of Modern Art / Licensed by SCALA / Art Resource, NY; 88, 89: Kent Larson; 90: Louis I. Kahn: Complete Work 1935-74 by Heinz Ronner, Sharad Jhaveri, Assleandro Vasella. Institute for the History and the Theory of Architecture. The Swiss Federal Institute of Technology, Zurich. Courtesy Louis I. Kahn; 91: © 2012 DigitalGlobe / Google Earth; 92-93: Raymond Meier / Trunk Archive; 94: © The Frank Lloyd Wright Fdn, AZ / Art Resource, NY; 95: Photograph by Biff Henrich / IMG_INK, courtesy Martin House Restoration Corporation; 97: © ADK (Akademie Der Kunste); 98: Foto Marbug / Art Resource, NY; 99: Photograph by Gilles de Chabaneix © Mittel Europa; 100: © 2012 Eusko Jaurlaritza – Gobierno Vasco / Google Earth; 101: © Jeff Goldberg / Esto. All rights reserved.; 102-103: © Ludovic Maisant / Hemis / Corbis; 104, top: Public domain; 104, bottom: © The Frank Lloyd Wright Fdn, AZ / Art Resource, NY; 105: Photo by Balthazar Korab, Courtesy The Library of Congress; 106: Photograph by Alexander Gorlin; 107: Jacob Stelman Collection, Athenaeum of Philadelphia; 108-109: © Iwan Baan; 111: Public domain; 112: Gianni Dagli Orti / The Art Archive at Art Resource, NY; 113: Photograph by Lucien Herve / The Getty Research Institute, Los Angeles (2002.R.41); 114, 115: Raymond Meier / Trunk Archive; 116-117: ©DB-ADAGP Paris; 118: © 1998 Kate Rothko Prizel & Christopher Rothko /Artists Rights Society (ARS), New York; 119: © 1998 Kate Rothko Prizel & Christopher Rothko /Artists Rights Society (ARS), New York / Photo © National Gallery of Canada, National Gallery of Canada, Ottawa; 120-121: Roland Halbe; 122: © Paul Warchol; 123: Steven Holl Architects; 124: © Štepán Bartoš; 125: Courtesy Moossbrugger, Zurich; 126-127: Hans Sylvester / Fondacion Le Corbusier; 128, top: Stanley Saitowitz / Natoma Architects; 128 bottom, 129: Photo by Rien van Rijthoven. Courtesy Stanley Saitowitz / Natoma Architects; 130-131: Photo by Bruce Damonte. Courtesy Stanley Saitowitz / Natoma Architects; 132-133: Jeff Heatley; 134-135: © Sigmar Polke / Grossmünster Zürich (Photo: Lorenz Ehrismann); 136-137: Francois Halard / Trunk Archive; 138-139: Photo by Peter Aaron / Courtesy Alexander Gorlin Architects; 141: © Carlo Orsi; 142: Courtesy Studio Daniel Libeskind; 143: © BitterBredt; 144-145: © Webb Aviation / Studio Daniel Libeskind; 146, 147: © Alan Karchmer / Esto; 148: © Duccio Malagamba / Courtesy COOP HIMMELBLAU; 149: bpk, Berlin. Art Resource, NY; 150-151: Courtesy the artist and Frith Street Gallery, London; 152: © Boden Davies / Courtesy LAB Architecture; 153: Courtesy LAB Architecture; 154-155: Photo Tom Vack, Munich. © Ingo Maurer GmbH; 157: Nigel Young / Foster + Partners; 158, top: Adoc-photos / Art Resource, NY; 158, bottom: © Corbis; 159: Album / Art Resource, NY; 160-161, 162-163: © Iwan Baan; 164, top: Courtesy of The Library of The Jewish Theological Seminary; 164, bottom: Louis I. Kahn Collection, the University of Pennsylvania and the Pennsylvania Historical and Museum Commission; 165: Kent Larson; 166, 167: bpk, Berlin / Art Resource, NY; 168-169: Courtesy of José Fernando Vázquez-Pérez; 171: Erich Lessing / Art Resource, NY; 172: © The Estate of Ana Mendieta Collection / Courtesy Galerie Lelong, New York; 173: Rimma Gerlovina, Mark Berghash, Valeriy Gerlovin, *Golem II* © 1987, collection of The Jewish Museum, New York; 174: The Jewish Museum, New York / Art Resource; 175: Photofest; 176, 177: Museum of Modern Art; 178-179: Public domain; 180: John Hejduk Fonds, Candadian Centre for Architecture, Montreal; 181: © spreephoto.de / Getty Images; 183, 186, 187: © Anselm Kiefer; 184, 185: © Anselm Kiefer / Courtesy Gagosian Gallery / Photography by Robert McKeever; 193: Courtesy of The Library of The Jewish Theological Seminary;

DEDICATION
In memory of my mother and father.

ACKNOWLEDGMENTS
I would like to thank my friend and publisher Suzanne Slesin, who had the vision to see the merits of this book, where others had "eyes that do not see"; Perri Lapidus, my Kabbalistic muse, for her indefatigable strength and organizational skills in gathering images from the four corners of the Earth; Stafford Cliff, for his gorgeous design; Dominick Santise, Jr. for his precise production; Regan Toews and Ed Lessard, for their superb research; and Deanna Kawitzky and Marion D.S. Dreyfus, for refining the text. To Moshe Idel, who encouraged me to pursue this book, despite my humble reticence in his brilliant presence; to Daniel Matt, whose magisterial translation of the *Zohar* inspired so many of my comparisons to art and architecture, and whose prompt response to a technical question taught me that a true scholar is open to dialogue; and to Rabbi Marvin Tokayer, who was open and supportive of Kabbalistic themes in the North Shore Hebrew Academy synagogue. I am grateful to Rabbi Adin Steinsaltz, for his inspiring books, and for meeting with me to discuss the possibility of the relationship between Kabbalah, art, and architecture, and to Rabbi Leibel Rockove, who was always open to discussion about architecture in the Bible and the *Mishnah*. Thanks to Craig Robins for inviting me to a private symposium with Rabbi Steinsaltz, Rabbi Poupko, and Margot Pritzker, which further opened my eyes to Kabbalah. Thanks to Rosemarie Bletter, for her great essay on German Expressionism, to Anastasia Eagle, for her careful research, to Richard Hayes, for his continued scholarship and help, and to Ealan Wingate, my liaison to Anselm Kiefer. Gratitude to Daniel Scheutz, for his lyrical translations into English of Bruno Taut and Paul Scheerbart, and many thanks to Anne Barlow, Michael Steinberg, and Lucie Steinberg for discovering young artists who are inspired by these themes.

ALEXANDER GORLIN is a noted architect, design critic, author, and scholar. His internationally recognized firm Alexander Gorlin Architects specializes in design for religious institutions, along with high-end residential, affordable, and supportive housing for the homeless, as well as master planning. Established in 1987, the firm has received many accolades, including four Design Excellence Awards from the American Institute of Architects. Principal Alexander Gorlin has taught at the Yale School of Architecture, and became a Fellow of the American Institute of Architects (AIA) in 2005.

COVER In contemporary Japanese artist's Yayoi Kusama's New York installation *Aftermath of the Obliteration of Eternity*, 2009, an entirely mirrored and darkened room is illuminated by the illusion of thousands of candles. The sense of an explosion in complete quiet recalls what happens when catastrophe occurs in the vacuum of space.

ENDPAPERS In Dhaka, Bangladesh, by American architect Louis Kahn, is a canopy of eight parabolic concrete shells that intersect at the central point of the space, 112 feet above the National Assembly. The domed crown of light appears to hover above the octagonal room, supported on eight points where the shells fold down to the corners, at the top of the sheer side walls. A network of cylindrical downlights suspended from overhead wires gives the appearance of stars in the heavenly sky. The space is the embodiment of *Keter*, the crown of the *Sefirot*, and a microcosm of the dome of heaven. In the *Zohar*, what is below in our world reflects the heavenly world above, and the Assembly perfectly embodies this concept of the Kabbalah.

OPPOSITE HALF TITLE The central space of Japanese architect Masaharu Takasaki's 1991 *Zero Cosmology* house on the island of Kyushu, in Japan, is an egg-shaped dome with apertures that let light in, recreating the night sky. The idea of our world as a microcosm of the Divine world above is a frequent message in the Kabbalah.

OPPOSITE TITLE PAGE In the vision of Ezekiel, God on his throne-chariot addresses the prophet as *ben adam*, the "son of man." This ambiguous phrase is reflected in German artist Sigmar Polke's 2009 window for the cathedral in Zürich, Switzerland, where the silhouettes of a man perceptually oscillate with the image of a glowing chalice of light.

OPPOSITE TABLE OF CONTENTS British artist William Blake's watercolor etching entitled *Ancient of Days*, from 1794, is based on medieval images of God as the architect of the universe, shown with a compass in hand. It illustrates the verse from *Proverbs 8:27*—He "set a compass on the face of the deep." Blake also emphasizes the hidden order of universal geometry by his use of the circle, triangle, and right angle—God's arm and beard—to organize the composition.

OPPOSITE The *shiviti* is a mystical device of images and words that direct the mind to prayer and meditation, like a Buddhist or Hindu mandala. *Shiviti* is the first Hebrew word of the verse "I have set the Lord before me always" *(Psalm 16-8)*. Highly decorative in its array of symbols and words, it was often set on a plaque at the entrance to a synagogue. They often included the Tetragrammaton, the four-letter unpronounceable name of God, which is portrayed here along with hands in the configuration of the priestly blessing, forming *shaddai*, another name of the Divine. Two *magen davids* (stars of David) flank the name, and three crowns of the Torah, referring also to the highest *sefirot* (*keter*). A seven-branched *menorah* is at the bottom, between the ten commandments.

Alexander Gorlin Architects
137 Varick Street
New York, NY 10013
www.gorlinarchitects.com

Inquiries should be addressed to:

Pointed Leaf Press, LLC.
136 Baxter Street, New York, NY 10013
www.pointedleafpress.com

Pointed Leaf Press is pleased to offer special discounts for our publications. We also create special editions and can provide signed copies upon request. Please contact info@pointedleafpress.com for details.

Printed and bound in Singapore
First edition
10 9 8 7 6 5 4 3 2 1
Library of Congress Control Number: 2012951386
ISBN: 9781938461071

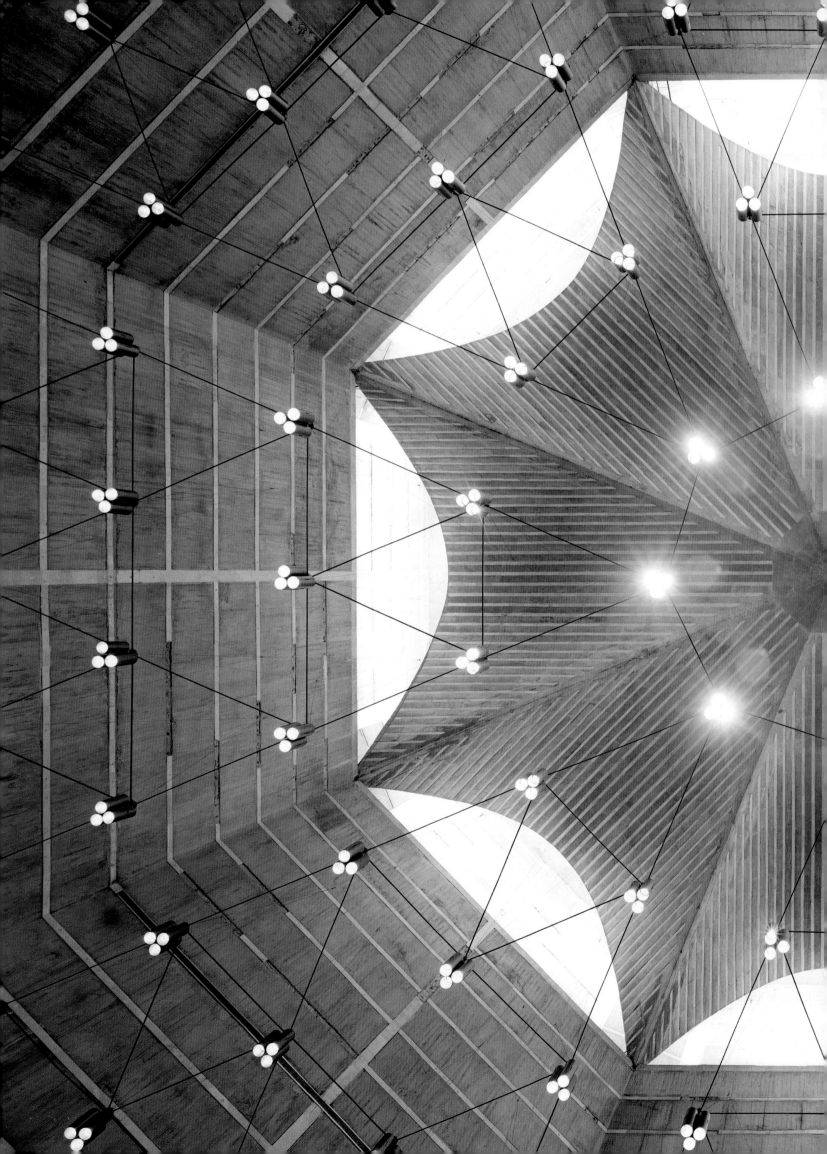